Art Labor, Sex Politics

Art Labor,

Sex Politics

Feminist Effects in 1970s British Art and Performance

SIONA WILSON

University of Minnesota Press
Minneapolis / London

Portions of chapter 2 were previously published as "From Women's Work to the Umbilical Lens: Mary Kelly's Early Films," *Art History* 31, no. 1 (February 2008): 79–102.

Published by the University of Minnesota Press
111 Third Avenue South, Suite 290
Minneapolis, MN 55401–2520
http://www.upress.umn.edu

Library of Congress Cataloging-in-Publication Data
Wilson, Siona.
 Art labor, sex politics : feminist effects in 1970s British art and performance / Siona Wilson.
 Includes bibliographical references and index.
 ISBN 978-0-8166-8573-8 (hc : alk. paper)
 ISBN 978-0-8166-8575-2 (pb : alk. paper)
 1. Sex differences in art. 2. Sex role in art. 3. Women and the arts—Great Britain—History—20th century. 4. Arts and society—Great Britain—History—20th century. I. Title.
 NX650.S54W55 2014
 704'.042094109047—dc23

 2014029552

Printed in the United States of America on acid-free paper

The University of Minnesota is an equal-opportunity educator and employer.

20 19 18 17 16 15 10 9 8 7 6 5 4 3 2 1

For Ben
and
in memory of my grandmother,
Jane Harvie (1915–2011)

We are witnessing a certain reversal of values: manual labor and art are being revalued. But the relation of these arts to sexual difference is never really thought through and properly apportioned. At best, it is related to the class struggle.

— Luce Irigaray, *The Ethics of Sexual Difference*

Contents

Introduction
Sex Politics

We were struck by how many mentioned in the same breath the Ford strike and a paper
written by an American, Anne Koedt, which had begun to circulate on ill-typed roneoed
sheets amongst British women in 1969. Entitled "The Myth of the Vaginal Orgasm," it
pointed out that the clitoris, not the vagina, was the center for sexual pleasure, and it drew
attention to the manner in which this potent little fact had been suppressed. . . . Women
clearly sensed that the two were part of the same problem, although few would have
consciously spelt out the connection at the time.

 —Beatrice Campbell and Anne Coote, *Sweet Freedom: The Struggle for Women's Liberation*

By common consent for decades now, the worst of time [in contemporary British history]
came between the election of Edward Heath in 1970 and the election of Margaret Thatcher
in 1979 . . . [but] the decade was not the hangover after the sixties; it was when the great
sixties party actually got started.

 —Andy Beckett, *When the Lights Went Out: Britain in the 1970s*

The germ of this book was a surprising detail about Mary Kelly's early collab-
orative work. It was just another art historical reference, a tidbit of information
that Griselda Pollock dropped in as background texture in a passage in her
essay "Screening the Seventies" about Kelly's best-known work *Post-Partum
Document* (1973–79). I was already familiar with *Post-Partum Document*, and
as a graduate student of art history and feminist theory I was studiously—if
rather coolly—interested in this icon of feminist conceptual art. But what I
had just discovered about Britain's best-known feminist artist was that she
had collaborated on a documentary film about women night cleaning work-
ers.[1] At the time this idea seemed improbable. Perhaps it was just a rumor, I

thought, but if true it would change my whole idea of the artist. And it did. It was 1997 before I got the chance to see the film. Mesmerized by the world that it conjured up, this experience was the kernel for this book. How could such different projects coexist and belong to a single artist's oeuvre? And more important, what else was there to find?

Pollock screened *Nightcleaners* (1972–75, Berwick Street Film Collective) at a conference called "Work and the Image" early on Sunday morning—a time for only the most committed. As the 16 mm film whirled through the projector, it occurred to me that there was more to the sexual politics of art in 1970s Britain than *Post-Partum Document*. *Nightcleaners* revealed the texture and landscape of an emerging sexual politics in postcolonial Britain with the silences and caesuras of its narration like visual scars. In marked contrast to Kelly's restrained use of Lacanian theory and iconoclastic reliance on text, *Nightcleaners* revels in the visual complexity of the medium of film. It offers a vivid sketch of this new political moment, a feminist politics, yet this is not a straightforwardly realist work. As I began to dig into the archives and read the aesthetic debates of the period—including the theoretical turn in film studies, the near revelatory enthusiasm for Brechtianism provoked by Jean-Luc Godard's post-'68 work, and the reengagement with the historical avant-gardes—this film opened a window onto a layered and complex political aesthetic where sexual difference was a central concern. A stranger story about 1970s Britain than the one we have come to know, *Art Labor, Sex Politics: Feminist Effects in 1970s British Art and Performance* gives an account of this conflicting, nuanced, and largely overlooked artistic milieu of which Kelly's canonical installation was but only one part.

Art Labor, Sex Politics is not a survey of art produced in Britain during the decade of the 1970s. This project has already been undertaken—impressively and comprehensively—by John A. Walker in his 2002 book, *Left Shift: Radical Art in 1970s Britain*. Walker begins by noting the numerous clichés of this period, or, as one critic put it, "the decade that style or taste forgot."[2] The "undecade" (1), Walker argues, has long been defined by a sense of fragmentation and a vaguely understood pluralism. In counterpoint, *Left Shift* offers a provisional coherence in defining art in the British 1970s by its "repoliticization and feminization, its attempt to reconnect to society at large" (2). He then

goes on to pinpoint his central thesis and explain his book's title by describing his "unitary theme" as a "shift to the Left." My account—a slice through the decade rather than a comprehensive overview—is a slowing of Walker's swift slide from "repoliticization and feminization" to the "unitary theme" of "the Left." Each chapter focuses on a case study of a significant artistic project that unfurls the different ways in which feminism destabilizes the idea of the political that is typically associated with the left. As Irigaray has pointed out, with the recent politicization of art, "the relation of these arts to sexual difference is never really thought through and properly apportioned," but rather, as we see with Walker, "at best, it is related to class struggle."[3] Taking my cue from the omission that Irigaray identifies, this art historical study starts with a basic problematic, the relation between sexual difference and class difference. Femininity and labor, or the trope of work and the interruptive presence of sexuality, have long been central aesthetic figures for modernist practices, occupying quite different—frequently opposed—conceptual terrains. But after the so-called sexual revolution of the 1960s and the political uprisings of May '68, the relation between these two categories became newly charged. When one lingers on the question of sexual difference, my book asks, to what extent does this political inquiry transform our approach to aesthetic debates? What does a proper apportioning of the significance of sexual difference in relation to the trope of labor have on the very conception of the political within cultural practice? Since this is not simply a question of adding women's work to our understanding of class politics, what other areas of experience does the focus on sexual difference force us to reconsider? The book takes the following case studies as key examples: the experimental documentary film *Nightcleaners*, Mary Kelly's film-loop installation *Antepartum* (1974), COUM Transmissions' performance-based installation *Prostitution* (1976), and Jo Spence and Terry Dennett's photographic series *Remodelling Photo History* (1979–82). Each chapter forms a node of focused inquiry into an aspect of sexual difference as it relates to questions of gendered labor, the reproductive female body, sex and sexuality, and psychic development. These interconnected case studies constitute a sustained set of practices addressed to the figuration of sexual difference in 1970s Britain. I hope that this book will finally help dispel the clichéd characterization of the so-called undecade

and open a door onto the exciting, innovative, and risky works that defined the sex politics of the period.[4]

"There was no nihilism in the contestation that burned up that month in May '68," Julia Kristeva recalls more than thirty years later. It was "a violent desire to rake over the norms that govern the private as well as the public, the intimate as well as the social, a desire to come up with new, perpetually contestable configurations."[5] Kristeva's is a familiar account of the condition of avant-gardist innovation, or "permanent contestation," that characterized the new conception of the political promised that spring. (The form that it took, the revolt, is of course very familiar.) But the "crisis of May '68," as Kristeva goes on to discuss, is when the "perpetually contestable" must "cleave to institutions that will realize it in the long term" (42). This is when the energy of the revolutionary impulse is put to work, when the upending of all norms ceases—is compromised, some might say—to create a new social order. The push and pull between the ongoing avant-gardist impulse of the revolt and this coalescing, or necessary, institutionalization in the slower work of social change generates the post-'68 condition that Kristeva calls "permanent crisis" (42). A more complex concept than the easily romanticized idea of the revolt, the permanent crisis is the focus of Kristeva's writing on the significance of '68. While the energy and the excitement of the revolutionary moment remains an important driving force, the shift is from violent rupture and contestation to social change. If May '68 is the political watershed for the sex politics of my book, it is in the form of permanent crisis rather than the permanent contestation of the revolt.

Sex Politics, a key phrase in my book's title, serves as shorthand for the collision of private/public and intimate/social given in the above quotation by Kristeva. But in its activist and its intellectual forms, the post-'68 condition of permanent crisis is much more difficult and seems decidedly less exciting when compared with the avant-gardist mise en abyme of the revolt. Because of this, in many of the art historical accounts of May '68 it is treated as an end point, and recent aesthetic returns are more often characterized by melancholia.[6] Moreover, with specific reference to the sexual politics of this book, "seventies feminism" has come to signify the quintessence of intellectual flat-

footedness and the joylessly dull. And a more generalized sense of post-'68 malaise has also contributed to the idea of the 1970s as the undecade, or, as the historian Andy Beckett puts it, "the hangover after the 1960s."[7] Like Beckett in *When the Lights Went Out: Britain in the Seventies,* a long-needed political reconsideration of the decade, I have also found that the decade of the seventies was, metaphorically speaking, when "the great sixties party actually got started" (209). This is when the 1960s promise of intervening in institutions began to be realized in practice, and this work was made possible by the libidinal energy that began with the rupture of the sixties. Thus, the generalized gloom about the 1970s (which is not restricted to Britain alone) only makes sense if we fixate on the (inevitably) lost revolt and overlook the day-to-day grassroots transformations that took place in the home, the bedroom, and in the workplace because of the explosive eruption of the women's liberation movement. We would also have to forget the brave and fabulous men and women of the gay liberation movement, whose movement name was derived from that of their feminist sisters.[8] (And after all, what's a good party without the queers?) Rather than Walker's left shift, the 1970s that this book describes witnesses the destabilization and feminist reinvention of the British left.

My study is characterized by the continuity and (feminist) transformation of key '68 cultural themes. Examples include the continued valorization of industrial production over consumption (the spectator as producer), ceding to the idea of sexual re*production*—the feminine body as psychically and biologically generative; the exploration of the mother/daughter axis and pre–oedipal notions of psychical formation following May '68's oedipal crisis against the father-state; the ongoing questioning and transgression of the heteronormative family unit (sexual freedom, queerness, transvestism, polymorphic sexualities); the continued celebration of the ludic, or nonproductive, notions of play; the inversion or displacement of the hierarchies of intellectual labor and manual labor, head/hand, mind/body, in relation to new democratic modes of education; the resurgence of nonreligious forms of the sacred; the tension between notions of sexual freedom and the (feminine) body as commodity; a rethinking of pedagogical hierarchies and new approaches to learning; and the questioning of institutional norms, including (but not restricted to) the art world.

The first significant second-wave British feminist text was published in 1966, well before May '68 and before any signs of a burgeoning women's liberation movement in the United Kingdom. "Women: The Longest Revolution," as the essay's author Juliet Mitchell later describes, was addressed to the New Left. In the 1970s it became a touchstone for the British feminist movement and was reprinted numerous times, often—as Mitchell proudly recounts—in pirated form.[9] It is also important for this study because it provides a structure for the way that my chapters interrelate. Mitchell's description, written in 1984, of the political context of that time is particularly revealing. While teaching in the English Department at the University of Leeds, she writes:

> I was active in the New Left, where we were then preoccupied with countries of the Third World. It was Frantz Fanon's argument from his Algerian experience that women—a conservative force—should be emancipated only after a revolution that provoked my indignation and tied in with my personal experience. . . . In the Marxist meetings on the politics of the Third World, in the University common rooms I frequented, where were the women? Absent in the practices and in the theories. Why this sort of common experience led so many of us to feminism at that particular time, though I can think of many explanations, I do not really know. . . . Finally I wrote "Women: The Longest Revolution"—very much for my New Left friends and colleagues.[10]

Mitchell seems to acknowledge Fanon's insight, but given the dearth of women in the New Left meetings she attended, her essay offers its own explanation.[11] She lays out the historical repetitions in the Marxist debate on the so-called woman question that reveals gender as the left's massive blind spot.[12] For socialist thinkers—citing Charles Fourier, Karl Marx, Friedrich Engels, August Bebel, and Vladimir Lenin—Mitchell concludes, "The liberation of women remains a normative ideal, an adjunct to socialist theory, not structurally integrated into it" (24). In laying the groundwork for a different approach, she argues that the "woman question" should be seen not as a unified single issue but rather as divided into different structural elements that overlap in complicated ways. She identifies this "complex unity" as "production, reproduction, sex, and the socialization of children" (26). Socialist thinkers have

typically explained reproduction, for example, through the much more fully elaborated model of production so that, as Mitchell puts it, "At present, reproduction in our society is often a kind of sad mimicry of production" (33). But "the mother's alienation," she points out, "can be much worse than that of the worker" (33). Sex and sexual freedom—the great taboo in Marxism—intersect with production and the capitalist system in contradictory ways. While women have long been appropriated for sex, and capitalism allows for an acceleration and intensification of the female body as commodity, she also speculates that it might also provide the *possibility* of the preconditions for sexual emancipation. In relation to her final point, the socialization of children, she invokes Freud, an author whose work Mitchell would become closely involved with in the following decade.

The elements of this four-part structure prefigure the key debates that shaped second-wave feminism in Britain. Indeed, the demands drawn up for the first feminist marches in 1971 echo and overlap with Mitchell's complex unity: (1) Equal pay now. (2) Equal education and job opportunities. (3) Free contraceptives and abortion on demand. (4) Free twenty-four-hour nurseries.[13] This is not to say, however, that there is any straightforward continuity between the theoretical structure Mitchell unfolds and its activist realization. Theory and practice do not align in such a direct way. Moreover, Mitchell's complex unity is not a programmatic model but rather a structure that is subject to a range of possible configurations *in practice*. It is for this reason that I place an emphasis on the idea of instability in the political framework that defines this book, since the works I take as the focus of each chapter reveal this complex problematic in their aesthetic and political working-through. Broadly speaking, the political aesthetic that unfolds across the arc of the book echoes the structure that Mitchell describes. Chapter 1, addressed to the experimental documentary film *Nightcleaners*, is one of the most significant instances of feminist labor activism and one that takes the postcolonial female subject as its focus. The question of production, moreover, is not restricted to the film's subject but was also a trope that defined the formal structure of the work and the new kind of viewing experience that it required. Through attention to affect, this chapter explores how this notion of production, a political aesthetic that comes from the left, intersects with gendered labor and feminist

activism. In chapter 2, the foundational leftist theme of production intersects with biological reproduction in relation to Mary Kelly's film-loop installation *Antepartum.* This chapter puts pressure on the points at which these two categories diverge and offers a reading of the work that suggests other erotic possibilities. If I am merely evoking the question of self-pleasuring as a hidden undercurrent in this work by Kelly, sex emerges full form in chapter 3, addressed to COUM Transmissions' *Prostitution.* In contrast with Mary Kelly's *Post-Partum Document,* which tracks the normative socialization and psychical formation of the (male) child, COUM's installation stages a riotously queer aesthetic. While these two projects are markedly different in tone, I argue that their shared engagement with sexual difference, sexuality, and the psyche finds unexpected points of connection that challenge many longheld assumptions about feminist art. In relation to a photographic series by Jo Spence and Terry Dennett completed in the early 1980s, the final chapter serves as a reflection on the social and psychical dimensions of sexual difference that have unfolded across the book. I use Spence and Dennett's work to track the shifting feminist debates about sex, sexuality, and representation following the scandalous tabloid reception of Kelly's and COUM's work.

Mitchell's reflections on the woman question in the context of the New Left of the mid-1960s evolved in relation to a broader political engagement with third world radicalism. This postcolonial frame, as current terminology has it, is a subtheme in my book. The question of postcoloniality is emergent during the 1970s, and the challenges of a newly radicalized diasporic generation begins to take form during this decade. The Institute of Race Relations, an antiracist think tank, had published their journal *Race and Class* since 1959. Birmingham Cultural Studies, founded in 1964 under the leadership of Simon Hoggart, was taken over by Stuart Hall in 1968.[14] But a full-blown postcolonial aesthetic doesn't emerge until 1981 when Salman Rushdie's *Midnight's Children* was published. In the visual arts, experimental film led the way with the formation in the mid- to late 1980s of the Sankofa Collective (Martina Atille, Maureen Blackwood, Nadine Marsh Edwards, and Isaac Julien) and the Black Audio Film Collective (John Akomfrah, Reece Auguiste, Lina Gopaul, Avril Johnson, Trevor Mathison, and Edward George), as well as significant individual films such as Stephen Frears's *Sammy and Rosie Get*

Laid (1987).[15] The postcolonial question is not more central in this book because, as Mitchell has put it elsewhere, "The search in those days of early second-wave feminism was for what qualities women had in common across the many huge divides of class, race, ethnicity, family ties. . . . The question was: what differentiates women, not from each other, but from men?"[16] The experimental documentary film *Nightcleaners,* discussed in chapter 1, intersects with (and is interrupted by) another postcolonial narrative, but this registers most profoundly through the expressive silences that disturb the film's feminist discourse. I point to the engagement with postcolonial issues in the next decade, and I conclude the chapter with a discussion of the Black Audio Film Collective as they develop a complex and subtle postcolonial aesthetic that allows us to read the silences in the Berwick Street Film Collective's formative work.[17] A sense of this postcolonial ferment is picked up once more as we move to Jo Spence and Terry Dennett's photographic practice in chapter 4. Here questions of post-Empire Britain come up more pressingly, and the predominantly racialized coding of British postcolonial space at this time crosses at a tangent with the sex politics of this book.

Just as this book is structured by a productive instability in the relationship between feminism and the left, there is also a necessary instability in the definition of feminism itself. In the 1970s—and to some extent now—being a feminist was a question of identity (an identity, moreover, that this author readily claims). It denotes a political position, sometimes with modifiers such as radical, socialist, lesbian, psychoanalytic, or sex-positive—but, as these various modifiers might suggest, the term *feminism* is subject to intense contestation. Part of my project is to track some of the conflicts in the claims made for feminism during the 1970s. For example, one of the main undercurrents I address throughout the book is a debate that coalesces toward the end of the decade between socialist feminism and psychoanalytic feminism about the place of the psyche in relation to social change. Other key conflicts emerge around the question of housework and affective labor (such as mothering) in relation to adapted Marxist models of production, the question of sexual freedom versus objectification, and more generally, the radicalization of art world norms.

Feminist instability notwithstanding, all the key works I analyze in this

book were shaped by and/or animated serious feminist debates. But not all of these works can be described using the curatorial category "feminist art," and not all of these artists would claim the term *feminist*. Thus I refer in my book's subtitle to feminist *effects* in order to prepare the reader for the fact that this is not straightforwardly a study of feminist art. I point this out since, in recent years, there has been a resurgence of women-only exhibitions of "feminist art" in mainstream art museums. While it is indeed the case that institutional sexism is still a huge issue in the art world, it nonetheless seems to be a peculiar anachronism that as feminist art becomes part of "the dominant" (to use Raymond Williams's term), the underlying assumption seems to be that *feminism equals woman*. While this book is addressed to the heyday of the organized women's liberation movement in Britain and is centrally concerned with debates within feminism, I nonetheless diverge from this women-only approach. I do discuss certain all-female collaborations (such as the Hackney Flashers' photography collective and the conceptual art installation *Women and Work* by Margaret Harrison, Kay Fido Hunt, and Mary Kelly), but mixed-gender collaborations make up most of this book's key examples. It is in such projects—perhaps *because* both women and men made them—that the complexities, aporias, and contradictions between sexual difference and social inequality, gender and class, femininity and the political are played out to the greatest extent. Furthermore, I am particularly attuned to the way in which the gender dynamics of these collaborations are negotiated in my analysis of the works, between the artists themselves, and through other art historical writings. For example, in one of the most influential recent art historical interpretations of the Berwick Street Film Collective's *Nightcleaners* (made by four men and one woman), the role of the woman participant, Mary Kelly, has become a defining voice. An indication of the art historical significance of Kelly's involvement can be seen in the fact that *Nightcleaners* was included in the all-*female* survey exhibition *WACK! Art and the Feminist Revolution* (the male coauthorship was overlooked).[18] In the recent feminist rediscovery of COUM Transmissions' installation *Prostitution* in the same museum context, only the contributions by the group's female participant, Cosey Fanni Tutti were shown. Tutti's work is severed from the overall installation, but when seen together with the other elements by her male collaborators, as I argue

in chapter 3, *Prostitution* stages sexuality and sexual difference in relation to assumptions about gendered authorship.[19]

Collaboration is the standard in British art of the seventies, and this is one of the ways in which the institution of art is redefined. "The Death of the Author," as the title of Roland Barthes's 1967 essay puts it, is often associated with art of the 1960s. But in practice, it is in the 1970s where we see the displacement of the *individual* author and the restructuring of the creative act in collective terms.[20] Focusing on collaborative work by both men and women is not an attempt to recover male contributions to feminist art. Rather, gender erasures and distortions attest to the ongoing difficulty—particularly within the discipline of art history—in accounting for collaborative modes of practice. And by extension this also reveals the continued interruptive challenges caused by gender dynamics in relation to institutional, interpersonal, and interpretative practices in the visual arts.

The title of my Introduction to this book is a deliberate echo of Wilhelm Reich's *Sex-Pol*, a term he coined in the late 1920s in order to convey a linkage between the question of sexuality (and psychical life) and revolutionary politics. Having been relegated to the wastebasket of history for decades, Reich's work was taken up by the May '68 generation. In 1967, the French Trotskyite Boris Frankel gave a public talk on Reich at Nanterre University, and this became a mobilizing force for the student movement that developed. Only one week later, Reich's booklet *The Sexual Struggle of Youth* was being sold across campus. With a new English translation in 1972, *Sex-Pol* became a touchstone in the 1970s for the British cultural left.[21] Indeed, one of the most substantial post-'68 engagements with Reich's oeuvre is seen in Juliet Mitchell's 1974 book *Psychoanalysis and Feminism,* a text that marks the first significant feminist engagement with the Freudian legacy.[22] My invocation of Reich is intended to mark the reverberations in the 1970s of his politicized notions of the social and the psychic that take on a decidedly feminist cast in this period.[23]

Astrid Proll recounts another version of Reich's conjunction that is particular to Britain. As an exiled member of the Red Army Faction, Proll spent four years in London in the seventies hiding out amid its expansive squatting

communities.[24] During the 1968 women Ford machinists' strike, a founding moment in British feminist history, she learned that "a celebrated unionist nearly raped a young female comrade amid the bizarre machine landscape." He, Proll concludes, "wanted a quick lay to make his euphoria of strike and triumph that much sweeter."[25] This rather dark conjunction of sex and labor activism is put into a more affirmative relation in the first epigraph that heads this Introduction. Anne Coote and Beatrice Campbell, in the first historical account of the British women's liberation movement, note a surprising juxtaposition that emerged during the course of their research. When they interviewed women who were actively involved in the movement, two formative examples in their personal feminist history were repeatedly cited: the 1968 strike of the women machinists (the scene of Proll's story) at the Ford factory in Dagenham, Essex—an event that eventually led to the Equal Pay Act of 1970—and Anne Koedt's essay about clitoral pleasure and the female orgasm. Sex is thus combined with politics, but, the authors point out, "Women clearly sensed that the two were part of the same problem, although few would have consciously spelt out the connection at the time."[26] As Juliet Mitchell describes in her analysis of the complex unity of the woman question, there is indeed a relationship between these two seemingly different events, but tracking the connections is not straightforward. As an index of the conflicts that mark the relationship between sex and politics, one example emphasizes female pleasure and the other its coercive inverse.

I use the word *sex* conjoined with *politics*, as opposed to other important terms, such as *sexual difference, sexuality, gender, femininity,* or *queerness,* because I want to suggest aspects of all these ideas without restricting my subject to only one. In the 1970s the relations between these distinct but interconnected concepts were still very much up for grabs. But after four decades of institutionalization within the academy, the new disciplinary formations of women studies, gender studies, masculinity studies, sexuality studies, and queer theory (and their various combinations) have all laid claims to each of these terms and shaped their meaning in differing ways. The tension between the social and the psychical instantiation of sex/gender were highly charged issues in the 1970s, but I must negotiate this in relation to the shifting sands of these subsequent intellectual histories. One of the most controversial ways

in which the relationship between sex and politics unfolds in the intellectual history of the period is in the reception of psychoanalysis. While Freud is the founding figure here, his work is read alongside the work of Jacques Lacan in particular and other more recent French theorists.[27]

The awkwardness of the term *sex/gender* marks a linguistic divide between English and French that adds an additional complexity to the disciplinary divergences noted above. The terms *sex (sexe)* and *gender (genre)* have markedly different meanings in English and French, and these differences have caused a good deal of confusion and misunderstanding, particularly in the context of the anglophone essentialism debates of the 1990s. While this is not the place to elaborate the more than fifty-year-long history of the sex/gender divide, an awareness of the different uses of these terms is part of the larger methodological framework of this book.[28] Simply put, gender understood in social terms is typically concerned with the institutional construction of masculinity and femininity. This anglophone framing of gender is defined against the ideologically powerful and commonsensical "natural-biological" notion of sex (the essentialist reduction of woman to womb) not the more philosophically evolved formulation of the French feminist tradition.[29] The social conception of gender might be summarized through the notion of rights-based feminism (labor equality, the critique of normative gender roles, reproductive freedoms, nonsexist language, etc.). This aspect of feminism is thematized in my book principally through the artistic (and activist) examination of women's work: inside and outside the home, sex work as another kind of female-specific labor (prostitution and pornography), and the re*productive* female body. The term *gender* usually cedes to *sexual difference* when psychical reality is brought into play. It refers to the lines of connection between biological notions of male and female as they intersect in complex ways with social and cultural ideas of masculinity and femininity. The term comes from the French *différence des sexes* (sex difference) or *la différence sexuelle* (sexual difference), where both phrases are used somewhat interchangeably. Although *sexual difference,* as it is used in anglophone feminist writing, is associated with psychoanalysis, it is not originally a psychoanalytic term. Rather, its use became widespread in the 1980s, and it describes feminism's encounter with and critical reworking of psychoanalytic accounts of sexuality.[30]

In the United Kingdom, in contrast to the United States, the debate about psychoanalysis within the women's liberation movement extended beyond academic circles. This narrative is told mainly in chapters 2 and 4 in relation to Mary Kelly, Laura Mulvey, and Jo Spence. It is interesting to note that members of the same London Women's Liberation Workshop that first coordinated with the labor activist May Hobbes for the unionizing campaign of the night cleaning workers in 1970 also produced two reading groups. The History Group, formed in 1971, including Kelly, Mitchell, Rosalind Delmar, and Sally Alexander, was dedicated to reading Karl Marx.[31] Certain members of the group in 1973 formed the Lacan Women's Study Group, shifting the focus from questions of production to sexuality and the psyche. One of the most important intellectual accounts of the shift from Marx to Freud—which also maintains a significant emphasis on social questions—is Juliet Mitchell's expansive 1974 study *Psychoanalysis and Feminism.* Soon after publishing this book, Mitchell trained as a clinical psychoanalyst, but the feminist themes of her first engagement with Freud have defined her subsequent scholarship. In the cultural context, however, Mulvey's 1975 manifesto-style essay "Visual Pleasure and Narrative Cinema" probably had a broader impact. In chapter 2 I read this text alongside Kelly's film-loop installation *Antepartum,* since both these projects in a sense originated with a shared experience in the Lacan Women's Study Group. In chapter 4, in relation to Jo Spence and Terry Dennett's *Remodelling Photo History,* I further develop the implications of Mulvey's argument in relation to photographic depictions of the female body, and here I reflect on later socialist–feminist debates in the early 1980s.

Perhaps the most influential of all feminist writing to come out of Britain in the 1970s, it is now widely acknowledged that "Visual Pleasure and Narrative Cinema" led to a significant misreading of psychoanalysis.[32] The "male gaze" as discussed in Mulvey's text is not the same as the gaze *(le regard)* in Lacan. In the latter context it refers to an absence in the field of vision, a place where subjectivity is erased, a stain or blind spot; it marks the unrepresentable, death. While I address this intellectual history in chapter 4, it should also be noted that artistic responses—and there have been many—are not beholden to the same kind of rules of verification as apply to scholarly works. Furthermore, as Mandy Merck has argued, Mulvey's essay should be read as a mani-

festo and not as a straightforward work of academic exposition.[33] The most
interesting response to this essay, however, comes from Mulvey herself, not
in written form, but as another kind of text. Her experimental film *Riddles of
the Sphinx* (1977), made in collaboration with Peter Wollen, shifts the debate
about femininity and representation from questions of fetishism and objecti-
fication to the exploration of female pleasure. Rather than conventional shot-
reverse-shot editing, *Riddles of the Sphinx* is structured by a series of single
takes with the camera panning in a wide, circling arc. Thus the objectifying,
disembodied "male gaze" of the essay, which aligns with the camera's point of
view, is transformed into an embodied feminine movement in the film. The
voice of the "sphinx" is recorded so that it is barely audible, a sonic envelope
that suggests the early childhood comfort of the maternal voice. The larger
narrative arc of *Riddles* evokes the themes presented in this book: it features a
young mother who leaves her husband, enters the workplace, and eventually
begins a sexual relationship with another woman, a black woman. The film
concludes with a suggestion of the protagonist's new erotic relationship with
her female partner.[34]

Like the intimate/social and private/public antinomies that Kristeva cites
in her account of May '68, tracing the labyrinthine channels between the
social and the psychic is part of the larger theoretical narrative I chart across
the book. The best-known part of the milieu in *Art Labor, Sex Politics* is the
theoretical revolution, but this is not intended as a comprehensive intellectual
history of exactly those developments. The theoretical aspect of this milieu is
what came to shape the so-called new art history, as well as the burgeoning
discipline of anglophone film studies.[35] While a certain necessary attention
to the ebb and flow of theoretical currents is essential to this history, I am
concerned with the ways in which artists responded to this context, how
they challenged and questioned it. Thus the work of art is not treated as an
illustration of this intellectual history, as has so often been the case in art
historical accounts. I set theoretical positions into a productive dialogue with
artists' work, but not simply so that the latter is explained by the former. Take
Jo Spence's *Revisualization* from the series of photographs *Remodelling Photo
History,* discussed in chapter 4 (Figure 4.4). For many readers Mary Kelly
is thought of as the best-known psychoanalytic feminist artist, but Spence's

staging of psychoanalytic theory and practice is more in keeping with the ludic sensibility of May '68. In the explosive release of humor given in this image, Spence offers a condensation of contradictory codes—labor/sexuality, body/psyche, advanced theory/slapstick humor—that coalesces in the form of a performed montage-in-camera. To read Spence's image we must track the rocky pathways between the social and the psychical understanding of the sex/gender distinction. For this I will settle on the term *sexual differ-ence* as Judith Butler—the most sophisticated Anglo-American philosopher of gender—has described it. This is sexual difference understood as a "bor-der concept" between biological, social, cultural, and psychical categories. "Sexual difference," Butler argues, "has psychic, somatic, and social dimen-sions that are never quite collapsible into one another but are not for that rea-son ultimately distinct." Thus I concur with Butler that sexual difference is, "therefore, not a thing, not a fact, not a presupposition, but rather a demand for rearticulation that never quite vanishes—but also never quite appears."[36] "Sex" is connected to "politics," in the title of my Introduction, but at the same time each word is held apart. Simultaneously articulated and disarticu-lated, this unstable linkage is the mark of a proposition, a spacing, or an open-ing onto a possibility that cannot fully be resolved.

1970 provides three beginnings for my book: political, theoretical, and aes-thetic. The first public action in the name of second-wave feminism came that year as the English translation of Walter Benjamin's "The Author as Producer" (1934), a formative text on the significance of production in politi-cal art practice. Likewise the first preproduction work on the experimental documentary *Nightcleaners* started late in 1970, in relation to which the po-litical and theoretical beginnings of this book slowly become intertwined.[37] While the political significance of production had entered francophone film discourse in the 1960s, *Nightcleaners,* I argue in chapter 1, shifted the terms of the existing debates. Adopting a post-'68 condition of permanent crisis, the film reveals the irreconcilable contradictions in adapting the political struc-tures of a conventional class struggle to issues of sexual difference and post-coloniality. In 1975 *Nightcleaners* was heralded as Britain's foremost feminist Brechtian film when it was presented alongside films by Godard, Jean-Marie

Straub, and Danièle Huillet, as well as Brecht's own films, at the Edinburgh International Film Festival's Brecht Event. I analyze the complex layers of repetition that constitute the film's reception in relation to the Freudian concept of dream work, but I argue that the film challenges the Brechtian logic that continues to be claimed for it. Instead, *Nightcleaners* addresses the ambiguities of activism through an emphasis on minor affects. Thus, even as the concept of production was being brought to the fore in advanced critical theory, feminist artists were already beginning to question the limits of this paradigm.

The second chapter continues this engagement with production with Mary Kelly's focus on the female body as a site for the production (or *re*production) of a child—the womb as factory—in her early work as a solo artist. *Antepartum* is a minor work in Kelly's oeuvre, a sketch for her first major installation, *Post-Partum Document,* but it marks a significant turning point in her practice. *Antepartum* reveals that understanding the female body through the logic of production is another example of sexual difference being subsumed by the politics of class with women acceding to the inferior position of "honorary brothers."[38] She turns to psychoanalysis to break free from such specular traps, and here I begin to elaborate the relationship between sex and gender, a theoretical distinction that will unfold across the rest of this book. My reading evolves through a strong feminist *mis*reading of the politics of sex and work in relation to Warhol's Factory scene, in particular his performance films of the early 1960s. Kelly's work evolves in relation to Marxist feminist debates about production and sexual difference, and this coincides with her involvement in two important feminist study groups (along with Juliet Mitchell, Laura Mulvey, and Sally Alexander). I analyze her identification of the feminine spectatorial position as a displacement of the Benjaminian spectator as producer in relation to her film-loop installation *Antepartum.* Although I only briefly refer to Kelly's canonical installation *Post-Partum Document* and the scandal that followed its 1976 presentation, the subtle and surprising ways in which it impacted the milieu of this book is part of the background of chapters 3 and 4.

One month after Kelly's scandalous exhibition, an even more provocative installation, *Prostitution,* opened at the same ICA venue. Art historians have

largely overlooked this mixed-gender collective despite the fact that the two main artists, Genesis P-Orridge (now Genesis Breyer P-Orridge) and Cosey Fanni Tutti, had a significant presence in the mainstream art world at the time. Music critics tend to be more familiar with COUM's work because *Prostitution* was the symbolic end of this performance art group and the beginning of Throbbing Gristle, the industrial rock band. Moreover, COUM self-consciously staged the emergent punk scene in the installation to dramatic effect. I argue that COUM's queer aesthetics expands our engagement with the tensions generated by the sex/gender distinction. Kelly's psychoanalytically inflected engagement with "normal" heterosexual reproduction and parenthood is juxtaposed with COUM's exploration of the "perverse." *Prostitution* included pages from pornographic magazines featuring the nude modeling of performance artist Cosey Fanni Tutti; in a hugely controversial Duchamp-inspired act, these commercial publications were reattributed as ready-made works of performance art. More recently P-Orridge has become known in queer studies because of his/her (or their) exploration of transgender identity within the context of both performance art and rock music; she (after transitioning) is lead singer of the band Psychic TV. While my discussion is focused solely on the 1970s, the question of queerness, I argue, emerges as a central aspect of the formal structure—rather than the subject matter—of this controversial work.

Chapter 4 turns to debates within photography in the second half of the decade with a focus on the relationship between a Marxist understanding of labor, photographic representation, and sexual difference. While COUM engages with the postconceptual idea of the photograph as a "deskilled" document, this chapter, centered on the figure of Jo Spence, charts the emergence of a new theoretically informed practice of photography.[39] Together with Terry Dennett, Spence founded Photography Workshop, an open-ended collaborative, grassroots photographic organization dedicated to historical research, pedagogical workshops, publishing ventures, curatorial projects, activism, and photographic practice. Unlike conceptual photographers of the period, Spence's work during the mid- to late 1970s is situated at something of a distance from the art world. Moreover, the deskilled or amateur aesthetic typical to conceptual photography became, in Spence's collaborative

documentary work, a politicized aesthetics of "proletarian amateurism."[40] She funded her practice as a photographer through working as a secretary in the British Film Institute's Education Department. Responsible for typing the groundbreaking film journal *Screen,* Spence took this opportunity to acquire an in-depth theoretical education that focused on the semiotic and psychoanalytic approaches to visual representation. The chapter focuses on a complex photographic series of staged images featuring Spence's nude body, *Remodelling Photo History.* This work is a reflection on the issues that emerge in the first three chapters of this book; it constellates anew the unstable relationship between the politics of class and psychically inflected questions of sex difference in the context of feminist debates at the end of the decade.

By the end of the 1970s, the term *postmodernism* is on everyone's lips. The political energy of the sex politics of this post-'68 period has begun to dissipate, and the theoretical questions that emerged through these rather marginal practices in Britain are assimilated, in different form, into the New York art world successes of critical postmodernism. The final chapter, with its reach into the early 1980s and focus on photography, is also a conclusion of sorts. If the idea of the photograph as ready-made served as a critical linkage to the interwar avant-gardes for critics of the Pictures Generation, the example of Spence, I argue, opens onto a different narrative centering on the documentary image that, at the same time, offers another perspective on the theoretical debates that came to define this period.

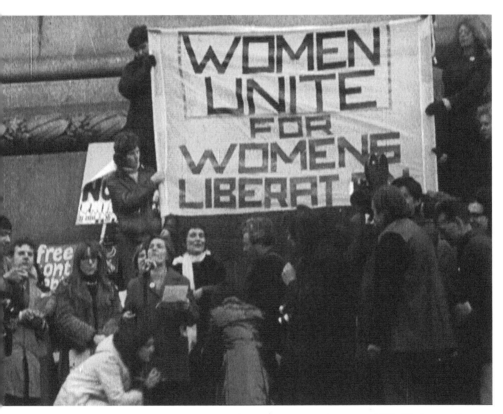

FIGURE 1.1. Film still from *Nightcleaners* (Berwick Street Film Collective, 1972–75) showing May Hobbs speaking at a women's liberation demonstration. Courtesy of the Berwick Street Film Collective and Lux, London.

Nightcleaners

The Ambiguities of Activism and the Limits of Production

Britain's first public action in the name of second-wave feminism took place in 1970 at London's Albert Hall. The occasion was the Miss World Beauty Contest, and two of the participants, Laura Mulvey and Mary Kelly, subsequently became important feminist figures. The British protest was inspired by the feminist disruption of the Miss America Beauty Pageant in Atlantic City in 1968. A landmark in the popular imaginary of feminism, this American protest produced the stereotype of the bra-burning feminist (although no bras were in fact burned that day).[1] After taking into account the self-critique by various American feminist groups, the British feminists shifted the focus of their action from the women in the contest to the event as spectacle, that is, its presentation as a seamless image. Coordinating with two different groups of feminist activists, they undertook a situationist-inspired attack on established norms for looking at women. The first interruption affected the televised stage show and involved a guerrilla-style attack with a number of women leaping on stage to hurl smoke and flour bombs. Echoing the televised images of May '68, this part of the protest invoked the street uprising. During the ensuing chaos, the audience's pleasure in looking was then supplanted by the suggested activity of reading, and several other women went about distributing a critical pamphlet that set this feminine spectacle into a post-colonial frame. "Why Miss World?" analyzed the emergence of the contest against the backdrop of 1950s anticolonial struggles, with feminine display as the ideological front for a new global harmony. Mary Kelly wrote the essay, but because of the political investment in collective production, at this point it did not bear her name.[2]

After the media furor of 1970, the door security was stepped up for the 1971 contest and media expectations were high. In 1971, outside the venue, members of the London Women's Liberation Theatre Group (including Dinah Brooke, Margaret Eyre, Alison Fell, Buzz Goodbody, and Michele Hickmott), stood with opened overcoats to reveal black catsuits decorated with homemade flashing electric bikinis. With lightbulbs attached on top of their clothing, one on each breast and the other at the crotch level forming a V-shaped triangle of light, *The Flashing Nipple Show*, as it was called, literalized and parodied the archetypical male exhibitionist, the so-called flasher (Figure 1.2).[3] The graphic clarity of the newspaper image—the only existing visual record of the protest—reveals the extent to which the protest was also addressed to its eventual representation in the media. In this grainy photograph we see the success with which the caricature of the bra burner is displaced by the electric bikini.[4]

Despite the invocation of the romantic post-'68 idea of the street-fighting woman and critical intellectual (as collective subject) in the 1970 protest, subsequent explorations of a feminist political aesthetic would displace the situa-

FIGURE 1.2. Members of the Women's Liberation Street Theatre Group performing *The Flashing Nipple Show* outside the Miss World Beauty Contest, Albert Hall, London, 1971. Participants included Dinah Brooke, Margaret Eyre, Alison Fell, Buzz Goodbody, and Michele Hickmott.

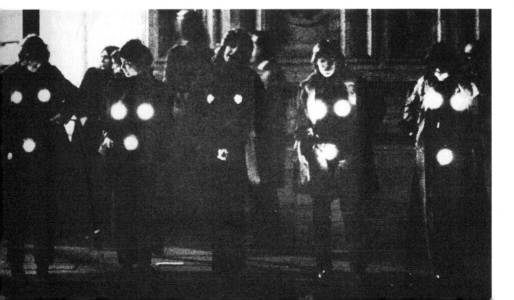

tionist notion of spectacle. Later in 1970, the Pimlico branch of the London Women's Liberation Workshop—a local chapter of the London-wide network of feminist activist, consciousness-raising, and study groups—was approached by May Hobbes, an activist for a group of night cleaning workers and a night cleaner herself, who was looking for help with the slow task of grassroots organization needed to unionize previously unrepresented immigrant and working-class women.[5] Very early on in this activist alliance, in November of that year, the Berwick Street Film Collective was asked to make a film about the campaign. *Nightcleaners* (1972–75) began as a straightforward agitprop film, but after four years in postproduction editing, this was not what reached the screen. After the spectacular immediacy of the Miss World actions, the night cleaners campaign went on to become one of the most significant activist campaigns in the early years of the British women's movement. While the earlier 1968 strike of the women machinist workers at the Ford factory in Dagenham precipitated the 1970 Equal Pay Act, the night cleaners' campaign deals with a different political situation because these women were outside of the union structure altogether. The campaign challenged a deeper set of exclusions within the organized left. The night cleaners' struggle met the demands of an emerging women's movement that was grounded in New Left thinking wherein a gendered politics of class intersects with the complexities of postcolonial Britain. It sought to define a feminist politics that went beyond the confines of middle-class women's experience to include working-class and immigrant women. This campaign thus promised to critically coordinate a political trio of terms that would become so important to feminism in the course of the 1970s: *race, class,* and *gender.* If Kelly's "Why Miss World?" suggested a longer history of the colonial investments in women's erotic display, *Nightcleaners* turned toward the new political landscape of a gendered postcolonial Britain. With the political stakes running fairly high, when *Nightcleaners* was first screened in 1975—after nearly four years in postproduction editing—it became controversial among some feminist audiences. On the one hand, many feminist activists harshly rejected it because it failed to deliver a straightforward campaign message: the intersections of race, class, and gender remained intractably dissonant. On the other hand, when it was screened at the Edinburgh International Film Festival in August

1975, Claire Johnston and Paul Willemen claimed it was the apotheosis of a new feminist avant-garde. They argued that *Nightcleaners* was exceptional because it diverged so markedly from other documentary examples and fulfilled a Brechtian aesthetic.[6]

Much of the footage in *Nightcleaners* is not unfamiliar to expository documentary. The Berwick Street Film Collective spent eighteen months filming the women cleaners at work, in meetings with the feminist activists and the male union representative, in interviews with various figures involved including the cleaning company boss, and at large-scale labor demonstrations. But it is the way the parts are connected together that caused much of the outcry. The film's documentary passages are continually interrupted by sections of black leader tape, an editing effect that makes the screen go dark. Instead of serving as a conventional spatiotemporal ellipsis—used either between different shots or directly prior to an intertitle, and permitting the smooth shift from one visual segment to the next—in *Nightcleaners* the black leader tape is present on-screen for much longer, and it appears between almost every segment of the film marking the editorial cuts. Understood in Brechtian terms—such as by Johnston and Willemen—viewers are made aware of the film as constructed through the cut and splice of the editing process. But the film's detractors—the feminist activists who rejected it—were confused and frustrated by the incessant interruptions to its visual and narrative flow.[7] Rather than raising awareness about the campaign, this interruptive device alienated certain members of the feminist audience by precluding straightforward communicability. Further confusion occurred for the disgruntled activists because the filmmakers repeatedly isolated individual shots that had been processed and refilmed to emphasize the visual properties of 16 mm film. These images included close-up head shots and isolated gestures, ambiguous visual details that further interrupt the expectations of documentary as a realist genre and connect *Nightcleaners* to the kinds of visual experimentation associated with avant-garde filmmaking.

At the Edinburgh International Film Festival in 1975, the film's avant-garde positioning was further consolidated. *Nightcleaners* was featured alongside Jean-Luc Godard's *Deux ou trois choses que je sais d'elle* (1967) and *Tout va bien* (1972), Jean-Marie Straub and Danièle Huillet's *History Lessons* (1972) and *Moses and*

Aron (1973), and Slatan Dudlow and Bertolt Brecht's *Kuhle Wampe* (1932) as part of a special event, Brecht and Cinema / Film and Politics (otherwise known as the Brecht Event). Since then the film has consistently been understood as part of a Brechtian tradition of political cinema that was in fact epitomized in the United Kingdom by Godard's collaborative work with the Groupe Dziga Vertov. The Brecht Event also included conference papers that were subsequently published in the journal *Screen*; Claire Johnston and Paul Willemen's "Brecht in Britain: The Independent Political Film (on *The Nightcleaners*)" continues to be the dominant contemporary understanding of the film.[8]

I use the term *Brechtian* to indicate that the British film studies interpretation of Brecht is particular to the post-'68 moment and oriented to film rather than theater. Not in any empirical sense is this interpretation true to the historical figure Bertolt Brecht, but rather this Brechtian*ism* speaks to a political desire that animated the period, a desire that made it impossible to read *Nightcleaners* in any way other than as a repetition and feminist rewriting of the 1930s political avant-gardes. I will elaborate this film cultural milieu in light of the complex reception of the film. The investment in the staging of *Nightcleaners* as an exemplary feminist work of *political* avant-gardism will allow me to establish some of the political and aesthetic stakes of this period. Then I will turn my attention to aspects of *Nightcleaners* that appear to contradict this Brechtian reading. What other interpretations of the film come to light when we set aside this well-established analytical framework? In deviating from the Brechtian interpretation of *Nightcleaners,* I argue that the conflict over the film's reception was rooted in its ambivalent staging of affect. Two distinct but related understandings of affect shape my approach. First, the film's staging of ambivalent affect finds it deviating from the political address of a typical activist film that, as Elizabeth Cowie has pointed out, is conventionally understood as serious in its address with a clear-cut emotional appeal that does not deviate or interrupt the viewer's position as a subject of knowledge.[9] Second, the film's staging of affect produced powerful affective responses in certain feminist viewers (both those who supported the avant-garde reading and those who rejected the film because of this), and I will elaborate how such responses have continued to shape interpretations of *Nightcleaners*. The complexity of the film's affective address *and* reception

points to questions of (political) desire and psychical effects that reveal the deep significance of this collective project.

Brechtian Legacies: Groupe Dziga Vertov as Model

The Miss World action of 1970 was shaped by the political aesthetic of the Situationist International, an aesthetic made explicit in the title (and text) of Laura Mulvey and Margarita Jimenez's 1970 account of the event, "The Spectacle Is Vulnerable." But as the impact of the politicization of filmmaking evolved in the United Kingdom, the work of Godard in particular grew exponentially in importance. The fact that the Situationist International had nothing but contempt for Godard—famously referring to him in a May '68 graffiti as the "biggest asshole of the pro-Chinese Swiss"—was of little concern to many in the British film scene.[10] Moreover, until the film *Société du spectacle* (1972) by Guy Debord, who is widely seen as the Situationist International's de facto leader, the Situationists were not particularly associated with filmmaking in the United Kingdom.[11] Having said this, it is interesting to note that there is an echo of the 1952 premiere of Debord's *Hurlements en faveur de Sade* [Howls for Sade] in the flour bombs used by the British feminists. The Situationists dropped flour on their audience during the screening of the film that included André Breton and other surrealist friends among the spectators. As Debord was well aware, the older generation of surrealists were undoubtedly drawn to the film by the violent sexual suggestiveness of the title, but any visual pleasure they might have expected was frustrated by the fact that the film's image track was made up solely of black leader tape. Thus Debord's negation of male heterosexual pleasure finds its feminist parallel in the Miss World protest. Despite the importance of the situationist presence during May '68 in Paris, in the years to follow Godard was perceived in the United Kingdom (and the United States) as France's most radical filmmaker. In 1969 he formed a low-budget film and video collective called Groupe Dziga Vertov. The reference to Dziga Vertov, the best-known Russian postrevolutionary documentary filmmaker, was seen in opposition to the fiction film of the more widely celebrated Sergei Eisenstein.[12] Groupe Dziga Vertov was modeled on a Maoist political cell, and the film and video that they produced referenced an international array

of post-'68 political groups. It is this work in particular that became the model for Brechtian film in the United Kingdom.

The period of *Nightcleaners'* production, 1970 to 1975, was also the most intense period of theoretical debate about politics and aesthetics to have taken place in British film culture. This led to major institutional transformations at the British Film Institute (BFI), the development of a critical avant-garde in anglophone film theory—previously moribund in the United Kingdom—and the elaboration of a new Brechtian political aesthetic in filmmaking. The year that the cameras began to roll for *Nightcleaners* saw the beginning of the organized women's movement in Britain and the publication of the first English translation of Walter Benjamin's 1934 essay "The Author as Producer." This text was formative for the British understanding of Brechtianism as establishing a new relationship between politics and aesthetics for which, as Johnston and Willemen would argue, *Nightcleaners* was the most significant feminist example.

In "The Author as Producer" Benjamin emphasizes the political significance of aesthetic form over and against the "correct" political message. As a critical response to the emergence of the Popular Front in the 1930s, he proposes a realignment of the relationship between spectator and artwork that draws critical attention to the relations of artistic production. Speaking of Brecht's theatrical work, Benjamin frames the relationship of audience to stage in explicitly economic terms: "The more consumers it brings in contact with the production process . . . the more readers or spectators it turns into collaborators."[13] By making the spectator *work* to produce meaning, Benjamin argues that he or she is incorporated as producer into the process of the work's production. This interwar argument about political theater was taken up and developed most vigorously by film theorists in Britain where Brecht was uniquely received principally as a filmmaker rather than as a playwright.

The reception of *Nightcleaners* at the Edinburgh International Festival's Brecht Event continues to shape the dominant interpretation of the film as Brechtian. The work of Godard and that of Straub and Huillet had already been presented elsewhere in light of debates about Brecht.[14] These works were well established and celebrated as exemplary Brechtian films, but it was Godard's collaborative work with Groupe Dziga Vertov that became

the critical focus in the United Kingdom. Godard formed Groupe Dziga Vertov in 1969 with Jean-Pierre Gorin, and although the group included other participants, Godard and Gorin were the key figures.[15] Peter Wollen's 1972 "Counter-cinema: *Vent d'est*" established the terms of this political aesthetic. He suggests the programmatic nature of this film as "the starting point for work on a revolutionary cinema."[16] Wollen begins by affirming Godard's new commitment to documentary over fiction film and goes on to specifically single out the seven ills of cinema, including fiction, narrative transitivity, identification, pleasure, and closure. The counter-cinema, he asserts, is defined by their negation.

The "Brecht in Britain" section of the Edinburgh International Film Festival's Brecht Event was dominated by an implicit comparison between the work of Lindsay Anderson (*If. . .* [1969] and *O Lucky Man!* [1973]) and the Berwick Street Film Collective's *Nightcleaners*, with the latter work being aligned more closely with the formal experimentation found with Straub and Huillet and even more specifically with the work of Godard. True to Benjamin's analysis in "The Author as Producer," the main emphasis was placed on the formal aspects of the film, with a particular focus on tropes of reflexivity. These included the persistent insertion of sections of black leader tape, the presentation of processed and repeated sequences, and the inclusion of the clapboard, all of which draw the viewer's attention to the process of the film's making, to *Nightcleaners* as *filmmaking*. These elements, Johnston and Willemen claimed, produce an effect akin to Brecht's *Verfremdungs Effekt*, interruptions that disrupt the theatrical (or cinematic) spell and as a result make the audience critically aware of the representational illusion being presented. Reflexivity was thus connected to the notion of critical distance and the idea that the viewer would become an active participant, or to use the Benjaminian term, producer of the film's meaning.

The choice of *Deux ou trois choses que je sais d'elle* and *Tout va bien* is also telling in that these films by Godard offer broad thematic intersections with *Nightcleaners*: *Deux ou trois choses* because of the staging of urban space and femininity and *Tout va bien* because of the treatment of femininity and labor. It is not simply the question of formal realization but also the way in which these Brechtian features intersect with a particular kind of political problem-

atic centered on femininity, labor, and urban space. The clearest comparison to Godard was not with these commercially successful and widely distributed films but rather to the experimental documentary films associated with Groupe Dziga Vertov. Shot on video, rather than film, and commissioned by commercial television stations, the Groupe Dziga Vertov films could not have been presented at the Edinburgh *Film* Festival. Thus in a sense the other works by Godard presented at the Brecht Event serve as their metonymic substitutes. The elements of the documentary narrative gradually evolve in *Nightcleaners* to reveal a campaign on the part of feminists and night cleaning workers to affiliate the women workers with an established union. In meetings with the male union representative it becomes clear that this is not going to happen, and he is shown to be patronizingly paternalistic and dismissive of the women's efforts. This implicit critique of institutionalized labor unions over and against worker-led action finds *Nightcleaners* conforming to a typical post-'68 theme. Likewise, the emphasis on women workers is also a common post-'68 theme.

Unlike the two films by Godard shown at the Brecht Event, *Nightcleaners* addresses these thematic elements through the genre of documentary rather than fiction film. The tension between avant-garde reflexivity and the expectations of documentary as a realist genre are writ large across the film as a whole, and this seemed to intensify the Benjaminian reading of the film particularly with regard to both the representation of labor and the trope of production. The theme of women and work is established in the opening sequences of *Nightcleaners* where the cleaning women are defined by their paid work. There are long passages of visual footage that follow two different women as they undergo their regular night's cleaning routine. We are shown the material nature of the work, and through the prolonged focus on the empirical presentation of cleaning activities, the film emphasizes the dull repetitiveness of the job. The camera scrutinizes the cleaning labor without offering a subjective point of view, that is, the perspective is not given as if seen through the eyes of the worker. One of the women moves from office to office swiftly dusting surfaces and emptying trashcans. This gives the viewer a sense of the amount of office space covered by a single cleaner. These passages are punctuated by an alternating sync-sound and voice-over description

of the number of buildings and the number of offices that the cleaners are responsible for. A female supervisor, who is also involved in the unionization campaign, counts off the number of offices: one, two, three, four, five . . . twelve . . . fifty-six, concluding by telling us the number of toilets. This opening sequence culminates in a real-time depiction of the cleaning of a toilet that appears to go on for an extremely extended period (the effect produced by the presentation of everyday mundane tasks in real time), and throughout this the toilet bowl is given center stage as if it were the main player in the action. The extended focus on the cleaning of this toilet is an instance of radical empiricism and is intended to reinforce the base materiality of the work that the women perform (Figure 1.3).[17]

Throughout these opening passages that depict cleaning labor, every editorial cut is marked by several seconds of black leader tape. The footage of cleaning is regularly intercut with sections of dark screen. Consequently, the film suggests two different forms of labor concurrently: the filmmakers' and the cleaning women's. These interruptions to the empirical depiction of labor serve as implicit evidence of the editorial labors of filmmaking. Placed side by side in this manner, they suggest there is a reciprocal relationship between the labor depicted on screen, and the work involved in making a film. Moreover, this interruptive device continues throughout the whole film, punctuating it rhythmically with black leader tape. In fact, the black leader marks almost every editorial cut, and it appears on screen for intervals ranging from approximately three to twenty-four seconds in length. This powerfully present withdrawal of cinematic action serves as an interruption to the documentary episodes and is a continuous reminder of labor on both sides of the camera.

A simple analogy cannot be made between the fragmented structure of the film and the fragmentary nature of the social situation described, nor does the withholding of image and sound simply imply the absence of meaning. Form and content do not correspond in such an uncomplicated way. Furthermore, the presence of the black leader tape is more than just a conventional editing device; it is a visual interruption: a cut in the flow of images. A much more positive presence in the film as a whole, this persistent jolting interruption immediately registers as a reflexive device used to provoke an awareness of the cuts and splices that make up the film. Thus the overall structure of the

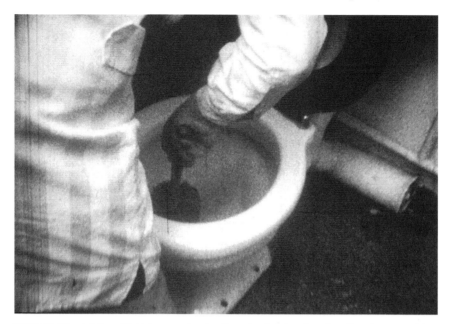

FIGURE 1.3. Film still from *Nightcleaners* showing the extended cleaning of a toilet. Courtesy of the Berwick Street Film Collective and Lux, London.

film was understood in Brechtian terms as demanding a particular kind of productive engagement from the spectator.

While interrupting the flow of images, the black leader tape also interrupts the sound track. Not only is sound withheld for approximately half the time that the screen is black, but when it returns the sound track has, in most instances, been replaced with a different voice or musical fragment. The black leader becomes a kind of metaphorical switching device for both sound and image that permits movement between different points of view in the drama. Throughout the film there is a persistent separation enacted between image and sound, a separation that is more explicitly marked visually by the black leader tape. Synchronized sound is used relatively infrequently. When used it is most often for non-vérité—TV-style question and answer—interview footage with the cleaning workers and the company boss. Much more typically, sound is given in voice-over, and a number of different voices are used.

The multiple voice-overs are largely constituted from direct sound footage recorded during the filming process, but this sound material is most often edited together with different film footage. There is no single voice employed as the voice-over, as with the didactic voice-of-god style of documentary; instead, as an aural representation of collectivity, the different voices all belong to participants in the action.

Humphry Trevelyan has described the collective's intentions in the film as escaping "the tyranny of sync-sound."[18] The film's disruption to conventional realist approaches to sound can certainly be understood as a further instance of reflexivity. But it also suggests a comparison with Godard who was well-known for his experimental treatment of sound recording.[19] In the Groupe Dziga Vertov films, the idea of politically devising a "correct sound" to accompany or transform the image track was particularly notable.[20] Furthermore, as Steve Cannon has argued, "Groupe Dziga Vertov were situated at the 'harder' end of French Maoism" with a rigorous conformity to the "correct" political position including a practice of "recitation and self-criticism."[21] The clearest example of this is found with *Letter to Jane* (1972), and with its focus on the image of the face, this comparison will become further significant later in my argument in light of the isolation of the very same motif in *Nightcleaners*. Although *Nightcleaners* is certainly indebted to the French auteur's work, comparing the approaches reveals two markedly different attitudes toward the reflexive staging of sound.

Letter to Jane is a clear example of Godard's didactic political privileging of sound over and against the image track, and it also reveals his implicitly gendered understanding of the image as feminine. As Jonathan Dawson describes it, *Letter to Jane* is "a very long lecture (or harangue) by two film-makers [Godard and Gorin] that is almost the purest example of agit-prop in cinematic history as well as possibly the most graceless."[22] Made immediately after *Tout va bien*, *Letter to Jane* is a self-excoriating response to the former film's complicity with the Hollywood star system because Jane Fonda was the main female lead in *Tout va bien* (Figure 1.4). Widely considered to be the apotheosis of Godard's misogynistic attitudes, he critically negates the feminized image by the masculine voice-over commentary.[23] The image track is predominantly made up of a close-up head-shot photograph of the ac-

tress taken during her much criticized antiwar trip to Vietnam that led to the moniker "Hanoi Jane."[24] Godard and Gorin provide the harrying voice-over sound track that consists of a bitter ideological critique of the political pathos of the image of Fonda. In *Letter to Jane,* unlike *Deux ou trois choses* and *Tout va bien,* the relation of sound to image follows the conventions of documentary film and is constituted by a voice-over that explicitly and repeatedly announces its suspicion of the image on the screen. Despite the hostile tone, the image analysis is very engaging, and as Laura Mulvey points out, Godard's misogyny is "always interesting."[25] In the same interrogative harrying tone that persists throughout the film, the narrator mobilizes an explicitly Benjaminian language stating that the viewer "will become a producer at the same time as he is a consumer, and we [the filmmakers] are consumers

FIGURE 1.4. Film still featuring Jane Fonda from *Letter to Jane.* Directed by Jean-Luc Godard and Jean-Pierre Gorin (Groupe Dziga Vertov), 1972.

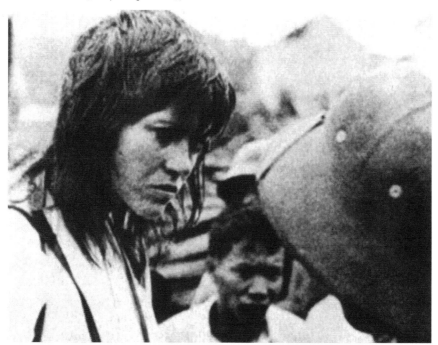

at the same time as we are producers." This use of voice-over as a critical interruption to what is being depicted on the image track is seen across the entire oeuvre of Groupe Dziga Vertov. Rather than the detached, seemingly objective voice of god, this voice-over narrative is an explicitly politicized and interested mode of critical analysis.

British Sounds (1969), Godard's first documentary film—later attributed to Groupe Dziga Vertov—is of particular comparative relevance to *Nightcleaners*. This is one of the earliest filmic depictions of second-wave feminist politics in Europe. Aside from being historically significant for this reason alone, analyzing Godard's staging of sexual difference in a Brechtian documentary will help to clarify some of the broader gender implications that underpin the Benjaminian idea of production in a post-'68 context. As the title indicates, *British Sounds* is set in Britain; moreover, it features the voice-over of one of the principal feminist activists in *Nightcleaners*, Sheila Rowbotham.[26] Like *Nightcleaners*, it is addressed to the intersection between labor movement politics and new post-'68 political vanguards. In relation to two Groupe Dziga Vertov–era works, *British Sounds* (1969) and *Pravda* (1970), Colin MacCabe has argued that they "persistently pose the existence of a correct sound and a new relation between sound and image which would produce the correct image to accompany it."[27] As in *Letter to Jane*, sound is used didactically to interrupt the viewer's—implicitly unthinking—engagement with the image track. Although the aural and the visual attain a certain mutual independence in *Nightcleaners*, the sound track is not used to critically negate the image track. Furthermore, unlike Godard, *Nightcleaners* reveals an exploration of the visual that is not determined by a corrective didactic voice-over.

Released in the United States with the title *See You at Mao*, *British Sounds* is Godard's first fully realized experimental documentary.[28] The film was completed the same year that he began his collaboration with Jean-Pierre Gorin under the name Groupe Dziga Vertov, and because of this it was released in the United States as part of Godard's collaborative oeuvre. *British Sounds* includes footage of British (male) car production workers, student radicals, and one of the first published British second-wave feminist texts, which was written and recited in the film by Rowbotham as a nude woman walks around on-screen.[29] Feminism appears in *British Sounds* not as an as-

sertion of Godard's own political sympathies but as part of a representation of an ongoing May '68. Sexual politics, student vanguards, the eroticized female body, and the laboring male body are juxtaposed in a six-part episodic structure that reveals a series of overlapping oppositions: male/female, collective/ individual, sound/image, politics/sex. The use of disjunctive juxtaposition follows Brechtian conventions in the belief that it fosters audience participation: that the viewers actively construct meaningful relations between the different sections of the film and therefore consciously *produce* meaning. While there are clear comparisons here between the Brechtian structure of *British Sounds* and *Nightcleaners,* it is important to note that Godard's is a structural overview of the political whereas the participants in the Berwick Street Film Collective are concerned with how these different political interests are negotiated at a grassroots level.

Groupe Dziga Vertov's macro overview is perhaps the greatest political weakness in this Maoist work. All Groupe Dziga Vertov's films were made overseas in other countries, which can be seen to reflect a particular disinterest in the concrete political situation in France. As Steve Cannon argues:

> *Groupe Dziga Vertov* addressed their films *not* in any way to the working class as a whole, *not* to the large sections of it radicalized in 1968, questioning the electoral strategy of the PCF [Parti communiste français] and the allied back-to-work machinations of the CGT [Confédération générale du travail] union leaders and thus open as never before to political alternatives, *not* to the mass of students and intellectuals whose view of the world was similarly shifting massively to the left in the period and *not* even to those amongst it who had already reached revolutionary conclusions.[30]

Rather, he goes on to say, "The *Groupe* required of its audience that it be both politically revolutionary *and* impassioned by the same aesthetic minutiae which enthused Godard and Gorin i.e. not at an audience interested in politics nor in political films but in 'making political films politically.'" Thus, he goes on to suggest, "One can detect in this approach a marked *reduction* in Godard's horizons, despite the political and cultural opportunities of the post-1968 period, from attempting to learn *2 ou 3 choses* to researching *2 ou 3 images* for an audience of *2 ou 3 copains*."[31] By contrast *Nightcleaners* was

directly engaged with following a specific grassroots campaign that animated a particular feminist, New Left agenda in relation to some of the most disenfranchised workers in Britain. Furthermore, after the film's release, it was shown widely in numerous alternative venues, including high schools and factories.[32]

British Sounds opens with a long, slow panning shot of men working on a sports car production line. This is accompanied by a male voice-over giving a political analysis of contemporary labor relations, which at times is largely drowned out by the loud factory noise. The sound track establishes a certain didactic critical distance in relation to the images of labor shown on the screen (Figure 1.5). This masculine scene of workplace interaction—a scene of collectivity—is followed by its feminine antithesis in the next section. In an extended shot, a solitary, slender, young nude woman walks around what is generally taken to be a suburban house but is in fact an independent cinema. The sound is mostly given in voice-over, and a woman's voice, Sheila Rowbotham's, reads out a text about women's oppression. The separation of image and sound is not complete since the nude woman also repeats part of the text into a telephone. This section concludes with a full frontal close-up shot of the nude woman framed so that only her torso and crotch appear on screen, emphasizing the visible bodily marks of sexual difference. It seems that the seductive power of the image—its affective appeal as erotically charged—is being put to the test in relation to the critical distance of the voice-over text. But in doing so, Godard reveals the gendered investment in his notion of the political.

The scene turns on the assumption of male heterosexual pleasure at the sight of a young nude female body that is then purportedly undercut by the extended filming and the critical feminist voice-over commentary. But Godard was no feminist. In her memoir of the 1960s, Rowbotham recounts a discussion with Godard about this scene where she questioned his "exploitative" presentation of the female body and suggested instead that he might film the placement of stickers on public advertisements by feminist activists that read, "This image exploits women." To which, according to Rowbotham, he responded with the line, "Don't you think I am able to make a cunt boring?"[33] Boredom would be described as an ambivalent affect that Godard uses to dis-

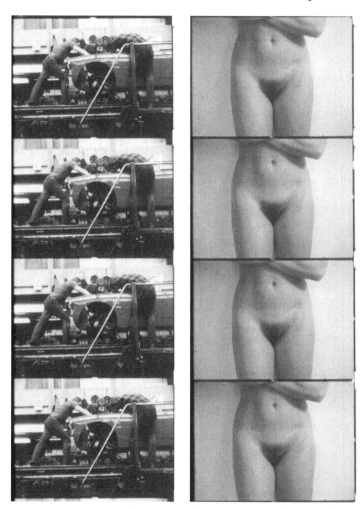

FIGURE 1.5. Film stills of male autoworkers and of a nude woman from *British Sounds*. Directed by Jean-Luc Godard, 1969. Courtesy of the Harvard Film Archive.

rupt the active affect of the arousal state typically evoked by the nude woman. He produces the effect of critical distance to disrupt the visual pleasure that this image would otherwise elicit. As with the photograph of Fonda in *Letter to Jane*, the image—seen as feminine—is invested with some suspicion precisely

because of its affective appeal. In *Letter to Jane* it is associated with commercialized sentimentality, whereas in *British Sounds* it occupies the ambivalent place of simultaneously evoking (sexual) liberation and commodification. This sentiment conforms to a typical post-'68 (particularly francophone) staging of sexual difference that is also seen in Debord's *Société du spectacle* (1972). In this latter film eroticized femininity, because it is consistently juxtaposed with images of labor, becomes associated with its inverse, consumption: woman equals commodity. This is the other side of femininity as the figure for liberation that so preoccupied the early twentieth-century avant-gardes.

British Sounds announces the fundamental stakes of its engagement with sexual difference by prefacing the nude-descending-the-staircase section with a voice-over announcement: "The relation between man and man is dependent on the relation between man and woman." While Godard's voice-over alludes to the idea of the heterosexual family as the model for the relation of worker and capitalist, in practice he seems mostly interested in the political relation of men to men. The filming of the woman's body is both anti-erotic and emphasizes the spectator's voyeurism, but this, like the previous workerist scene, is fundamentally determined by male collectivity. Rowbotham gives two anecdotal accounts of audience responses to the part of the film featuring the nude descending the staircase, both from male spectators. This reveals a further degree to which male collectivity determines the film.

> When *British Sounds* was shown in France, Charlie Posner told me the audience cheered as I declared, "They tell us what we are. . . . One is simply not conscious of 'men' writers, of 'men' film-makers. They are just 'writers,' just 'film-makers.' The reflected image for women they create will be taken straight by women themselves. These characters 'are' women." As for Godard's intention for making a cunt boring, I cannot say, except that a friend in International Socialism told me that his first thought had been "crumpet"—until the shot went on and on and on, and he started to listen.[34]

The solely male collectivity of workingmen in the first section of the film corresponds to the imagined male collectivity of spectating men in the second section. Godard constructs his cinematic analysis with woman placed on the side of sexuality and with the masculine worker as the sole participant

in the collective activity of politics. Thus female sexuality can interrupt and challenge politics but only when it is conceived as a masculine mode of practice. For Godard political collectivity is determined by a homosocial contract, or as Luce Irigaray has put it, "Woman thus has value only in that she can be exchanged."[35] This insight raises important questions with regard to the Brechtian interpretation of the audience's role: To what extent is the spectator as producer of the film's meaning implicitly gendered as masculine? And inversely, does this tally with a feminized notion of the spectator as consumer?[36]

If the notion of critical distance is associated with the productive masculine spectator, the feminized position of consuming cinema is typically understood as a form of unthinking identification (one of Wollen's seven evils of cinema). During the 1970s this latter attitude became associated with the idea of cinema as visual pleasure exemplified by mainstream Hollywood films (pleasure being another cinematic bête noire).[37] This was a position also held by the structural/materialist filmmaker and theorist Peter Gidal, who saw narrative itself as the principal enemy. Gidal's view was grounded in an opposition to its identificatory capacity. Furthermore, as I will elaborate more fully, for Gidal identification was also aligned with the suspicion of affective responses in viewers. In order to avoid this, he argues, filmmakers should strive to eliminate all metaphoric, allegorical, or otherwise referential dimensions and instead "the actual relations between images, the handling, the appearance, the 'how it is' etc, takes precedence over any of the 'associative' or 'internal' meanings."[38] Gidal thus also seems to endorse Wollen's views about the cinematic traits that must be negated even if the resulting films are quite different in their subject matter. Gidal developed a radical materialism that was addressed solely to film form and asserted an iconophobic eschewal of the referential dimensions of representation altogether. Interestingly, this iconophobia would soon be reinforced by an engagement with feminist theory. As a political response to the inevitability of film's objectification of women, in the late 1970s he publicly pledged never again to depict the female form.[39] I will elaborate further on Gidal's interesting affiliations with Brechtian ideas later, but, as we have seen, Godard offers the most influential model of film viewing as (masculine) *hard work*, and one that tends toward the politically moralistic. The audience is expected to strike a studious attitude in relation to

this cinematic "blackboard," but they are also meant to expend mental labor in doing so.[40] Within this moral universe the apparently frivolous pleasures of cinema viewing—the affective experience of fantasy and identification— are to be avoided at all costs. This form of cinematic didacticism has subsequently persisted as the dominant model for political cinema, and it has had a significant influence on feminist-engaged film, particularly the work of Laura Mulvey and Peter Wollen. The so-called feminist film essay, in name alone, gives a clear enough indication of the attitude taken.

Institutional Rupture and Repetition: The Politicization of Film after May '68

The example of Godard, Swiss auteur turned Maoist, has already figured largely, and now I would like to draw the reader's attention to another example, the feminist film theorist and filmmaker Laura Mulvey. Mulvey provides a useful point of intersection for our consideration of the broader institutional and political issues that shaped transformations in the film cultural milieu in the first half of the decade. In addition to being an organizer-participant in the Miss World protest, Mulvey was employed at the BFI and was directly involved in the institutional transformations that shaped the avant-garde turn in British film culture. This is not to imply that Mulvey is single-handedly responsible for these various institutional forces. Rather, she allows us to see the connections between several strands in the intersection of post-'68 political vanguardism as the groundwork for the evolution of a cultural avant-garde milieu. Furthermore, it need not be labored that her 1975 essay "Visual Pleasure and Narrative Cinema" is perhaps the single most influential text for feminist film theory and would go on to shape a whole generation of film theorists.[41]

Film played an unusually important role during the May '68 uprisings, and this produced a political working-through in Britain in the years to follow. During May '68 the editorial team of France's leading theoretical film journal *Cahiers du cinéma*, along with members of the major film technicians union and film students, organized an extensive program of film screenings in temporary screening facilities set up in public schools, factories, and other provisional venues. The idea that film critics would mobilize their film expertise within this political context set an important precedent for their BFI col-

leagues.[42] This led Peter Wollen, at the time Mulvey's husband and collaborator on several experimental films in the 1970s, to predict a shift from art to film as the new dominant avant-gardist medium. Writing in 1972, the same year as his essay on Groupe Dziga Vertov's *Vent d'est*, he describes the time as a "transitional period," and using Godard as an example speculates about future "victories for the avant-garde."[43] When Wollen wrote these lines, Mulvey had just participated in major institutional transformations at the BFI, Britain's national film organization, which included establishing a film archive, a public screening program, an educational facility, a library, and a press that published books and journals, including *Screen*.[44] Colin MacCabe describes how "a series of bruising institutional battles had resulted, in 1971, in new funding for *Screen*, a magazine charged with the explicit task of developing a theory of film," and he goes on to point out, "I was delighted to join this intellectual endeavour and thrilled to find that Godard was the central point of reference."[45]

Driven by an avant-gardist impulse of revolt that was inspired by May '68, these ruptures within the state institution of the BFI are part of the long-term work of political change that Julia Kristeva named "permanent crisis."[46] As opposed to the bohemian phantasm of the instantaneous revolutionary act, the slower work of institutional transformation can be said to betray the very avant-gardist logic that propelled it in the first place. Semi-independence from this state institution was thus necessary in order to sustain the political desire of avant-gardism, the dream work of the avant-garde that continued to propel the changes underway. The ongoing work of political rupture within the institution of the BFI added a considerable weight of political desire to the avant-gardist staging of *Nightcleaners*.

In 1971 Sam Rohdie took over as the journal's editor; he instituted a major shift in editorial policy, and from that point onward *Screen* began its ambitious film-educational project. At this time the education department of the BFI—called the Society for Education in Film and Television (SEFT)—was responsible for publishing *Screen*, and these institutional shifts brought SEFT into direct confrontation with the BFI governors. Consequently, six staff members resigned, and SEFT—the department where Mulvey was also employed—seceded from its host institution to become an independent organization funded by a BFI grant.[47] This new institutional independence

enabled the development of a cutting-edge educational program that included workshops, weekend courses for college and high-school teachers, and course-pack publications. This was all part of a practical extension of *Screen* journal's new theoretical focus.[48]

SEFT was also partially responsible for organizing the Edinburgh International Film Festival, which likewise saw significant changes at this time. The film festival's program included new releases in world cinema, Hollywood, documentary, and avant-garde film. U.S. and European film within the structuralist tradition dominated the avant-garde category and brought a different type of critic and filmmaker to the event, facilitating the interaction between these different aesthetic traditions. For example, Gidal (who also wrote film criticism) as well as the American film critics Annette Michelson and Noël Burch were in regular attendance. Furthermore, the role of the new type of theoretically informed film critic became even more significant with an important feminist change in festival programming. In addition to its regular program of film screenings, in 1972 the festival included a "Special Event," organized by Claire Johnston and Mulvey, on the theme of women and film. With film screenings as well as conference papers and roundtable discussions, the special event of 1972 reinvented a festival tradition that had lapsed in the early 1960s; this new intellectual focus would continue throughout the 1970s.[49] The special events were a theoretical intervention in the festival's general program and can be understood as an extension of the avant-garde turn that had recently occurred in the film journal *Screen*. The Brecht Event, where *Nightcleaners* was screened, perhaps more so than any of the other Edinburgh International Film Festival special events of the 1970s, was part of SEFT's broader educational project. Not only were the conference papers published in a special issue of *Screen* after the festival, but another special issue of the journal, dedicated to the analysis of Brecht's work, was published prior to the festival, thus providing a theoretically elaborated intellectual context for the subsequent discussions.[50]

Although the Brecht Event became a point of intersection for the institutional, theoretical, and practice-based transformations associated with the BFI and *Screen*, this was not the only context for experimental film culture in Britain during the 1970s. In fact, Britain's better-known experimental film

movement of the period was not associated with *Screen* at all. The London Filmmakers Coop was more typically aligned with the European and U.S. tradition of structural film.[51] While it is not generally emphasized in historical accounts of the group, they also responded to the political transformations of May '68 and its feminist rewriting in Britain in the 1970s. This is most immediately apparent in the theoretical writing and film criticism of Peter Gidal in the mid- to late 1970s that, I suggest, evolved in critical response to the Brechtian debates about the political significance of film form. In his 1976 essay "Theory and Definition of Structural/Materialist Film," Gidal argues for the political transformation of structural film by adding the term *materialist*. He develops a political analysis of the group's avant-garde aesthetic based on the question of form that evokes the very same Benjaminian language adopted by the Brechtian theorists. Echoing Brechtian debates about the political importance of reflexivity, Gidal states, "Each film is a record (not a representation, not a reproduction) of its own making."[52] He argues that these films deserve the label structural/*materialist* because they foreground the film's "means of production" (6). In common with Brechtian arguments, the viewer has to work as she watches the film, and in doing so she becomes conscious of producing meaning. This is set in explicit opposition to the spectator's relation to mainstream narrative film that—in common with the Brechtian critics—Gidal considers to be a passive position of consumption. Gidal, however, goes further than these critics with his view that the only proper avant-garde inquiry must work from the basis that "narrative is an illusionist procedure, manipulatory, mystificatory, repressive" (4). His analysis is a direct attack on the procedures used by the mainstream entertainment commodity offered by Hollywood, and any engagement with narrative structures at all is seen as a capitulation to this dominant form. This is a further index of the influence of Brechtian ideas at the time and the avant-garde discourse that defined them.[53] Gidal responded to this discourse by claiming that structural/materialist film, the formalist practice that he was involved with, was the only true avant-garde. A typically avant-gardist claim in its declaration of avant-gardist exclusivity, Gidal's assertion of the political significance of film form ups the ante on the Brechtian debates.

All of this indicates a broader field of conflict over the political significance

of reflexivity and critical distance as the negation of affect and identification. But when the modernist trope of reflexivity was combined with a political subject, Brechtianism was the prevailing interpretative norm. *Nightcleaners* was not the only film subsumed beneath the Brechtian banner at the Edinburgh International Film Festival in 1975. Annette Michelson, in an extensive two-part review essay in *Artforum,* had already connected Yvonne Rainer's *Lives of Performers* (1972) and her minimalist dance from the 1960s with Brecht.[54] But the 1975 screening of *Film about a Woman Who . . .* (1974) in the avant-garde program of the Edinburgh International Film Festival provided Rainer with the nickname, in British film circles, of "the American Godard," a comparison that she has strongly rejected. In 1976 when the special event was under the heading "The Avant-Garde," Rainer was invited to participate, along with Michelson and Marc Karlin of the Berwick Street Film Collective, thus further consolidating "Brechtian" and "avant-garde" for a long time to come.[55]

Avant-Garde Rupture and Repetition Redux

Griselda Pollock was the first to take up the Brechtian reading of *Nightcleaners* in connection with a broader political idea of "critical distance" in an art historical context in her 1988 essay "Screening the Seventies." This perspective has since been reiterated and loosely endorsed by Mary Kelly.[56] But the other members of the Berwick Street Film Collective did not adhere to the dominant Brechtian reading of the film.[57] While this is not in itself a reason to discount this view, it does raise the question of artistic intentionality in the context of collective production. When the idea of a documentary film was first suggested, the Berwick Street Film Collective was an all-male group that included Marc Karlin, Humphry Trevelyan, and Richard Mordaunt. The artist James Scott, whose previous filmmaking experience was a short experimental documentary about the British pop artist Richard Hamilton, was also invited to participate in the project, further consolidating the seemingly male bias. In order to be sure of there being an advocate for the activists' feminist agenda, it was agreed that the collective would be supplemented by one of the workshop participants, the young artist Mary Kelly. Kelly had recently graduated from St. Martin's School of Art, was an organizer and

participant in the Miss World protest, and perhaps spurred on by her friend-
ship with Mulvey, was becoming keenly interested in filmmaking.[58] In 1970
she began as the feminist liaison to the filmmakers but soon became a central
participant in the making of *Nightcleaners,* an involvement that would lend
far greater complexity to a film that her fellow feminist activists had hoped
would be speedily produced and would deliver a straightforward message.
While Kelly's role in the making of *Nightcleaners* was pivotal, it should not
(as it has in some quarters) be overplayed. As Humphry Trevelyan has noted,
Karlin and Scott did most of the editorial work.[59] Kelly's perspective will be
addressed independently in the next chapter, where I argue that her work on
Nightcleaners fundamentally shaped her emerging solo practice. While it is
much more common for women artists to be written out of the picture when
art history's traditional monographic model is applied to collaborative work,
in this case the opposite would appear to have taken place.[60] Having said this,
my approach does not rest on artistic intentionality as decisive to the film's
historical and aesthetic significance. Rather, I am much more engaged with
how the interpretation of *Nightcleaners* is shaped by a complex intersection of
political and institutional determinations that follows an avant-gardist logic. I
would thus locate the question of intentionality within a broader institutional
and disciplinary framework. Kelly's subsequent importance to feminist art
history has certainly contributed to the revival of interest in *Nightcleaners* and
to the ongoing consolidation of the Brechtian point of view. It was because of
Kelly's involvement that *Nightcleaners* reemerged in an art historical context
in 1998 at a conference at the University of Leeds, coorganized by Griselda
Pollock, "Work and the Image." Here the Canadian art historian and cura-
tor Judith Mastai presented a paper on the film that was a development from
her research on Kelly's collaborative installation (with Kay Fido Hunt and
Margaret Harrison) *Women and Work* (1973–75).[61]

The Sunday morning screening of *Nightcleaners* at the "Work and the
Image" conference had only a very small audience. First-time viewers like
myself, Gail Day, and Steve Edwards joined some who had last seen the film
twenty years earlier, such as Pollock and most significantly the feminist his-
torian Sally Alexander, who also appeared in *Nightcleaners* as one of the ac-
tivists. Mastai's essay never made it into the two-volume publication that

appeared two years later. In its place Pollock presented an alternative, impassioned, and theoretically robust analysis that functioned as an implicit response to Mastai.[62] Both Pollock and Mastai refer to Johnston and Willemen's article that was presented at the Edinburgh International Film Festival and later published in *Screen*. While Mastai rejected the avant-gardist argument presented by Johnston and Willemen—claiming that the film was not in fact true to Brecht's legacy—Pollock both endorses and updates their account. Situating *Nightcleaners* in relation to three other films of the period, *Riddles of the Sphinx* (dir. Laura Mulvey and Peter Wollen, 1977), *The Song of the Shirt* (dir. Jonathan Curling and Sue Clayton, with the Film and History Project, 1978), and *Gold Diggers* (dir. Sally Potter, 1983), Pollock seeks to establish its place along the "thread of an avant-garde poetics" of feminist film.[63]

Of all the feminist films Pollock discusses, *Nightcleaners* is the most significant. This is not just because of its avant-garde origin—a primal scene for this feminist aesthetic—but more because the film is subject to a complex modernist temporality that goes in two directions. *Avant*, the forward thrust into the future, is supplemented by a counterposing movement, *garde*, the protective backward turn to memory (or remembering) as a guarding of the past. Articulating her belief in the profound significance of the film, Pollock encapsulates the ambiguity of the double movement present in the term *avant-garde*:

> It has taken over 20 years for what was perceptible through an aesthetic configuration (within the film) to be theoretically elaborated in such a way that a retrospective viewing of the film finds them yet again to be one step ahead, and at the same time, timely and legible in their address to current burning questions. It is as if we are, at last, and belatedly, theoretically advanced enough to comprehend the traumatic and shocking events of the revolt of women that burst upon the world in the 1970s. . . . I call this moment avant-garde poetics.[64]

While Mastai's paper argued that *Nightcleaners* was a political failure, an alienating formal experiment, unable to be "useful" either to the women's movement or the night cleaners' campaign, for Pollock, this very failure would become a mark of its avant-garde success.[65] *Nightcleaners* was "one step ahead," and only now, in the future, are we able to (truly) understand the film, since "it has taken over 20 years," for us to become "theoretically advanced enough." The tem-

poral fulfillment of its avant-garde promise is all the more evident precisely because of its initial failure as a political film, of *our* failure—and here Pollock is speaking as, and on behalf of, her own generation of second-wave feminists.

With this in mind, consider Karlin's account of one aspect of the film's reception controversy. The negative reaction to *Nightcleaners* on the part of some feminist activists was so vehement that a petition was even organized against it. As Karlin later remarked, "I think it was about two years after that petition that one of the people who organized it went back to see the film, and generously conceded: 'I was really wrong, now I can *see* the film.' In other words, at the time there were so many constraints operating on the vision of that film that it took two years to be able to see it."[66] This peculiar interruption to vision and cognition coupled with virulent rejection is evocative of the psychical condition of disavowal. A defensive operation that guards the ego against external reality, disavowal is a psychical response to trauma that takes the form of denial of the traumatic event. While this is not to say that the viewing of the film was equivalent to a trauma, it does suggest that psychical considerations are relevant to the broader reception of *Nightcleaners*. In Karlin's example the feminist activists are blinded to seeing certain aspects of the film because it deviated from documentary expectations and their own view of the political campaign. Indeed, Pollock seems to endorse such a view in her own experience of seeing the film in 1998. Likewise, at the "Work and the Image" conference the feminist historian and activist Sally Alexander, who also appeared in *Nightcleaners,* spoke about a similar incomprehension when seeing the film back in the 1970s that to her own deep surprise she no longer felt when she saw it again. Moreover, Pollock's reading of *Nightcleaners* is built on her and Alexander's latter-day viewing.

Despite the persuasiveness of Pollock's position—part of which she presented off-the-cuff in the lively discussion that followed Mastai's paper—not everyone had reached the same "advanced enough" position. Mastai remained unconvinced, as did Steve Edwards, whom I overheard assuring Mastai of his confidence in the rightness of her reading of the film. Part of Mastai's argument was that the Brechtianism claimed for *Nightcleaners,* and for other films and theatrical approaches of the period, was not true enough to 1930s Brecht. While Pollock aims to restore the avant-garde claims of the 1970s, Mastai is

looking back to the 1930s to the way in which *Nightcleaners* fails to measure up to its purported avant-garde origin.

Rather than taking up a stance on one side or the other of this debate, what strikes me is the extent to which the rediscovery of *Nightcleaners* is shaped by a repetition of its first appearance in the mid- to late 1970s. If avant-gardism involves the fantasy of pure rupture, a new beginning, a tabula rasa, this singular moment belongs to a larger temporal structure of modernist repetition. As Jean-François Lyotard has argued, "We now suspect that this 'rupture' is in fact a way of forgetting or repressing the past, that is, repeating it and not surpassing it."[67] The *Nightcleaners*' debacle seems to bring to light this modernist logic of rupture and repetition as a self-conscious process. As opposed to the forward-progressing phallicism that typifies the avant-garde fantasy of pure rupture, Lyotard suggests an alternative structure, one that also seems particularly apt for *Nightcleaners*: "The true process of avant-gardism was in reality a kind of work, a long, obstinate, and highly responsible work concerned with investigating the assumptions implicit in modernity . . . a working-through *(durcharbeiten)* performed by modernity on its own meaning" (79–80).[68]

Writing from amid the debates about postmodernism, the question of repetition and return had become all the more pressing for Lyotard who felt compelled to reflect on the temporality of modernism. He counterposes the view that postmodernism functions as a break with modernism and instead argues that "the 'post-' of 'postmodern' does not signify a movement of *comeback, flashback,* or *feedback,* that is, not a movement of repetition but a procedure in 'ana-': a procedure of analysis, anamnesis, anagogy, and anamorphosis that elaborates an 'initial forgetting'" (80). The telling of *Nightcleaners,* that is, its reception, which is inseparable from the film object itself, appears to perpetually enact the rewriting of modernism as an aporetic movement. This is the contradictory logic of the revolution that moves forward, starts over, breaks with the past, wearing the well-worn clothing of the revolt, only to turn back, work through, and retell.

Reading *Nightcleaners* beyond the Brechtian Grid

Thus far I have presented some of the stakes in the Brechtian interpretation of *Nightcleaners* in terms of film form, broader institutional transformations,

and how these two aspects converge so that the film conforms to a modernist logic of rupture and repetition. This latter reading is informed by the way in which the reception of *Nightcleaners* provoked a psychical interruption; Karlin, Pollock, and Alexander's observations indicated a delayed ability to *see* the film. It also seems clear that the very features that for Johnston and Willemen satisfied the political fantasy of feminist avant-gardism were what occluded these viewers' vision in the 1970s. Now I want to ask: What is it that the avant-gardist critics of the 1970s were themselves unable to see? What aspects of *Nightcleaners* escaped their Brechtian interpretative grid?

In the discussion following their paper at the Brecht Event, it became clear that there were some difficulties in the positioning of *Nightcleaners* as a Brechtian film. Martin Walsh, perhaps the most orthodox of the new Brechtian thinkers, contested the argument made for the film's reflexive treatment of cinematic form. Walsh was concerned with what he described as a turn to "emotionalism" that he saw as excessive to, and in contradiction with, the more analytic approach that defined other Brechtian practice. Or, bringing to bear a term we have already used, Walsh was uncomfortable with the affective aspect of *Nightcleaners*, and instead he asserted the priority of the idea, the intellectual. Interestingly, Johnston and Willemen were also uncomfortable with this apparent turn to affect. But they countered Walsh by arguing that the emotionalism of *Nightcleaners* was successfully undone by the filmmakers' otherwise analytic attitude. All seemed to agree that the intellectual or analytic attitude is antithetical to the emotional or affective. Walsh was able to identify the stumbling block in *Nightcleaners* precisely because he was immersed in a Brechtian mode of filmmaking and analysis. Moreover, he even isolates the deviant feature of the film as the recurrent use of the close-up head-shot motif without, as he puts it, "some kind of commentary to clarify the meaning."[69]

Walsh argues that the close-ups of the women's faces, to the film's detriment, align it with the humanist strain within documentary practice where the idea of an analytically oriented political critique is replaced by an emotionally driven sentimentality. But the particular example that he identifies is in fact the only instance where the depiction of one of the cleaners' faces is anchored in a diegetically transitive manner (Figure 1.6). Nevertheless, he

FIGURE 1.6. Refilmed, grainy head shot of night cleaning worker in *Nightcleaners*. Courtesy of the Berwick Street Film Collective and Lux, London.

indicates that this critique extends to the use of the faces throughout the film. The shot Walsh specifies also becomes an aspect of Pollock's reading where she reasserts Johnston and Willemen's argument in a more rigorous and psychoanalytically inflected way. This particular processed head shot is preceded by a short interview with two of the night cleaners conducted during a work break. One of the women explains that even though her doctor has told her to stop night work because of the damage it is doing to her health, she persists because it is the only way she can adequately provide for her children. She cannot work during the day because she must fulfill the expected gendered labor of child care and housekeeping while her husband earns a less-than-adequate family wage. Her dilemma is expressed in explicitly gendered terms. As the children's mother, she has the sole responsibility for her children because her husband is unable or unwilling (the latter case is

strongly suggested) to properly support the children. The woman is explicit that the risks to her health in doing this work are likely to be fatal, and so the dilemma is acutely felt: her work will bring about her death. She is hemmed in by the social expectations of her gender, experienced as a moral impera- tive that is fatally compounded by the capitalist system. The close-up on her face that follows becomes charged with the emotional force that this tragic disclosure would suggest.

Counterposing Walsh's dismissal of this sequence because of its emotional- ism, Pollock argues that the "slowing down of the film and the prolongation of her eyes closing and reopening *opens* the film to a moment of trauma, of almost-encounter with the real that is death."[70] This scene was so affectively charged for Pollock that it provides the psychical kernel for her reading of the film as a whole. She argues that *Nightcleaners* "signifies the trauma of work for women caught in the triple bind of the capitalist relations of production, of reproduction and of gender and class as inseparable."[71] In her analysis of the film's staging of affect, Pollock substitutes her own affective response as a viewer of the film for the film's use of affect as a device. She elides the two different understandings of affect, and her analysis of the film is driven by her own affective investment as an interested viewer. Thus, I agree with Pollock's analysis as it describes the manifest feminist problematic that the film ad- dresses, and I also concur with her identification of the face motif as signifi- cant; but as an overall account of the film, this reading does not adequately address the face motif as it is deployed throughout. The staging of affect in *Nightcleaners,* I contend, does not live up to Pollock's own affective invest- ment as a feminist art historian.

The example that Pollock cites is the only instance when the representa- tion of the women's faces is narratively sedimented in the kind of explicit way described, and it is in fact the sole instance when this motif is directly connected to the film's documentary message. Furthermore, it is the only instance when the close-up is used to clearly articulate a strong emotion such as pity or compassion. The other examples of faces suggest a greater diversity and a fundamental ambiguity in the emotional states depicted. The most am- biguous is also the very first image in *Nightcleaners.* Immediately before the title the screen starts to bleed irregular patches of light. As if occupied by a

ghostly presence, it pulses slowly but erratically until the isolated contours of a woman's facial features—mouth, nose, eyes—begin to emerge before dissipating again into an abstract haze of light and film grain (Figure 1.7). This image appears again and again during the course of the film, and the fragmentary factual narrative never offers a secure diegetic anchor for it.

In some of *Nightcleaners'* later scenes, where the activist meetings are shown, the face motif recurs in a slightly different way. Through a prolonged focus on the depiction of listening, the motif's interstitial relationship to the film's political narrative is further reinforced. Here there is no cutting back and forth between the speaker and the listener, as is conventionally seen in an expert interview. In a group context where one speaker is dominating, or where there is a discussion between two people, the camera does not move between the two speakers but rather lingers on a third party or a small group of listen-

FIGURE 1.7. Refilmed, grainy detail of night cleaning worker in *Nightcleaners.* Courtesy of the Berwick Street Film Collective and Lux, London.

ing women (Figure 1.8). One of these scenes is especially notable; it involves a prolonged focus on a single woman's face, the night cleaning worker and activist Jean Mormont (Figure 1.9).[72] The scene lasts for several minutes, and the woman's expression shifts through a range of subtle and somewhat indefinable emotions. Rather than communicating a narratively specific emotional state, this scene describes far more ineffable shifts in expression. It tracks the movement of consciousness without decisive content. These passages are a counterweight to the focus on the empirical depiction of cleaning elsewhere in the film, since they indicate unverifiable interiority as opposed to absolute external materiality. But as depictions of affect, the emotional quality expressed remains fundamentally unreadable, traces that do not cohere into the solidity

FIGURE 1.8. Film still of Mary Kelly (left) with night cleaning workers, including Jean Mormont (second from the right) in *Nightcleaners*. Courtesy of the Berwick Street Film Collective and Lux, London.

FIGURE 1.9. Film portrait of night cleaning worker Jean Mormont in *Nightcleaners*. Courtesy of the Berwick Street Film Collective and Lux, London.

of being signs of something determinate. The fact that these more ambiguous representations of the face are repeated far more frequently than the example that Pollock focuses on would suggest that the face motif is more than a psychically inflected support for the political problematic outlined in the film.

Kelly, supporting a more open-ended understanding of this motif, refers to these close-ups of the women's faces as "portraits." She describes them as indicating "something excessive," that is, the image's "affective force."[73] The comparison for her may have been Warhol's *Screen Tests* or his other performance films of the 1960s that emphasize the face.[74] Another important reference, most relevant to Karlin, would have been the work of Chris Marker. Marker's preoccupation with the face is seen as far back as his best-known work *La jetée* (1962), a film, Vered Maimon reminds us, that is about a man preoccupied with a woman's face.[75] Karlin, a native French speaker, was liv-

ing in Paris at the end of the 1960s during the events of May '68. He then worked as a cameraperson for Marker's *Le fond de l'air est rouge (Grin without a Cat)* (1977). This process was formative, and Marker's attention to body language as a vehicle for collective identification was particularly significant.[76] Tracing Marker's engagement with the face motif in relation to the more recent photographic project *Staring Back*, Maimon draws out the importance of this motif for tracking the shifting understanding of political collectivity in Marker's practice from the 1960s onward. This, I want to suggest, offers another trajectory for *Nightcleaners* than the dominant Brechtian pattern.[77]

As I have already suggested, Pollock's analysis is compatible with the original interpretation of the film made by Johnston and Willemen at the Brecht Event, but she supplements their account with a more elaborate psychoanalytic approach. In fact, this psychoanalytic reading situates her even more squarely in this mid-1970s context. The first *Screen* special issue dedicated to Brecht included one of the most influential texts on the psychoanalytic strain within Brechtian film theory. Bearing the appropriately didactic title "Lessons from Brecht," Stephen Heath builds on Roland Barthes's structuralist reception of Brecht's work that began in the 1950s. More than twenty years after Heath's important essay, Kaja Silverman offers a theoretically informed critique of this still prevalent view as it relates to film theory developed in 1970s Britain.[78] She argues that this political aesthetic is incompatible with psychoanalysis because of the question of identification. Silverman points out that a psychoanalytic model of spectatorial production draws on a theory of identification that is strongly rejected by the Brechtian approach. Although Silverman references the writing of Brecht, which suggests that her critique is directed toward his interwar literary output, it must be noted that her important insights are filtered through the lens of 1970s Brechtianism (where she uses "Brecht," I would use "Brechtian"). She describes how "Brecht seeks to excise identification, precisely that relation which psychoanalysis posits as an irreducible condition of subjectivity." Brecht, she writes, "dreams of a theater uncontaminated by the imaginary, a theater that would 'appeal to the reason,' and engage the spectator more at the level of the conscious than the unconscious."[79] When this Brechtian attitude was adapted as a model for political cinema in the 1970s, the idea was that "the viewer could somehow be led

out of the 'cave' of the imaginary into the clear light of day—released from the captation to which he or she is unknowingly in thrall, and endowed with a politically enabling knowledge about cinema and its structuring effects."[80] This desire for political understanding and communicability, Silverman points out, is addressed to the rational conscious mind. This is a contradiction that is akin to making psychoanalysis work against the unconscious.

As I have already noted, all of the Brechtian claims for *Nightcleaners* isolate a single exceptional use of the face motif. None of the aforementioned writers, Walsh, Johnston and Willemen, or Pollock mention that all of the other ways in which this motif is staged counteract the didacticism of the Brechtian attitude. The face motif is in fact the very first image in the film, and here it appears in its most ambiguous way. It comes in and out of visibility, melting back into the grain of the film and establishing a particular kind of affective reflexivity. This opening image is repeated periodically throughout *Nightcleaners* and so are images of the other women's faces, all having been reprocessed and altered to emphasize the grain of the film. Each face is given the same refilming treatment: shot straight from the viewing screen of the Steen Beck flatbed editor, presented as a cited, repeated image, excised from the cinéma vérité footage, arrested to the point of near stasis, and devoid of sound (Figure 1.10). These haunting images function as interruptions to the film's diegetic flow. While other motifs are isolated and repeated in a similar way, for example, refilmed shots of work, isolated gestures, and exterior nighttime shots of women at office windows, it is the women's faces that are the most persistently present and the most ambiguous in their meaning. The face motif decisively disrupts the symmetrical opposition between mental and manual labor, the productive worker and the productive viewer, that is, *Nightcleaners*' Brechtian moments. This is a disturbance that Martin Walsh immediately recognized and then objected to. Furthermore, because of the insistent repetition of this motif, it is closely identified with the persistently present black leader tape. The conjunction of the affective (image of the face) with the reflexive (insertion of black leader tape) is even more puzzling for the intellectual Brechtian respondent. Although both motifs punctuate the film with a rhythmic force, drawing our attention to the medium of film and its visual and structural properties of light, movement, editorial cut, reproduc-

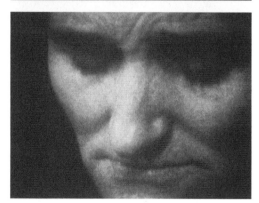

FIGURE 1.10. Film portraits of night cleaning workers, including activist May Hobbs (center) in *Nightcleaners*. Courtesy of the Berwick Street Film Collective and Lux, London.

ibility, and so on, the faces introduce an affective element that fundamentally diverges from Brechtian expectations.

Materialism and Minor Affects in *Nightcleaners*

The consideration of questions of feeling or affect is strikingly absent from materialist and semiotic analysis of the 1970s. This marginalization of affect, Sianne Ngai has argued, "stemmed from its perceived incompatibility with 'concrete' social experiences."[81] The British Marxist literary critic and cofounder of cultural studies, Raymond Williams, in his development of the concept of "structures of feeling," stands out in this field of cultural inquiry as the exception that proves the rule.[82] Williams's concept is particularly significant since he goes against what Rei Terada terms the "expressive hypothesis," where feeling is thought to flow from a centered subject.[83] Instead, "structures of feeling" are a way of accessing the complexity of a lived social space. But even with Williams's formulation, affect proves typically elusive for analysis since it exerts a pressure that is prior to rationalization. Or, as Lawrence Grossberg has put it, affect is so difficult "to define and describe . . . because it is a-signifying."[84] If materialist and semiotic critics have typically avoided considerations of affect, filmmakers from the same era have frequently demonstrated open hostility or suspicion. In the Brechtian work of Godard as well as in the structural/materialist film of Peter Gidal, an explicit attempt to delimit affect is a central critical strategy. This is particularly notable in two examples: one I have already discussed, *Letter to Jane* by Godard; the other is *Key* (1968) by Gidal. Both these films, even more than *Nightcleaners*, centralize the motif of the face. Undoubtedly this focus on the face is used precisely in order to disrupt its conventional affective functioning in film. Briefly turning to these two examples will also help to consolidate my earlier comparison between Gidal's formalism and Godard's Brechtianism while at the same time allowing us to clarify the different way in which this motif is put to use affectively in *Nightcleaners*.

As we have already discussed, the sound track in Godard's *Letter to Jane* offers an excoriating critique of the expression of empathy evident on Fonda's face, connecting this to the commercial importance of the close-up still of the face in the Hollywood star system (compounded because of her film star

father). Thus Godard asserts the face motif in order to negate its conventional use. It is as if he were trying to inoculate viewers against an emotional response to the image by the political commentary. Gidal demonstrates a similar attitude in his film *Key*, and in this work the relationship between image and sound track is also decisive. *Key* is a ten-minute film that simply shows a still image coming into focus. For a considerable portion of the film's duration, the image is not recognizable as depicting anything at all. Eventually, by zooming out from extreme close-up, the image becomes identifiable as the face of an anonymous woman. As an extended, slowed-down, and static version of *Nightcleaners'* interruptive face, *Key* shows the process of the image emerging into recognizability—although it never reaches full clarity—and for some time it remains completely indistinguishable, aside from the registration of the effects of light passing through celluloid. After visual coherence is attained, the camera stops zooming out and slowly begins to pull out of focus until the screen becomes blank. *Key* stages a tension between the referential capacity of the image and the disinterested formal properties of film. Once you know you have been looking at a picture of a face the whole time, there is a retrospective reconstruction in which the face rewrites the (previously unreadable) sections of film precisely as having some kind of reference. In *Letter to Jane* there is a similar process of realization, but the viewer of Godard's film becomes aware of the complex relay between the denotative aspects of the image—what we see—and the shared cultural assumptions that shape our apprehension, that is, the ideological dimensions of the image. In *Key* this process of reconstruction, or rewriting, of the image track has a corollary in the film's sound track. For the first part of *Key* Gidal plays Bob Dylan's song "Sad-Eyed Lady of the Lowlands" in reverse. Once you recognize the song (which happens as soon as the lilting hook of the chorus kicks in, discernable even when played in reverse) the impulse is to listen for recognizable passages. The oscillation between the referential capacity of sound (music) and its self-referentiality (noise) alerts the spectator to a similar dynamic also being played out at the level of the image track. Although the sound is not synchronized with the unmoving image, there is a conceptual correspondence between the two tracks.

Gidal draws on the mainstream cinematic convention where the sound

track establishes the emotional or mood-related support for the visual image. But watching this film makes the viewer self-conscious about the process of visual cognition and about the kinds of associative affectively charged meanings that we have become accustomed to adopt. It is in this sense that Gidal shares the attitude of critical distance seen in Godard's ideological critique. The correlation between the image of the face and the association with the sad-eyed lady of Dylan's song can only be made by recourse to an act of retrospective reconstruction that, like Godard's critical voice-over, necessarily creates a distancing effect. Put another way, we know that the relationship between image and sound track is an affective one, but we feel no affect from it. Like Godard, Gidal's *Key* creates critical distance in the viewer, allowing us to examine the mechanisms by which cinema achieves its emotional effects. In this conceptual corralling of affect, both filmmakers rely on the foregrounding of a rational, intellectual approach that is adopted as a means of erasing affect.

Although *Nightcleaners* presents the same kind of motif as *Key,* one that has been explicitly processed to emphasize the oscillation between the materiality of film and its referential capacity, it is not used to the same end. Working with, not against, established cultural associations wherein the face is the privileged filmic vehicle for affect, the Berwick Street Film Collective deviate from both Gidal's structural/materialist approach and Godard's Brechtian attitude. Unlike *Key,* the face motif in *Nightcleaners* coexists alongside a political narrative, interrupting its temporal and diegetic flow. Contrasting with Gidal's attempt to erase affect, these peculiar and ambiguous images shift the intellectual significance of the reflexive and turn it toward something affective. But the particular emotional signification associated with these affective images, with certain exceptions—such as the one Pollock and Walsh identify—remains highly ambiguous. Moreover, the connection between the black leader tape and the images of the women's faces is further reinforced during the course of the film when the slowed-down, grainy, close-up head shots appear to recede in space and become surrounded with, and thus framed by, blackness. These images appear to become swallowed by the black leader tape physically and metaphorically embedded within it.[85] I contend that rather than negating affectivity, these interruptive moments in the film draw the viewers' attention to the ambiguous staging of affect throughout

Nightcleaners. This issue of affective ambiguity, as we will see, is central to the political problematic staged in the film.

Take the film historian Brian Winston, who has more recently reiterated the Brechtian reading of *Nightcleaners* in order to critique its representation of political activism. In doing so he reveals certain assumptions about the conventional way that documentary film stages affect that, I argue, *Nightcleaners* does not in fact deliver. Winston claims, "The collective's concerns with the nature of image production, while neither unimportant nor trivial, look impossibly sterile and irrelevant when yoked with the raw plight of a group of exploited women trying to organize a strike against the advice of their union. The result was to reduce the deconstructionist agenda to a bathetic formalism."[86] Winston sees an irreconcilable opposition between the emotionally charged political struggle of the women that, by implication, contrasts with the cold, unfeeling experimentation of the objective technological apparatus. While this is the contrast that both *Letter to Jane* and *Key* critically stage, the engagement with issues of affect in *Nightcleaners* does not in fact produce the strong emotions assumed by Winston in his reference to the "raw plight of a group of exploited women." Rather, a more ambivalent range of emotions that are attuned to the push and pull of competing desires are staged in the film.

Unlike other post-'68 activist films that address extra-union political action, such as Godard's *Tout va bien* and Marin Kamitz's *Coup pour coup* (1972), *Nightcleaners* is remarkable in its refusal to depict the *action* of political activism. Less immediately obvious, although much more significant for the psychical interruption we have already noted, is the absence from *Nightcleaners* of the associated emotions of anger, excitation, passion, and agitation. I find this withdrawal from the depiction of such strong emotions especially intriguing. Instead, the film consistently emphasizes what Ngai terms "minor affects." These are "far less intentional or object-driven" and "more likely to produce political ambiguities than the passions in the philosophical canon."[87] Minor affects are neither the "grander passions" nor "ennobling or morally beatific states." Instead, they take the form, for instance, of irritation, boredom, anxiety, envy, and resentment; negative affects that "interfere with the outpouring of other emotions."[88] This turn to minor affect in *Nightcleaners* is clear both in the depiction of emotion as well as with reference to camera work and

editing. At the level of film form, then, *Nightcleaners* gives us a dampening of the passionate emotions associated with activist film.

The significance of the idea of minor affects to *Nightcleaners* rests on an understanding of the distinction between affect and emotion. This demands a brief clarification of how these two terms will be put to work. Typically, "affect" is defined as distinct from "emotion" following a psychoanalytic model with the latter understood as subjectively experienced by the analysand and the former as describing what the analyst perceives. Emotions are thus associated with a first-person experience that is bound up with a subject and affects with third-person perception that floats free of a particular subject. Following this logic, therefore, many cultural commentators maintain the distinction between the terms with the assumption that *affect* alone is the proper term for aesthetic analysis, since this is a third-person mode of inquiry. While the distinction between the two terms is essential, I do not dispense altogether with first-person emotion in my aesthetic analysis. As we have already noted, the staging of affect in *Nightcleaners* must be read in relation to the affective responses on the part of viewers (which would typically be classed as emotion).[89] Instead, I want to propose shifting between a first-person and third-person approach as an important aspect of my reading. Furthermore, following Ngai, when I talk about affect in a work of art, this is not restricted to the representation of emotions or the affective response on the part of spectators; it also includes the more general question of tone. This is something like Williams's structures of feeling: "We are talking about characteristic elements of impulse, restraint, and tone; specifically affective elements of consciousness and relationships: not feeling against thought, but thought as feeling and feeling as thought: practical consciousness of a present kind, in a living inter-relating continuity."[90] Williams is principally concerned with works of art and literature as indexes of these structures of feeling, as "social experiences *in solution*."[91] Likewise this is a focus in my approach. But addressing the film also includes its impact on audiences who were and are particularly invested in the world it conjures up. The affective investment on the part of its viewers—their own emotional involvement in the campaign and the film—has been a significant aspect of my analysis thus far. This affective investment produced an inability to "see" the film on the

part of certain feminist activists. Furthermore, this was a point of view that Pollock reiterates in her own account, and she was explicit in her mobilization of her own emotional reaction to certain scenes in *Nightcleaners*. This emotional involvement shifts the emphasis from a third-person mode of analysis to a subjective first-person reaction. Further, we can mobilize the tension between these two understandings of affect, first person and third person, as a mode of aesthetic analysis that is particularly useful for exploring the aesthetic function of so-called minor affects.

One might even say that a strong emotional response is typical of the activist film, since it seeks to incite its viewers into making an active response, being moved to *get involved*. But *Nightcleaners* is different from other post-'68 activist films. Take by way of comparison *Coup pour coup* by Kamitz. Although its subject is similar to that of *Nightcleaners*—a reenactment of a wildcat strike by women workers that took place in the immediately post-'68 period in a provincial French town—the two films could not be more different. *Coup pour coup* was made in collaboration with some of the workers involved in the original incident, who also appeared as actors in the film. This generates a fusion between reality and representation that is encapsulated by the genre hybrid docudrama. The mobility of the vérité camera work and the use of long single takes produce an internal energy and vibrancy that is matched by the urgency of the political action and fervency of the women's discussions. The depiction of strong emotions as a component of goal-oriented action is matched by camera work and editing. The camera is used subjectively, identified with the first-person perspective of the emotionally charged action of the women workers. *Coup pour coup*'s vérité style uses long single takes, and the mobile subjective camera creates energy for scenes already driven by the depiction of impassioned emotions. By minimizing the interruption of the editorial cut—and when used, it is sutured into the action—the movement of the camera seems coextensive with the spectator's vision, and as a result the action is naturalized as if produced *for* the spectator, assimilated to her subjectivity. This produces the effect of apparently seamless continuity between the cinematic apparatus and the depicted action that is driven by strong emotions enhanced because the willing participants in the film desire an ongoing May '68 with its easy incorporation of women

into the abstract collectivity of class struggle. This point of view is further reinforced by the reality effect produced by having some of the actual workers from the original action appearing as actors in the film.

This is not the political fantasy that *Nightcleaners* describes. The much less mobile camera work used in *Nightcleaners* produces a very different experience of objective duration (an issue that I alluded to in the toilet-cleaning scene mentioned earlier). This creates an effect akin to third-person observation, and the use of an objective camera emphasizes empirical observation rather than subjectively invested action. *Nightcleaners* uses cinéma vérité real-time duration to produce an experience akin to inertia, a slowing-down of the temporality of political action and consciousness. In this regard the film attempts to describe the temporality of a present without any clear resolution or implied blueprint for the future. *Nightcleaners* depicts the movement of time, thought, and decision in a decidedly nonemotive way. This becomes particularly clear in the contrast between the vigorous and impassioned political debates in *Coup pour coup* and the numerous scenes in *Nightcleaners* showing subdued meetings without a clear sense of what is actually taking place. Furthermore, it is here that the close-up shots of the women's faces appear in the most ambiguous way. In contrast to the impassioned action of *Coup pour coup*, these close-up shots of the women's faces are extremely difficult to read.

Rather than the new class unification of *Coup pour coup*, *Nightcleaners* points to the conflicts of race, class, and gender that persist within this post-'68 activist alliance: between the working-class, white male union movement; the middle-class, white female feminist activists; the middle-class, predominantly male, white filmmakers; and the working-class, racially divided cleaning women. An awareness of the tensions in these different positions is woven throughout the film, not, however, through the strong emotions typically associated with political activism and conflict, but in much more subtle and ambiguous ways. Indeed, the following insight by Heather Love seems particularly apropos here. She suggests that the "persistent attention to 'useless' feelings is all about action: about how and why it is blocked, and about how to locate motives for political action when none is visible."[92] In fact, at a larger structural level, the segmentation of the film into discrete, often incomplete passages facilitates the various shifts in the relations between the parts. The

black leader tape produces a rhythmically controlled juxtaposition between different scenes and therefore also between different points of view and socio-political positions.

In addition to the various parties depicted on screen, the position of the viewing audience must also be considered, particularly because of the Benjaminian claims made for *Nightcleaners*. The viewers' activity of watching is most clearly figured through a frequently repeatedly motif of medium and long shots, taken from the street, of cleaning women seen at night against the lit-up windows of office buildings. The first appearance of this kind of shot shows a bright oblong window that resembles the letterbox dimensions of the cinema screen (Figure 1.11). On/behind this screen/window is a night cleaner working, and while she works she acknowledges the audience watching her work by a small wave of her hand. This glancing gesture of acknowledgment invokes the spectating audience watching her at double remove, but at the same time it draws attention to the predominantly male film crew and, together with the voice-over commentary, this suggests a gendered reading of this motif. The first time this shot appears—it is repeated throughout the film with several different women at different windows—it is juxtaposed with a voice-over commentary by Rowbotham talking about the role of sexuality within capitalism. Rowbotham's voice-over is free-flowing, casual, and exploratory as opposed to the didactic recitation of the Groupe Dziga Vertov's *British Sounds*. Her open-ended probing tone is due to the fact that her remarks derive from an interview with a sympathetic interlocutor. Moreover, the rather strident staging of Rowbotham's voice in *British Sounds* must also have affected the way in which her voice was, contrastingly, presented in *Nightcleaners*. The juxtaposition of this speculative analysis with the image of the cleaners invokes the question of the voyeuristic nature of this scene and by implication the voyeuristic nature of film itself. This scene uses the visual rhetoric of the sexual voyeur to raise the issue of class voyeurism, but the position of the voyeur as separate and at a distance is also strongly marked. This comparison is further reinforced by the visual resemblance between the lit-up window and the cinema screen. Because the camera quickly zooms in on the scene and frames the illuminated window, both the speed and the slight clumsiness of the zoom suggest intrusiveness, as if the woman were being

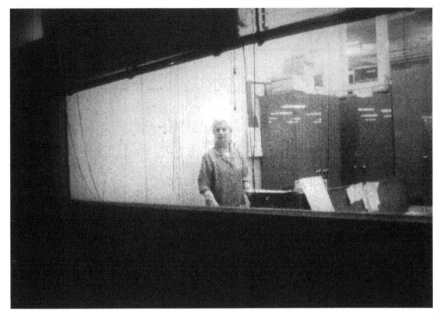

FIGURE 1.11. Anonymous night cleaning worker through an office window in *Nightcleaners*. Courtesy of the Berwick Street Film Collective and Lux, London.

spied on from a distance, except each of the observed women demonstrates an awareness of the watching camera through a small wave or gesture. While these gestures can be understood as a sympathetic acknowledgment of the filmmakers and of our presence as viewers, they also remain highly ambiguous within the narrative as a whole.[93] Likewise, this watching motif is made visible only because of the very separation and distance that it must invariably mark. It thus acknowledges and reinforces the gulf between the filmmakers and the filmed, the viewers and the viewed, further supporting the disjunctive affect these minor affects produce as an aspect of the film's overall tone.

The question of sexual difference is one of the central complications in the women's situation, but their own investment in activism, unlike the feminist activists, is not driven by a feminist agenda.[94] Sexual difference thus remains a minor affect for the women cleaners: a complaint, an annoyance, or an occasion for defeated resignation. In *Coup pour coup*, however, the political impli-

cations of sexual difference are largely unexplored. The fact that the workers are women does not fundamentally alter their struggle; it merely makes for an additional set of background details: men with strollers. Because of the alliance between the cleaners and the feminist activists, the question of sexual difference emerges as a central issue, and by way of the cleaners' affective ambivalence it becomes a central feature of the filmic representation of their struggle and, moreover, the very reason for the lack of an adequate political resolution. The film demonstrates that the circumstances of the women's paid work are inextricably bound up with their (unpaid) domestic work. With the inclusion of footage showing domestic labor, *Nightcleaners* makes clear that almost all the cleaners have children, and despite working all night, during the days they are still fully responsible for child care, cooking, and cleaning. It is because of the responsibility they feel toward their children (also depicted in the film) that they take on the paid work even though it is extremely physically demanding. Over and over again, the women interviewed describe how they are only able to catch a very few hours of sleep and frequently none at all; their daytime hours are almost as busy as at night. It becomes immediately apparent that the political issue here is not only the working wage but also the sexual division of labor. *Nightcleaners* explores how sexual difference determines the mutually dependent relationship between paid employment and nonpaid domestic work and how the women's capacity as political agents is seriously constrained by this situation. Undoubtedly, many of the feminist activists felt particularly passionate about this issue, but the film is not able to offer any solutions; it can only indicate the limitations to conventional labor union activism in dealing with the women's wage-labor issues and point toward the necessity for a radically different approach to political change.

In *Coup pour coup*, the unofficial strike by the women is precipitated by the ineffectuality of the male union representative, and thus their self-directed collective action is contrasted with the formulaic and meaningless rhetoric of the union man. The contrast suggested is between the genuine struggle of the workers (who happen to be women) and a corrupted union representative who is presented as a lackey for the bosses. But the night cleaning workers persist in their attempts to work within the union structure. And the ineffectuality of this institution is linked both to endemic sexism and veiled

racism. For example, a fragment of footage from a demonstration describes the problem in three words, rendered in uppercase letters: FREEDOM, UNITY, BROTHERHOOD. This slogan, which appears in bold type on a labor union banner, indicates the extent to which male collectivity is the basis for organized political agency. This point of view is humorously illustrated in an extended sequence showing two miners who break from their (all-male) union ranks at the same political demonstration, and in a performance explicitly staged for the camera, they dance with each other. This playful staging of homosociality only reinforces the gender asymmetry of the labor slogan Freedom, Unity, Brotherhood.

In the very next scene, the film suggests that this notion of fraternal unity is also racially coded. In a gesture of camaraderie, the union representative tries to establish the basis on which they can communicate by his claim that "we're all Cockneys here." No doubt this attempt to consolidate a common working-class identity is also intended to marginalize the middle-class feminist activists, but it is also a blatant (and implicitly racist) misrepresentation of the women involved in the campaign. The union representative is drawing on the nationalistic stereotype of the Cockney as a figure for the white working class, since to be considered a genuine Cockney requires being born within the sound of the Bow Bells, a church deep in the East End of London, as opposed to being one of the many immigrant East End residents. The significant number of immigrant women working as cleaners and involved in the campaign as activists makes the union man's invocation of some mythically authentic British white working-class identity all the more stereotypical and ridiculous. It nonetheless suggests a much more complex set of exclusions that lie behind the claims to Freedom, Unity, Brotherhood.

The question of racism among the British working class and its ramifications within the labor movement were emerging as important issues in the 1970s, but aside from a few scenes like this, the problem of racism lies somewhat beneath the surface in *Nightcleaners*. The relative lack of attention to racism contrasts with the political literature produced by the women's movement about the night cleaners' campaign that in fact centralized this concern.[95] Moreover, this racism was expressed by some of the white cleaning women as well as by the union structure, thus revealing entrenched conflicts in this

postcolonial scenario. Another brief interview scene seems intended to allude to such issues. In response to the interviewer's suggestion that the cleaners could "get together" to form a power base from which to organize—an explicit call for action—a Caribbean woman flatly responds, "There's no 'get together' here." A feminist voice-over commentary suggests that this seeming refusal to contemplate collective action is also a simple statement about the lack of opportunity for them to even meet and talk. But this terse riposte from the black cleaning woman, I feel, suggests a more profound diagnosis of the problems faced. For those directly and indirectly involved in the campaign, this would no doubt bring to mind some of the racial tensions made more explicit elsewhere. Indeed, the British neofascist movement—on the rise in the 1970s—drew much of its support from the working class. While this has been well charted in cultural studies literature, an anecdote offered by the artist Ian Breakwell in his published diaries of the period vividly illuminates the brutal public nature of British racism at this time. He describes witnessing an anti-immigration demonstration in Smithfield market that featured mothers, with children in tow, chanting, "Castrate black men! Castrate black men! Castrate black men!"[96] The emotive power suggested by Breakwell's example only further highlights the tendency in *Nightcleaners* to focus on minor affects and the way in which such emotions contrast with the call to action typically associated with—and embedded in the very word—*activism*.

Postcolonial Rewritings: The Black Audio Film Collective

The idea of minor affect as a political aesthetic that permits the exploration of contradictory and competing positions has not been completely overlooked in subsequent experimental film in Britain. The work of the Black Audio Film Collective has taken this strategy as something of a modus operandi. In the 2007 retrospective exhibition at the Arnolfini Gallery in Bristol, England, the group makes their debt to the Berwick Street Film Collective's film explicit. Alongside the key works from their oeuvre, produced from 1982 to 1998, the collective included a 2007 sculpture made out of colored Perspex and light. As a reflection on the memorializing function of the retrospective exhibition as an idiom, this sculpture took the form of a broken and truncated obelisk, a modest monument to the films that had influenced them. Alongside works

by great European auteurs such as Godard, Antonioni, and Tarkofsky is the Berwick Street Film Collective's *Nightcleaners,* a much less well-known film addressed to a comparatively obscure subject. The broken form of the sculpture declares that this group understands its relation to past models of politicized experimental film as incomplete, inadequate, and fractured. Although this is a monument that declares its own flaws, in adopting the monumental form, with all of its associations with genealogical modes of descent, the Black Audio Film Collective acknowledges the dominance of this as an approach to history. But the epistemic violence of colonial history and the ongoing rupture of postcoloniality decisively shape this group's disjointed and ambivalent relation to their historical forebears. In films like *Handsworth Songs* (1986), *Testament* (1988), and *Twilight City* (1989) in particular, they emphasized the unreliability of diasporic memory and offer a reflective attention to the way that psychical questions of loss and separation were entwined with historical representation.[97]

Members of the Black Audio Film Collective met in the early 1980s as art students at Portsmouth Polytechnic, England (the same backdrop, incidentally, for the central work discussed in the next chapter, which features the first, though not final, presentation of Mary Kelly's film-loop installation *Antepartum*).[98] By the 1980s, the political debates of the previous decade that I have been tracing in this chapter had been significantly refocused by the politics of the postcolonial diaspora. The influence of the Birmingham school of cultural studies was at its peak, and while the Black Audio Film Collective inherited the reinvention of the documentary tradition seen in *Nightcleaners,* postcolonial concerns became much more central. The political landscape of a postcolonial Britain was coming into all-too-sharp a focus with the bloody inner-city street riots in Brixton and Handsworth that were provoked by state-sanctioned racist violence and intimidation. The postcolonial backdrop that remains latent and largely unarticulated in *Nightcleaners* emerges in full form in the work of this next generation of filmmakers.

Thus while *Nightcleaners* is an early sketch of the new social landscape of a postcolonial Britain, it certainly would not be accurate to describe it as a postcolonial film. Nonetheless, the filmmakers seem to acknowledge this as a failing, and the film declares its own inability to bring the gendered postcolonial-

ity of its subject into representation. It self-consciously marks this very blind spot in the starkest of terms. The concluding scenes of the film show a group of cleaners leaving the offices in the early morning. With the opening sections showing the beginning of a nighttime cleaning shift, the overall diegetic framing of *Nightcleaners* suggests the length of a working "day," from dusk to dawn. In this closing scene, the camera is trained in long view on a lone black woman cleaner who has been featured consistently throughout the film. She stands at the end of the station platform after the break of dawn. In the foreground the (seemingly solely male) film crew engage in a jovial cut-and-thrust political debate with a white middle-aged railroad worker. The ease of this interaction is clearly shaped by the mutual comfort found with the homosociality of the scene, and this is reinforced by the expectation of inter-generational difference that conforms to a familiar father–son model. The status of this figure as a representative of the old working class is secured when he spontaneously breaks out into a few lines from the "Internationale." Written in response to the Paris Commune of 1871, this song to workers' solidarity can only function ironically as part of the film's closing sequence. This ghostly echo of a class-unified past must be understood as a staging of ambivalence regarding political genealogies. But the new postcolonial alliance that the film does not quite manage to articulate is acknowledged in the silent black cleaning woman standing apart from and unconnected with this scene of homo*socialist* camaraderie. The cutting back and forth between the two contrasting spaces powerfully marks this juxtaposition, and as a conclusion to the film, it reiterates the feminist problematic addressed in *Nightcleaners* while simultaneously revealing its postcolonial blind spot.

As Marc Karlin was later to describe it, *Nightcleaners* was "about the distance between us and the night cleaners, between the [women's liberation movement] women and the night cleaners, and [it] was choreographing a situation in which communication was absolutely near enough impossible."[99] The complexity of the film's political aesthetic, I contend, is encapsulated in the final clause of this sentence, in its suspension of a contradiction. That is, by the way "near enough" works to qualify and at the same time to prize apart the finality of communication being "absolutely . . . impossible."

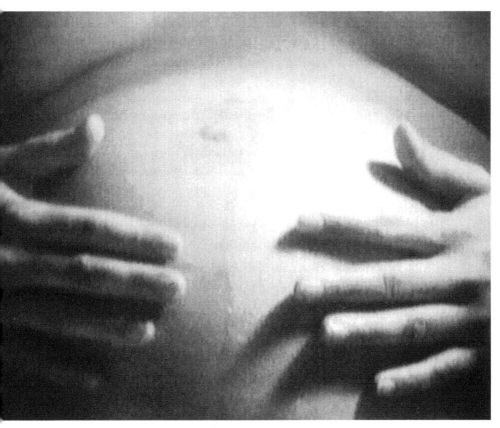

FIGURE 2.1. Film still from Mary Kelly, *Antepartum*, 1973. Silent 8 mm black-and-white film loop, 1 minute and 30 seconds. Collection of the Whitney Museum of American Art, New York. Copyright Mary Kelly. Courtesy of the Generali Foundation.

The Spectator as Reproducer

Mary Kelly's Early Films

We cannot help but read Mary Kelly's first known public performance, *An Earth Work Performed* (1970), retrospectively through the lens of British labor activism. In three different recording media (8 mm film, video, and taped sound), followed by a twenty-minute live sequence, a figure repeatedly shovels a pile of coal (Plate 1). Although the artist stages labor in action, the political resonances of the performance are shaped largely by later events that seem only obliquely relevant from the perspective of 1970. The year 1972 saw the first national miners' strikes in Britain since the general strike of 1926. This inaugurated a series of labor disputes involving mine workers that brought the figure of the miner to national prominence once again during the 1970s.[1] The strike of 1972 led to the 1973 overtime bans, the three-day week, and the national brownouts that followed, culminating in another major strike toward the end of 1978, the so-called winter of discontent. This crisis point in the labor government's ability to negotiate with (and control) the unions—the backbone of its support—was the single most significant factor in the election of Margaret Thatcher the following spring. (Her destruction of the British mining industry is such a well-known chapter in the political landscape of Britain in the 1980s that the disputes of the early seventies have now been eclipsed.)[2] While all of this could not have been predicted from the perspective of 1970, the miner is, nonetheless, the cultural archetype of masculine manual labor. He serves as the standard for the left's assumed gendering of work as a masculine norm. But the idea of the miner is invoked metonymically in *An Earth Work Performed* through the material of coal, since the labor the artist performs belongs to the realm of distribution not production. This

is *coke*, coal that has been processed for household use, not the raw material produced by the labor of miners.

With this difference in emphasis, *An Earth Work Performed* evokes important feminist questions that would go on to define Kelly's early practice. What is the relationship of domestic labor to the traditional Marxist category of production? What happens when we adapt this Marxist approach to address the political aspects of *non*productive gendered labor, such as housework and the affective care of the mother or wife? This chapter begins with the relationship between gender and production and explores various ways in which it might be considered more expansively in relation to Kelly's early forays into experimental film, produced prior to and in tandem with the earliest stages of her major installation *Post-Partum Document* (1973–79). One of the key comparative examples I present adopts another mining theme, the London Women's Film Group's documentary film *Women of the Rhondda* (1973). Featuring four wives of Rhondda Valley miners, this film was inspired by the International Wages for Housework Campaign. The second half of the chapter is a close reading of Kelly's film-loop installation *Antepartum* (1973), where I argue that she pushes the Benjaminian idea of the spectator as producer—discussed in the previous chapter—toward the feminine. The Marxist notion of production intersects with the psychoanalytically understood idea of sexual difference in this evocative and sexually ambiguous film featuring Kelly's heavily pregnant body.

Labor and Exploitation: Cleaning Warhol's Factory

With the title of this early piece, *An Earth Work Performed*, Kelly makes a direct reference to the U.S. art world of the late 1960s. *Earthworks* (one word) was the name of a 1968 exhibition at the Dwan Gallery in New York featuring photographically mediated sculptural transformations of various outdoor spaces. Several of the artists included, such as Michael Heizer, Walter de Maria, and Robert Smithson, remain closely associated with the art movement that is generally thought to have taken its name from the title of the Dwan Gallery show. The two-word term *earth work*, however, was first mentioned in an essay by Smithson published in *Artforum* in 1967, a year before the exhibition. It is perhaps more likely that Kelly is referring to Smithson's

original use of this word in the title of her performance, since *Artforum* would have been more easily accessible to her than the New York show.[3] In "Towards the Development of an Air Terminal Site," Smithson draws a link between a series of unassuming land alterations typical to construction sites and the (utopian) idea of global technological mediation:

> Like other "earth works" . . . pavements, holes, trenches, mounds, heaps, paths, ditches, roads, terraces, etc., all have an aesthetic potential. . . . Remote places such as the Pine Barrens of New Jersey and the frozen wastes of the North and South Poles could be coordinated by art forms that would use the actual land as medium. Television could transmit such activity all over the world.[4]

In Kelly's performance, the suggestion of labor associated with the construction site is replaced with the evocation of a domestic coal cellar, and the question of mediation and transmission is also constitutive of the work. Each recorded element is layered over the next: 8 mm film (the quintessential home movie form), then video (a medium that then evoked televisual transmission), followed by recorded sound, and the piece culminated in live performance. For the final twenty minutes of live action, a microphone was attached to the shovel so that *An Earth Work Performed* must have concluded in a cacophony of laboring noise. As with many of the works included in the 1968 Dwan Gallery exhibition, the ephemerality of the live performance segment of *An Earth Work Performed* was given a provisional stability in the form of a conceptual artwork made up of a text and photograph. The textual description together with photographic documentation was, until recently, presented as the sole record of this early work.[5] With an emphasis on the multiple levels of mediation involved in the live-action performance (and evident in the written description), Kelly draws our attention very strongly to the virtualization of labor rather than the celebration of the figure of the worker. Through the abstraction involved in the sound and image presentations of labor, Kelly's work thus suggests the Marxist idea of abstraction in contrast with the romantic celebration of the worker's body, materials, and tools. Kelly's engagement with late 1960s earthwork practices, including the presentation as conceptualist documentation of a task-based performance, should not be understood as a

form of passive influence. Rather, I read it as an active attempt to rewrite such artistic strategies in political terms. But, as Kelly herself has noted, it was not until her involvement in *Nightcleaners* that a greater feminist complexity would be brought to bear in her understanding of these issues of work. This marks a shift from the idea of the "art worker" to an interrogation of the gendered assumptions that underpin the trope of production.[6]

Between 1970 and 1975, Kelly collaborated with the Berwick Street Film Collective on the making of the documentary *Nightcleaners*, a film that forms the central case study of this book's opening chapter. Indeed, Kelly appeared in *Nightcleaners* as one among a small group of feminist activists who were working to unionize London's most disenfranchised of workers, women night cleaners, many of whom were immigrants (Figure 1.8). During the early stages of the filming of *Nightcleaners*, Kelly suggested that the group make a "durational film" rather than the planned documentary.[7] This was going to be an eight-hour film made up solely of toilet-cleaning action that was intended to evoke a different New York art world figure, Andy Warhol. Kelly's proposal for *Nightcleaners* was modeled on Warhol's performance films of the early 1960s, such as *Sleep, Empire, Eat,* and *Blowjob.* And like the politicized rewriting of late 1960s conceptual strategies seen in *An Earth Work Performed,* Kelly's idea for *Nightcleaners* is likewise a political, feminist rewriting of Warhol. Of films that, as Matthew Tinkcom has argued, "not only thematize work but in fact make it part of their formal and technological strategies."[8]

The question of labor is not restricted to Warhol's films alone; it is a central aspect of his whole project, and moreover it is a key theme in U.S. art of the 1960s. However, Warhol's engagement with the trope of production is rather different from his contemporaries. In contrast to minimalist and postminimalist artists such as Carl Andre, Robert Morris, Donald Judd, Dan Flavin, and Richard Serra, who turned to industrial materials and processes, as well as with the "workman-like" approach to painting established by Frank Stella in 1959, Warhol is exceptional because his work challenges the heteronormative masculinity of the art worker.[9] In 1964 Warhol renamed his studio the Factory and set up a coterie of assistants to produce his production-line art. But labor in Warhol's Factory included the sex work of male hustlers as well as the "hard work," as Warhol put it, that it took for a drag queen to be a

woman.[10] Somewhere between a countercultural business manager and bourgeois manufacturer, Warhol is Walter Benjamin's author as producer reborn in queer form.[11]

At first glance, the examples of Kelly and Warhol might stand as two sides of a coin that exemplify opposing political positions with regard to the trope of production. Hers took a post-'68 model of political collectivity, and his the perverse reflection of capitalist individuality.[12] In keeping with the antihierarchical organization preferred by both British and American feminist groups, Kelly's collective practice eschewed a Marxist-Leninist form of vanguardism in favor of a consensus model. But if we can set aside the contrast in political tone (Warhol's bohemian subculture of drag queens and socialites is indeed wildly different from Kelly's activist feminist milieu), it is nonetheless possible to discern points of intersection with regard to the complexities of sexual difference, sexuality, and production that challenge the masculist workerism dominating both artistic milieus.

Some time after the Factory scene had dissipated, Tally Brown, one of its regulars in the 1960s, remarks in an interview, "Andy did not, as one whole school of thought has it, exploit people."[13] Although Brown does not elaborate on the history behind this comment, the first public accusation of exploitation is in fact bound up with a spectacular feminist-inspired attack on the artist, Valerie Solanas's 1968 shooting. Popularly understood as an individual act of a disgruntled and psychotic artist-groupie, the political significance of Solanas's violent attack would soon be claimed as part of an emerging mass feminist struggle. At the trial, radical feminist lawyer Florynce Kennedy enlisted the radical feminist Ti-Grace Atkinson to argue that Solanas did indeed shoot Warhol as a political act, a feminist political act. This made Warhol's attacker a cause célèbre for many East Coast feminists, and her 1967 mimeographed *SCUM Manifesto*—an acronym for "Society for Cutting Up Men"—was published for the first time and widely read.[14]

Kennedy argued at the trial that the rationale for Solanas's shooting could be found in the Factory's gendered regime of worker exploitation. I am not interested in this legal point (and Kennedy's strategy involves a good deal of feminist bravado); rather, I want to understand how Kennedy's claim can help us read the trope of labor when sexual difference is brought to bear.

Moreover, this reference to Solanas's plea will allow us to clarify the gender stakes in Kelly's politicized rewriting of Warhol.

Writing in response to Tally Brown's point, Tinkcom, in the most elaborated engagement with the question of labor in Warhol's work, reminds us that exploitation "was at the heart of Marx's critique of capital, where Marx found the division of labor in class societies devoted to the creation of wealth as predicated on exploitation." So, he goes on to suggest, "It is absurd to ask whether Warhol's relation to those around him is one of exploitation: all relations under capital take on that valence, and thus it is more productive to consider how the exploitative features of his work differ in specific fashion from the more general aspects of exploitation as we understand them to define modernity."[15] Although Tinkcom does not refer to the specific feminist rhetoric of the Solanas trial, this is a useful insight, since it helps to close the gap between the activist milieu of Kelly and the bohemian scene of the Factory. And in shifting the emphasis from ethical considerations to an examination of the complex figuration of labor understood in relation to gender, we can read Kelly's proposal in different terms.

Although Kelly's suggested eight-hour version of *Nightcleaners,* depicting the endless cleaning of a toilet, was never finally realized, the idea was distilled into a photographic proxy and appeared on the cover of the London Women's Liberation Workshop's ironically named magazine, *Shrew* (Figure 2.2).[16] This collage is a minor work in Kelly's oeuvre, and her imaginative relation to Warhol is likewise a minor connection. But the composition, staging of temporality, and the laboring theme are all features that recur in other related works of the period. Thus I am less concerned with Kelly's relation to Warhol as a conventional understanding of artist influence than I am in using this comparison—triangulated with Solanas's violent feminist attack—to explore the relation between sexual difference and the trope of production as it evolves in a selected body of Kelly's early individual and collaborative works.

The most appropriate comparison for Kelly's proposed film is Warhol's first extant film *Sleep* (1963) (Figure 2.3). The solitary sleeping male figure that remains inactive during the 5 hour 21 minutes (16 fps) of the film's duration is reversed by Kelly's proposal for this eight-hour sequence of abject female labor.[17] We cannot help but recall Solanas's feminist turn to the abject

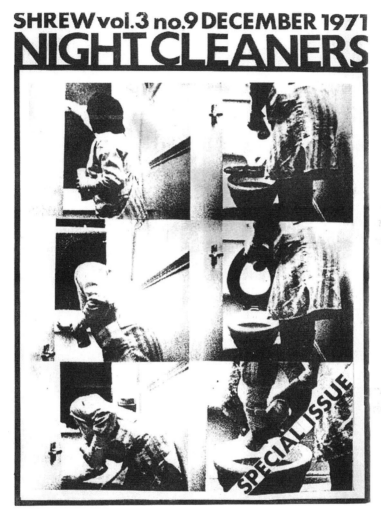

FIGURE 2.2. Cover of *Shrew* magazine (1971), designed by Mary Kelly.

with the *SCUM Manifesto*; as Avital Ronell reminds us, "We do not want to lose a sense of the excremental site to which Solanas relentlessly points and from which she speaks."[18] Kelly's own address to the excremental has a relentless insistence like that of Solanas in the *SCUM Manifesto*, and in 1976 this

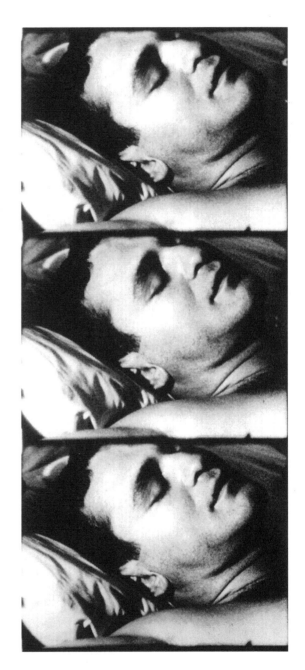

FIGURE 2.3. Film still from *Sleep*, directed by Andy Warhol, 1963. 16 mm black-and-white film, 5 hours and 21 minutes, 16 fps. Courtesy of the Andy Warhol Museum.

London-based artist would also be the subject of infamy for another scatological turn: Kelly's installation *Post-Partum Document* included twenty-eight diaper liners stained with her infant son's feces, which provoked an art scandal that received international press coverage.

The *Nightcleaners* photo sequence was Kelly's first artistic engagement with the excremental, and if realized in filmic form, it would have been the most monumental. The collage shows a cleaning woman, seen from behind, in eight different photographic views and presented as if in a time-lapse sequence. The images are arranged in two vertical rows to resemble two continuous filmstrips. In relation to the proposed eight-hour film, this photo sequence of film stills represents a single cycle in the potentially endless repetitive action of cleaning the remains of office workers' feces. Like Warhol's *Sleep*, the montage suggests cyclical repetition rather than a true durational work.[19] *Sleep* was edited from a series of thirty-minute sections that were shot over a period of six months. The final edit, which is quite heterogeneous in terms of film speed, angle, and the use of repeated sequences, is run through the projector twice at screenings in accordance with Warhol's instruction. Strictly speaking, *Sleep* is a double-cycle film loop.

Furthermore, the conceptual status of Kelly's unrealized film might also be said to mirror that of *Sleep* itself, a work that Callie Angell has described as one of the most famous *unwatched* films in the history of cinema.[20] Indeed, Warhol was the first to suggest that his films need not be watched, and others have since reiterated this point.[21] Moreover, Kelly's use of the photo sequence as cinematic proxy echoes Warhol's silk-screen prints of *Sleep*; the latter also function for most viewers as a substitute for the unseen film. These formal analogies, however, only serve to heighten the social disjunction that marks the shift in Kelly's conceptual response. With a bodily temporality circumscribed and defined explicitly by wage labor, the working-class women cleaners are a far cry from the seedy glamour of Warhol's bohemian subculture. Kelly uses this social contrast to rewrite Warhol's mimicry of labor and mass production in his Factory into an explicitly activist frame. In her political rewriting of Warhol, she pushes his engagement with the trope of production to its logical Marxist-feminist conclusion.

For such a task this feminist artist has some great raw materials to work

with. In naming his studio the Factory, Warhol developed a self-styled iden-
tification with this pseudo-industrial space of art production. He commis-
sioned Billy Name to cover all surfaces in silver—walls, ceiling, windows,
and toilet—and then Warhol took to wearing his signature silver wig. The
Factory as a glistening site of image production included Warhol's self-image
production. His unwavering coolest-of-the-cool pose helped to engender a
critical effect comparable to what Roland Barthes has called "the death of
the author."[22] In the 1960s Warhol persistently displaced himself as the final
source for the artwork's meaning. He famously told curious interviewers to
make up whatever they wanted about his work, and with photographs of his
assistants working in this pre-Fordist production-line Factory, he actively
promoted confusion about who actually made these works called Warhols.
With this he frustrates established art historical approaches to the question
of influence for this period that are strongly modeled on the oedipal complex
and ideas of heterosexual male rivalry.

Warhol's embodiment of the death of the author has not, however, stopped
his work from being discussed in relation to the oedipal notion of influence, a
critical strategy that is modeled on Harold Bloom's 1973 book, *The Anxiety of
Influence*.[23] As many feminist commentators have discussed, Bloom's Freud-
ian account has proven particularly problematic for women artists, not least
because of the unquestioning use of the male oedipal model. While Bloom as-
sumes a masculine Oedipus complex, Roszika Parker in her exploration of the
feminine Oedipus complex points out that this only creates further problems
for women artists. She explains, "Feminine identification expressed as recep-
tivity, concern, mirroring, giving and avoidance of conflict drastically inhibits
creative expression. The father has been cited as the daughter's saviour, inter-
vening between the child and her identification with the maternal ideal. . . .
Nevertheless, at the same time, fear of injuring the father, fear of joining the
mother in castration of the father, have been offered as a key explanation for
creative inhibition in women."[24] Rather than providing a feminist model for
influence, the feminine oedipal complex seems to confirm and explain Linda
Nochlin's famous question, "Why have there been no great women artists?"[25]
Phallic models of creativity that, following Freud, are predicated on sublima-
tion, Parker points out, "fundamentally exclude femininity from art practice."[26]

Drawing on the work of Melanie Klein, Parker goes on to critically explore the figure of the muse as a generative creative strategy for women—a figure that Bloom also evokes as the poet's creative companion—but this, she warns, can be a risky business.[27] For example, a figure such as Elsa Baroness von Freytag-Loringhoven, associated with New York Dada, has long remained marginal in art historical accounts of the movement despite, or perhaps because of, the powerful way in which she inhabits the place of the muse.[28] Warhol, however, precisely because of his (queer) masculinity seems able to rewrite the place of the muse more successfully, and in the milieu of the Factory "she" appears with renewed force. Warhol's muses, his superstars, were not restricted solely to the women in his circle. Alongside figures such as Edie Sedgwick, Baby Jane Holzer, Ultra Violet, Viva, Brigid Polk, and Nico were drag queens Candy Darling, Jackie Curtis, and Holly Woodland and many beautiful young men, such as John Giorno and Joe Dallesandro. Moreover, Warhol's passive role as a director (Tally Brown recalls, "Nobody was behind the camera. The camera was just on.") meant that he in fact made room for others to take up a more active role as performers. Certainly Solanas's brand of feminist queerness also found a place within Warhol's campy scene, and Jennifer Doyle has offered an important feminist account of women performers, including Solanas, within Warhol's films.[29] At the same time, Solanas violently rejected—following the logic of the male oedipal crisis—being positioned as one of the many Warhol muses. Moreover, her opposition to this came with a hefty price. She was institutionalized in a series of state-run mental institutions and spent the rest of her life struggling with mental illness. As the title of Pauline Oliveros's 1970 feminist score demonstrates, *To Valerie Solanas and Marilyn Monroe in Recognition of Their Desperation*, Solanas had already become a tragic feminist victim, and coupling her with Monroe only drives the point home. For women artists, Parker argues, the real problem is the continued externalization of the figure of the muse, a situation that she warns against and that Warhol appears to reproduce.

All this makes me wonder: Must the discussion of the relations between works of art necessarily be couched in subjective terms, as if they are relations between individuals in a symbolic family tree? Is this not in keeping with a very traditional monographic approach to art history that locates all interpretative

significance in the intentionality of the artist, whether conscious or unconscious?[30] Not, as Paul de Man has put it in his review of Bloom's book, "a productive integration of individual talent with tradition," but rather that taking a nonsubjective approach might offer a better insight into a more radical theory of "reading as misreading."[31] In dealing with the relations between works of art instead of the symbolic relation between artists, networks of interconnection can be forged through unlikely means. Thus instead of sidelining Barthes's death of the author, we should remember instead that the reason to celebrate the author's demise is found in "the birth of the reader."[32] The triangulation offered here—between Solanas, Kelly, and Warhol—is not meant to evoke the horizontality of siblinghood or the verticality of the parent to child relation, whether father to son or mother to daughter, but I am concerned with the working-through of a widely felt political problematic, shared collectively, and comprehensible via a politicized act of reading as a "type of misreading."[33]

Social Reproduction: Women of the Rhondda

According to John Giorno, Warhol's lover and the star of *Sleep,* the film was inspired by the intimacy of a lover's gaze. During the unwitting dress rehearsal for the role, which took place after an evening of alcohol- and drug-fueled indulgence in Connecticut, Giorno recounts waking up periodically from the early hours to the late morning, and each time he saw Warhol watching him with "Bette Davis eyes."[34] Warhol apparently spent eight hours just watching his lover sleep, and as the story goes, this inspired him to buy his first movie camera, a 16 mm Bolex. Kelly's reinterpretation of *Sleep* using the night cleaning worker draws out the laboring theme that underpins Warhol's film. *Sleep,* Tinkcom suggests, "wonders about whether a celebrity might not have his efforts as a performer seized at all moments, even those of which he is not conscious."[35] So Warhol's loving gaze can also be seen as the ever-watchful manager. And if we look again at Kelly's photo sequence, does it not in fact likewise suggest a managerial point of view? The camera can be understood as adopting a supervisory perspective with the spectator closely surveilling the worker. Understood via Kelly's unrealized film, spectating becomes the equivalent of overseeing a grueling night shift in a coercive reworking of

the Benjaminian notion of the spectator as producer. Furthermore, films like *Empire* and *Sleep*, Tinkcom points out, "make overwhelmingly apparent the labor of the spectator simply to maintain somatic presence for this film."[36]

In another photographic series made three years later, Kelly's presentation of the film stills in sequence also suggests the performance film. In these works she emphasizes a different viewing position from that shown in the *Shrew* collage, one that evokes the affective point of view of *Sleep*. *Primapara, Manicure/Pedicure Series* (1974) and the related work *Primapara, Bathing Series* (1974) (Figure 2.4) were first exhibited at the Artist Meeting Exhibition in London, and like the *Shrew* cover design they were presented in a series of sequentially arranged connecting photographs. Whereas the stills from *Nightcleaners* are composed in a grid to fit the format of an A4-sized magazine cover (210 x 297 mm), the *Primapara* photographs are presented linearly, in a horizontally arranged successive chain. With one digit followed by the next, this series of photographs also suggests a temporal sequence. The repetition of the action implies future replication according to the cyclical demands of the body. Thus, the narratively continuous arrangement of the images is a single occurrence of a necessarily repeatable action.

FIGURE 2.4. Mary Kelly, *Primapara, Manicure/Pedicure Series,* 1974. Two of twelve black-and-white photographs, 7.5 x 11 cm each. Collection of the Whitney Museum of American Art, New York. Copyright Mary Kelly. Courtesy of Mary Kelly.

The *Shrew* cover and *Primapara, Manicure/Pedicure Series* represent the two poles of Kelly's practice in the early 1970s. *Primapara, Manicure/Pedicure Series* explores maternal labor and affective care; the *Shrew* cover shows women's work. The relationship between labor and affect, as we have seen, is also central to Warhol's work, an issue that we will return to. The cyclical narrative presented in the *Shrew* cover is delimited by the social and political determinations of a wage-labor economy and the disenfranchised place of women within it. In *Primapara, Manicure/Pedicure Series* the maternal hands are also the artist's, and in order to make these photographs Kelly needed assistance. Someone else (Ray Barrie, the father) had to hold the camera up to the artist's/mother's eye during the laboring activity and then click the shutter.[37] This means that the point of view offered to the spectator is the mother's, producing the effect of spectatorial proximity in relation to the child's body. Not only is the spectator presented with a more intimate viewing perspective than in the *Shrew* sequence, but also the intimacy of the point of view suggests a gendered viewing position. We are shown maternal labor mediated as if through the mother's eyes. Furthermore, our proximity to the child's body suggests a reading that supersedes the parameters defined by work.

The resemblance of *Primapara* to the supervisory view in the *Shrew* cover reminds us that feminists were asserting that the managerial control of women's work extended into all aspects of everyday life, from the nursery to the bedroom. Indeed this also underpins Ti-Grace Atkinson's political reading of Solanas's actions and the exploitation of women in Warhol's Factory. At the same time, however, the comparison between the two forms of labor also suggests an exploration of their potential equivalence. This inquiry evolved for Kelly in relation to the political interrogation of the trope of production and through her participation in feminist labor activism as well as her involvement in the London Women's Liberation Workshop study group, the History Group.

The History Group also included Sally Alexander, Rosalind Delmar, and Juliet Mitchell and was dedicated to critically reading the work of Karl Marx. These women were not alone in their Marxist-feminist inquiries, since these issues were of widespread concern in the British women's movement. The most dedicated activist engagement with adapting the Marxist logic of pro-

duction to women's work was the International Wages for Housework Campaign. While Kelly was never directly involved in this, she did participate in the making of a short documentary film that explored these political ideas.

In December 1970, using skills she had learned from *Nightcleaners,* Kelly was a crew member for the London Women's Film Group's short documentary *Women of the Rhondda* (1973). This is typically attributed to the London Women's Film Group because it was completed after the formation of the group, of which Ronay herself was a part. As Ronay recounts, the project was initiated when Mary Capps, an American scholar and activist doing oral history research on the general strike of 1926, discovered the profound feminist insights that her interviewees had to offer. Capps encouraged Ronay to make *Women of the Rhondda,* and she put together an ad hoc crew of Brigid Segrave as "nominal director," Humphry Trevelyan of the Berwick Street Film Collective as cameraperson, Margaret Dickinson as sound recordist, and Kelly as the boom swinger (or assistant sound recordist).[38] Capps and Ronay conducted the interviews with the four women—Doreen Adams, Alice Boxall, Beatrice Davies, and Mary Elizabeth Davey—and Ronay later completed the editing process largely without further input from the others.

Women of the Rhondda is a short documentary film that features four women from the Rhondda Valley mining community in South Wales. Inspired by the International Wages for Housework Campaign, the women are defined in the film almost exclusively by the domestic work they do. In a combination of voice-over and talking-head commentary, and without the interjection of an interviewer's questions, they describe their working lives (Figure 2.5). The women discuss the crucial part played by women in the local economy because of their role in the maintenance of the miners' bodies. This unpaid labor of cleaning and care—a full-time job in itself—is shown to be the unacknowledged infrastructure for the economic functioning of the community. The working-class women featured in this film present the relationship between women's reproductive labor and wage labor as equivalent.[39]

In Marxist terms, the film depicts the part played by women in the reproduction of "that peculiar commodity, labour power," that is, the worker's capacity to work.[40] The social reproduction of the worker—the reproduction of "his" capacity to work—through nourishment and care, is an acknowledged

FIGURE 2.5. Film still from *Women of the Rhondda,* 1975, directed by the London Women's Film Group. 16 mm black-and-white film. Courtesy of Cinenova.

part of Marx's analysis of capital even though he does not develop the gendered aspects of this process.[41] By this I mean that Marx does not give an analysis of the reasons why women are primarily responsible for this kind of work; he simply indicates the way in which it relates to the "reproduction" of capital. This concern is reflected by Kelly—and extended to include heternormativity— in the 1973 introduction to her installation *Post-Partum Document*:

> The sexual division of labour is not a symmetrically structured system of women inside the home, men outside it, but rather an intricate, most often asymmetrical, delegation of tasks which aims to provide a structural imperative to heterosexuality. The most obvious example of this asymmetry is that of women engaged in social production or services who are still held socially responsible for maintaining labour power (i.e. males and children).[42]

Women of the Rhondda develops this Marxist inquiry in relation to the sexual division of labor. It focuses on social reproduction in a multigenerational nar-

rative of the women's lives as daughters, wives, and mothers that also empha-
sizes the sociogenetic dimensions of women's labor.

Women of the Rhondda details the elaborate physical maintenance required
for the daily "reproduction" of the miner's body, not only by nourishment
(shopping, cooking, etc.), but also by the labor of cleaning his body and
clothes blackened with coal dust and maintaining and repairing knee pads,
boots, and other work paraphernalia. The film stages the women's mainte-
nance of the worker through their verbal description; this labor is not shown
on-screen. Unlike the long tradition of British documentary film, *Women of
the Rhondda* foregrounds the women's descriptions of their work and not the
miners' bodies.[43] The women's eloquent descriptions of this process make
literal Marx's own analogy of the "reproduction" of the worker's body as
structurally equivalent within capital to the cleaning of the machinery of
production. Marx's analysis of this issue within his theory of capital is worth
citing at length, since many feminists closely scrutinized these compelling
and eloquent passages at the time.

> The capital given in return for labour-power is converted into means of sub-
> sistence which have to be consumed to reproduce the muscles, nerves, bones
> and brains of existing workers, and to bring new workers into existence.
> Within the limits of what is absolutely necessary, therefore, the individual
> consumption of the working class is the reconversion of the means of sub-
> sistence given by capital in return for labour-power into fresh labour-power
> which capital is then again able to exploit. The production and reproduction
> of the capitalist's most indispensable means of production: the worker. The
> individual consumption of the worker, whether it occurs inside or outside
> the workshop, inside or outside the labour process, remains an aspect of the
> production and reproduction of capital, just as the cleaning of machinery
> does, whether it is done during the labour process, or when intervals in that
> process permit. . . . *The maintenance and reproduction of the working class
> remains a necessary condition for the reproduction of capital.*[44]

The final sentence of this quotation indicates that social and genetic repro-
duction is the substructure for capitalist reproduction. It is a "necessary con-
dition" for capital's own remarkable process of reproduction, but this rela-
tion is not something that Marx remarks much further upon. For Marx this

sociogenetic substructure is located outside of history, available simply to be appropriated for capital's own historical process of reproduction. Marx's unsentimental analysis of labor power as an abstract category is evoked and challenged in *Women of the Rhondda*. The women describe an invisible gendered infrastructure that makes the thinking of labor power possible. This looks something like a feudal relation that underpins, and is assumed by, the contract between capitalist and worker. One of the film's subjects, Beatrice Davies, formulates this relationship in the following way: "One realizes that not only were we a slave because we were in a miner's home, but also because my father and brothers were miners, they also were slaves, and we were slaves because they were slaves to the mine owners."

Women of the Rhondda reveals a twofold problematic in the depiction of women's domestic labor. On the one hand, the work these women do as housewives is presented as an important part of the reproduction of capital. On the other hand, the film describes the psychological experience of the general devaluation of women's work, and because women's domestic labor is not acknowledged *as work*, this has an effect on their sense of self. They are effaced as individuals in their own right as well as collectively as women and as workers. The film thus leaves us with an irresolvable problem: to inscribe women's domestic labor into the abstract collectivity of the working class, the women must conform to an existing structure of collectivity through shared labor as a means of defining female collectivity. Here the women are understood as "honorary brothers."[45] The affective aspects of their labor—their collective female experiences of being wives and mothers—has to be overlooked. Simply put, their gendered labor cannot be written in Marxist terms. For this reason the International Wages for Housework Campaign turned to precapitalist models such as feudalism and slavery.[46]

The tone of political sincerity of *Women of the Rhondda*'s Marxist-feminist inquiry, like Kelly's aforementioned work, could not be further from the camp irony of Warhol's Factory scene; nevertheless, both share an engagement with production and its affective substructures. In light of this, I want to ask: How do the issues raised by *Women of the Rhondda* help us to better understand the feminist stakes in Kelly's relation to Warhol? How does this

documentary engagement with the politics of housework attenuate Kelly's conceptual engagement with these theoretical questions?

Following *Women of the Rhondda*, the *Shrew* photo sequence can be understood as rewriting Warhol's natural bodily activity of sleep as necessary for the reproduction of a laboring body. The worker needs physical replenishment in order to maintain her capacity to work. As Marx points out, leisure is not simply opposed to work, but is part of a continuum. Indeed, part of the political point of *Nightcleaners* was to show that the women's labor was all-consuming. Like Warhol for the making of *Sleep*, these women were also awake for almost twenty-four hours (but not because of an amphetamine habit). The sexual division of labor meant that their "leisure time" was spent performing housework for their husbands and caring for their children rather than engaging in their own necessary social reproduction as workers through sleep. Kelly's invocation of Warhol's *Sleep* is thus particularly poignant because sleep was precisely what the night cleaning workers could not get, however necessary it may have been for their subsistence.

I suggest that Kelly's relation to Warhol can be further developed using a different Freudian idea, working-through. This less gender-specific concept allows me to propose a different approach to the question of influence, one that Jean-François Lyotard has developed for cultural analysis. Freud distinguishes working-through from repetition and remembering in his discussion of the psychoanalytic process. Repetition, Lyotard explains, is something that takes hold of the patient like a destiny and determines "the whole existence of the subject like a drama." The original trauma gets repeated as if it were the subject's fate, compelling her to remember the scattered pieces of temporality to find the origin, the cause of, the repetition. This, Lyotard argues, is the typical understanding of "rewriting modernity": "the sense of remembering, as though the point were to identify crimes, sins, calamities engendered by the modern set-up—and in the end to reveal a destiny that an oracle at the beginning of modernity would have prepared and fulfilled in our history." This process is driven by desire, the desire to know, to unlock the hidden source, to find the primal scene. In contradistinction to this, Lyotard suggests an alternative idea. Modeled on the free association of the analytic process,

Lyotard's notion of rewriting, like working-through, "gives no knowledge of the past. . . . The result is not the definition of a past element. On the contrary, it presupposes that the past itself is the actor or agent that gives to mind the elements with which the scene will be constructed," a process that in "no way claims faithfully to represent the supposed 'primal scene.'"[47]

Both versions of rewriting modernity are at work in Kelly's oeuvre during this period. The former idea—repetition and remembering—inspired her idea for *Nightcleaners* as an extended eight-hour performance film and is the same basis for the *Shrew* photo sequence. Understood in relation to the contradictions of the Factory scene, Kelly's approach is a strong misreading of Warhol, but it is one that is driven by desire, a feminist desire. This is the desire to make a political corrective to Warhol, to resolve the contradictions of the Factory in a decisive statement about worker exploitation and gendered labor. But this approach shifts direction and starts to become closer to the idea of working-through when we look at how this rewriting of Warhol unfolds in *Primapara*, *Manicure/Pedicure Series* and *Antepartum*. This takes us a long way from any conventional idea of influence.

"A Sad Mimicry of Production"

At Portsmouth Polytechnic, England, in 1974, Kelly presented a dual-screen 8 mm film-loop installation, a work that would later be given the title *Antepartum*. The two 8 mm projectors with continuous loop attachments were placed side by side and in the same space as the spectators. The spectator's position "within" the work, alongside this filmic apparatus, interpellates her as part of the ongoing process of the work's production. Except for the whirring and clicking of the two projectors, the double-image track had no sound. On one screen a woman's hands operate an industrial machine; this is a factory worker given in partial view. Her laboring action is repeated on-screen and ad infinitum by the film loop. The other screen shows a truncated view of a woman's torso, nude and heavily pregnant. (This is the artist's body, though there is no way of knowing this from the image alone.) The camera frames a partial view of a swollen belly that is cropped just above the pubis and partway across the bottom edge of the breasts. This image is a female nude redrawn through the antepartum maternal body. The only action on this screen

is a brief self-caress. The woman's hands enter the frame for a few seconds and, in a gesture of autoaffection, gently stroke her own enlarged belly (Figure 2.6). There are no known reproductions of *Antepartum* as it appeared in 1974, and the artist herself recalls little else beyond its having taken place. In 1974 *Antepartum* was simply an untitled work in progress. Nevertheless, both films do still exist, and they have each been shown again, although not side by side as in this earlier format. As I will go on to argue, Kelly's decision to abandon the double-screen format indicates a decisive shift in her exploration of the gender implications of the question of production.

Antepartum was not shown again until 1999 when it was publicly titled for the first time and presented in a slightly different format. Here, at the Generali Foundation in Vienna, Kelly presented it as a single-screen installation showing

FIGURE 2.6. Film stills from Mary Kelly, *Antepartum,* 1973. Silent 8 mm black-and-white film loop, 1 minute and 30 seconds. Collection of the Whitney Museum of American Art, New York. Copyright Mary Kelly. Courtesy of Mary Kelly.

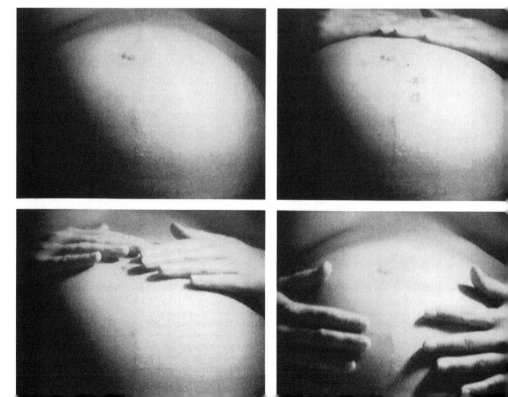

only the footage of her pregnant body. The footage of the factory worker be-
came part of the multimedia installation *Women and Work* (1973–75), which
Kelly produced along with Margaret Harrison and Kay Fido Hunt.[48] The shift
from double- to single-screen format indicates that the two etymologically re-
lated words, *production* and *reproduction*, do not make for a simple comparison
and are in fact interconnected in much more profound and troubling ways.

The dual-screen projection compares reproductive labor with productive
wage-labor and connects the question of social reproduction by analogy to
value-producing labor. Here the activities of care, love, and affection, as well
as the imposition of sanctions and punishment, would be understood as part
of a mother's work. The sequence of ideas provoked by this juxtaposition
might run something like this: one woman is laboring, the other will go into
labor; one woman works a machine, the other "works" her pregnant body;
one woman's labor is productive, the other's is reproductive. In common
with *Women of the Rhondda*, Kelly's staging of affective labor demands to be
understood as social reproduction. Understood in strictly economic terms,
the care and socialization of infants is the (re)production of future workers.
Or, in the language of Marx: "The sum of means of subsistence necessary
for the production of labour-power must include the means necessary for
the worker's replacements, i.e. his children, in order that this race of peculiar
commodity-owners may perpetuate its presence on the market."[49]

In 1974 the projector with film-loop attachment was in the same space
as the spectator; the filmic apparatus was an integral part of the work. The
repetitive mechanical whirring and clicking sound of the film being drawn
through the projector gate served as the film's only sound track. This also
aligns Kelly's work with other experimental films of the period such as Lis
Rhodes's *Light Music* (1975) and Annabel Nicholson's *Reel Time* (1973). In
Light Music the projector is positioned in such a way so as to ensure that the
bodies of the viewers interrupt the projected film. In Nicholson's *Reel Time* it
is the body of the artist that interrupts the film. This is film used as part of a
live performance that suggests a different kind of gendered labor: sitting be-
tween the audience and the projector with her silhouette projected on screen,
Nicholson ran the celluloid through a sewing machine before it went through
the projector; the marks of the stitches formed patterns on the screen. In

Kelly's 1999 digitized version, the aural texture of the projector is removed, which empties the space in more ways than simply removing the apparatus of reproduction.[50] The sight and sound of the film projection apparatus would have been an important visual and aural reminder of the film-loop repetition. The mechanized sound of the projector can also be read as a metaphoric reference to the female factory worker silently depicted on the second screen. The sound of one piece of machinery—the projector—becomes the sound track for the film footage of the factory worker. The repetitive action required by the worker's labor is a result of the type of low-paid industrial work she is doing. The repetitive projector noise is thus an aural reminder of this repetitive labor. With this intersection of sound and image, Kelly's installation stages the aesthetic idea of the spectator as producer and its relation to a workerist understanding of production. Being located alongside the projection equipment, the spectator is also part of the work's ongoing production. Through the visual representation of labor, Kelly connects the spectator's involvement in the production of meaning to the economic understanding of production.

The stroking gesture on the other screen serves as a temporal stroke that beats to the rhythmically defined tempo of the film: a ninety-second repetition. The pregnant woman's hands define both a space (the expanse of the belly visible on screen) and a time (that of the loop). This visualization of a rhythm does not, however, strictly speaking, coincide with the filmic apparatus. The taped join in the celluloid strip is faintly apparent as a barely noticeable glitch in the loop, but the hand movements serve as the narrative marker for the film's repetition. Because of the work's analogical structure, the slower tempo of one pair of hands is understood in relation to the repetitive mechanical regularity of the other. Reproduction is understood through production.

In her 1966 essay "Women: The Longest Revolution," Juliet Mitchell, who later belonged to two of the same feminist study groups as Kelly, argued that the left positioned women's reproductive capacity as "a sad mimicry of production." This might provide a description of Kelly's installation, and the root, perhaps, of the double-screen experiment. Mitchell goes on to say, "The biological product—the child—is treated as if it were a solid product. Parenthood becomes a kind of substitute for work, an activity in which the child is seen as an object created by the mother, in the same way as a

commodity is created by a worker."[51] This is likely the dominant cultural interpretation of *Antepartum*'s compare-and-contrast structure, and undoubtedly Kelly was well aware of it. But the analogical structure works two ways. As well as seeing the woman's reproductive labor as the social reproduction of the worker, *Antepartum* might also suggest that capitalist production can be understood through species reproduction: the factory as surrogate for the womb. This is a position developed by Mary O'Brien in her radical feminist reversal of the Marxist relationship between production and reproduction. Capitalist production's self-generative ability, O'Brien argues, allowed male-dominated bourgeois society for the first time "to improve on Plato's mystic brotherhood, for it had the capacity to reproduce and multiply without recourse to sexuality and without any need for females."[52] O'Brien describes the differential in men's and women's relation to genetic reproduction and, borrowing Marxist language, analyzes men's "alienation" from the reproductive process. This alienation has far-reaching social and psychological effects that must be treated in their historical specificity, and, as we have already seen in the example from Marx, they rarely are. Her most daring claim is that fraternal collectivity—Freud's brotherhood—and the whole ideological edifice of male superiority are a massive defensive gesture against male alienation from the reproductive process. While O'Brien's perspective is theoretically limited in its feminist revaluation of reproduction, it hints at the complexity of the sociopsychic effects of species reproduction on both men and women and suggests how undeveloped these questions have been.[53]

O'Brien further claims that Marx's historical materialism is inadequate in its assessment of the relations of production because he does not attend to the question of gender in species reproduction, even though, as we have seen, he acknowledges its importance for capital. Other writers have observed the damaging effects on women's reproductive health and psychosocial well-being with the substitution of reproduction by production, but O'Brien's analysis offers a longer view, rooted in the activist politics of British feminism, and is one that helps elucidate Kelly's artistic trajectory.[54] While O'Brien draws a good deal from Marx's work, she argues, "History has two concrete substructures in the continuity of the species as well as in the modes of production."[55] Likewise, Kelly's *Antepartum* also suggests this dual undergirding.

More recently, Griselda Pollock has further elaborated this issue for an art historical context in relation to the competing temporalities of the avant-garde. What O'Brien refers to as "species reproduction," Pollock calls the "maternal-feminine."[56] Drawing on the writing of Julia Kristeva, she identifies two conflicting temporalities: linear time and monumental time. Linear time is the time of history, progress, avant-garde opposition, and of modernity itself. Pollock's "maternal-feminine," on the other hand, is akin to monumental time (also related to cyclical time), a temporality typically associated with femininity and reproduction as well as the body, the tides, and nature. "Kristeva posits," Pollock elaborates, "a counterpoint between sequence/ language (linear) and repetition/body (monumental/cyclical) to stage a profound and longlasting cultural drama with sexual difference and sexuality at its heart that emerged into historico-symbolic significance at the moment of the first historical avant-garde that challenged state, family, and religion in bourgeois society."[57] Thus Kristeva claims that monumental time, or Pollock's maternal-feminine, is repressed within modernity, but it is permitted expression in the realm of avant-garde practice (and not only by women).

Kelly's dual-screen installation might seem to stage these two competing temporal modes: the linear time of production on one screen and the monumental time of reproduction on the other. But when placed side by side in this way, the woman's body is presented as analog or equivalent to the apparatus of production, with the counterposing temporalities of the maternal-feminine subsumed by the dominant linear temporal mode. This would have the pregnant woman be machine, worker, and factory for the production of her "commodity," the child. In the dual-screen version of *Antepartum*, Pollock's maternal-feminine is assimilated to the linear time of production, reinforcing, in the words of Juliet Mitchell, reproduction as "a sad mimicry of production." But as I will go on to argue in the rest of this chapter, with the laboring body removed, a different set of ideas begins to come forth.

Antepartum against "Narrative Cinema"

Laura Mulvey's widely influential essay "Visual Pleasure and Narrative Cinema" is one of the first feminist uses of psychoanalysis in relation to film. Although it was first published in the journal *Screen* in 1975, Mulvey had

the completion date of 1973 printed below the title. 1973 was also the year Kelly filmed *Antepartum* and when they both became founding members of the Lacan Women's Study Group, together with Rosalind Delmar, Juliet Mitchell, and Jacqueline Rose. Kelly has described this group "as sort of a closeted cult organization. It only 'came out' in 1976 when Lacanian psychoanalysis was presented at the 'Patriarchy Conference.' After that, psychoanalysis was seriously debated in the [women's] movement."[58] Mulvey could hardly have imagined the impact that this text would go on to have on film theory or the vehemence of some of the subsequent feminist critiques.[59] I want to bracket this complex academic history and read Mulvey's essay as a kind of avant-gardist manifesto statement on the future possibilities for feminist experimental film, in relation to which Kelly's *Antepartum* serves as a kind of case study.

As Mandy Merck points out, "Visual Pleasure and Narrative Cinema" was not written as an academic essay. At the time, Mulvey was "a feminist activist, part-time filmmaker, occasional bookshop worker, housewife, and mother who had never attended graduate school or held a teaching position."[60] A manifesto of sorts, the text is highly polemical in its tone. Mulvey asserts that psychoanalysis will be used as "a political weapon" to attack the dominant visual regime of classical Hollywood cinema.[61] "The alternative cinema" she writes, "provides a space for a cinema to be born which is radical in both a political and an aesthetic sense," and writing in the future tense of the avant-garde, this mode of practice will "exist as a counterpoint" to the Hollywood mainstream.[62] The examples that she uses from this Hollywood mainstream are not contemporary films but films that belong to a bygone era. As a rhetorical device within the structure of the manifesto form, this only reinforces her claims to a new future that is yet to come. "Visual Pleasure and Narrative Cinema" is structured according to the double temporality of avant-gardism in its desire to break with the past and start over and at the same time to embrace the future-oriented (utopian) idea of linear progression. Thus I understand Mulvey's essay not simply as a new approach to analyzing Hollywood film but rather as a dialectical avant-gardist position paper on the possibilities for a feminist filmmaking: the negation of one dead art form will, she asserts, bring about the birth of another. Two years later Mulvey, together with Peter

Wollen, would go on to release her own alternative cinematic counterpoint in the feminist film essay, *Riddles of the Sphinx* (1977). This film, as I argue in the Introduction, also functions as a response to, or rewriting of, Mulvey's *Screen* essay. *Riddles of the Sphinx* also includes some brief footage of Kelly discussing her now canonical feminist installation, *Post-Partum Document*. *Antepartum*, as Kelly has recounted, was intended as part of this multimedia work. Although it was not included in the finished installation, it can be understood in relation to the ideas that defined the first part of *Post-Partum Document*.

Some of the basic components of *Antepartum*, in terms of its attitude toward the representation of the female body and the work's pared-down, simplified film form, are implied in dialectical counterpoint to Mulvey's critical analysis. This is not to say that one was actually modeled on the other but rather that the remarkable inverted relation between text and film only further reinforces the sense of the shared nature of these aestheticopolitical concerns.

In *Antepartum* the camera is positioned in close proximity to the woman's body, and it remains immobile throughout. The body is likewise immobile except for the regular, rhythmic rising and falling of her breath and some possible (though hardly detectable) intrauterine movements. This establishes a reciprocal mimetic relationship between the body and the camera; each remains more or less fixed and unmoving. Kelly's use of the fixed camera contrasts with Mulvey's analysis of the camera's shifting point of view in classical Hollywood cinema. As is well known, Mulvey argues that this establishes both spectatorial identification with the male protagonist and a voyeuristic attitude toward the image of the female body. In contrast to this, Kelly offers an unedited real-time sequence presented as a film loop that also circumvents goal-oriented narrative logic. (The title *Antepartum*, with its reference to the very final stages of pregnancy and birth to come, plays a high-stakes game with the narrative possibilities of the pregnant female body.) Spectatorial identification with the male protagonist, Mulvey argues, is achieved through the shot-reverse-shot technique. This use of a subjective camera works through editorial splicing: the first shot shows the protagonist and the next what the protagonist sees. In this way the spectator's visual attention is directed by way of the hero on-screen, and through this the spectator is subjectively stitched,

or sutured, into the narrative.[63] Kelly, on the other hand, gives us no access to the on-screen subject's point of view, at least not according to these conventional identificatory means. Hers is a solipsistic form of self-involvement.

Mulvey goes on to describe how "woman" does not hold a viewing position but rather is only present as an image, and her visual presence is so abundant in cinema that she connotes "to-be-looked-at-ness." Looking itself, Mulvey argues, is determined by sexual difference, so that woman "holds the look, and plays to and signifies male desire." This relationship is voyeuristic because it requires the spectator's "repression of their exhibitionism and projection of the repressed desire onto the performer."[64] Mulvey argues that there is a strong separation between the looking (male spectator) and the looked-at (female performer), to the extent that looking itself is understood to be an exclusively masculine perogative. In *Antepartum,* however, there is no on-screen gaze to return the spectator's. Moreover, there is no possible identification with a character, in the terms that Mulvey describes, or even a specific individual. And Kelly's female nude is far from idealized in the manner described by Mulvey. This truncated view produces an immediate sense of unfamiliarity, an effect that is further exacerbated by the harsh lighting that, along with the cropped view of the body, creates an effect of visual uncertainty. The body is lit from top right so that the light emphasizes the spherical shape of the belly, and with the bottom left corner in shadow, it suggests a waning or waxing moon. Before the hands enter the frame, there appears to be a slight oscillation in our perception of the domed shape as it shifts from convexity to concavity. The visual strangeness of the close-up view of the pregnant body is made familiar by the introduction of the caressing gestures. It is not until the woman's hands enter the frame that this partial body is rendered fully recognizable by way of the everyday touching motion.

The hand movements also describe the spatial expanse of the swollen belly as it is presented in the frame. They travel the length and width of the body shown on-screen, demarcating it spatially as if it were topographical terrain. In contrast to Mulvey's negative emphasis on looking—the so-called male gaze—Kelly uses touch as a way of comprehending the body. The gestures are a coordinated and symmetrical arrangement of simple components, somewhere between care and orchestration. Without a reciprocating gaze, the

woman's body is rendered spatially comprehensible through the representation of touch. This tactile relation is further emphasized by the proximity of the camera to the body, which by analogy brings the spectator close to the woman on-screen.

Mulvey describes the fragmentation of the female body as producing a fetishistic response in male spectators. Drawing on Freud's oedipal narrative (for the male child), the female body becomes a substitute for the absent penis. In an act of disavowal, the male spectator simultaneously denies and acknowledges sexual difference. In *Antepartum,* however, fragmentation is used in a quite different way. Instead of fetishistic disavowal, Kelly offers a series of displacements. She presents a different invocation of the mother's sexually differentiated body and a different kind of implied spectatorial experience. The implied viewer of *Antepartum* is positioned close to the woman's body, just above the pubis. This position of proximity is one that suggests a certain kind of spectatorial embodiment, which is emphasized through touch. The lower part of the belly has a muscular seam, called a linea alba, that tracks down off-screen toward the woman's genitals.[65] Although the pubis is not visible in the frame, its presence is implied by the linea alba, which functions as a line pointing downward like an arrow. Furthermore, the woman's genitals are narratively suggested by the fact that the term of the pregnancy has almost reached completion. Even more important, however, is the position of the camera, the body of which is placed level with the woman's pubis. Spatially, the camera *body* is situated at the pubic rim, physically below the camera lens and the threshold of what is visible on-screen: the woman's sex. This comparability is further reinforced by a reciprocity between the (camera) body and (pregnant) body because they both exhibit similar slight movements while otherwise remaining static.[66]

It is Mulvey's contention that cinema rehearses, reiterates, and assuages the continued anxieties produced only in the *masculine* psychical narrative. *Feminine* subjectivity in these films, she tells us, is wholly "subjugated to her image as bearer of the bleeding wound."[67] Mulvey's spectator is thus psychically gendered as masculine. Whether an actual man or woman, this spectator is conceived of as an imaginative figure who is interpellated by the film and *his* psyche is bolstered and reproduced in the darkened space.[68] Mulvey

argues that the image of woman in cinema is a sign that represents something in the masculine unconscious.

In lieu of the imagined bleeding wound of the fetishistic female body, Kelly offers a different kind of bodily inscription. The spectator of *Antepartum* is eye to navel. The screen is filled with the maternal body, and the navel is emphasized as an important feature within the frame through the orchestrated hand actions. During the sequence of movements the hands briefly rest either directly above or below this bodily knot, thus the caressing action serves to frame the navel. The slight quavering of the camera is a physical registration of an insecurely anchored tripod, and this is mirrored by the slight movement that seems to be coming from inside the woman's body. This emphasizes the camera's presence as an object, a body that is physically located in relation to the woman's nude body: adjacent to her genitals. This proximity suggests a form of sexual embodiment that works by way of a technobiological fantasy and is an aspect of the work that lies beneath the visual register. In *Antepartum* the spectator is embodied by way of the camera's body. Thus it is the body of the camera, its recording or reproductive capacity and not the visual aspect, the lens, that enables the spectator's identification with the apparatus.

The relationship between touch and visibility as an approach to knowledge of the reproductive process has radically changed since the early 1970s. In fact *Antepartum* was made on the cusp of a major shift in obstetrics. The mid- to late 1970s saw the widespread use of sonogram technology in Britain for the first time. Prior to this, the mother's own bodily sensation was the principal means of monitoring intrauterine development. Because of her focus on touch, Kelly's caressing action draws our attention to the tactile dimensions of the mother's experience. Her perception of the subtle shifts of body within body is referenced in her gesture, although of course it cannot be made visible.[69]

With the camera's unusual partial framing of the maternal body and the particular focus on the repeated everyday gesture of self-caress, Kelly's *Antepartum* belongs to a more widespread feminist project of reimagining the female body. A brief comparison with another feminist-engaged work from around the same period, Susan Hiller's *Ten Months* (1977–79), will give insight into this as a shared feminist project while at the same time I can more clearly circumscribe the specificities of *Antepartum*. Like Kelly's *Antepartum*,

Hiller's photo-and-text work presents her own transforming pregnant body from an unconventional point of view (Figure 2.7). Hiller is also seeking a new kind of representation of the maternal body, one that defies conventional sentimentalities. She presents a sequence of photographic images in ten rectangular panels showing a close-up of her own belly. These are accompanied by an equal number of typewritten textual panels of a slightly smaller size. The cumulative effect of the photographic sequence gives a time-lapse depiction of the pregnant body that resembles a lunar calendar. Moreover, the ten months of Hiller's title is the measurement of the average period of pregnancy in lunar months. Hiller's image of the maternal body is an objectified view: she presents us with a minimalist grid showing the most immediately apparent physical manifestation of the maternal body presented as a radically antisentimental temporal sequence. The accompanying textual fragments are drawn from her diary entries, and in counterpoint to the image sequence they offer both a subjective response and a critical analysis of pregnancy as an embodied experience. As the artist later put it, pregnancy is "an incredibly fertile *mental* time, quite extraordinarily rich, not just the body and its

FIGURE 2.7. Susan Hiller, *Ten Months,* 1977–79 (detail). Copyright Susan Hiller. Courtesy of Susan Hiller and Timothy Taylor Gallery, London.

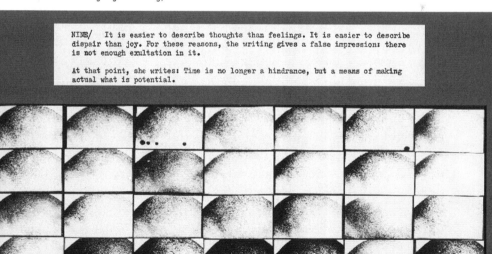

changes, but the mind as well."[70] Thus *Ten Months* offsets the objective visual depiction of the pregnant woman's body with a textual presentation of the complexities of a lived subjective experience. In *Antepartum* Kelly does not share Hiller's focus on the experiential.[71] Unlike *Ten Months*, *Antepartum* does not include any reference to pregnancy as a linguistically articulated lived experience. Kelly's emphasis on the affective qualities of touch stands in place of the linguistic. I would even go so far as to say that *Antepartum* focuses on specifically extralinguistic qualities. This leads me to conclude that, unlike Hiller's, Kelly's work is not solely about the maternal point of view but also suggests an imagined intrauterine perspective. Furthermore, together with the careful mirroring of the camera and the woman's body, it is my contention that *Antepartum* stages a technological fantasy of intrauterine return.

Freud initially theorized the psychical significance of such a fantasy in his 1919 essay "The Uncanny." The uncanny is an affective response, which according to Freud is "that class of the frightening which leads back to what is known of old and long familiar."[72] He describes the uncanny as a process of doubling that invokes a psychical return, and Freud develops this line of reasoning with reference to the semantic doubling he discovers in the etymology of the word. *Unheimlich* is synonymous with its apparent opposite, *Heimlich*. The uncanny *(Unheimlich)* is something that was once familiar (*Heimlich*, or "homely") but has been repressed. I have already noted the visual strangeness of Kelly's view of the mother's body, which produces the effect of the unfamiliar, an unfamiliarity that turns out to be most familiar. Freud's own narrative leads us back to the mother's genitals, and he suggests that the uncanny response provokes the fantasy of intrauterine return. This is a return that takes us back to our very first home, the womb. Moreover, just as both Mulvey and Kelly were involved in developing a mode of aesthetic analysis through psychoanalytic theory—from the perspective of the film theorist and artist, respectively—Freud uses psychoanalysis in "The Uncanny" in order to develop an aesthetic theory. This process involves the production of a series of uncanny doubles, and, as Sarah Kofman has argued in "The Double Is/and the Devil," this is a psychically invested operation of mimesis.

Kofman develops the implications of Freud's essay for aesthetic theory. She argues that if it were not for the "seductive artifice of beauty to divert the

ego's attention and prevent it from guarding against the return of repressed fantasies" all aesthetic pleasure would be uncanny.[73] While Mulvey argues in "Visual Pleasure and Narrative Cinema" that the presentation of female beauty in classical Hollywood cinema is a fetishistic disavowal of a repressed psychical anxiety, Kelly's work explores the idea of a feminine spectatorial position over and against Mulvey's description of the male gaze of classical Hollywood cinema. Her engagement with feminine spectatorship is not, however, simply reducible to an empirically verifiable female audience. I am therefore not proposing that the work is made for a women-only audience but rather that it offers a feminine spectatorial position. This is an imagined point of view available to any spectator and evident from the work's structures of address. The suggestion of the "labor" involved in viewing works of art and film was understood politically as suggesting a shift in the aesthetic relations of production. *Antepartum*'s exploration of the relationship between production and reproduction pushes the debate in a decisively feminine direction.

The Umbilical Lens

The navel is a manifestation of our connection to, and disconnection from, our mother's body. It is the mark we all bear (male and female) as evidence of this separation from the maternal body; at the same time it reminds us of the former connection with that bodily origin. As reproductive adults, men and women are positioned differently in relation to the navel. Certainly, we were all once connected to our mother's body via the umbilical cord, but women also have the capacity to connect again—as mothers to their own child—through the other end of an umbilical cord. In Gayatri Chakravorty Spivak's words, "We [women] carry the womb as well as being carried by it."[74]

Shoshana Felman discusses Freud's invocation of the navel in *The Interpretation of Dreams* as a metaphor for moments of difficulty in the analysis of dreams. Freud refers to aspects of the dream that are resistant to understanding as the dream's "navel." Felman develops this bodily metaphor thus: "To ask a question at the level of the navel is to ask a question at the level of a certain birth and of a certain scar: the question is posed out of a certain wound, a certain severance, a certain impossibility."[75] Felman's essay was written in memory of her former teacher Paul de Man, and it includes a response from

de Man to these insights, given to Felman in a letter that she received not long before his death. De Man proposes a challenge to Felman's feminist analysis based on the fact that the navel is a "bisexual" bodily inscription (68). This is indeed the case, but my point is that although both sexes bear the primary mark of the navel, this is because of our former connection to the mother's body. Bisexuality is the case for only one end of the umbilical cord. Furthermore, de Man effaces this disconnection from and connection with the body of the mother in his assertion that the navel is a "knot that is cut" (68). In an unacknowledged moment of gendered interpretation, he sidelines Felman's attempt to address questions of birth and pregnancy by implicitly proposing the obstetrician as philosopher. Felman in eulogistic mode concedes his correction and develops his reading further. Instead of the "undoing of a knot" that the process of analysis suggests, Felman goes on to elaborate, philosophy "is founded on the violence of Gordian knots" *that are cut* (71). In de Man's analogy, however, the philosophical obstetrician enters the scene in order that the mother can be wheeled offstage and her part in this philosophical birth can be forgotten. Following Felman's de Manian analysis, the maternal body ends up being relegated once more to inert ground, emptied container, or reproductive machinery to be managed.

In *Antepartum* the action is suspended at the prepartum moment. Kelly's continuous film-loop installation remains poised at this crucially late antepartum stage of pregnancy. Instead of cutting Felman's philosophical Gordian knot, Kelly stages a form of embodied spectatorial identification by means of the maternal body. The camera/projector lens is an imaginary umbilical cord extending out from the mother's navel to the spectator. The projector functions as a stand-in for the camera, and this interchangeability of camera and projector suggests a two-way flow of light across time and technology. Light flows into the camera body from the maternal mise-en-scène and out of the projector onto the surface of the screen. This flow of light may be read as a visual metaphor for the umbilical cord, which is also a two-way flow (of nutrition and waste) between mother and embryo. With the navel presented as a vanishing point, this umbilical lens is the visual anchor that secures the imagined spectatorial position in relation to the on-screen mother's body.

The interconnection between camera and projector in this relational econ-

omy is further secured by the camera position. The camera is located directly below the pelvic rim, and thus it is level with the woman's genitals. This suggests the off-screen intrauterine space of the baby. Note that the woman's navel on-screen is the mark of her separation from her own mother, and as such this implies her own former intrauterine connection. This means that *Antepartum* doubly maternalizes the implicit spectatorial position. First, the spectator is imaginatively *re*connected as mother to the woman's navel on-screen by way of the umbilical lens. And second, she is imaginatively connected as mother to the unborn child not yet visible on-screen but narratively implied. The mechanization of the natural process of human reproduction has its uncanny double in the anthropomorphization of the machine: the camera as womb. Moreover, this double maternal re/connection articulates a sexually differentiated relation to the womb. The imagined spectator is feminized and like the on-screen woman has the potential for connecting and disconnecting at both ends of the umbilical cord. *Antepartum* posits a temporally concurrent staging of Spivak's formulation: "We carry the womb as well as being carried by it."

Recent feminist scholarship suggests that the in utero relation of mother and child might offer a model for theorizing an ethical relation to the other. This argument emerges from an understanding of the peculiar negotiation of mutual dependency and respect for life between the mother and the embryo. In developing this theory, biologist Hélène Rouch and psychoanalyst-philosopher Luce Irigaray counterpose the widely held belief that the in utero relation is one of fusion.[76] According to this erroneous but quite commonsensical view, the idyllic fusion with the mother is abruptly terminated by birth, and this idea of severance is figured most powerfully in the cutting of the umbilical cord. Rouch points out that this so-called first mark of castration, the cutting of the umbilical cord, does not, in fact, sever the child from the mother; rather, this cut separates the child from the placenta. The placenta, or afterbirth, is naturally discharged from the woman's body shortly after the birth of the child, but the Western practice of cutting the umbilical cord has come to represent the decisive moment of severance from the mother's body. The placenta, along with the umbilical cord, is produced by the embryo and not through the fusion of mother and child. It nevertheless performs the unique task of mediating between the needs of the embryo and the needs

of the mother as if it were an independent entity. The placenta regulates the correct portions of nutrients to the fetus and mother alike. It therefore enables the coexistence of both parties in a situation of negotiated interdependency.

While Felman's argument follows a Lacanian logic of birth as the first death, Kelly's installation can be understood as an aesthetic equivalent to a philosophy of the feminine.[77] Following Rouch and Irigaray, the mother and baby are foreigners to each other, and their détente is negotiated by the third party of the placenta. The umbilical cord is the means through which this encounter is achieved. It is for this reason that the metaphor of the umbilical lens takes on such crucially important significance in my reading of *Antepartum*.

Umbilical metaphors are not without precedents in the history of writing about photoreproductive technology. Siegfried Kracauer deploys such a metaphor to describe a heightened form of realism for certain documentary films. He argues that in such vivid and dreamlike works, the camera appears to have "just now extricated [its object] from the womb of physical existence as if the umbilical cord between image and actuality [has] not yet been severed."[78] A similar kind of claim to affective immediacy is made by Roland Barthes in his posthumously published essay on photography, *Camera Lucida*. Written in response to the death of his mother, Barthes argues that the "photograph is literally an emanation from the referent. From a real body, which was there, proceed radiations that ultimately touch me, who am here. . . . A sort of umbilical cord links the body of the photographed thing to my gaze: light, though impalpable, is here a carnal medium, a skin I share with anyone who has been photographed."[79] Although several writers have challenged his claim that photography is a *literal* emanation from the referent, Barthes's widely influential argument is based on the indexical nature of photographic technology.[80] The indexical sign establishes a causal relation to the referent by means of physical proximity: the footprint, the cast shadow, or the symptom. The photograph is thus an imprint in light of the object that was set before the camera. For Barthes and Kracauer the idea of the umbilical cord is used to suggest a kind of psychophysical immediacy for the spectator. Both these writers use the metaphor of the maternal body to propose a form of psychically invested realism that for Barthes also suggests the psychoanalytic idea of reconnection with the Real.[81] Barthes's analysis, however, like Felman's, reinforces the association of birth with castration and death because *Camera*

Lucida is also a eulogy of sorts, in memoriam for the writer's dead mother. *Antepartum* avoids these associations by suspending the prepartum moment. And like Barthes, Kelly emphasizes skin and touch. At such an advanced stage of pregnancy, the taut skin of the belly becomes a palpable threshold between the mother and the in utero infant. The caressing action reinforces this as a mutually perceptible interface between the two bodies.[82]

I have already established that Kelly's own engagement with psychoanalysis was part of a collective feminist inquiry in the Lacan Women's Study Group, which also included the filmmaker and theorist Laura Mulvey. In relation to the psychoanalytic concept of fetishism, Mulvey argues that classical Hollywood cinema is wholly addressed to the implied male spectator. How, then, does sexual difference operate for the implied spectator of *Antepartum?* Following Spivak's speculative theorization of the concept of womb envy, I claim that in *Antepartum* the spectator is figuratively *given* the womb. In a symmetrical inversion of Mulvey's formulation, Spivak describes "womb envy" as follows: "If to give and withhold to/from the mother a phallus is *the* male fetish, then to give and withhold to/from the man a womb might be the female fetish in an impossible world of psychoanalytic equilibrium. The icon of the sublimated womb in man is surely his productive brain, the box in the head."[83] The camera box as a technological means of reproduction might offer another form of womb sublimation.

In relation to the concept of womb envy, the imagined spectator of *Antepartum* is subjectively stitched, or sutured, into a maternal position. She is reattached as mother/womb to the technological umbilical cord. The male spectator is imaginatively given the womb through an operation of gender transvestism. This relation can best be understood as an experiment in female fetishism: womb envy. Men are only carried *by* the womb, but *Antepartum* imaginatively positions the male spectator as also carrying the womb. This installation acknowledges male alienation from species reproduction, and at the same time it is a decisive challenge to exclusively masculine models of collectivity. Kelly's film reverses the gender transvestism described by Mulvey for classical Hollywood cinema, with an implied viewing position that is feminine and embodied. The feminine spectator is imaginatively connected to her mother at the same time that she connects as mother to her child. She simultaneously carries the womb as well as being carried by it.

By the "feminine spectator" I do not mean an empirically identifiable biologically female audience. All spectators, female *and* male, are feminized in *Antepartum* in a reversal of the masculine gender transvestism argued by Mulvey in "Visual Pleasure and Narrative Cinema." My analysis here is not directly concerned with actual spectators, whether men or women, or for that matter gay or straight, differentiated by race or class, or ideologically formed through a number of different institutional frames. Whether or not an actual female spectator has been, is, is able to be, or even wants to be a mother might find her relating to this double maternalization in very different ways, which certainly would not all be positive. These speculations on individual psychology and actual spectatorial response are not the concerns of this argument. Having said this, the very real complexities of this process of spectatorial maternalization, when we imagine real spectators, only reinforces the importance of this work as a feminist intervention.[84]

Mary O'Brien's theorization of reproductive consciousness together with Pollock's idea of the "maternal-feminine" have given us insight into Kelly's decision to abandon the analogical format of *Antepartum*. This is a shift from Kelly's rewriting of Warhol's Factory scene through the reproductive female body to the exploration of an imagined ethical relation that exists prior to production. *Antepartum* in its final single-screen format explores the idea of a feminine spectatorial relation that was hidden and obscured by the political preoccupation with production. In terms of Lyotard's idea of rewriting modernity, this is a shift from the repetition of the trope of production as it applies to the *re*productive female body to the bringing-forth of another set of gendered concerns that remained hidden by this motif. Rather than the impoverished gender transvestism that Mulvey describes for the putative female spectator, in *Antepartum* Kelly presents a philosophically and psychically rich set of possibilities for reimagining both feminine subjectivity and masculine alienation from genetic reproduction.

The unfurling of the process of rewriting modernity begun with *Antepartum* would continue throughout the decade in Kelly's multipart installation *Post-Partum Document*. It is a massive durational installation that charts the psychological and social development of the mother and child for which, in one sense, *Antepartum* can be understood as a filmic sketch. The tactile dimensions

of *Antepartum* are pushed in a slightly different direction in this later work. Kelly self-consciously avoids all iconic depictions of the female body, and in its place she presents indexical traces.[85] The first parts of *Post-Partum Document* were exhibited in 1976, the same year that the Lacan Women's Study Group, as Kelly put it, "came out." Kelly's rejection of all iconic representations of the female body set an important precedent for other feminist-engaged artists and art historians in the years to follow. In its representation of touch, however, *Antepartum* suggests an alternative approach. As we will see in the next two chapters, Kelly's iconoclastic turn cast a long shadow over the rest of the decade.

Coda: On the Caress

I published an earlier version of this chapter in abbreviated form in the journal *Art History*.[86] In the course of revising the text for this book another quite surprising reading of the film came to light. This other reading—an erotic reading—emerged between the lines, so to speak, of my own writing about *Antepartum*, in the language used to describe the caress. Like Lyotard's analogy with the psychoanalytic process, this reading of my own text is also a rewriting of Kelly's. Here, rendered in italics, is how I have described the film: Kelly's *gesture of autoaffection,* her *self-caress,* is a familiar *everyday touching motion,* a *stroke that beats to the rhythmically defined tempo of the film,* and is echoed in the *regular, rhythmic rising and falling of her breath.* The body presented in this *truncated view produces an immediate sense of unfamiliarity.* This rereading of my own text allows for another kind of bodily pleasure to emerge, a reference to self-pleasuring. Kelly's *stroking gesture,* I want to suggest, can also be read as a figuration of masturbation with her *swollen belly* serving as a displaced reference to another engorged body part: clitoris, labia, breast, or even penis. This is the body in pleasure, erotic self-pleasure, but one that is not genitally fixed or even necessarily gendered in its reference. This rewriting of my own text (a masturbatory act as well, perhaps) offers a different kind of coupling—another linkage—with the next chapter about COUM Transmissions. Their explicit (full-frontal) staging of sexuality was closely connected with Kelly's best-known work from the period, *Post-Partum Document,* and my reading of COUM's queer aesthetic also evolves in relation to psychical issues.

October 19th-26th 1976

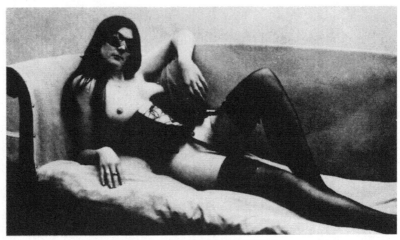

SEXUAL TRANSGRESSIONS NO. 5

PROSTITUTION

COUM Transmissions:- Founded 1969. Members (active) Oct 76 - P. Christopherson,
Cosey Fanni Tutti,Genesis P-Orridge.Studio in London.Had a
kind of manifesto in July/August Studio International 1976. Performed their works
in Palais des Beaux Arts,Brussels; Musee d'Art Moderne, Paris; Galleria Borgogna,
Milan; A.I.R. Gallery, London; and took part in Arte Inglese Oggi, Milan survey of
British Art in 1976. November/December 1976 they perform in Los Angeles Institute
of Contemporary Art;Deson Gallery,Chicago;N.A.M.E. Gallery,Chicago and in Canada.
This exhibition was prompted as a comment on survival in Britain,and themselves.

2 years have passed since the above photo of Cosey in a magazine inspired this
exhibition.Cosey has appeared in 40 magazines now as a deliberate policy.All of
these framed form the core of this exhibition.Different ways of seeing and using
Cosey with her consent,produced by people unaware of her reasons,as a woman and an
artist, for participating.In that sense,pure views.In line with this all the photo
documentation shown was taken,unbidden by COUM by people who decided on their own
to photograph our actions.How other people saw and recorded us as information.Then
there are xeroxes of our press cuttings,media write ups.COUM as raw material.All of
them,who are they about and for? The only things here made by COUM are our objects.
Things used in actions,intimate (previously private) assemblages made just for us.
Everything in the show is or sale at a price,even the people. For us the party
on the opening night is the key to our stance,the most important performance.We
shall also do a few actions as counterpoint later in the week.

PERFORMANCES: Wed 20th 1pm - Fri 22nd 7pm

Sat 23rd 1pm - Sun 24th 7pm

INSTITUTE OF CONTEMPORARY ARTS LIMITED
NASH HOUSE THE MALL LONDON S.W.I. BOX OFFICE Telephone 01-930-6393

FIGURE 3.1. Poster for COUM Transmissions' *Prostitution* at the Institute of Contemporary Art, London, 1976. Copyright Cosey Fanni Tutti. Courtesy of Cabinet Gallery and Cosey Fanni Tutti.

Prostitution and the Problem of Feminist Art

The Emergent Queer Aesthetic of COUM Transmissions

1976 was Britain's year for art scandals and each one fed into the next. The first was provoked by the Tate Gallery's purchase of Carl Andre's minimalist sculpture *Equivalent VIII* (1966)—a rectilinear arrangement of unaltered house bricks. Later that year the media were again up in arms because of Mary Kelly's installation *Post-Partum Document* at the Institute of Contemporary Art (ICA). Her presentation of framed diaper liners with traces of her infant son's feces was considered comically obscene, not just a hoax like "the bricks"; and the "dirty nappies" were in bathetic contrast to the artist's extended intellectual exposition drawing on Marxist, feminist, and psychoanalytic theory (Figure 3.2).[1] While Kelly was forced to go into hiding for a time to avoid the unwanted media attention, this was nothing compared with the experience of the performance artists of COUM Transmissions when, one month later, they presented another challenging installation about sexual difference at the same ICA venue.[2] The all-too-familiar tabloid outcry against cultural decline was about to reach epic proportions with COUM's provocatively titled installation *Prostitution*. While Kelly's *Post-Partum Document* has long since transcended the sensational scandal that accompanied its entry into the public sphere, COUM's installation has yet to do so. In fact, it is doubtful it ever fully will. This is not simply because the media scandal reached the scale of a moral panic but because of the complex performative way in which the media was staged by COUM as part of this exhibition. From the framed and signed pages from pornographic magazines featuring the nude modeling of COUM's most prominent female member, Cosey Fanni Tutti, to the presentation of the group's archive of press cuttings that continued to be added to

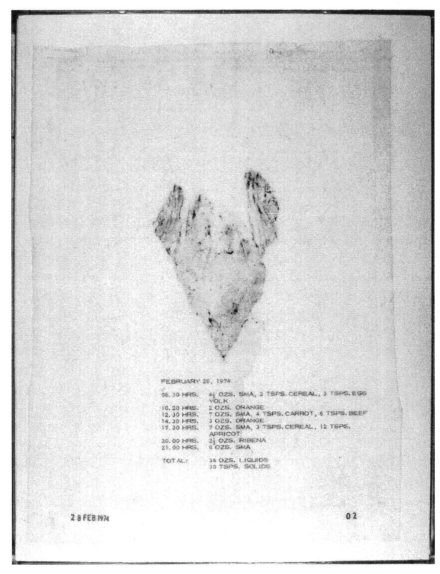

FEBRUARY 28, 1974

08. 30 HRS.	4½ OZS. SMA, 2 TSPS. CEREAL., 3 TSPS. EGG YOLK
10. 20 HRS.	2 OZS. ORANGE
12. 30 HRS.	7 OZS. SMA, 4 TSPS. CARROT, 6 TSPS. BEEF
14. 30 HRS.	3 OZS. ORANGE
17. 30 HRS.	7 OZS. SMA, 3 TSPS. CEREAL., 12 TSPS. APRICOT
20. 00 HRS.	2½ OZS. RIBENA
21. 00 HRS.	8 OZS. SMA
TOTAL:	34 OZS. LIQUIDS
	30 TSPS. SOLIDS

2 8 FEB 1974 0 2

FIGURE 3.2. Mary Kelly, detail from *Post-Partum Document: Documentation I, Analysed Faecal Stains and Feeding Charts,* 1974. Perspex unit, white card, diaper linings, plastic, sheeting, paper, ink; one of thirty-one units, 28 x 35.5 cm. Collection of Art Gallery of Ontario. Copyright Mary Kelly. Courtesy of Mary Kelly.

during the course of the exhibition, the media was a central component of *Prostitution*.

Although Kelly's *Post-Partum Document* is now widely accepted as the most significant work of feminist art produced in Britain in the 1970s, its relation to COUM's *Prostitution* has barely been acknowledged. This is partly because *Prostitution* is not obviously a work of feminist art; nonetheless, feminism makes an appearance in the installation as part of a larger crisis in the cultural signification of femininity.[3] It is only relatively recently that COUM's complex, chaotic performance event has begun to be acknowledged in an art historical context in Britain. This is largely due to the inclusion of Tutti's pornographic performance actions in both Helena Reckitt and Peggy Phelan's 2001 book *Art and Feminism* and the major survey exhibition and publication *WACK! Art and the Feminist Revolution* (2007).[4] Both of these projects are North American, and Tutti's use of her own eroticized body seems to fit easily into this company of artists. In Britain, however, COUM is typically seen as swimming against the tide of emerging feminist art.[5] This is partly because their mode of artistic engagement draws on a historical legacy that is different from the one that has preoccupied us so far. *Prostitution* does not adopt a strategy of political critique, as is the case with Mary Kelly's *Post-Partum Document*. Rather, COUM's work emerges in critical relation to other political art of the period. That is, it was opposed to the very idea of political art. Nonetheless, in common with Kelly's *Post-Partum Document*, *Prostitution* is fundamentally defined by an interrogation of the symbolic codes of sexual difference. If Kelly's installation was framed as a critical interrogation of the heteronormative imperative, COUM embraces a queer aesthetic. This chapter is not an attempt to reclaim COUM for the curatorial category of feminist art, although both Tutti and P-Orridge acknowledge the significance of the cultural and social impact of feminism on their work.[6] While *Prostitution* does indeed mobilize feminist codes, it does so to stage a queer aesthetic: not homosexuality as an identity or a generalized post-1960s idea of camp, but the mutual contamination of gender and genre. The queer aesthetic of *Prostitution*, in common with Kelly's *Post-Partum Document*, articulates the relationship between the social instantiation of gender and the psychical notion of sexual difference, provoking a disruption in both.

Transmissions: COUM as Mediatic Formation

Prior to the ICA scandal, COUM had become a major presence in the British art press, so much so that they were able to amass a significant quantity of press clippings to constitute a wall display in *Prostitution*. As a measure of their burgeoning success, earlier in 1976 they were included in a survey exhibition of British art in Milan, *Arte Inglese Oggi 1960–1976* [English Art Today], and their performance, *Towards Thee Crystal Bowl*, was the only work that received any critical analysis in Richard Cork's review of the exhibition in the *London Evening Standard*.[7] Earlier in 1976 P-Orridge had been subject to another censorship scandal, and prominent art world figures such as Sir Norman Reid, director of the Tate Gallery, and G. M. Forty, director of the Fine Arts Department of the Arts Council, took up his defense.[8] P-Orridge was charged with obscenity because of his dissemination through the mail of pornographic collages featuring Tutti. Prior to the trial COUM issued wedding-style invitations inviting members of the art world to attend, and the proceedings were documented and subsequently published as an artist's book.[9] The treatment of the trial as a performance event sets a precedent for *Prostitution* in both the use of the media and the parodic attack on established norms of heterosexuality.

Today COUM is better known to fans of alternative (industrial) rock music and those art historians with an eye on the music scene. This is because the 1976 ICA exhibition was COUM's swan song to the British art community; on the opening night of the exhibition, they shifted the orientation of their practice back to music under the name Throbbing Gristle.[10] Like Andy Warhol's presentation of the Velvet Underground in his *Exploding Plastic Inevitable*, the opening night of *Prostitution* was a multimedia performance event. It included the punk band Chelsea, Throbbing Gristle (COUM's own band), and a hired female stripper, all performing in the exhibition space. Journalistic accounts of the opening reception were folded back into the exhibition as COUM updated the wall of media clippings. Later P-Orridge referred to Warhol's assertion of fame as a new medium of art (alongside the other more traditional media such as painting, sculpture, and photography), and Warhol was an important figure for COUM's evolving art practice.[11] If Warhol provoked art historians to question the institutional function of the proper name

"Andy Warhol," as it came to serve as a kind of brand, COUM took this in a slightly different direction. In *Prostitution* they incorporated their media presence into the very fabric of the installation itself. In doing so, COUM asserted that the broader discursive framework for understanding a work of art, its critical reception, and the notion of an artistic biography (including sensational and erroneous accounts) should also be considered part of the work. This situated the moment of the artist's production decisively in the past and as just one part of a larger network of factors that shaped the work's meaning.[12]

Although vocal about the pornographic images by Tutti, the press maintained a stony silence about its own presence in *Prostitution*. Furthermore, as this element of the installation expanded, COUM's staging of the media continued to be ignored. This was not the only part of *Prostitution* that was overlooked by the press. There was little discussion of P-Orridge's *Tampax Romana*, a series of small mixed-media sculptures featuring Tutti's used tampons in small wall-mounted vignettes, even more embarrassing, it seems, than Kelly's diaper liners. Because of COUM's staging of the media as part of the installation, together with the various occlusions that this produced, a clear picture of *Prostitution* has yet to emerge.[13]

Originally, the media wall was conceived by COUM as a kind of epitaph for the art world. *Prostitution* marked the cessation of COUM Transmissions and Throbbing Gristle's inception. This collaged obituary indicated the death of COUM, and, with the Throbbing Gristle set titled Music from the Death Factory, death is an important dimension of *Prostitution* as a whole. But the media wall served another important temporal function. As COUM continued to add the numerous articles written in response to *Prostitution*, this section of the exhibit functioned like a slowed-down feedback loop. This continually expanding wall of press cuttings propelled the ongoing sequential unfolding of *Prostitution*.[14] While Kelly took her model from film, and *Post-Partum Document* can be understood as a visualization of linear narrative sequence, the temporality of *Prostitution* was unpredictable. Thus *Prostitution* should also be read as an extended improvisatory performance existing temporally as well as spatially that, following the group's name, is structured by the logic of *transmission*.

The mediatic orientation suggested by the name COUM Transmissions

declares the group's engagement with one of the dominant themes in 1960s and 1970s art. The use of new video technology and experiments with television broadcast are the most obvious manifestation of the so-called mediatic turn in postwar art.[15] More broadly conceived notions of information, communication, and feedback associated with conceptual art and mail art practices in particular demonstrate the widespread structural impact of ideas of media at this time. (The touchstone for many of these 1960s artists was undoubtedly Marshall McLuhan's enormously influential 1964 book, *Understanding Media*.) COUM's engagement with the distributive structure of mail art provoked a disciplinary shift around 1972 from the context of experimental theater and alternative music to the art world. Before further consideration of this first disciplinary shift—*Prostitution* inaugurated the second—we must go back to the beginning and address COUM's formation.

Genesis P-Orridge (né Neil Megson) founded COUM in 1969 in Hull, Yorkshire, in the context of experimental street theater and alternative music. The group's first Arts Council of England bursary was filed in 1969 under the category of experimental theater, and in 1972 the COUM artists were the first to win an award using the new category of performance art. COUM has all of the features of an early twentieth-century avant-garde group with its primitivist investment in new beginnings, the idea of remaking language, and the transgressive presentation of sexuality. But their invocation of spirituality and the mythic, together with a preoccupation with art and life, also suggests an affinity with the German artist Joseph Beuys.[16] As the name Genesis might suggest, COUM was born (by its own account) as a result of a kind of mystical revelation, and as Simon Ford has described, P-Orridge's "missionary zeal" formed much of the group's energy in the early years.[17] Soon after the founding of COUM in 1969, Cosey Fanni Tutti (née Christine Carol Newby, aka Cosmosis P-Orridge) joined P-Orridge; while COUM had numerous members during the eight years of its existence, P-Orridge and Tutti formed the backbone of the group as it shifted orientation around 1972 to an art world context. Inspired by the Dada movement, the name COUM, like the word *Dada*, has multiple nonsensical meanings and associations. The only actual known use of the word is in a botanical context: the cyclamen coum is a hardy cyclamen that originates near the Black Sea and in South-

ern Turkey. But, according to Ford, "COUM could refer to communication, commune, or, more obviously, to either come, cum or quim." The ideas suggested by these different associations evoke a trio of key countercultural themes: media transmission, social collectivity, and sexual freedom. Capitalizing the name also suggests that it is an acronym, and for a time P-Orridge claimed, "COUM stood for Cosmic Organicism of the Universal Molecular."[18] P-Orridge consistently used his own idiosyncratic spelling for certain words: "E" instead of "I" and "thee" instead of "the," and the proliferation of puns on the name COUM was a constant feature of the group's mail art. This reveals an investment in the improper use of language that is frequently connected with the sexually obscene and the adulteration of the sacred by the profane, a combination of elements that was most powerfully developed by the early twentieth-century British poet and mystic Aleister Crowley (a figure whom P-Orridge took as a historical model).[19] For example, in COUM's mail art project *Thee Million and One Names of COUM*, the group's name stands in for "God," and because of the sexual pun on cum/come, the title becomes a sexual obscenity. Even the names of the two principal members of COUM follow the contradictory logic of the sacred/profane and high/low art. The first book of the bible, Genesis, is coupled with porridge, the cheapest kind of nourishing food (something that P-Orridge survived on as an impoverished student), and it is also a colloquial term in British English for prison time. Likewise, read as a reference to high art—Mozart's opera *Così Fan Tutte*—the anglicized misspelling of the title as Cosey Fanni Tutti includes a sexual pun ("fanny" is British English slang for a woman's genitals). The opera is about sexual infidelity, and the loose translation of the title of Lorenzo da Ponte's libretto for the opera as "women are like that" is widely recognized as an everyday form of sexism that finds its contemporary low-art equivalent in Tutti's graffiti-style signature rendition of her first name. She puts a dot in the middle of the roundly drawn "C" and the "O," turning these letters into a graffiti-style image of women's breasts (Figure 3.3).

Neil Mulholland understands COUM's approach as evidence of the thematization of transgression as a form of avant-garde rupture; a strategy that, in another context, Griselda Pollock has dismissed as a superficial signifier of the avant-garde.[20] I argue that a more profound exploration of the logic

of transgression inhabits COUM's work at the level of form. Lyotard has elaborated on this with regard to the aesthetic operation of the dream work, which he sees as a violent transformation or disfiguration at the level of form. He refers to the transgression of form as the working of the "figure" on the otherwise rational communicability of "discourse."[21] In analyzing the performance practice of COUM Transmissions, I look beyond the immediate shock value of their violation of social norms in order to address transgression as a violation of the law. This is a form of contamination that leads to a disturbance in the ability to distinguish between subject and object, living and dead, male and female, here and there; a condition that Julia Kristeva refers to as abjection. As I will elaborate later in the chapter, the idea of abjection is connected in COUM's work to an antisocial mode of queer aesthetics. This analysis draws on the psychological idea of abjection as a way of understanding the effects of transgression, which, I suggest, is bound up with transgressions of gender and sexual identity more typically associated with queerness.

FIGURE 3.3. Page showing Cosey Fanni Tutti in COUM Transmissions' artist's book *Copyright Breeches*, 1973. Copyright 2013 Genesis Breyer P-Orridge. Courtesy of Breyer P-Orridge Archive, New York.

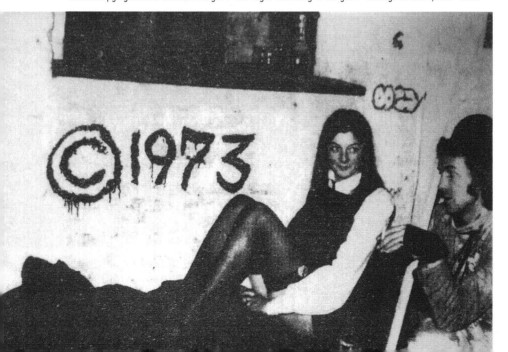

Furthermore, P-Orridge is now best known for *her,* or *their* (after transition-
ing) exploration of transgender identity—pandrogyne is the term she uses—
as a performance artist and musician.[22] Although this trajectory adds additional
weight to my historical argument, it is not the decisive factor in my analysis
of this 1970s work.

Like the twelve-year collaboration between the Yugoslavian performance
artist Marina Abramovic and her German boyfriend Ulay (né Uwe Laysiepen)
of 1976–88, the connection between Tutti and P-Orridge was founded on an
erotic bond. Further, like Abramovic and Ulay, their heterosexual relation-
ship became a means of exploring issues of sexual difference, sexuality, and
power in a performance art context. But COUM diverges from these better-
known European artists by the way in which the heterosexual couple was sub-
sumed within the open-ended, loose collectivity of COUM Transmissions.
While Tutti and P-Orridge were consistent participants, COUM had numer-
ous different members, and its inclusive approach to collaborative identity
allowed COUM to locate the artist(s) positionally as sexually differentiated
while avoiding the idea that their practice was easily reducible to the particu-
lar biographies of *this* heterosexual couple.

The media wall in *Prostitution* told the story of COUM through press clip-
pings. This contrasts with Kelly's carefully staged diary entries in *Post-Partum
Document* because COUM's "obituary" was written by others and appeared
in the form of a sensationalized media parody. Nonetheless, both *Post-Partum
Document* and *Prostitution* self-consciously stage the broader discursive frame-
works used for understanding works of art within the work itself. Moreover,
both positioned the artist as sexually differentiated: Kelly is simultaneously
both artist and mother, whereas COUM's staging of the sexually differenti-
ated artist was achieved through the framework of a collective formation.

Unlike many contemporaries in the British art world of the early 1970s,
COUM's turn to collaboration was not an expression of the political orienta-
tion of their practice (although the question of the political is nonetheless
decisive). Following May '68 a politicized model of artistic collectivity was
the dominant one in the United Kingdom. This had an important impact on
artistic production, attitudes to spectatorial engagement, and very often the
dominant themes addressed. Art & Language, the best-known conceptual art

collective in Britain at this time, acted like a Marxist-Leninist political cell with ideological purges and rigorous (intellectual) self-examination.[23] Their intellectual application of analytic philosophy, dry humor, and a minimalist aesthetic became widely influential in Britain. Feminist collectives tended to follow the antihierarchical structure of the groups in the London Women's Liberation Workshop. The Berwick Street Film Collective, although a mixed-gender group, because of its grounding in post-'68 politics had a lot in common with such feminist approaches. The London Women's Film Group (see chapter 2) and the Hackney Flashers (see chapter 4) also adopted consensus-based models. What all of these artistic examples have in common is that their turn to collective practice was broadly understood in socialist terms. This was a political rejection of the idea of bourgeois individuality that had come to define the modern artist and an embrace of art practice as either modeled after activism or following the logic of unionized labor. COUM followed neither approach. First, because COUM was formed out of street theater and alternative music—where the idea of collective practice is constitutive—their model of collectivity was not grounded in a critique of individuality per se. In fact, P-Orridge in particular took—and still maintains—a 1960s countercultural celebration of the individual that verged on the cultish. Second, their approach to collaboration was much more open-ended than the other groups. As P-Orridge put it (using his own idiosyncratic spelling) in a mail art correspondence to Harley Lond,

> COUM is not a group in the normal sense, it is simply a movement of like minded creative people. COUM is defined most accurately as being simply thee sum total of thee people in COUM at any given moment in time, or TIMEFIX. However, people can be, and are in COUM whom we have not seen in years. Because they still perceive thee world in a COUM way, and once touched by COUM, you are no longer not COUM.[24]

Third, their work reveals an active hostility toward what they saw as the political instrumentalization of art practice after May '68.

This was very much in keeping with the attitude of U.S. Fluxus artists. Indeed, it was their involvement with the Fluxus movement that brought about COUM's shift from the disciplinary context of street theater to the art

world. Two of COUM's early mail art projects, *L'ecole de l'art infantile* (1972) and *Ministry of Antisocial Insecurity (MAI)* (1972), display an active resistance to post-'68 ideas about art's political purpose. Moreover, the primitivist embrace of the infantile in *L'ecole de l'art infantile*, with illustrations showing pacifiers and teddy bears, contrasts with the growing political and conceptual intellectualism of many artists during this period. At the same time, the use of the French language ironically invokes generalized (post-'68) francophile tendencies typical of the British cultural left. Although engaged with the issue of transmission, the members of COUM are not concerned with the dissemination of a political message. Rather, in keeping with McLuhan's argument in *Understanding Media*, their engagement is more with the structure or form of dissemination itself.

COUM's parodic invocation of the political turn in British art is further evidenced in *Ministry of Antisocial Insecurity.* The acronym *(MAI)* from its title is the French spelling for the month of uprisings in 1968, often referred to simply as "the events of May." This reference to the much-fetishized anarchic opposition to the state seen in May '68 is combined with the invocation of the British governmental bureaucracy dealing with unemployment (the Department of Social Security). *MAI* thus gives a condensation of contradictory signs that do not add up to a logical political message. At the same time, *MAI* resembles a work of conceptual art with its mock bureaucratic application that is made up of a series of questions to be filled out by the recipient and returned to COUM to be filed. But COUM's *Ministry for Antisocial Insecurity* promises no outcome, neither remuneration nor sanction; an applicant to this mock ministry is a willing participant in absurdist bureaucracy for its own sake. Thus COUM mobilizes an "aesthetics of administration" typical of conceptual art in order to undermine the idea of political rationality.[25] Likewise, in following a structure of transmission, the content of the form distributed for *MAI* belies the rationality typical of other politically invested groups. Bureaucracy is shown to be a form of irrationality.[26] As COUM's work developed within the field of art practice—performance art rather than street theater—it demonstrates a continued oppositional awareness of both the political currents in British art at this time and the rational model of practice that these approaches shared with conceptualism.

The logic of transmission seen in *MAI* is similar to the one developed in *Prostitution*. Both projects adopt the form of a temporally delayed feedback loop. In *Prostitution* the print news media is now the unwitting vehicle for COUM's structure of transmission. In *MAI* COUM distributes forms through the mail with the expectation that they will be completed and returned for filing. While *MAI* continued to be disseminated in mail art form at least through 1974, in 1973 P-Orridge presented another version of the work as part of the Nottingham leg of the *Fluxshoe* exhibition. The formative relationship of *MAI* to *Prostitution* can be further drawn out by recourse to this version in which P-Orridge set up a table and chair in the street and solicited applications for the *MAI* files. In this format, the previously remote and dispersed audience for these mail art works became incorporated into a performance event.

Photography: Transgressing Transmission

Fluxshoe is also notable because COUM deployed photography for the first time as a significant visual component of their work. Photography is treated as a form of visual information that fits into the structural logic of transmission. COUM's staging of photography transgresses the institutionalized function of photography as visual documentation for performance art, and is akin to conceptual art's complex mode of dissemination. I am thinking of artists such as Douglas Huebler and Vito Acconci whose use of photography as part of performance art projects disrupts any clear understanding of before and after or event and record that came to shape early debates about performance.[27] While it is not clear whether COUM would have known these conceptual performance artists' work particularly well, photographic documentation of the work of Acconci, Abramovic/Ulay, Gina Pane, and Chris Burden was widely disseminated.[28] By the early 1970s, the use of photography to document ephemeral time-based works had become an established practice in the art world. Such images were frequently reproduced in international art journals and followed a recognizable "artless" visual aesthetic. Unlike the glossy, professionally produced images of theatrical productions, the grainy, badly lit, and often ill-composed quality of performance art photography sets it apart as a particular subgenre within

photography. COUM's shift into an art world context around 1972 is marked by an engagement with this particular aspect of performance art. By 1976, with *Prostitution,* COUM's boldest and final—at least in symbolic terms— engagement with the art world, the staging of photographic documentation is particularly significant.[29] This can be seen in two distinct parts of the installation. The media wall was an ongoing record of the group's public presence, made up of documentation by others that is incorporated into the installation itself. Also staged through the framework of media publications, Tutti's pornographic images are reattributed in *Prostitution* as photographic records of magazine actions (Plate 2).[30] Both these examples rely on institutionally established ideas about performance art documentation but only in order to interrupt its proper function.

In art historical and performance studies' accounts of performance art, there has been a good deal of discussion of the use of photography. These images have been variously understood; for example, Susan Sontag, offering a negative analysis, has argued that photographic documentation inaugurates "a consumer's relation to events."[31] Without obvious value coding, Mary Kelly has described such images as a kind of "pictorial quotation," and more recently Carrie Lambert argues that they shift the temporality of the work's reception, since the photograph makes it "a matter of future mediation."[32] But Kathy O'Dell's idea of photographs as both "relics and records of these live events" is, I find, the most compelling description of the contradictory function of photography by performance artists.[33] As relics these images are understood as haptically invested substitutes for the body of the performer, a surviving trace of the event that is held as a remembrance, souvenir, or precious keepsake. The idea of the relic, with all its religious associations, is also a means of access to a body no longer present. Indeed it is the body itself that is the principal stake in performance art, and because of this O'Dell draws on Roland Barthes's Christianized metaphorics of light from *Camera Lucida* to firm up the particular play of absence and presence, loss and plenitude, that the photograph can suggest. The notion of these photographs as records— also suggested by Barthes—works at an entirely different register. In this understanding they are pseudolegalistic contracts that function as visual proof that a particular event took place. Photography's metaphysical significance is

therefore offset by the term *record*: a visual contract attesting to the fact that the action has taken place.

Performance art emerged in the 1960s as part of a general opposition to the commodity status of the work of art, with a new emphasis placed on experience and participation.[34] There is no fixed material object for an artist or dealer to sell. Paradoxically, photographs make present the otherwise absent commodity status of the art object; they are often the only remnants of the transient event, and as such they serve an ambivalent economic function. Artists, galleries, and the news media use these images as promotional materials. Thus photographs exist as part of the larger institutional framework of the work of art.[35] As secular relics they link the publicity machine of the art world to the (no longer present) body of the performer and attest to the fact that the work of art existed and will, in photographic form, continue to exist historically.

In *Prostitution* the media wall marries the idea of transmission with the logic of photographic documentation. COUM explicitly incorporates the broader discursive framework of art criticism and media promotion into the material form of the installation itself. In doing so the artists transgress the proper temporal logic of the photographic document. The media wall adopts a structure that is more like a distorted, specular mise en abyme. Moreover, in this context the relic's function as an emblem of the dead finds its proper place in COUM's performance art obituary. This is reinforced by the idea that journalism as such can be understood as a form of death writing.

The "improper" use of photographic documentation is a continuous theme in COUM's oeuvre. From *Fluxshoe* onward, photography proliferates. On first look this archive of images of COUM's performances appears to be consistent with the photographic documentation of works by performance artists such as Abramovic/Ulay and Burden. But this is misleading. Unlike these artists, COUM put photography into a more dynamic and integrated relationship with the live event. In at least two major performances, COUM explicitly incorporated the documenting process into the live action. In *Studio of Lust* (Southampton, 1975) the three performers, P-Orridge, Tutti, and Peter "Sleazy" Christopherson, held—as if in freeze-frame—a series of typical pornographic poses that were then photographed using a camera rigged up in the performance space (Figure 3.4).[36] Similarly, in *Towards thee Crystal Bowl*

(Milan, 1976) P-Orridge, having ascended to the top of the scaffolding tower used during the performance, took a series of photographs of Tutti as she moved through a pool of styrofoam beads on the ground below.[37] Again, the photographic process was performed as part of the live event. In these two instances the staging of photography suggests that it is understood as more than just a secondary documenting device as it was for most U.S. Fluxus artists and for many other performance artists of the time.[38] Instead, the audience in both *Studio of Lust* and *Towards thee Crystal Bowl* were made aware that the live experience was incomplete without a series of photographs, and these images would effectively replace the original live work. While photographic documentation is typically reserved for publicity about the work of art—to be used in grant applications, magazine articles, and other publications—here it is incorporated into the performance itself. Rather than privileging the live experience as more authentic, COUM worked to disrupt the stability of both categories.

FIGURE 3.4. COUM Transmissions, *Studio of Lust,* 1975. *Left to right:* Genesis P-Orridge, Cosey Fanni Tutti, and Peter Christopherson. Copyright 2013 Genesis Breyer P-Orridge. Courtesy of Breyer P-Orridge Archive, New York.

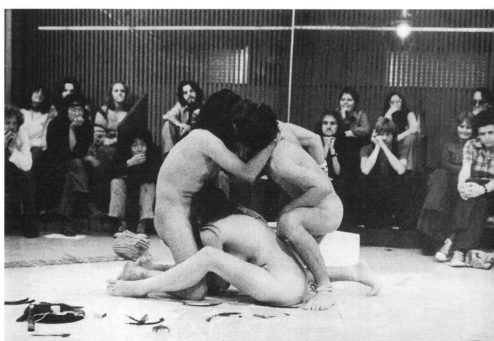

While the COUM artists drew attention to the broader discursive formation of performance art through their use of photography, at the same time they transgressed the established institutional function of photographs as documents. The photographic documentation from *Studio of Lust* is particularly misleading since these images—made as part of the performance itself—have also come to function as straightforward records of the performance. Indeed the iconic quality of the images is due to the fact that the poses were devised as pornographic quotations, but because of their very iconicity, these photographs now appear as if they are records of live-action pornography. Furthermore, during the course of the same performance, Christopherson laboriously applied wound makeup to himself and Tutti, using techniques he learned from movie special effects. But in the later photographic records, the fact that these lesions were explicitly staged within the performance is also lost. Performance artists like Marina Abramovic, Chris Burden, and Gina Pane had become notorious for their "masochistic" performances, and as Mary Kelly has argued with reference to the writing of Lea Vergine, their pain became a means of reinforcing the authenticity of the artist's bodily presence.[39] In *Studio of Lust*, however, these images are neither haptic relics nor accurate records of the performance that they purport to document. And because of the institutional expectations that apply to performance art documentation, their status as representations within representations is no longer visually transparent. Indeed, Roselee Goldberg's brief reference to COUM in her history of performance art, where she understands Tutti as straightforwardly adopting a stereotypically masochistic position, suggests such a misreading.[40]

In *Prostitution* Tutti's art actions are offered as documents of a prior performance. The pages from pornographic magazines featuring Tutti are entered into COUM's exhibition as contractual documents; they are signed by Tutti as both artist and model. Here the evidential logic of photographic documentation of a live action—the contractual status of the photographic image—coincides with the Duchampian logic of the ready-made. As seen with *Studio of Lust*, the live performance event includes photography as a constitutive element. But in *Prostitution* we are asked to see the pornographic images as "documents" of a preexisting performance by Tutti that the art audience can

only encounter remotely through the photographic image. This is achieved by the signature of the artist in tandem with the institutionally validated idea of photography as performance art document. The pornographic images of Tutti are now *by* Tutti, and as Carrie Lambert-Beatty has suggested in another context, this turns the immediacy of the live into "a matter of future mediation."[41] Lambert-Beatty's central concern is with the issue of art historical interpretation, whereas Tutti circumvents the live altogether, making these interpretative issues constitutive of the work itself.

Copyright Breeches/Breaches: Transgressing Gender/Genre

The first significant attempt to insert *Prostitution* into a comprehensive history of feminist art was an American undertaking. Tutti's pornographic pages—excised from the other elements of *Prostitution*—were included in the major survey exhibition *WACK! Art and the Feminist Revolution*. In the United States, unlike the United Kingdom, there are many examples of feminist-identified women artists who have presented their own nude (often eroticized) bodies in their work. With important examples by artists such as Yoko Ono, Carolee Schneemann, Eleanor Antin, Adrian Piper, Martha Rosler, and Hannah Wilke, it could even be described as one of the dominant instantiations of feminism in post-1960s American art.[42] But in three recent exhibitions featuring Tutti's work in the United Kingdom, at the Barbican Centre and Tate Britain, there has been a general avoidance of the work's relation to other feminist trends of the period, despite the fact that feminist critics, most notably Margaret Harrison, Lisa Tickner, and Rozsika Parker, seriously debated *Prostitution* at the time.[43]

The closest comparable work to Tutti's appeared two years prior to *Prostitution* and is an American example. In 1974 Lynda Benglis presented a similar use of the formal conventions of pornographic display within an art world context in a renowned advertisement in *Artforum* (Plate 3). The photograph of Benglis showing her oiled, slender, nude body wielding a double-headed dildo was used to announce her latest exhibition at the Paula Cooper gallery in New York. The scandal that ensued is well-known; the *Artforum* editors published a letter of protest in the next month's issue, and two of them, Rosalind Krauss and Annette Michelson, soon after resigned.[44]

The same year as the Benglis scandal, Tutti began posing for small underground pornographic publications. This was initially a way of making money, but COUM immediately began to archive these magazines in preparation for use as part of a future work. That Tutti's engagement with the sex industry began as a matter of employment is not immaterial, since this aspect persists as an important dimension of the work's subsequent appearance in the ICA in 1976. Moreover, Tutti's identification with the classed position of the sex worker is decisive to the work. While Benglis's advertisement satirically adopted the visual conventions of pornography for the purposes of avant-garde interruption, *Prostitution* displayed Tutti's own labor in the sex industry (Figure 3.5).

There is a significant body of scholarship on the close relationship between modernism and prostitution/pornography, and COUM even invoked Manet's *Olympia* (1863)—one of the "high holy prostitutes of modernism," as Rebecca Schneider puts it—in the poster for the ICA show (Figure 3.1).[45] The nineteenth-century poet and art critic Charles Baudelaire is frequently cited for equating the modern artist with the prostitute, a sentiment that COUM saw itself echoing. But as Rebecca Schneider has pointed out, Baudelaire's suggestion remains metaphorical, whereas "it is quite another thing when an actual prostitute attempts to claim the place of the artist in the museum."[46] While Tutti is not, strictly speaking, a prostitute, the literalism of her work as a pornographic model is nonetheless pertinent to Schneider's point. Furthermore, despite Baudelaire's assertion and its critical elaboration by the much-lauded theorist of modernity Walter Benjamin, many modernist art historians seem to have a particular difficulty with artists that come too close to sex work. Jennifer Doyle has explored this very problematic in the art historical writing on Warhol. What she calls the "rhetoric of prostitution," the suggestive, often moralizing, invocation of prostitution in relation to Warhol's work, ends up occluding the critical examination of the relationship between sex, sexuality, and capital in his complex oeuvre.[47] When it comes to women artists such as Benglis and Tutti, the operation of critical occlusion is even further marked.

These general issues aside, the important difference between Benglis and Tutti's project—over the question of female-specific labor—brings us back

FIGURE 3.5. Cosey Fanni Tutti, *Exposure 2, no. 7, 1974*. Magazine action. Black-and-white lithograph on paper, 520 x 686 mm (framed). Copyright Cosey Fanni Tutti. Courtesy of Cabinet Gallery and Cosey Fanni Tutti.

to the political concerns of other British artists of the period, and this was noted in critical accounts at the time.[48] With *Prostitution*, however, Tutti enacts a Duchampian transformation of her erotic labor through a gesture of contractual reattribution. The pages of the magazines featuring her image were signed by Tutti in order to reattribute the authorship of the works from the (anonymous) photographer to the (no longer anonymous) model. Each double-page spread was framed to declare the work's new status as a magazine action. Thus the question of gendered authorship is also brought to bear as a central issue.

I will not analyze the pornographic content of these images, since it is their unexceptional conformity to the genre—lazy-eyed sensuality, lacy lingerie pulled back to openly reveal the genitals—that enables them to function as ready-mades. It is the transgressive display of pornography in the art gallery and the equally transgressive—in the context of the feminist movement— idea of the woman artist's complicity with, as Margaret Harrison put it, an "activity which debases women as sexual objects" that is significant.[49] Setting aside the sexual content of the images, I will examine the nature of the transformation enacted by means of the artist's signature, that is, the particular gendered relationship between the categories of artist and sex worker. This is about the form that the work takes, its transgression of genre from pornography to art, and how this is also a transgression of gendered authorship. Indeed, as Schneider points out, with reference to Lynn Hunt's book on the emergence of the modern idea of pornography in the nineteenth century, "The demarcation between art and porn has not been concerned with the explicit sexual body itself, but rather with its agency, which is to say with *who gets to make what explicit where and for whom.*"[50]

The relationship between the proper name, the signature, the contract, and the Duchampian idea of the work of art as a performative text is first elaborated in COUM's 1973 photolithographic artist's book *Copyright Breeches* (Figure 3.6 and Plate 5). It is worth exploring this formative work in some depth since it is also COUM's first elaborated engagement with photography as a kind of performance art document. In this work the question of the sexually differentiated performing body emerges as one of the central issues.

The title, *Copyright Breeches,* is a visual pun that refers to a pair of enormously flared pants printed with copyright symbols that were first worn by P-Orridge in a performance of the same title and are shown in the opening sequence of images in the book (Figure 3.7).[51] This use of costume is perhaps the last remnant of COUM's involvement with experimental theater, since the ill-fitting sculptural quality of P-Orridge's copyright breeches coupled with the long hair and unruly beard has a whimsical absurdity that, when compared with *Prostitution,* looks like it belongs to COUM's nonage. With the subtitle "An Interim Report," in common with COUM's mail art works from this period, *Copyright Breeches* evokes conceptual art's aesthetics of

copyright

COPYRIGHT
BREECHES

by

COUM

1972-3

a work in progress
interim report

printed by the Beau Geste Press

FIGURE 3.6. Title page of COUM Transmissions' *Copyright Breeches,* 1973. Photolithographic artist's book published by Beau Geste Press. Copyright 2013 Genesis Breyer P-Orridge. Courtesy of Breyer P-Orridge Archive, New York.

FIGURE 3.7. Page showing Genesis P-Orridge from COUM Transmissions, *Copyright Breeches,* 1973. Photolithographic artist's book published by Beau Geste Press. Copyright 2013 Genesis Breyer P-Orridge. Courtesy of Breyer P-Orridge Archive, New York.

administration.[52] Furthermore, at the end of the book is a list of captions for each image stating that the named individual "performed" at the named date and place. This further reinforces the idea of the photograph as proof that a particular event took place. The notion of the image as a form of visual proof is further reinforced because the issue of copyright invokes a legalistic discourse that connects to broader institutional questions of ownership, authority, and authorship.[53]

Avant-garde precedent for such concerns can be found in Marcel Duchamp's early twentieth-century ready-mades, and so it is unsurprising that COUM connects the copyrighting gesture directly to the work of Duchamp. But in the context of the recent art world deification of Duchamp, and after a flurry of new monographic publications, there seems to be a significant diminishing of Duchamp in this rather modest, small-scale publication.[54] The front cover of *Copyright Breeches* announces this with a hand-drawn rendition of one of Duchamp's earliest ready-mades, *The Bicycle Wheel* (1913) (Plate 4). Turning to the title page establishes an immediate visual connection between the Duchamp sculpture and COUM's typographic design for the copyright symbol—the circular shape of the bicycle wheel echoes that of the copyright symbol (Figure 3.6). Seven years after Duchamp's first major British retrospective exhibition at the Tate Gallery in 1966, bringing the ready-mades (*re*made for the Philadelphia Museum in 1953) to a British art audience for the first time, COUM illicitly produced twelve copies of the *Bicycle Wheel*. A photograph of one of these, labeled "super copyright breech of Marcel Duchamp's Ready-Made Bicycle Wheel," is the final image in the book (Figure 3.8). These twelve replicas were made in preparation for a 1974 performance titled *Marcel Duchamp's Next Work*. In this multimedia work of experimental music performed at the Palais des Beaux Arts in Brussels, Belgium, the twelve Duchamp sculptures, referred to as "Duchamp's harps," were played to a score by P-Orridge and Paul Woodrow. This marks a further mistreatment of Duchamp, with the *Bicycle Wheel* illicitly reproduced once again as a repurposed functional object.

COUM's invocation of Duchamp in *Copyright Breeches* is not, therefore, a straightforward homage. With *Bicycle Wheel* Duchamp puts the signature of the artist to work in order to obey the law of copyright, but COUM's *Copyright*

Breeches repeatedly transgresses this law. In enacting the copyrighting gesture again and again—in a range of different European cities, both indoors and out—COUM invokes the law of copyright only in order to break it. After all, these photographs are copyright *breaches*. Indeed, *Copyright Breeches* is marked from the outset by COUM's *breach* of language. The book is the literalization of a pun. The breach of copyright is an item of clothing: a pair of breeches covered in the copyright symbol. Thus every assertion of copyright is at the same time a breach of copyright, and the first breach takes the form of a rebus: a clownish pair of breeches.

Jacques Derrida has described this same peculiar contradiction in his essay "The Law of Genre." Initially posed in the form of a question, he asks: "What if there were, lodged within the heart of the law itself, a law of impurity or a principle of contamination? And suppose the condition of the possibility of the law were *a priori* of a counter-law, an axiom of impossibility that would confound its sense, order, and reason?"[55] This is precisely the contradiction that *Copyright Breeches* performs. Enforcing the law of copyright, Derrida suggests, is always already a transgression of this very law. In *Copyright Breeches* the slip of the pen from "breaches" to "breeches" follows numerous other linguistic slips scattered throughout COUM's work—"the" to "thee," "I" to "E," and "cum" to "COUM"—and the appearance of P-Orridge's trousers, the copyright breeches, is but the first mark of the text's ongoing series of breaches.

"The Law of Genre" is also useful for understanding *Prostitution*, and here the gender stakes of Tutti's art actions become immediately visible. The French word for literary (or artistic) genre is the same as the word for gender. Thus the law of genre referred to in the essay's title should also be read as the law of gender. As Derrida puts it,

> The question of the literary genre is not a formal one: it covers the motif of the law in general, of generation in the natural and symbolic senses, of the generation difference, sexual difference between the feminine and masculine genre/gender, of the hymen between the two, of a relationless relation between the two, of an identity and difference between the feminine and the masculine. (74)

FIGURE 3.8. Final page of COUM Transmissions, *Copyright Breeches,* 1973. Photolithographic artist's book published by Beau Geste Press. Copyright 2013 Genesis Breyer P-Orridge. Courtesy of Breyer P-Orridge Archive, New York.

If the foundation of this law, as Derrida argues, is a prohibition on the mixing of genres/genders, then Tutti's pornographic images enact both kinds of transgression. The transgression of genre is immediately apparent: by putting the works signed by the artist in the art gallery, "low" pornography becomes "high" art. But this is not some kind of alchemical transformation; both parts of the opposition, pornography *and* art, are simultaneously kept in play, which is one of the causes of the controversy. In her feminist analysis of the exhibition, Margaret Harrison points out, "By bringing these photographs into the art world, they exposed the double standards existing in the media and society in general."[56] Because of the use of the artist's signature, further contractual shifts occur: the commercial employee becomes the noncommercial artist and the pornographic model the performance artist. Thus, following speech-act theory and related philosophical debates, the artist's signature functions performatively. Through signing the pornographic images, Tutti brings them into being as works of art, and she, at the very same time, is brought into being as the artist.[57] Thus Tutti's reference to "Magazine Actions" goes further than the genre of performance art. The signature renders these images the textual equivalent of speech-acts. These works of art are performative texts. As such they follow the peculiar contradictory logic of other much more august performative texts such as the U.S. Declaration of Independence. As Derrida describes in "Declarations of Independence," this performative political text is signed in the name of the American people who could not exist as a political entity until the document had in fact been signed.

Similarly, in *Prostitution,* through the act of signing the magazine pages, the pornographic model becomes the artist; she moves from inside to also being outside the picture frame. This in turn brings us to the law of gender. Tutti's transgression of gender does not just rest on the idea of sexual display. Is this not a typical instantiation of sexual difference? Rather it is because she couples this with an assertion of *female* authorial control. With reference to U.S. artists such as Benglis and Carolee Schneemann, Schneider diagnoses the issue thus: "Nudity was not the problem. Sexual display was not the problem. *The agency of the body displayed, the author-ity of the agent*—that was the problem with women's work."[58] In *Prostitution,* Tutti makes this contradiction transparent. Not only does she usurp authorship from the (unnamed)

male photographer, but also this genre of imagery, hard-core pornography, is typically produced both by and for men. (This is not, after all, alternative woman-centered pornography.) Therefore in transgressing the law of genre, Tutti also transgresses the law of gender. She takes up authorship within a genre that is typically reserved for the male gender. In *Prostitution* both gender and genre are subject to contamination.

In *Copyright Breeches*, however, the relationship between signature, image, and gender is somewhat different, and this clarifies the significance of *Prostitution*. The equation between the individual artist (the proper name) and performing body (the work of art) is from the outset transgressed by COUM since *Copyright Breeches* is not the work of an individual artist but an amorphous collectivity. All participants are named (some consciously misnamed) in the list of illustrations, and the final page of the book extends the collectivity to include the reader with the following message: "Copyright Breeches is a continuous project by COUM to which all readers of this book are invited to contribute ideas, examples, photos." Having said this, the two principal participants in COUM, P-Orridge and Tutti, are the only individuals who appear more than once, and the depiction of the two principal "authors" is quite different from the other participants. Furthermore, there are notable differences between the images of Tutti and those of P-Orridge. In differentiation from the other male and female participants pictured in *Copyright Breeches*, both Tutti and P-Orridge occupy explicitly gendered positions. Moreover, the masculine and feminine positions taken up in the work directly relate to COUM's staging of authorship as sexually differentiated.

All depictions of P-Orridge in *Copyright Breeches* are outside in different urban environments in British, French, Belgian, and Swedish cities. Many, including the opening sequence, show P-Orridge wearing the copyright breeches and are labeled in the index as "situations." These images are not fragments of a live event or an interactive performance like *Fluxshoe*; instead, they are performed simply in order to be photographically documented. P-Orridge addresses the camera directly and frequently adopts a pose so that the images appear to be directed by P-Orridge, that is, authored by him as well as featuring him. He becomes an active figure both within the frame and behind the camera (Plate 5). As such he is understood to be the active masculine subject:

author, creator, and performer. The public location of P-Orridge's performance situations contrasts with the images of Tutti, all of which are restricted to interior, "private" spaces, and three of the four images are explicitly sexualized. The first image featuring Tutti looks like a snapshot taken in a casually bohemian social situation (Figure 3.3). One other person is in the frame, and Tutti is positioned between a large, hand-painted copyright symbol next to the date 1973 and her signature. Tutti's gaze is averted away from the camera lens—apparently listening to a male speaker—and she does not adopt a self-conscious pose. The effect is quite unlike the active depictions of P-Orridge as both author and performer. In this photograph of Tutti authorship seems to reside with the photographer rather than the performer. Adopting a typically feminine position, she is the passive object of the photographer's look, as opposed to the active (masculine) subject who authors the work. Although her name has been painted on the wall to the right of her head as if she were the copyright holder, when compared to the images of P-Orridge, Tutti's authorial presence is much less certain, or rather the idea of authorial identity is sexually differentiated and identified with the active masculine position.

This is more clearly demonstrated in the other three images of Tutti, which are close-up shots of her nude body. These images are more immediately assumed to have been taken by a male artist. Although these images are clearly also staged for the camera—like those of P-Orridge—an ambiguity about her authority as the author persists. In contrast with the male figure that performs within an environment, the female body here *is* the environment. In all three of these images, the female body completely fills the frame and any detail of context is absent. *Copyright Breeches* stages a typically gendered understanding of space wherein the female figure is associated with the interior (and inactivity) and the male with the exterior (and activity). On one page spread (shown in Plate 6), labeled in the index as "copyright breech, Cosey Fanni Tutti's Tutti Frutti," two full-frontal images of Tutti's torso are shown side by side. In the left-hand image the copyright symbol is placed over the labia at the vaginal opening; for its partner image Tutti holds her labia open, and the copyright symbol is positioned at the clitoris. In order to further emphasize her sexuality, the image is cropped at the neck and thighs—she is a body without a head—which contrasts with P-Orridge's intense gaze. This

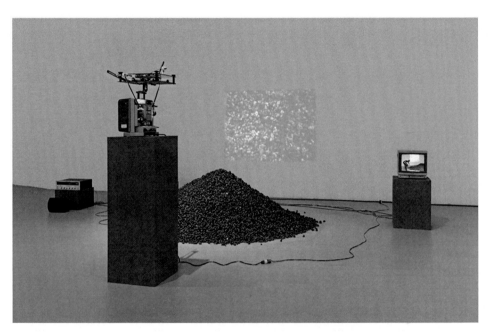

PLATE 1. Mary Kelly, *An Earth Work Performed,* 1970, London New Arts Lab, performance with Stephen Rothenburg. Installation view, Museum of Contemporary Art, Los Angeles, 2012. Black-and-white 8 mm film loop, film projectors, shovel, microphone, tape recorder, amplifier, 4 hundredweight of coke. Copyright Mary Kelly. Courtesy of Mary Kelly.

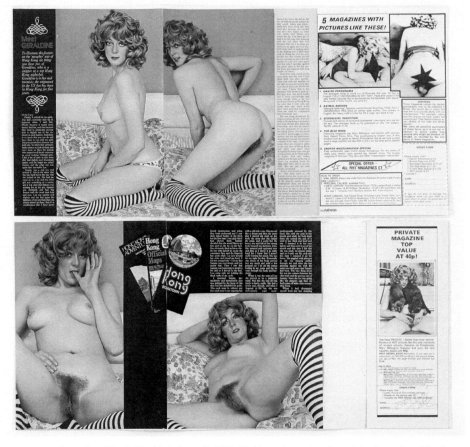

PLATE 2. Cosey Fanni Tutti, *Playbirds 1, no. 5, 1975–76*. Magazine action. Copyright Cosey Fanni Tutti. Courtesy of Cabinet Gallery and Cosey Fanni Tutti.

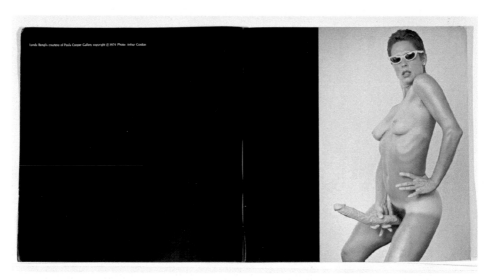

PLATE 3. Lynda Benglis, *Artforum* advertisement, 1974 (double-page spread). Copyright Lynda Benglis. Licensed by VAGA, New York, NY. Courtesy of Lynda Benglis and Cheim and Read, New York.

PLATE 4. Cover of COUM Transmissions, *Copyright Breeches*, 1973. Photolithographic artist's book published by Beau Geste Press. Copyright 2013 Genesis Breyer P-Orridge. Courtesy of Breyer P-Orridge Archive, New York.

PLATE 5. Page showing Genesis P-Orridge from COUM Transmissions, *Copyright Breeches,* 1973. Photolithographic artist's book published by Beau Geste Press. Copyright 2013 Genesis Breyer P-Orridge. Courtesy of Breyer P-Orridge Archive, New York.

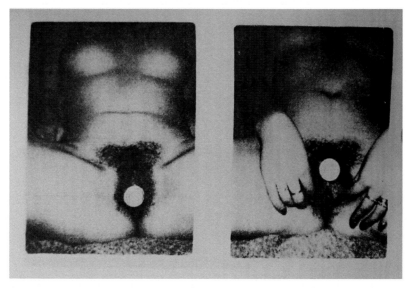

PLATE 6. Pages showing Cosey Fanni Tutti from COUM Transmissions, *Copyright Breeches,* 1973. Photolithographic artist's book published by Beau Geste Press. Copyright 2013 Genesis Breyer P-Orridge. Courtesy of Breyer P-Orridge Archive, New York.

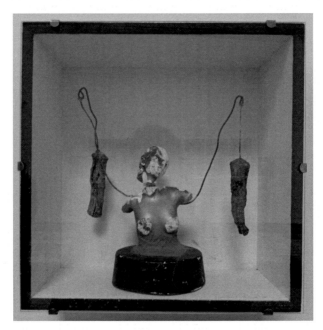

PLATE 7. Genesis P-Orridge, *Venus Mound,* from *Tampax Romana,* 1976. Mixed-media sculpture with used tampons. Copyright 2013 Genesis Breyer P-Orridge. Courtesy of Breyer P-Orridge Archive, New York.

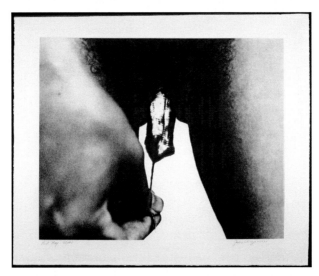

PLATE 8. Judy Chicago, *Red Flag,* 1971. Lithograph, 20 x 24 inches. Copyright 2013 Judy Chicago. Courtesy of Judy Chicago / Artists Rights Society (ARS) New York. Photograph by Donald Woodman.

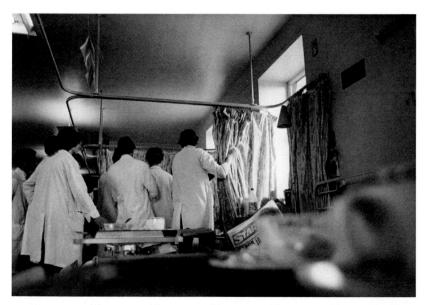

PLATE 9. Jo Spence, *Consultant Doing His Rounds, Nottingham,* from *The Picture of Health?* 1982. C-print. Copyright Terry Dennett / Jo Spence Memorial Archive. Courtesy of Terry Dennett / Jo Spence Memorial Archive.

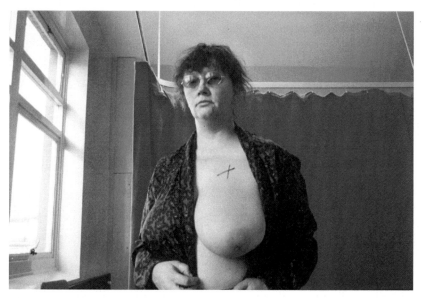

PLATE 10. Jo Spence and Terry Dennett, *Marked Up for Amputation,* from *The Cancer Project,* Nottingham, 1982. C-print. Copyright Terry Dennett / Jo Spence Memorial Archive. Courtesy of Terry Dennett/Jo Spence Memorial Archive.

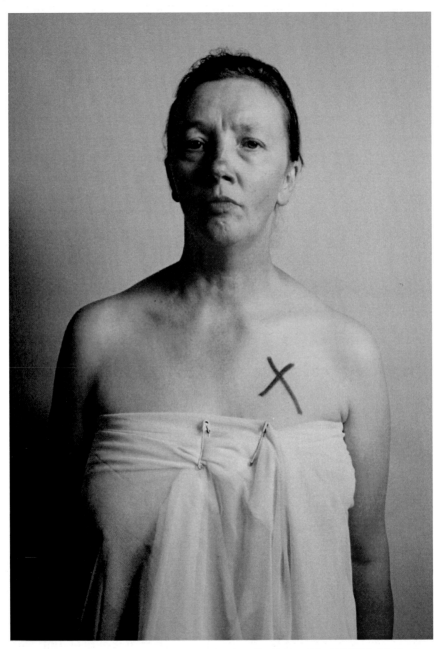

PLATE 11. Jo Spence and Rosy Martin, *Infantilization,* from *The Picture of Health?* 1984. Gelatin silver print. Copyright Terry Dennett / Jo Spence Memorial Archive. Courtesy of Terry Dennett / Jo Spence Memorial Archive.

image featuring Tutti conforms to a masculine avant-garde staging of female sexuality, which overwrites Tutti's authorial presence. David Summers has described how this gendered opposition has been understood within philosophy from Aristotle onward and continues to shape current thinking: the "perfect potentiality" of feminine *matter* is set in opposition to the "perfect activity" of masculine *form*.[59]

In *Copyright Breeches* the collective formation typical of the experimental theater troupe or rock band intersects with the deeply gendered notions of individual authorship found in the art world. Within this collective formation the two principal "authors" remain sexually differentiated with Tutti positioned as feminine and P-Orridge as masculine. Because of this, P-Orridge's masculine authorial individuality is produced at the expense of the images of Tutti that conform to established gendered notions of her as model and muse. *Copyright Breeches* reveals a typical problem faced by women artists when they occupy a feminine position within the work: authorial identity is gendered as masculine. Within the framework of COUM's collaborative structure, collectivity as egalitarianism seems to be riven by femininity as difference.[60]

Writing to Harley Lond, an American writer and magazine publisher who later founded the Throbbing Gristle fan club, P-Orridge expresses what might be described as a feminist sentiment regarding COUM's origin and mode of collective organization. He writes, using his own idiosyncratic linguistic disruptions: "She [Tutti] is also equal co-director of COUM. This is important because E built COUM with her so that neither is indispensible. And also to prove that women are strong and essential as men. That sounds corny but anyway it seemed for many reasons vital to any group to be honest and balanced" (letter to Harley Lond, September 21, 1974). P-Orridge's assertion of Tutti's role as his full collaborator and the cofounder of COUM suggests that he (and perhaps also Tutti) was well aware of the implication of gender-differentiated authorship in *Copyright Breeches*. Especially so given that P-Orridge also included in the same mail art correspondence the four images from *Copyright Breeches* that are analyzed above: two of himself wearing the copyright breeches and the two full frontal images of Tutti with the copyright symbol over her labia and clitoris. This suggests that he did

not want Lond to misunderstand the implications of these images, which, along with P-Orridge being the signatory of the mail art correspondence, might otherwise imply that he was the sole author. P-Orridge then goes on to describe an unofficial "interventionist" performance with Tutti that took place in a shopping mall in Birmingham, England. In contrast with *Copyright Breeches,* this work stages the breaking of gender archetypes through the idea of transvestite performance. The work enacts the contamination of femininity by masculinity and vice versa. In the same letter to Lond, P-Orridge describes the performance, titled *Orange and Blue*:

> It starts with Cosey in blue evening wear and me in orange labourers wear. Thee table is half orange and blue to match. Split down thee middle. By various movements and actions we swap clothes and roles to end up in reverse. Me as woman her as man. Our gestures change accordingly. But at first glance this is not usually noticed. It is a piece about the area of ambiguity between male and female, and thee way our visual responses are keyed to symbolic images.

In this performance COUM stages a transvestite process of gender interchangeability using the social codes of costume and gesture combined with the symbolic codes of complementary colors. It is particularly interesting to note that COUM aligns masculinity with labor. This invocation of (masculine) labor, a central trope for many politically engaged artists at this time, is further evidence of COUM's continued awareness of the political preoccupations of the period. As outlined in chapter 2, feminist artists were struggling to reconceive the opposition between sexual difference and the political. But when sexual politics is addressed in egalitarian terms (most commonly through the model set out by class), women become honorary brothers, their difference elided by sameness. Instead of femininity being subsumed by masculinity, in *Orange and Blue* each is subject to mutual gender contamination. COUM's performance thus shifts the terms of this feminist debate by invoking a queer sensibility. As Eve Kosofsky Sedgwick has put it, queerness "can refer to: the open mesh of possibilities, gaps, overlaps, dissonances and resonances, lapses and excesses of meaning which the constituent elements of anyone's gender, of anyone's sexuality aren't made (or *can't be* made) to signify

monolithically."[61] Gendered heterosexuality is enacted in *Orange and Blue* only in order to be destabilized, disrupted, and dissolved. This queering of gender is taken even further in *Prostitution*.[62]

Looking at all of the elements of the 1976 ICA installation—Tutti's pornographic magazine actions, the disruptive presence of the punk performers and fans, Throbbing Gristle's performance, P-Orridge's used-tampon sculptures, and the media wall—reveals a complex queer scenario. Queer theory, as Biddy Martin puts it, "seeks to complicate hegemonic assumptions about continuities between anatomical sex, social gender, gender identity, sexual identity, sexual object choice and sexual practice."[63] *Prostitution*, I contend, enacts the very same kind of destabilizing tendencies that Martin describes in the entropic feedback loop of the exhibition's temporal structure.

Queer Aesthetics and the Death Factory

There are well-established avant-garde precedents for the male artist adopting codes of femininity, from Duchamp's Rrose Selavy to the portraits of Warhol made up in drag, but for a woman artist to occupy both feminine and masculine positions, a more radical gesture is needed.[64] Tutti's transgression of gender/genre in *Prostitution* enacts this shift. In transgressing genre from "low" pornography to "high" art, Tutti occupies both feminine and masculine positions simultaneously, and her authorship is secured by the performative assertion of the artist's signature. Tutti's is a queering of gender/genre; in terms of authorship, this work attacks the stability of the binary opposition, demonstrating that masculinity and femininity are mutually permeable. This is gender understood as a social instantiation, regulated through institutions and social practices. Although this understanding of gender is not restricted to sexed bodies (male and female), the social and institutional practices of gender normalization produce the effect of naturalizing these social and cultural norms. Certainly *Prostitution* enacted a violent disruption of the social instantiation of gender norms, but COUM's queer aesthetic also operates at the symbolic as well as the social level (I mean symbolic in the psychoanalytic sense, related to the production and psychical regulation of sexually differentiated subjectivity). Although COUM was certainly not associated with the emerging intellectual and aesthetic interrogation of Freudian-Lacanian

psychoanalysis in British feminism, as Mary Kelly was, *Prostitution* nonetheless speaks to some of these shared concerns. The idea of queer aesthetics articulates the relationship between the social and the psychical domains, provoking a disruption in both.[65]

The punk fans at *Prostitution* caused an immediately apparent disruption of gender in social terms. In inviting the band Chelsea to perform, COUM knew that they would bring an entourage that would provide a visual spectacle of vanguard street style, drawing on the mixing of codes of gender and sexual identity. Because Chelsea's guitarist William Broad (soon to be Billy Idol) was part of the so-called Bromley Contingent—the inner circle that formed the entourage for the Sex Pistols—COUM was certain to attract representatives of cutting-edge punk style.[66] In October 1976, it should be noted, punk was still very much an underground subculture that would not attain national recognition until two months later with the scandalous TV appearance of the Sex Pistols and some of their entourage. Earlier in 1976, COUM's Christopherson was commissioned by Sex Pistol's manager Malcolm McLaren to photograph the band. Perhaps in order to make explicit the original U.S. vernacular meaning for "punk"—slang for someone who receives anal sex in prison—he staged the Pistols as if they were rent boys.[67]

The punk fans also provided irreverent (predictably unpredictable) behavior. This was a transgression of genre—an alternative music audience in an art gallery—that was matched by the exhibiting artists also taking on the role of musicians.[68] *Prostitution* was thought of as the symbolic termination of COUM Transmissions the performance art collective and the beginning of Throbbing Gristle the rock band. While it was not unusual to have music performed at an art opening, and the music space in the ICA had become a venue for punk bands, it was unusual for the artists themselves to take up instruments and perform as a corollary to the visual art on display. While little was said about the musical component in the mainstream press, a lot was made of the incongruity of the punk fans and their outlandish appearance. In at least one example, the theme of queerness is made colorfully explicit. Helen Minsky wrote in the *London Evening News*: "As I walked in a drunken young woman was being carried out. She had green hair. At the bar, a girl in trousers and bright orange hair was embracing a blond in a gold lamé dress.

Next to them was a 6 foot 5 inch tall West Indian transvestite in a red off the shoulder gown."[69]

This brief descriptive passage offers a metonymic chain of interconnected codes that evokes a scenario of queerness. From the unruly drunken woman with green hair to the girl with "bright orange hair," whose innocuous "trousers" become a signifier of her butch lesbianism when put together with her femme partner, the "blond in a gold lamé dress," and their neighbor, the "West Indian transvestite." In this brief passage gender and sexuality are disrupted principally by female figures. This aspect of punk's queering of gender is typically overlooked in many critical accounts in favor of male figures. As Simon Frith and Howard Horne have argued in one of the few early discussions of *female* punk style:

> From the start [punk] raised questions about sexual codes. It is often argued
> that punk opened a space which allowed women in—with its debunking of
> "male" technique and expertise, its critique of rock naturalism, its anti-
> glamour. But the spaces were there because of women's involvement in the
> first place. Punk *bricolage*, for example, was most effective in the work of
> Vivienne Westwood and Poly Styrene, in the play of the female art student
> musicians on images of femininity. Iconography which is consistent in
> patriarchal ideology—women as innocent/slut/mother/fool—was rendered
> ludicrous by *all being worn at once*.[70]

Indeed, before COUM titled their installation *Prostitution*, in 1974 Vivienne Westwood was decorating her punk boutique Sex with graffiti slogans from Valerie Solanas's 1967 *SCUM Manifesto*. A photograph taken outside the ICA of Siouxsie Sioux—soon to be lead singer of Siouxsie and the Banshees and a member of the Bromley Contingent—wearing one of Westwood's topless blouses appeared in the *Daily Mail* newspaper (Figure 3.9). The blouse is designed so that the fabric covering the breasts is removed in a kind of reversal of a bikini. Thus for the press who were not able to reproduce images of Tutti's magazine actions, these punk fans served as a visual stand-in, and all of this was incorporated into the feedback loop of *Prostitution*'s media wall.

The band name Throbbing Gristle, Northern English slang for an erect penis, is, of course, the normative heterosexual masculine response to Tutti's

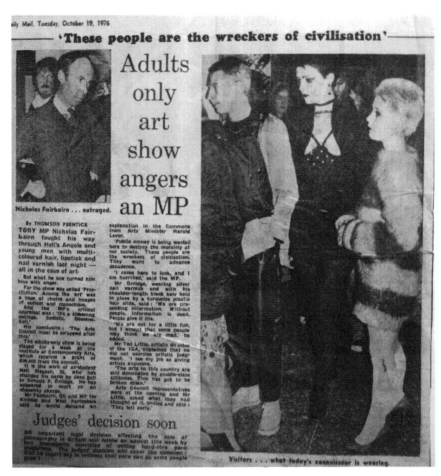

FIGURE 3.9. The Bromley Contingent outside the Institute of Contemporary Art. Newspaper photograph from the *Daily Mail,* October 19, 1976. *Left to right:* Steve Severin, Siouxsie Sioux, and Deborah Juvenile.

magazine actions. Because Tutti played the lead guitar topless during this opening-night set—seated, rather than adopting the typical thrusting male guitarist's pose—further reinforces the linkage with pornographic images. Furthermore, the theme of illicit or deviant sexuality was a dominant motif in punk bands of the period, and in name at least Throbbing Gristle sounds

quintessentially punk. A brief list of other band names from the period illustrates this point: Sex Pistols, Slits, Foreskins, Discharge, Nipple Erectors, Penetration, Pork Dukes, Homosexuals, Vice Squad, Members, Masters of the Backside, Buzzcocks, Sham 69, and UK Subs. But Throbbing Gristle evoked punk in name alone since the band's music was far from the primitivist, speeded-up, three-chord rock that was typical of the early punk sound. Thus while male sexuality is suggested in the band's name, Throbbing Gristle's sound would have stood in stark contrast to the virile masculinity of a band like Chelsea. Throbbing Gristle is now usually defined as a post-punk band—a stylistic rather than strictly temporal category—and the *Prostitution* performance was typical of its dark industrial soundscape.[71] The slow rhythmic drone of Tutti's guitar overlaid with heterogeneous recorded samples and the synthesized sound of Christopherson and Carter provided a textured backdrop for P-Orridge's dark vocal narratives of sexual violence and postapocalyptic urban degradation. As a further transgression of genre, COUM invoked punk but only in order to frustrate the audience's musical expectations. (On the recording, you can clearly hear the punk fans loudly talking as a theatrical display of their disinterest in Throbbing Gristle's music.) Contrasting the Throbbing Gristle sound to the Stooges and the Sex Pistols, Drew Daniel evocatively writes, "The clammy, weedy, thin, unpleasant sounds of Throbbing Gristle's needling high-end and dull ache inspired by their relentless low-end throb weren't the sounds of petty gripes about 'no fun,' they literally *were* no fun."[72]

Likewise, the title of the set for the evening, Music from the Death Factory, was in equal parts homage to Warhol's Factory and another punk reference. This invocation of Nazism, common to the early punk scene, was not a mark of right-wing political affiliation but rather another means of shocking the Second World War generation with a feigned association with the nation's former enemy. As a general punk condemnation of the society made by the so-called victors, COUM takes it one step further with the suggestion of an ongoing "death factory." The Death Factory became the name for their recording studio, and Throbbing Gristle derived the band's insignia from a picture taken at Auschwitz 1. In 1978, after the source of the insignia had been

publicly revealed, P-Orridge explained the thinking behind this reference in an interview in the music magazine *NME*:

> Humanity as a whole is stupid to allow anything like that to begin to occur. There's no one person that's guilty . . . we didn't even know it at the time, but the local people in Poland used to call Auschwitz the factory of death. We called our album 'Music from the Death Factory' as a metaphor for society and the way life is. . . . What we're saying is: be careful, because it's not far from one to the other.[73]

Daniel offers the following anticapitalist interpretation of the logo: "The concentration camp was not a historical memorial to a forty-year-old war but the secret truth of everyday life: the camps had shown that the factory model can be applied to anything, including life and death."[74] From the death writings of COUM's obituary wall, *Prostitution* inaugurates the (second) musical phase of their practice under the sign of the Holocaust, the factories of death.

Lee Edelman's *No Future*, a queer theory polemic against what he calls "reproductive futurism," offers compelling points of intersection with COUM's politics of death. Written in reaction to the gay community's embrace of normative heterosexual institutions such as marriage and queer theory's turn to utopian thinking, Edelman argues that this politics of futurity conforms to a logic of heterosexual procreation. Against this, he contends that "*queerness* names the side of those *not* 'fighting for the children,'" and he embraces an "antisocial" queer politics wherein "the queer comes to figure the bar to every realization of futurity, the resistance internal to the social, to every social structure or form."[75] Despite the reference to the Sex Pistol's lyric from their most famous single "God Save the Queen" in the title of his book, *No Future*, Edelman's argument is not concerned with punk. Elsewhere he has dismissed the negatory politics of punk as "little more than oedipal kitsch."[76] This latter comment discloses the rather aristocratic tone of Edelman's work that contrasts markedly with the class formation of a subcultural movement that emerged during an economically fraught era. As Tricia Henry comments, "For the large number of people on welfare—or 'the dole,' as it is known in Great Britain—especially young people . . . the irony, pessimism,

and amateur style of the music took on overt social and political implications, and British punk became as self-consciously proletarian as it was aesthetic."[77]

Queer theory scholars have debated the limitations of Edelman's position, but the value of his approach is clear since the most thoughtful responses (and there have been many) offer important supplements to the underlying premise of his argument. Tavia Nyong'o, writing about the punk reference in Edelman's title, convincingly argues, "Punk performers were highly cognizant of precisely the challenge of abiding negativism that Edelman raises."[78] Despite his titular reference to punk, *No Future*'s central metaphor in fact brings us to a key feminist theme, abortion. Edelman seeks to negate reproductive femininity—the maternal—and instead to occupy the place of the aborted fetus. But, as Jennifer Doyle has pointed out, he fails to engage in any significant way with the complex feminist literature on the question of abortion—more than thirty years of scholarship that critiques feminism's heteronormative emphasis on reproductivity.[79] In doing so, Edelson's identification with the *image* of the aborted fetus is in danger of blindly repeating a masculist tendency that feminism has roundly critiqued. As Carole Stabile has put it, fetal imaging "depend[s] on the erasure of female bodies and the reduction of women to passive, reproductive machines."[80] In other words, for the fetus to emerge as subject, the mother's subjectivity must be erased.

Like Nyong'o and Doyle, I am mobilizing Edelman's argument in order to supplement it. As Daniel vividly puts it, "TG [Throbbing Gristle] wasn't music that let you feel any comfort in the idea of belonging; it was a scraping sound that rubbed raw your paranoid suspicion that the need to belong to anything, including a music scene, was a sign of subjection, just one more form of alienated pleasure."[81] Indeed, the figure of heterosexuality that marked this nonbelonging in P-Orridge's lyrics for Music from the Death Factory was the infamous 1960s child murderers, Ian Brady and Myra Hindley. As a monstrously chilling echo of COUM's deviant staging of heterosexual coupledom, this reference to the so-called Moors murderers is an abject literalization of Edelman's queer negation of the child.

The final link in the exhibition's scattered signifying chain that coalesces around the crisis of genre and gender is P-Orridge's series of sculptures titled

Tampax Romana (Figure 3.10 and Plate 7). As figures of reproductivity without reproduction, these works evoke certain feminist themes that intersect with Edelman's argument. If mentioned at all in the press, these sculptures are simply read as transgressive. Along with the punk audience in their queer attire, *Tampax Romana* was not understood qua sculpture but only as another example of the obscene. References to menstruation, however, and used tampons in particular—the modern instantiation of the taboo of female reproduction—had become something of an emblematic figure within feminist art. In one sense therefore we can understand *Tampax Romana* as an engagement with a particular form of cultural feminism, but it is not a typical one. This is a feminism that Julia Kristeva has associated with "monumental time."[82] An aspect of the second-wave feminist movement is related to a post-'68 suspicion of linear history that identifies universal aspects of femininity with a particular focus on female corporeal experience. These are the dimensions of femininity that have been occluded from culture, such as menstruation, pregnancy, birth, and lactation. Typically this form of woman-centered feminism tends to produce a separatist politics. Thus P-Orridge's invocation of this kind of feminism in his used-tampon sculptures can also be understood as a form of gender transgression. Indeed, through a practice of omission, art history has proved this point. While Tutti's pornographic imagery was included in the recent survey exhibition of feminist art *WACK! Art and the Feminist Revolution*, P-Orridge's sculptures *Tampax Romana* were not. The very fact that the most comprehensive survey of feminist art in recent years only included work by women artists attests to the fact that even as "feminist art" becomes a curatorial category, "feminism" and "woman" remain continuous.

The best-known feminist works featuring used tampons are by Judy Chicago, a quintessentially woman-centered artist. Chicago cotaught (with Miriam Schapiro) the first women-only studio art program in the United States and then went on to cofound the Women's Building in Los Angeles.[83] In the art world, Chicago remains the exemplar of 1970s feminist separatism. Although *Menstruation Bathroom* (1970) is her best-known work referencing used tampons, her lesser-known photolithographic print *Red Flag* (1971) establishes the political stakes in her feminist use of this motif (Plate 8). *Red Flag* shows a close-up crotch-level view of a woman in the process of remov-

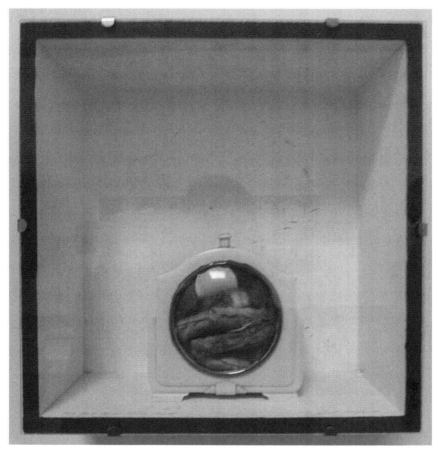

FIGURE 3.10. Genesis P-Orridge, *It's That Time of the Month* from *Tampax Romana*, 1976. Mixed-media sculpture with used tampons. Copyright 2013 Genesis Breyer P-Orridge. Courtesy of Breyer P-Orridge Archive, New York.

ing a soiled tampon from her vagina. Still attached to the body and centered in the print, the stained tampon is highlighted in a rich maroon ink to appear jewellike against the apricot tones of the woman's skin and the dark shadow of her genital area. As a taboo-breaking celebration of female experience, the title, *Red Flag*, also suggests the feminist appropriation of this long-standing symbol of class struggle. Chicago's work therefore asserts that *feminist* politics

is rooted in female bodily experience, which she celebrates and transforms by aesthetic means. In contrast, the used tampons in P-Orridge's *Tampax Romana* remain abject things, not aestheticized like Chicago's *Red Flag*, and they have been disconnected from their proximate relationship to the vital female body.

Red Flag can be understood as an affirmative reworking of Chicago's earlier installation *Menstruation Bathroom* (1970). This latter work is more immediately comparable with *Tampax Romana* since here the tampon is staged in a more abject state. Chicago's pristine white bathroom with shelves stacked with brand-new feminine hygiene products serves as a theatrical stage set for an overflowing trashcan of what appear to be soiled tampons and sanitary products. In fact Chicago did not use actual menstrual blood; these sanitary items had not been anywhere near a woman's vaginal canal. The theatrical approach applied to this installation was reinforced by Chicago's use of red paint in place of actual menstrual blood. Despite their abundance in the installation, the fact that these were constructed props—something that must have been apparent at least to all female visitors because of the vivid red color—diminishes the revulsion produced by their obscene display.[84] P-Orridge, by contrast, presented actual soiled tampons used by Tutti, his lover, and these metonymic tokens of female sexuality—even more repulsive over thirty years later—serve as a "feminist" counterpoint to Tutti's pornographic display. Tutti's complicity with the making of pornography—an activity by men and for men—has made it difficult for this work to signify in feminist terms. By the same token, P-Orridge's explicit feminist theme has also been occluded from consideration as feminist art precisely because of his gender. In relation to the art historical investment in authorship, both P-Orridge and Tutti transgress gender.

P-Orridge's transgression of gender is matched by a transgression of genre. In one example the used tampons hang from small statuettes of classical female torsos. Like Tutti's magazine actions, *Venus Mound* (from *Tampax Romana*) combines "high" and "low," "art" and "nonart." One part is a reference to the apotheosis of idealized mimesis (classical art)—an iconic representation of the highest order—and the other part is an indexical trace of a bodily process, barely readable as art. The classical reference in the title *Tampax Romana*—

a pun on Pax Romana, a Latin term used to describe the golden era of the Roman Empire—reinforces this opposition. Like the iconic image of classical feminine beauty *Venus de Milo,* P-Orridge's *Venus Mound* is damaged and partial. But there the similarity ends. In P-Orridge's sculpture, the figure's arms are degraded stumps, and her face and breasts seem to have been roughly scraped away and defaced. *Venus Mound* has been disfigured, damaged, and degraded almost as if to match the indexical equivalents. The used tampons hang from wires attached at the shoulders, and this spindly framework looks like an elongated substitute for the figure's lost limbs. As prostheses the wires also enact a shift at the level of representation: between the iconic depiction of the female body (the statue) to the indexical tokens of female sexuality (the tampons). Moreover, the cast of the female torso has been cut off at the midriff and mounted onto a disk-shaped plinth. This creates a division in the iconic representation of the body with only the upper torso and head shown. The breasts, face, and belly are scarred and crumbling as if the sculpture is in the process of becoming a piece of rubble. The intimacy of scale (the vitrine is approximately 12 inches square) along with the combination of elements makes *Venus Mound* suggestive of a sacred object that is intended to mobilize feminine powers. Its combination of female corporeal experience and the sacred archetype—as if it were a modern instantiation of a female cult—further reinforces the sculpture's connection to the type of feminism that Kristeva identifies with monumental time.

While these obscene feminine objects retain an indexical relation to the (absent) female body because they have been removed from the body of the woman (artist), they are now abject. Kristeva's theorization of abjection in her book *Powers of Horror* has many points of overlap with Edelman's treatise on queer theory and the death drive. Abjection is an affective psychological state that, according to Kristeva "does not have, properly speaking, a definable *object.*"[85] Thus abjection is not directed toward or inherent in the object itself, but it is related to a psychological response that can be provoked by objects. In the 1990s the art world became preoccupied with abjection as a kind of curatorial theme. I want to be clear that this is not my approach. While certain things can incite abjection—the skin on milk, a corpse, bodily waste, or an infected wound—Kristeva clarifies that this is the opposite impulse to

desire. This is an important distinction. Desire is object-oriented; it is aimed at the discovery of meaning. Abjection, however, is produced by the confusion between subject and object—life and death, inside and outside, male and female, between different genres—that Kristeva claims "draws me to the place where meaning collapses."[86] Abjection, like Edelman's queer, which he aligns with "the signifier's collapse into the letter's cadaverous materiality," is about the death drive.[87] In this regard *Prostitution* as an installation provokes an experience of the abject. In contrast, the used tampon in *Red Flag* transcends abjection through aestheticization. Chicago's carefully composed photographic image has been subjected to further artistic processes by the ink and texture of the lithographic print. Likewise we view *Menstruation Bathroom* as if it were a stage set; as onlookers we remain protected by a white gauze curtain. Chicago's work is not about abjection as the collapse of meaning; instead, she is concerned with representation—visualizing what has previously been hidden—and remaking meaning via aesthetic means.

Unlike other notable feminist examples that reference this feminine/feminist motif, such as Shigeko Kubota's Fluxus performance *Vagina Painting* (1965), the used tampons in the *Tampax Romana* series have been disassociated from the body of the woman artist. Because *Tampax Romana* is by P-Orridge, a male artist in COUM, femininity is separated from the sexed female body. For *Vagina Painting* Kubota squatted over a canvas laid out on the floor painting abstract marks in red paint with a paintbrush attached to her underwear (but appearing as if it were held in her vagina). This performance is widely understood as both a response to Nam June Paik's *Zen for Head* (1962) and as a feminine interpretation of Jackson Pollock's drip painting. Kubota displaces Paik's Cartesian focus on the head as the vehicle of performance with her reference to the vagina. She debases Pollock's balletic dance with her primitive squatting pose and literalizes the metaphor of the paintbrush as a phallus. The work turns on a contradiction. Placing herself visibly within the scene—as the object of the look—Kubota adopts a traditional feminine position that is typically associated with the artist's model. This is exemplified by Yves Klein's performance *0* (1960) where nude female models are instructed by the artist to use each other's bodies as live paint

brushes with Klein hovering on the sidelines acting as conductor of the scene. In *Vagina Painting* the prone canvas becomes a figure for the female body in relation to which she adopts a masculine position because of her use of the paintbrush as phallic extension.[88] Thus the reproductive reference suggested by the red paint and the paintbrush as used tampon is transformed by a phallic logic. The elementary Freudian lesson asserts that to be an artist, the woman must claim the phallus. Likewise, Chicago's *Red Flag* can also be understood in phallic terms, and the notion of abjection is overwritten by the opposite, the phallus. As the privileged stand-in for the lost object, the phallus is the representation of desire. The tampon is again transformed into an object, *the* object of desire.

This phallic logic is not deployed in COUM's installation. Instead, *Tampax Romana* is doggedly turned toward abjection. P-Orridge has consistently claimed that his interest in this motif is an acknowledgment of feminine power. But what kind of feminine power is this? Earlier I referred to this as reproductivity without reproduction. Edelman, however, might challenge this distinction in the following terms:

> The biological fact of heterosexual procreation bestows the imprimatur of meaning-production on heterogenital relations. . . . The child, whose mere possibility is enough to spirit away the naked truth of heterosexual sex— impregnating heterosexuality, as it were, with the future of signification by conferring upon it the cultural burden of signifying futurity . . .[89]

This, I argue, is a futurity that COUM's installation reverses and turns back toward the uncanny. Abjection, Kristeva argues, is a version of the uncanny; it is a reaction to, or psychological protection against, the memory of the mother's body. In his identification with the aborted fetus separated from the mother's body, Edelman, Doyle argues, "comes awfully close to speaking from exactly the reproductive position he so forcefully challenges—speaking as Child cut from the body of mother (which I take here to be not only the maternal body that disappears into the background of the anti-abortion poster, but the 'past' feminist theory *No Future* ignores)."[90] Furthermore, in reading Kristeva's *Powers of Horror* alongside Edelman's *No Future,* it seems

remarkable the extent to which the uncanny figure of the mother is replaced by the death-identified gay man. This unremarked-on displacement of sexual difference in Edelman's work reinforces Doyle's insights about the dangers in his occlusion of feminist politics.

The uncanny is the familiar, longed-for home that has become terrifyingly unfamiliar. P-Orridge's wizened objects are dried out to the point of blackened desiccation; they hang limply from their wires, absent of any sense of vitality that they may once have had. Having come from the interior of the woman's body, they are now deathlike emblems of "an opaque and forgotten life."[91] Both in their invocation of the past and of death—another life no longer lived—the psychical aspect of these abject things links to the death writing of the media wall and Throbbing Gristle's *Music from the Death Factory*.

Prostitution, I contend, has more in common with Kelly's *Post-Partum Document* than the accident of their historical conjunction. Both installations are concerned with the symbolic codes of sexual difference, but the difference in their modes of address has veiled the many points of connection. As I discussed in chapter 2, Kelly was part of a feminist study group, which included Juliet Mitchell, Laura Mulvey, and Jacqueline Rose, dedicated to the feminist analysis of Lacanian theory. While psychoanalysis is writ large in Kelly's installation, COUM does not lay claim to such theoretical motivations. Because of this, Kelly's and COUM's addresses to the symbolic codes of sexual difference—the tone, if you like—are significantly different. If Kelly's installation is a demonstration of the proper realization of the law, according to Lacanian psychoanalysis, COUM's queer aesthetics is an attempt to transgress this law, to interrupt it. *Post-Partum Document* tracks the male child's entry into the symbolic order—his acquisition of language—and how this is also a process of heteronormative gendering.[92] *Prostitution*, however, is an exploration of the perverse. Through a queer aesthetic, COUM disrupts the apparently fixed symbolic codes charted by Kelly. While *Post-Partum Document* is more obviously "self analytical" in its attempt to "explore the constitution and functioning of this [symbolic]

contract," COUM tries to "break the code, to shatter language, to find a specific discourse closer to the body and emotions, to the unnamable repressed by the social contract."[93] Paradoxically, the extent to which this task was realized might be seen in the historical failure of *Prostitution* to register as feminist art.

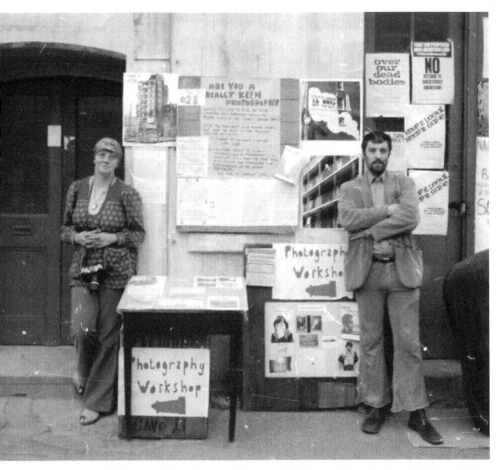

FIGURE 4.1. Jo Spence and Terry Dennett, Photography Workshop, Covent Garden, 1974. Copyright Terry Dennett / Jo Spence Memorial Archive. Courtesy of Terry Dennett / Jo Spence Memorial Archive.

/ 4 /

Revolting Photographs

Proletarian Amateurism in Jo Spence and
Terry Dennett's Photography Workshop

In 1975 there were two exhibitions in London titled *Women and Work.* They
were organized independently by groups of women collaborators. Their co-
incident appearance dramatizes different aesthetic ways in which photogra-
phy engaged questions of gender and labor during this period. *Women and
Work* by Margaret Harrison, Kay Fido Hunt, and Mary Kelly deployed a
recognizable conceptual art format with visual and textual information—
photography, tape recording, film footage, and typewritten data—addressed
to the implementation of the Equal Pay Act in a South London metal box
factory. The other *Women and Work,* by the Hackney Flashers (the first all-
female photography collective in Britain), presented panels of documentary
photographs of women in the workplace, unemployment lines, and working
in the home, with brief handwritten descriptive captions. It is significant that,
to my knowledge, no previous commentator has compared these two exhi-
bitions of the same name that appeared in the same city in the same year.
This is not, I think, simply an academic oversight, another lost intersection
of feminist concerns yet to be unearthed. Rather, I suspect that such a direct
comparison has been avoided thus far precisely because of the marked con-
trasts in aesthetic approach between each project. While feminist art histo-
rians are typically leery of making evaluative aesthetic judgments, the most
striking difference between the exhibitions is that the Hackney Flashers ap-
pear uncomfortably amateurish. With documentary images of various sizes
irregularly arranged and attached bulletin-board-style to plain backing card,
the Hackney Flashers' *Women and Work* contrasts markedly with the cool
sophistication of Harrison, Hunt, and Kelly's mixed-media conceptual art

aesthetic (Figure 4.2). In the latter exhibition, photography, presented in a modernist grid format, is but one kind of information alongside textual, aural, and filmic. This show might be seen as a prefiguration of the smooth conceptual aesthetic of political installation art that is familiar in the world's Biennials to this day (Figure 4.3). By contrast, the Hackney Flashers collective also included amateur, untrained photographers whose participation belonged to a larger pedagogical project. The Hackney Flashers collective was initiated by the activist photographic organization known as Photography Workshop, begun by Jo Spence and Terry Dennett in 1974. The crudity of its presentational strategy—influenced by Photography Workshop's theoretical and historical concerns—was not due to the absence of aesthetic complexity in an evaluative sense, as it might initially seem. Rather, it was a clear aesthetic strategy, a political aesthetic that, following the photographer Jeff Wall, can be described as a form of "proletarian amateurism."[1]

Proletarian amateurism was originally associated with interwar worker photography. Photography Workshop revived the idea in the 1970s as a theoretically significant political aesthetic, but it is not easily recognizable or widely written about. This is a period when photography itself was undergoing a theoretical renaissance unseen since the same interwar period, and a more generalized trope of amateurism was one of the first art world manifestations of this shift. More typically referred to using the vaguely workerist term *deskilling,* conceptual artists have been understood as having brought photography back into the art world as a straightforwardly mechanical—anti-aesthetic—documenting device. The narrative that leads from conceptual art's deskilled use of photography to critical postmodernism's investment in photographic appropriation and the simulacrum in the early 1980s is a well-rehearsed chapter in the history of art.[2] Furthermore, for the first time, women artists—American women artists such as Cindy Sherman, Sherrie Levine, and Barbara Kruger—feature prominently, and feminist and nonfeminist art historians alike see gender concerns as central. Although the Hackney Flashers certainly seem to be worlds apart from a canonical art world figure like Sherman, with Spence and Dennett's later series of staged photographs, *Remodelling Photo History* (1979–82), Photography Workshop's most widely known project, the gulf begins to close. In contrast with the

FIGURE 4.2. The Hackney Flashers, *Women and Work*, 1975. Detail of panel. Copyright Jo Spence Memorial Archive. Courtesy of Terry Dennett / Jo Spence Memorial Archive.

FIGURE 4.3. Margaret Harrison, Kay Fido Hunt, and Mary Kelly, *Women and Work*, 1973–75. Detail of photographic panel. Collection of Tate Britain. Copyright Mary Kelly. Courtesy of Mary Kelly.

documentary aesthetic of the Hackney Flashers, this series presents Spence, often nude, in acts of performance staged only for the camera.

In 1982, when *Remodelling Photo History* was published as a photo-essay in the film journal *Screen*, Spence and Dennett described the series as a "visual/ verbal statement on work and sexuality."[3] In double-image juxtapositions, *Remodelling Photo History* is a reprise and reworking of my book's central themes. It presents a condensation of competing terms that ricochet back and forth between the categories of labor, gender, sexuality, and reproduction in both the social and psychical realms. Take, for example, *Revisualization* (Figure 4.4); one half shows a proletarian figure—Spence in the guise of a male worker—reading Freud's *On Sexuality*, mouth agape in laughter (or pain) and wearing joke spectacles with the eyeballs ready to pop right out in a marvelous visual pun on Oedipus and castration. This image is paired with a cloyingly sentimental depiction of maternity—the Madonna-like mother's head illuminated with a soft-focus halo of light—that has been utterly transformed by the transgressive insertion of (middle-aged) adult sexuality. Other pairings include images that suggest lurid sexual violence, colonial-era ethnography, and prosaic depictions of women's domestic labor. Spence's bulky white middle-aged body is far from fixed in its range of meanings; instead it becomes signifying putty in relation to a reflection on the multiple uses of photography: the crime scene, ethnographic photography, advertising, documentary, pornography, and landscape.

This chapter provides a narrative about the turn to photography, the development of photographic theory, and the importance of sexual difference in Britain in the late 1970s that is different from the canonical U.S. account associated with figures such as Sherman. Focusing on the open-ended collaborative practice by Photography Workshop, this chapter analyzes the importance of documentary photography in contrast with the conceptual art document, the critical transformation of documentary photography's appeal to the real through a semiotic understanding of photography derived from the writing of Roland Barthes, and a totally different psychoanalytic understanding of the Real that was emerging in the context of film theory. But this is not a straightforward intellectual history since photography, as it is understood in the newly theoretical terms that I am charting here in Britain, emerges in,

is tested by, and is transformed into photographic *practice* (intellectual, political, and aesthetic) in a way very different from the critical postmodernist account we know so well.

In relation to the overall arc of the book, Spence and Dennett's "visual/verbal statement on work and sexuality," as they put it, offers a pointed reflection on the debates that emerged in the wake of the consecutive exhibitions of *Post-Partum Document* by Mary Kelly and *Prostitution* by COUM Transmissions in 1976 at the Institute of Contemporary Art. These two projects brought the themes of work and sexuality to the fore in a particularly volatile public way. Furthermore, the scandal surrounding Kelly's installation in particular led to a widespread debate about the value of psychoanalysis for feminism that Spence was also party to. In chapter 3 I sought to elaborate the unremarked-on connections between Kelly and COUM's projects, but it should be noted that they each developed very different attitudes toward the

FIGURE 4.4. Jo Spence and Terry Dennett, *Revisualization* from *Remodelling Photo History*, 1979–82. Copyright Jo Spence Memorial Archive. Courtesy of Terry Dennett / Jo Spence Memorial Archive.

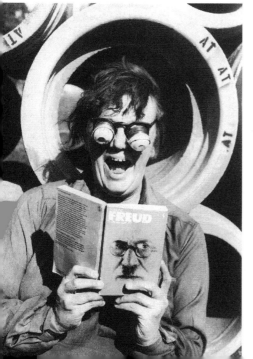
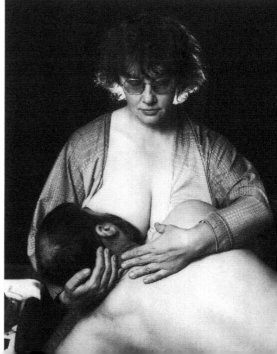

photographic representation of female sexuality. In marked contrast to Kelly's earlier practice (discussed in chapter 2), in *Post-Partum Document* (1974–79) she avoided all photoreproductive technology as well as all other iconic representations of the female body. This aesthetic choice was not a casual one; it denoted a negation that Peter Wollen described in his 1978 essay "Photography and Aesthetics" as "an instance of rigorous non-use of photography."[4] Thus if Kelly's *Post-Partum Document* suggested a certain iconophobia, COUM's practice in contrast might be said to be iconophilic. Tutti turned pornography into performance art by reassigning, in a performative Duchampian gesture, photographs showing herself modeling in pornographic magazines as documentation of art actions. In the context of 1970s feminist debates about the objectification of the female body, Tutti's performative works are doubly transgressive. The typical avant-gardist assertion of the popular—"low" pornography in the space of "high" art—is coupled with Tutti's claiming of artistic authority via an industry that was hardly considered a friend to feminism.

Analyses of the paired series of photographs that constitute *Remodelling Photo History*, together with a single introductory image, are the central focus of this chapter. Like the bones of a skeleton, my readings of these images are embedded in a fleshy history that traces the evolution of Photography Workshop in the mid- to late 1970s and other significant developments in photography of the period. This is not a comprehensive history of the many collaborative projects instigated by Photography Workshop, an undertaking too ambitious for just one chapter of a book. Instead, I present a different narrative about the turn to a politics of representation in the early 1980s and another account of the feminist turn to photographic theory than the one that we are familiar with.

Conceptual Art and Documentary Photography: The Politics of Amateurism

Wollen's "Photography and Aesthetics" was one of the earliest texts published in Britain to situate contemporary photography within a broader history of the medium. It is significant that Wollen mentions Kelly—as a *non*photographer— together with other contemporary photographers such as Victor Burgin and Marie Yates but that Spence makes no appearance. This is not exactly an oversight. Spence's trajectory and pedagogical mode of practice did not conform to the conventional artistic career.[5] When she formed Photography Workshop

with Dennett in 1974, it was a politicized alternative to the commercial work that they were both trained in (Figure 4.1). Spence had recently given up her main-street photography business of seven years, and Dennett was a photographer for the London Zoo. Spence learned the mechanics of the medium on the job as a professional photographer and only received an art school education much later.[6] Photography simply was not taught in art schools at this time, and other photographic artists contemporary with her, such as Burgin, John Hilliard, and Alexis Hunter, took up the camera only after being trained as painters and sculptors.[7] Wollen's 1978 essay marks a significant shift in the cultural status of photography in Britain from obscure marginal interest to a politically significant aesthetic form with its own historical determinations. It is interesting to note that Spence had a unique firsthand working engagement with Wollen's text and with the journal *Screen* as a whole: in 1977 she took a job as a typist at the Society for Education in Film and Television at the British Film Institute. Since the BFI was an institution marked by the transformations of May '68, she was actively encouraged to undertake an intensive theoretical self-education, which she did. Spence and Dennett were both autodidacts—intellectual amateurs, if you like—initially through contact with an idiosyncratic community of political émigrés and then through Spence's active engagement with the educational wing of the BFI. One part of her job involved typing the articles that appeared in *Screen,* and so in her role as an intellectually engaged secretary, she would have read Wollen's text before it went to print. This idea of intellectual amateurism, together with Spence's working-class upbringing, is intended to show that her relationship to the theoretical transformations in photography was always shaped by a politicized awareness of her personal history, and her relation to the politics of class also became an important aesthetic aspect in her work.

The only solo image in the series *Remodelling Photo History,* an introductory image of sorts, establishes Spence's identification with the figure of the worker. She literally acts the part in this staged photograph, and it directly connects the series to photography of the interwar period. The title of this photograph, *The Finest Products of Capitalism (after John Heartfield),* echoes that of its partner image, made fifty years earlier by another photographer (Figures 4.5 and 4.6). We are explicitly asked to compare the 1970s with the

1930s—the last significant period for a theoretical and political avant-garde photographic practice. Given the shifts in Spence and Dennett's later image, we are also directed to address photography's institutional use.

In Heartfield's original photomontage, the cut-and-paste juxtaposition rests on our recognition of his ironic presentation of the class-divided male and female couple as bride and groom. The bride is a store mannequin displaying a high-end wedding dress, and the groom is a desperate unemployed man with a sign that reads, "Nehme jede ARBEIT on!" ("I'll take any work!"). In breaking with the visual opposition of this precursor image, wherein the worker, like the bridal gown, is presented as a commodity in a store window, Spence and Dennett disrupt the neat symmetry of heteronormative gender as a vehicle for a political reflection on class. Her identification with the worker is thus a feminist transformation of the assumed masculinity of this classed figure. Not only is Spence in drag as a male worker-cum-bridegroom, but also

FIGURE 4.5. Jo Spence and Terry Dennett, *The Highest Products of Capitalism (after John Heartfield)*, from *Remodelling Photo History*, 1979–82. Copyright Jo Spence Memorial Archive. Courtesy of Terry Dennett / Jo Spence Memorial Archive.

Spitzenprodukte des Kapitalismus

Brautkleid für 10.000 Dollars

20 Millionen Arbeitslose

FIGURE 4.6. John Heartfield, *The Finest Products of Capitalism [Spitzenprodukte de Kapitalismus],* originally published in *Arbeiter Illurstriete Zeitung,* March 1932. Copyright Artists Rights Society (ARS), New York / VB Bild-Kunst, Bonn. Courtesy of the Witt Gallery, the Courtauld Institute of Art, London.

the horizontal format of the composition introduces a third element (and one that evokes Spence's former occupation): the commercial photographer. To the right of Spence are two photographs of bridal couples and a sign advertising "Gordon Dunning Photographs." The introduction of this third element, in a composition that is now organized according to the golden ratio rather than a symmetrical division, draws attention to photography as a socially embedded practice. The vertical signboard held up by Spence becomes another visual element in the sign world of this image echoing the rectilinear shape and frontal arrangement of the photographs in the window. With this visual and textual interplay between signboard and photographs, *The Finest Products of Capitalism (after John Heartfield)* presents photography as a semiotic form; like a language, viewers should *read* the image.

Spence and Dennett were particularly indebted to Barthes's approach to photography in the 1960s that he developed in a series of essays written for the interdisciplinary journal *Communication*. This is prior to, and a less well-known body of work than, his 1979 book *Camera Lucida* (published in English translation in 1981). Addressed specifically to the mass-circulated photographic image—photojournalism, advertising, and such—Barthes establishes the grounds for a semiotic analysis of photography within a proto-cultural studies framework. In contrast with the psychoanalytic approach of the later book, this writing is shaped by structuralist analysis and addressed to the photograph as a *message*. While Spence and Dennett evoke an earlier period of art photography in this homage to Heartfield, his image, like their own, was also presented in a publication. Each photographic "message," to use Barthes's words, "is formed by a source of emission, a channel of transmission and a point of reception."[8] Furthermore, the shift in Spence and Dennett's updated version includes an additional vernacular source, the professional photographer, whose work contributes to the construction of the heteronormative family album.

The historical aspect of Spence and Dennett's work, its direct engagement with the history of photography, may not seem particularly unusual to us now. But their more widely known contemporaries had a different trajectory. Unlike Spence, the contemporary photographers mentioned in Wollen's 1978 essay all came to photography through conceptual art, where the medium was initially

seen to be in equal parts a kind of tabula rasa and a short-circuit to social questions. Burgin, perhaps the most influential figure as a writer, photographic artist, and teacher, has described how, though it seems unimaginable today, in the early 1970s photography functioned like "a window through which you could punch a hole in the gallery wall and bring into the gallery issues that had previously been considered not proper."[9] Burgin is not referring to photographs with obvious social content, such as documentary photography or the photomontage of Heartfield; these images would have been aesthetically unremarkable, deskilled examples of the camera as a dumb "recording mechanism."[10] As John Roberts has argued, the photographic document—the typical strategy deployed by conceptual and performance artists—was related to a more directly politicized documentary photography only insofar as it signified the *non*artistic, the *a*cultural, and in doing so any social or political purpose associated with this realist practice was remaindered.[11]

The conceptualist understanding of photography as crude, amateur, and aesthetically unsophisticated was first elaborated in relation to the history of photography by Jeff Wall in his influential 1996 essay "'Marks of Indifference': Aspects of Photography in, or as, Conceptual Art." Wall is preoccupied with photography's challenge to pictorial modernism. He argues that conceptual uses of photography drew on the legacy of photographic reportage (the conceptualist photodocument) and the politicized idea of deskilling to provide a self-reflexive critique of the Western picture form that attended to the specificity of the photographic image and at the same time engaged with the longer history of painting. He mounts an impressive argument of Hegelian scope with a telos that implies an artistic solution in his own photographic practice. Several commentators have critically elaborated the self-serving features of Wall's argument, and certain aspects of his discussion of conceptual photography have also been convincingly challenged.[12] Unlike other accounts of conceptual art, this text is of particular significance because it directly addresses the history of photography.

My interest, however, is not so much with Wall's central argument, since Spence's work does not emerge out of deskilled conceptual practice; rather, it is with a throwaway reference that he makes to the idea of "proletarian amateurism." He indicates that this is a counterpart to the deskilled aesthetic

of conceptual art (a term that has almost become a cliché in art criticism). Although he does not fully develop this line of analysis, nor does he offer any specific examples, Wall nonetheless evokes the figure of the crass proletarian as a political challenge to the sophistication of the "classicizing aesthetic of the picture." This is an argument about the politics of form that, Wall suggests, offers "a new level of pictorial consciousness."[13] Furthermore, his brief reference to the idea of proletarian amateurism may even have been made with Spence and Dennett in mind given that he was living in London in the 1970s and remained closely engaged with theoretical debates in film and photography.

Certain aspects of Wall's argument about U.S. conceptual photography have been taken up by John Roberts in relation to British work of the 1970s. Roberts suggests that conceptual photography in Britain was related to "the idea that the work of art is closer to 'ordinary' labour and the 'ordinary' skills of the artistic amateur."[14] For Roberts the idea of amateurism in the context of conceptual art seems to be aligned with a kind of loosely understood workerism. I want to differentiate this general notion of amateurism that Roberts associates with early conceptual uses of photography from Wall's more politicized suggestion of *proletarian* amateurism that forms the political aesthetic of Photography Workshop. Thus I am borrowing Wall's term—one that he seems to be happy to discard—and leaving behind his particular focus on photography as a challenge to high modernist criticism. In counterpoint to other better-known conceptual strategies of the period, Spence was actively engaged with the history of photography and with documentary photography in particular, since historically this was the point of intersection with questions of social and political relevance.

Furthermore, Spence's response to the issue of the politics of class is altogether more personal than previous examples in this book. Her political engagement was tempered by a keen firsthand awareness of the way in which the cultural politics of class was deeply entrenched in British society. Thus my use of the idea of proletarian amateurism is also a reflection of Spence's identification with being raised working-class as opposed to the much valorized, frequently sentimental, workerist engagement with this figure.[15] Furthermore, as a political aesthetic, Spence's identification with this trope—as exemplified

in the homage to Heartfield—was shaped by a feminist politics of the personal that is frequently evoked by the slogan "The personal is the political."[16] She thus applied her grassroots experience of the politicization of gender politics in feminist consciousness-raising groups to her own class experience. Because of this, the tenor of Spence's exploration of the relationship between class and feminism is rather different from most of the other artists discussed in earlier chapters who conceived of the issue principally in political terms, and typically from a position of educated privilege. Take, for example, her groundbreaking 1979 autobiographic project *Beyond the Family Album* (published in expanded form in the 1986 book *Putting Myself in the Picture*), where Spence narrates her own gendered class history through a semiotic analysis of the formal codes of family photography. Using her own family album as a found object, Spence's account of these generic childhood snapshots, mementos of family trips, and unremarkable portraits includes an extended textual commentary that critically reads the poses, gestures, lighting, and context—the rhetoric of the images, as Barthes put it—for the inscriptions of gender and class norms. *Beyond the Family Album* draws on the most prevalent amateur use of photography, the family album, and she incorporates her evolution as a professional photographer into this vernacular form. Thus, with the family album serving as the frame for this later professional work, the trope of photographic amateurism is evident at the level of form.

If, in *Beyond the Family Album*, Spence mobilizes a semiotic analysis of her own unwitting repetition of a set of visual codes, for *Remodelling Photo History* this semiotic approach becomes fundamental to the making of the image itself. Rather than critically decoding preexisting images, Spence and Dennett manipulate the visual codes of photography to actively construct meaning in this complex reflection on photography's history and social use. Spence and Dennett's training as professional photographers gave them a technical competence and a hands-on social understanding of photography that could then be redirected politically. As Wall suggests, conceptual art's use of the photographic document empties it of the social dimensions that are typically part of documentary photography, but Spence's first preoccupation was with the latter understood as a politicized strain in the history of photography.

In early Photography Workshop projects, Spence undertook relatively conventional socially oriented subjects with a focus on marginalized groups such as Romany gypsies. In pedagogical workshops they taught photographic skills to enable a broad range of children and adults from marginalized communities to represent themselves. While this has all the hallmarks of a naïve community art model, Photography Workshop was from the outset much more politicized. Dennett also began to research radical models from the past in order to trace a genealogy for their political pedagogical practice. In 1975 Spence and Dennett began a short collaboration with two documentary photographers, Mike Goldwater and Paul Trevor, who were running a gallery attached to the Half Moon Theatre in London. During the two years of its operation, with an Arts Council of England grant, Half Moon Photography Workshop published the broadsheet journal *Camerawork*, organized a series of photography exhibitions, and ran a pedagogical program of workshops and seminars on critical perspectives related to photography.[17]

Much of the energy of Photography Workshop at this time was focused on pedagogy and historical research, but Spence did undertake a significant documentary project in collaboration with the Hackney Flashers. *Women and Work* directly reflects the gender theme underpinning *The Finest Products of Capitalism (after John Heartfield)*. Furthermore, during the development of *Women and Work*, Spence came into direct contact with artist and photographic theorist Victor Burgin. Here the parallel paths that I have charted, between conceptual uses of photography and Spence and Dennett's pedagogical and historical focus, begin to intersect. Burgin served on the Arts Council panel that decided on the Half Moon Photography Workshop's award and was the principal figure in securing the grant for them. But it came with a proviso. Burgin was given the role of adviser and informal overseer of the project, and Spence became the liaison with him for the group. In the mid-1970s Burgin thus served as an informal mentor, and Spence recounts feeling particularly intimidated at the prospect of these meetings, since along with Dennett she was familiar with his considerable reputation as both a conceptual artist and a theorist.[18] In comparison with Burgin's academic credentials—he headed the highly regarded photography program at the Polytechnic of Central London

and received a master's degree from Yale University—Spence and Dennett were indeed proletarian amateurs.[19]

Women and Work: Proletarian Amateurism in Practice

Women and Work offers a concrete example of Spence's engagement with the trope of proletarian amateurism in relation to subject, form, and mode of realization. Photography Workshop's pedagogical orientation meant that the Hackney Flashers included skilled photographers, such as Spence and Liz Heron, as well as untrained amateurs.[20] Dennett was present at the inaugural meeting of the group, along with another male photographer, but the men withdrew from the group following a majority decision to restrict the participants to women. In common with several other projects initiated by Photography Workshop, the Hackney Flashers did not remain under its organizational control.[21] Spence, however, was a central member of the collective throughout its period of operation, and its work developed and was transformed by other Photography Workshop projects that ran concurrently.

Like the Hackney Flashers, Harrison, Hunt, and Kelly's *Women and Work* exhibition emerged out of activist projects but had a slightly different focus. Taking the implementation of the Equal Pay Act as the beginning point, Harrison, Hunt, and Kelly focused on a single metal box factory. The Equal Pay Act, entered into law in 1970 but not fully implemented until 1975, was from the outset widely understood by feminists to be deeply flawed. It legislated for equal pay within the same categories of work, but employers typically got around this by classifying the work typically done by women as unskilled and that done by men as skilled or semiskilled, regardless that the tasks were remarkably similar. Even the women Ford machinist workers, whose 1968 strike at the Dagenham factory in Essex precipitated the Equal Pay Act, never managed to change the skill categorization of female workers as compared to male; their pay rates were ultimately unaffected by the legislation that came about in their name. Since the project emerged out of a shared involvement in feminist activism, Harrison, Hunt, and Kelly's postconceptual installation, unlike earlier conceptual art examples, includes direct social reference. The exhibition was organized with visual and textual elements presented as forms of data to be analyzed by viewers, making the model of the artist closer

to that of the sociological investigator. Following a conceptual art approach, visual material is given much less of a priority and authority than the textual aspects.

The inspiration for the Hackney Flashers' exhibition, however, was directed toward the labor movement rather than the State. *Women and Work* was conceived as a response to the Hackney Trades Council's exhibition in celebration of "75 years of brotherhood." As Liz Heron points out in her article on the subject, "Sisterhood was an afterthought."[22] In a more or less conventional documentary mode, the Hackney Flashers' exhibition presented images of women in all kinds of working situations: professions and office work, as well as care work, service industry labor, manual work, and women in unemployment lines (Figure 4.7). Alongside the photographic images were brief handwritten statistical records and other information, such as levels of pay. It was the first exhibition of its kind to publicly display so many images of women at work. In contrast with the emphasis on textual information seen in Harrison, Hunt, and Kelly's postconceptual installation, the Hackney Flashers drew on the tradition of documentary photography that, since its emergence in the 1930s, has been understood as a form of visual investigation into social and economic inequity. There is thus an inversion in the ratio of text to image, with the Hackney Flashers placing a much greater emphasis on visual elements.

Both exhibitions interpreted work in an expanded feminist sense, and they each included reference to the hidden labor of housework. Harrison, Hunt, and Kelly do so through the use of typewritten textual logs breaking down the working day into units of laboring time that also included the labor of housework.[23] The Hackney Flashers' exhibition included documentary photographs of women doing housework, and these images did not differ in any significant way from the depictions of paid employment. These similarities at the level of subject matter and political theme only highlight the notable differences in formal presentation.

Photography in Harrison, Hunt, and Kelly's exhibition was one part of a stylish postconceptual installation that also included recorded interviews, film footage, and printed text (Figure 4.8). The aesthetic codes of conceptual art are now accepted as a sign of art world sophistication, so the historically specific

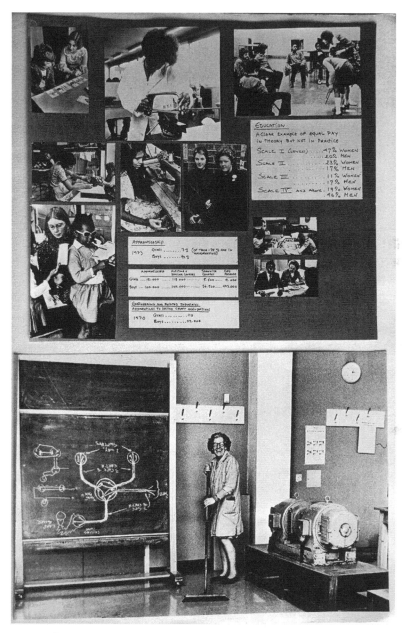

FIGURE 4.7. The Hackney Flashers, *Women and Work,* 1975. Detail of panel. Copyright Jo Spence Memorial Archive. Courtesy of Terry Dennett / Jo Spence Memorial Archive.

idea of a conceptualist aesthetics of amateurism seems much less tenable. (Wall uses the term "re-skilled" to indicate the shift.)[24] Kelly and Harrison have indicated that *Women and Work* was influenced by Conrad Atkinson's work of the early to mid-1970s and Kelly has also referenced the sociological turn seen in the work of Hans Haacke, which had received a good deal of coverage in the art press.[25] Haacke's 1971 installation *Shapolsky et al. Manhattan Real Estate Holdings: A Real-Time Social System as of May 1, 1971* is widely acknowledged for the shift that it marks in the use of photography within a conceptual art framework because of its direct engagement with the social issues. This is not through the use of documentary photography as a genre; instead, as with the other conceptual uses of photography that Wall discusses in his aforementioned essay, there is a deskilled consistency in Haacke's use of photography as a straightforward tool to document Manhattan properties. Haacke researched a notorious slum landlord; he presented the information in narrow columns of typewritten text at the top of which is an unremarkable,

FIGURE 4.8. Margaret Harrison, Mary Kelly, and Kay Fido Hunt, *Women and Work,* 1973–75. Installation view, South London Art Gallery, 1975. Photographs, charts, tables, photocopied documents, film loops, audiotapes. Collection of Tate Britain. Copyright Mary Kelly. Courtesy of Mary Kelly.

FIGURE 4.9. Hans Haacke, detail of photographs and typed sheets, *Shapolsky et al. Manhattan Real Estate Holdings: A Real-Time Social System as of May 1, 1971*, 1971. Copyright Hans Haacke / Artists Rights Society (ARS), New York / VB Bild-Kunst, Bonn. Courtesy of Hans Haacke and Paula Cooper Gallery, New York.

badly exposed photograph of each property. The framing and composition of the photographs are similar: artlessly shot to resemble the perfunctory appearance of a real estate file (Figure 4.9). The difference is that the photographs are part of a larger political critique, a shift in conceptual practice that has since been referred to using the term "Institutional Critique."[26] The abundance of textual information offered by Haacke contrasts with the paucity of visual information given in the photographs, which suggests a continued iconophobic suspicion of the visual also seen with conceptual art.

The recognizable art world sophistication of Harrison, Hunt, and Kelly's *Women and Work*, with its reliance on a postconceptual aesthetic, is all the more marked in light of the Hackney Flashers' self-conscious crudity. This

difference in sensibility is even evident in the sexual joke suggested by the latter group's name: Hackney Flashers brings to mind the unwanted attentions of a male pervert together with the idea of the invasive flashbulbs of the photographer.[27] In contrast with the framed black-and-white prints arranged in a grid formation of the former, the unframed black-and-white photographs in the latter exhibition were crudely pinned onto cheap backing card in irregular groupings. The typewritten text of Harrison, Hunt, and Kelly's project—a signifier of the spare intellectualism of conceptual art—is presented in handwritten form by the Hackney Flashers. Likewise the use of photography in each project is contrasting. Harrison, Hunt, and Kelly use photography sparingly. Visual information is secondary in this installation to the textual. As I indicate at the beginning of the chapter, the iconophobic tendency seen with Harrison, Hunt, and Kelly's *Women and Work* evolves even further in Kelly's first major solo project, *Post-Partum Document*. Here she deploys a "rigorous non-use of photography," to use Wollen's phrase, and dispenses altogether with all iconic representations. Text, in this later work, is supplemented by a range of indexical traces, including imprints, casts, and infant scrawl.

While both projects offer a necessarily incomplete and fragmentary view of their subject, it is especially difficult to get a unified overview of the Hackney Flashers' exhibition. *Women and Work* has appeared in numerous different configurations—reproduced, reorganized, and even retitled as *Women at Work*—so that the constituent parts take on a fundamentally shifting, modular form. The photographs are not treated like fixed compositional elements but rather as reproducible units of visual information. For example, in Spence's 1986 book *Putting Myself in the Picture,* a series of panels from *Women and Work* are reproduced in irregular groupings with handwritten text, all attached to low-cost backing card. Here Spence has integrated the panels into another autobiographically oriented project, *Putting Myself in the Picture.* The cheap bulletin-board-style format is an indication of the shifting modular arrangement that structures the installation as a whole (and Photography Workshop's approach in general). Like photography itself, these images are subject to the logic of reproduction: reused, rearranged, resized, and republished ad infinitum.

This aspect of photography was first exploited to its full extent in the interwar period, and there is a direct reference to the proletarian amateurism of this era in the layout of the Hackney Flashers' exhibition. The temporary bulletin-board arrangement comes from the widely used practice of the wall newspaper. Common in factories and other contexts, the wall newspaper was a temporary makeshift collage of information and imagery that served as a leftist alternative to the mainstream press. At the same time that Spence was working with the Hackney Flashers, Dennett had begun to undertake extensive research on the use of photography among working-class political groups in 1930s Britain. The wall newspaper was one of a variety of display strategies that formed a concrete point of reference for the aesthetic of proletarian amateurism. In light of this, the invocation of John Heartfield in *Remodelling Photo History*'s introductory image is also a way of referring to a much more heterogeneous and largely unknown range of anonymous collective practices.

Dennett was particularly focused on the British Film and Photo League of the 1930s and other working-class photographic organizations of the early twentieth century. While these historical practices suggested specific visual strategies—such as the wall newspaper—it was the organizational structure and the idea of photography as a form of political pedagogy that became much more significant. Dennett's research culminated in two major exhibitions at the Half Moon Gallery, *The General Strike 1926: How it Affected London's East End* (1975–76) and *The Thirties and Today* (1976–77), followed by a research article on the Film and Photo League published in Photography Workshop's first book, *Photography/Politics: One.*[28] For the latter, Dennett tracked down the eleven remaining living members and took oral history accounts of the league's emergence. This research was aided by the recent discovery of an archive of films, negatives, and documentation from the Film and Photo League by Jonathon Lewis and Elizabeth Taylor-Mead of Metropolis Pictures.[29] The significance of the research and public presentation of these previously unknown interwar film and photographic works was not simply for empirical historical interest. Dennett's research provided a model in these precursors for the organization of Photography Workshop as a kind of dispersed counterinstitution. In *Photography/Politics: One,* Liz Heron's article,

"The Hackney Flashers," immediately followed Dennett's on the Film and Photo League, thus establishing a link between the two periods. There are many other parallels with Photography Workshop. For example, the use of a truck to house a mobile movie projection system was echoed in Photography Workshop's mobile darkroom in a decommissioned ambulance; and Spence and Dennett's numerous low-tech how-to guides published in *Camerawork* and other places were similar to those published in the 1930s. The key point is that this historical connection was part of a pedagogically oriented mode of political *practice* and not simply a series of stylistic or technical innovations.[30]

Dennett's research unearthed another formal strategy that was commonly used in the 1930s and served as the underlying structure for the double-image juxtaposition seen in *Remodelling Photo History*. Charles Henry Parkes first developed the so-called deadly parallel earlier in the twentieth century, and it became widely deployed in the 1930s by the left-wing press. This was a form of double-image juxtaposition wherein photographs showing different points of view, from different incidents, spaces, and times, were brought together in order to draw out a political analysis. Echoing Brecht's famous remark, recounted by Walter Benjamin in "A Small History of Photography," that a photograph of the Krupp factory tells us very little about the factory's economic, political, and social significance, Dennett pointed out that the rationale for the deadly parallel was shaped by the assumption that "the interconnected or causative elements of many events were not necessarily present at the event itself."[31] Prior to *Remodelling Photo History*, Dennett used this technique as the design for the posters for his two historical exhibitions on working-class practices of the interwar years that were presented at the Half Moon Gallery (Figures 4.10 and 4.11). With *Remodelling Photo History*, the deadly parallel serves as a kind of formal infrastructure for a project addressed to a set of theoretical and aesthetic questions that had become central to feminist practices.

The Deadly Parallel: *Remodelling Photo History*

Remodelling Photo History is perhaps the sole photographic project produced as part of Photography Workshop that has been completely accepted within the art world. It was finally given the full stamp of institutional legitimation

THE THIRTIES & TODAY

PHOTOGRAPHS & DOCUMENTS OF SOCIAL STRUGGLE

1930's – Unemployed trade unionists "raid the Ritz" for a meal

1970's – Trade union leader at a "Working Together Luncheon"

Half Moon Gallery 27 Alie Street London E1

19 June – 25 July 1977 Monday – Saturday 11-6

Telephone: 01-488 2595 ⊖ Aldgate East

With the support of the Arts Council of Great Britain and the Greater London Arts Association

FIGURE 4.10. *The Thirties and Today: Photographs and Documents of Social Struggle.* Exhibition poster for the Half Moon Gallery, 1977. Copyright Terry Dennett / Jo Spence Memorial Archive. Courtesy of Terry Dennett / Jo Spence Memorial Archive.

STRIKE '26

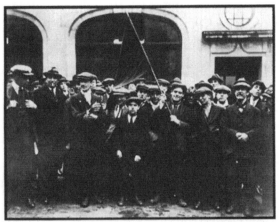

Photographs and Documents of the General Strike

Half Moon Gallery 27 Alie Street London E1

⊖ Aldgate East 1 May ~ 4 June 11 ~ 6 Mon ~ Sat tel 01 488 2595

Pictures by courtesy of Klugman Collection. With assistance of the Greater London Arts Association and the Arts Council of Great Britain

FIGURE 4.11. *Strike '26: Photographs and Documents of the General Strike.* Exhibition poster for the Half Moon Gallery, circa 1976–77. Copyright Terry Dennett / Jo Spence Memorial Archive. Courtesy of Terry Dennett / Jo Spence Memorial Archive.

when it was included in Documenta XII (2006) almost twenty-five years after its completion. In 2005 Spence received a retrospective exhibition at the Museu d'Art Contemporani in Barcelona, Spain, followed by the first full retrospective in London in 2012, across two venues, Space and Studio Voltaire. In both these exhibitions the proper name Jo Spence functioned as the stabilizing vehicle for a body of work that also included the dispersed collaboration of Photography Workshop.[32] But this belated recognition of Spence is not a straightforward case of an artist's work being undervalued because Spence never fully accepted the title of "artist," and furthermore, all of her work was made in collaboration with individuals and groups (some of whom objected to the privileging of Spence as the named figure).[33] Photography Workshop was located within the interstices of the art world, so it cannot easily be assimilated into established models for artistic collaboration. As an alternative institution—a counterinstitution, one could say—Photography Workshop supersedes the proper name Jo Spence, with a practice that included alternative educational workshops in photography for children and adults, activist work, theoretical inquiry, and publishing ventures. Photography Workshop's modus operandi was to generate further projects whose direction typically became independent, and even the name Photography Workshop would not necessarily remain attached to these new growths.

Remodelling Photo History, at the time of its first reception, was clearly marked as a collaboration with Dennett. In *Screen* it is staged as a photo-essay, a popular form rooted in the 1920s and 1930s that Spence and Dennett had extensively researched. Taking yet another format, it was circulated as an education pack to high schools and community groups with the images laminated for easy handling. In the latter format the images were used for, quite literally, hands-on discussion and analysis. It is important in the context of this chapter to retain this aspect of the work's reception even though such work is not typically privileged in art historical accounts.[34]

The first pair of images in *Remodelling Photo History* establishes the gender stakes in Spence and Dennett's use of this early twentieth-century format (Figure 4.12). This opening comparison anchors the art world address of the series as a whole. *Industrialization* invokes two approaches to a common early twentieth-century motif in art photography: the nude in the landscape and

the figuration of industrial progress. But only one of the two images confirms the constructivist and Bauhaus theme of modernity suggested by the caption; the other conforms to the aestheticizing expectations of early pictorialist photography. This image shows a supine nude with a delicate curved form that is echoed by an irregularly shaped tree on the horizon to the right. The all-too-easy equation that this offers—woman as nature—is contrasted with the inversion suggested in the other half. Here the bulky wall of flesh that dominates the right of the image has its own visual echo in the anthropomorphized electricity pylon to the left. But a comparable shift in the equation does not easily fall into place: woman as modernity? industrialization? progress? If woman as nature is a shared cultural connotation evoked in the pictorialist image, the companion image does not quite attain a comparably

FIGURE 4.12. Jo Spence and Terry Dennett, *Industrialization* from *Remodelling Photo History*, 1979–82. Gelatin silver print. Copyright Terry Dennett / Jo Spence Memorial Archive. Courtesy of Terry Dennett / Jo Spence Memorial Archive.

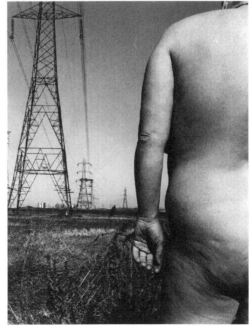

stable signification. With a landscape dominated by electrical pylons, this photograph certainly suggests the iconography of modernist innovators such as El Lissitzky and Germaine Krull—modernity figured through the trope of electrification—but the female body seems strangely out of place and for that matter not exactly secure in its gender.

The recognizably feminine form of the prone body has been transformed in the upright figure on the right into powerful shoulders and irregular fleshy bumps that might just as easily indicate an unconditioned male body. While Spence is indeed the same model in each—and is present across the whole series—in this opening comparison the camera begins to establish interpretative ambivalence with regard to gender. Is not the nude typically considered to be stable in its gender codes, and indeed, is not the genre itself fundamentally shaped by such stability? But in order to realize such an assumption, I find myself fixating on an inch of shadow underneath the right hand figure's left arm, a minute suggestion of a female breast that hints at a clearly identifiable gender otherwise under question. Furthermore, our visual proximity to the body—it dominates the foreground of the image, and variations in the texture of the skin are clearly in focus—reinforces the potentially unsettling effect. The point of view is also decisive; we are positioned like a child in relation to this monumental adult body giving this proximate physicality a haptic quality. To use Barthes's vocabulary, our semiotic play of "denotation" (body, landscape) and "connotation" (femininity, nature)—of meaning achieved as much through what is absent as what is present—cedes to the suggestion of a more uncontrollable psychical realm of interpretation with the viewer as child.

The social analysis of photography that the deadly parallel was intended to elicit begins to intersect in *Remodelling Photo History* with a different kind of psychical interpretation. This suggests an understanding of photography in relation to what Lacan described as the Imaginary.[35] First developed in a 1949 essay "The Mirror Stage" (published in an English translation in 1968 in *New Left Review*), this early Lacanian concept became particularly influential in the context of film theory during the 1970s.[36] Photography is one among a broad range of other cultural forms associated with the Imaginary that function as a stabilizing veil for narcissistic identifications. Given that Lacan's mirror stage articulated a point of intersection between the social,

somatic, and psychical, we can see how this concept might have become particularly significant in Spence and Dennett's "statement on work and sexuality." We will return later to a fuller elaboration of the analytic friction caused by the difference between psychic and social space, since this is at the core of the series as well as an important debate in feminism of the period. But first, another fundamentally modernist theme is offered up in the next pair of photographs, *Colonization* (Figure 4.13).

As in *Industrialization,* we have a contrast between the body presented as both part and whole. Several interconnected photographic traditions converge in this juxtaposition, but the use of photography for the purpose of ethnography is most readily apparent. The right-hand photograph, with the close-up, cropped view of a single foot positioned above the kind of scale indicator used

FIGURE 4.13. Jo Spence and Terry Dennett, *Colonization* from *Remodelling Photo History,* 1979–82. Gelatin silver print. Copyright Terry Dennett / Jo Spence Memorial Archive. Courtesy of Terry Dennett / Jo Spence Memorial Archive.

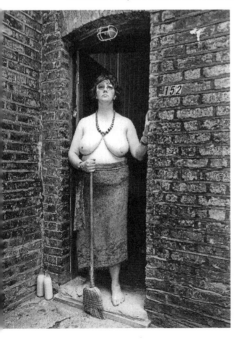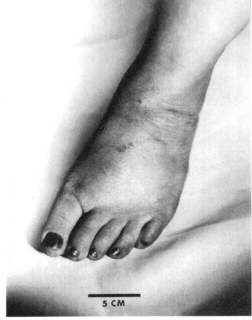

on maps, denotes the idea of bodily measurement. The practice of photograph-
ing an ethnographic subject with an actual measuring device is combined here
with the idea of cartography—spatial mapping—to bring together two impor-
tant aspects of colonial imaging: the body and the territory.[37] This evokes the
scientific mapping of humanity, for which in the nineteenth century photogra-
phy was seen as a proper objective tool. But this fiction of objectivity is rendered
comically absurd in the companion image where Spence is shown decked out
in mock tribal wear, standing—like a proud working-class wife—on the door-
step of her house. These two images, even more so than the previous pair-
ing, adopt a visual language of metonymic displacement in order to generate
meaning. The setting, proprietorial stance, and proud facial expression (not to
mention the white skin and northern European features) belong to a tradition
of documentary photography of the working class, a form of social observation
that was not typically connected to colonial imaging. And through the collision
of these forms of observation, a displaced reflection on sexuality emerges. Here
it must be noted that, while such intersections have now become commonplace
in cultural studies accounts, Spence and Dennett are truly at the forefront in
pioneering such a connection in photographic *practice*.[38]

 The African American comedian Richard Pryor identifies the voyeuristic
appeal of ethnographic photography in a stand-up skit where he refers to the
magazine *National Geographic* as the black man's *Playboy*.[39] In *Colonization*
Spence and Dennett offer a racial reversal of Pryor's politically charged joke
that activates the codes of female sexuality and ethnic or racial difference in
a comparable way. In order to decipher the rebus-like conundrum that the
photograph produces, the only accounting for the exposed white breasts in
the left-hand image—substituted for the black breasts of the ethnographic
photograph—is through the discourse of pornography. If this white woman
is not a tribal figure, why is she shown topless? This question leads to the
genre of pornography. But unlike COUM Transmissions' Cosey Fanni Tutti,
Spence is not a convincing porn model. The bedspread wrapped around her
waist emphasizes her thickening middle, and the haughty upturned chin and
defiant mouth, together with the tinted lenses of the spectacles and her un-
wavering gaze are far from the stock expressions of seductive availability. Yet
sexuality is the only means by which the white breast is able to signify when

openly exposed like this. Indeed, the two bottles of milk set down unevenly by the doorstep serve, in the form of a well-worn body joke, are an additional metonymic play on the erotic aspect of the breast's maternal potential. Like the viewing position of the monumental nude discussed earlier, we are once again situated as if in a diminutive stance in relation to the female figure. The camera lens, and by extension our eyes, are exactly level with Spence's breasts, thus drawing our attention to the significance of this highly charged, erotically invested part of the female body.

Here Spence is also exploring the power relations of viewer and viewed in documentary photography. She had long been involved in this genre, and in many ways her approach prior to *Remodelling Photo History* was typical in that the subjects photographed were the poor or the working class, the marginal, and the victims of society. In this earlier work the viewing position of the photographer was largely occluded. Martha Rosler explores this issue in her essay, "In, Around, and Afterthoughts (on Documentary Photography)," and many of the ideas she discusses resonate with Spence's thinking of the time.[40] Rosler makes the powerful argument that the political gesture involved in documentary photography's revealing of socioeconomic inequality simultaneously reinforces that inequality by consolidating the viewer in his or her position of power. The psychological point runs something like this: the viewer, "we," are not in the abject position of the disenfranchised, "them," and our feeling of benevolent concern is a means of consolidating our position of superiority in relation to the subject depicted. In Rosler's argument, the viewer of the images becomes the focus of the analysis and not the subject of the photograph. Incidentally, Laura Mulvey first developed the structure elaborated by Rosler—in relation to sexual difference rather than economic inequality—in her canonical feminist analysis of cinema viewing, "Visual Pleasure and Narrative Cinema." Here Mulvey's focus is not straightforwardly addressed to the depiction of women in film; rather, she analyzes these fetishistic depictions in relation to the psychic life of the male viewer. Cinema viewing is both a repetition of and an attempt to soothe the anxiety produced by the male Oedipus complex and is therefore not about women as such. Mulvey's essay was enormously influential at the time, and I want to suggest that by putting Spence herself both in front of the camera and behind

the camera (as author), Spence and Dennett could interrupt the power relation between viewer and viewed in terms of both class and sexual difference, social and psychical experience.

This preoccupation with ethical aspects of photography differentiates her work from Burgin's. He was turning to a surreptitious kind of documentary photography—street photography—while Spence was becoming critical of it. In his series *USA '77* Burgin presented a photograph of a nude woman walking around a New York loft space (Figure 4.14). In an updated version of Hitchcock's *Rear Window*, he plays the part of the voyeuristic photographer

FIGURE 4.14. Victor Burgin, *Graffitication* from *USA '77,* 1978. Gelatin silver print with text. One of twelve panels, each 40 x 60 inches. Copyright Victor Burgin. Courtesy of Victor Burgin.

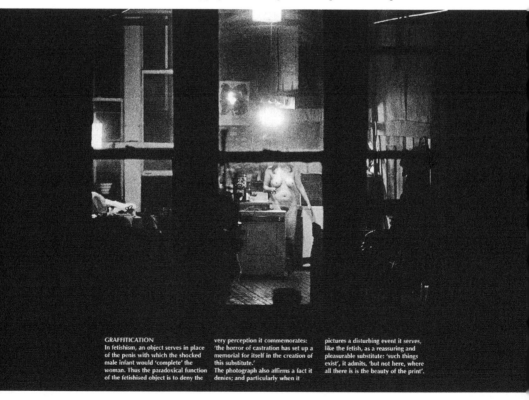

GRAFFITICATION
In fetishism, an object serves in place of the penis with which the shocked male infant would 'complete' the woman. Thus the paradoxical function of the fetishised object is to deny the very perception it commemorates: 'the horror of castration has set up a memorial for itself in the creation of this substitute.' The photograph also affirms a fact it denies; and particularly when it pictures a disturbing event it serves, like the fetish, as a reassuring and pleasurable substitute: 'such things exist', it admits, 'but not here, where all there is is the beauty of the print'.

watching his female neighbor from an undisclosed position across the street. In contrast, using herself in her work allowed Spence to explore the power relationship involved in viewing and being viewed without repeating it.

Spence's *Victimization* directly engages these political and ethical themes (Figure 4.15). With a sharply contrasting depth of field from one image to the next, the expansive landscape setting presents us with a lurid crime scene scenario. The suggestion of sexual violence that the splayed and anonymous nude woman so clearly evokes is juxtaposed with the prohibitive warning sign to the right. The landscape is thus divided according to private and public, entitled and not, inside and outside: a fenced and gated line of separation defined by ownership. With the open car door on one half and the closed gate on the other, the nude figure lies on the wrong side of the private property borderline. More than any other of the images in the series, this one offers open-ended and inconclusive narrative elements. It provokes a list of questions that might go something like this: What happened here? Why is the woman naked? Is she dead? Injured? Raped? Whose property is this? Was she breaking in? Who is to blame?

The multiple narrative threads and the expansive depth of field offered in this exterior scene contrasts with the compressed space and prosaic aspect of its companion image, and the whole body of the former view has been reduced to a part in the latter, a close-up of strong working hands. In the history of documentary photography, there are numerous examples of laborers' hands marked by the signs of a lifetime of work, a catalog of images that serve as a metonym for the idea of honest manual labor. The dusty dryness of Dorothea Lange's iconic photograph of a sharecropper's hands comes immediately to mind, but Spence's hands do not denote simply labor or laborer; rather, they suggest the specificity of gendered labor. These are the hands of a housewife or washerwoman, large and powerful as if formed by a lifetime of work. The line of division between paid and unpaid work, the workplace and the home, has already been seen as an important aspect of the Hackney Flashers' *Women and Work* and has recurred repeatedly throughout the book as a central feminist theme of the 1970s, one that is clearly evoked in this image. Perhaps more pressingly, the dull immediacy of the task is emphasized through the use of spatial compression, which contrasts with the lurid narrative expectancy of

FIGURE 4.15. Jo Spence and Terry Dennett, *Victimization* from *Remodelling Photo History*, 1979–82. Gelatin silver print. Copyright Terry Dennett / Jo Spence Memorial Archive. Courtesy of Terry Dennett / Jo Spence Memorial Archive.

its companion image. Two different kinds of victimization are suggested in these two images: one stages sexuality; the other stages female labor.

The ideas generated by *Victimization* set the scene for the next pairing, *Realization* (Figure 4.16). Both images evoke domestic scenarios: in one Spence plays the part of the housewife, a *feminist* housewife perhaps, in T-shirt and chunky beads. This "liberated" figure is combined with her antithesis: a parody of the idealized commercial housewife with blond hair and a masked face that is quite literally fixed in a plastic smile; she adopts the recognizable pose and prop for a dish-soap commercial. Its companion image, a domestic still life, is the only one from the series where no actual body is evident. As an echo of the frozen-smile mask of the other photograph, a pair of plastic

FIGURE 4.16. Jo Spence and Terry Dennett, *Realization* from *Remodelling Photo History*, 1979–82. Gelatin silver print. Copyright Terry Dennett / Jo Spence Memorial Archive. Courtesy of Terry Dennett / Jo Spence Memorial Archive.

breasts substitutes for Spence's. The repetition of a price tag on the dish soap and on the joke breasts reinforces the theme of commercialization that is a dominant connective thread in these two images. The process of realization, suggested by the title, must refer to the feminist consciousness-raising of the 1970s, for example, realization of the political stakes in domestic labor, of the body understood as a commodity, of the relation between sexual oppression and social oppression.

This pair of photographs is also a reflection on the montage-in-camera of the series as a whole. The backdrop of the housewife image is made up of an actual montage of what looks like different political posters from the 1930s and 1970s, while the face mask, with its crudely cut eyeholes, together with the wig, gloves, and jewelry, all suggest the awkward, self-conscious misalignments of this updated version of the montage technique. No longer the cut-and-paste juxtapositions of Heartfield and Hannah Höch, Spence and Dennett's theoretically engaged work is a semiotically informed montage of signs.

At this point it becomes apparent that the series can be read as a narrative sequence of sorts. Thus far we have the following: industrialization, colonization, victimization, and realization, suggesting a historical account of capitalist development and socialist consciousness that also includes a gendered understanding of each stage. A strictly economic, traditional Marxist narrative is thus evoked but only in order for it to be disrupted and recast in feminist terms. The relationship between sexual difference and class does not coalesce into a new socialist-feminist narrative; instead, these elements are put together in a discontinuous relation. The series is discursive in structure and address; it poses a set of questions for viewers to further discuss.[41]

The next pair of images, *Revisualization*, seems to shift the sequence into a further reflection on the psychoanalytic understanding of sexual difference. With the explicit invocation of Freud, we have a much more direct address to the kinds of psychical issues that have so far been only hinted at in my analysis. The intersection of a psychoanalytic and a semiotic approach to photographic practice (and theory) at this time is more usually associated with Burgin, whom we know was a mentor for Spence in the mid- to late 1970s, and in 1979 Burgin persuaded her to become an undergraduate in the photography program at the Polytechnic of Central London where he worked. Burgin's

approach to photography and theory from the early 1980s onward became aligned with debates within critical postmodernism in the United States in a way that Spence's practice never did. Before elaborating on Spence's engagement with psychoanalysis, I want to ask why, given that there are many shared points of interest between U.S. and UK debates about the theoretical significance of photography, is Spence's work not more widely known?

Photography and Theory: United Kingdom / United States

Reading a section of their introductory essay to the *Screen* presentation of *Remodelling Photo History* reveals a particular focus on photography, its institutional dissemination, and the question of theory:

> In trying to make a piece of work "about" photography, we are making a break with our former work, but as life-long photographers we feel it might be useful to look at the ways in which various institutions and apparatuses have used and validated photography, and to try, within that perspective, to make a visual/verbal statement on work and sexuality.
>
> Above all, we wanted to get away from the dry didacticism which pervades so much worthy work on photographic theory and to provide instead a kind of "revolt" from within the ranks. . . . We aimed to produce something which was perhaps not quite in such "good taste" as is usually expected.[42]

Remodelling Photo History was an intervention into an established field of theoretically engaged photographic practice. The years between receiving the Arts Council Grant in 1975 and the completion of this project in 1982 saw the evolution of a whole new theoretical discourse on photography that Spence was also part of. *Remodelling Photo History* was perceived as a critical reflection on the dominant direction that this theoretical turn had taken, a "revolt[ing]" challenge, they suggest, to its apparent "good taste." This reference to the allusive social codes of taste—an idea that resonates with the proletarian amateurism discussed earlier in the chapter—evokes a language of class-based exclusion that Spence and Dennett reclaim as a critical position.[43] Their self-staging as subaltern soldiers within the ranks of the art world reinforces the extent of their proletarian investment in the cultural politics of the period. To extend the military metaphor they use, their commanding officer would

have to have been Burgin. He is associated with the interpretation of *Screen* journal's theoretical project into the realm of photography as a practitioner, teacher, and theorist, and he had served as a key mentor for Spence's theoretical development in the late 1970s.

Burgin's practice as a photographer followed a period of language-based conceptual work of the 1960s and early 1970s. He is thus an exemplary figure in British conceptual photography and its shift to the politics of representation, which was shaped by an engagement with psychoanalytic theory. Burgin's very first photographic work, titled *Photopath* (1967–69), made for the London leg of the 1969 exhibition of postminimalist art *When Attitudes Become Form*, was first conceived in 1967 as an unrealized instructional piece. The type-written instruction card offers a straightforward empirical description of the work that he followed to the letter two years later: "A PATH ALONG THE FLOOR, OF PROPORTIONS I X 21 UNITS, PHOTOGRAPHED. PHOTOGRAPHS PRINTED TO ACTUAL SIZE OF OBJECTS AND PRINTS ATTACHED TO FLOOR SO THAT IMAGES ARE PERFECTLY CONGRUENT WITH THEIR OBJECTS."[44] The spare, program-matic nature of the language belies the subtle elegance and philosophical richness of the installed work. *Photopath* is a piece that seems to probe the relationship between photography as an iconic sign and as an indexical sign, or as Barthes would put it, the apparent contradiction of the coded message that is realized by means of a "message without a code."[45] There is a signifi-cant transformation in the relationship between language and photography in Burgin's next series of work, beginning with *Performative/Narrative* (1971). Rather than the before-and-after instruction of *Photopath*, text and image are put into immediate proximity and into a dynamic, productive relationship. Here Burgin begins to explore the limits of the photographic caption in an approach that would have a significant impact on Spence's more conventional use of text in a project like *Women and Work*. *Performative/Narrative* is a series of ten black-and-white photographs of the same office view together with brief, noncontinuous, romantically inflected narrative fragments about a male boss and a female secretary. The photographs are unpeopled, with nearly identical compositions that feature the same workstation but with slight variations in the internal components: the position of the desk drawer (open or closed), file folder (open or closed), desk chair (pulled out or tucked

in), and Anglepoise lamp (turned on or off). *Performative/Narrative* seems to establish a series of terms that persist in his subsequent work of the period. As viewers we are asked to undertake a hermeneutical task, to construct meaning in the space between image and text that includes a normative staging of (hetero)sexual difference as a central component. The *work* of visual/textual analysis was broadly understood through the trope of production—the spectator as producer—and the discontinuities between image and text were vital to this process. In the next series of works, including *VI* (1973), *Lei-Feng* (1974), *Sensation* (1975), and *Possession* (1976), Burgin explores a similar productive tension between image and caption, but he now uses images drawn from glossy women's magazines.[46]

This use of commercial imagery in the manner of a ready-made aligns his practice with the so-called Pictures Generation artists based in New York. *Pictures* was the title of a 1977 exhibition at the Artists Space in New York that was curated by Douglas Crimp, but the name has come to refer to a broader group of artists who began to use photography, most significantly Cindy Sherman, Barbara Kruger, Sherrie Levine, Richard Prince, and Louise Lawler.[47] In 1984 Burgin's work, together with other photographic works by Mary Kelly, Jeff Wall, and Marie Yates, was included in the exhibition *Difference: On Representation and Sexuality* with several Pictures Generation artists.[48] *Difference* marked the critical consolidation of a set of feminist-informed practices that were associated with the idea of critical postmodernism. With an important essay by Jacqueline Rose, it also serves as an institutional landmark for the theoretical shift toward the cultural application of psychoanalysis. The activist orientation of 1970s work ceded to a politics of representation. This is in no sense a *de*politicization of art, but rather the idea that representational forms needed to be understood in political terms. *Remodelling Photo History* did not appear in this exhibition, even though it clearly engaged with the photographic turn to psychoanalysis. Perhaps the explicitly comedic reference to Freud's *On Sexuality* in *Revisualization* seemed to brush up too closely against a crudely popular understanding of Freud.[49] We will get to these psychoanalytic issues, but suffice it to say that Spence and Dennett's work emerges from a different kind of politicized intellectual milieu than the one we readily associate with the U.S term "critical postmodernism."

If "pictures" was the key word in 1977, by 1980 it had been replaced by "photography." "The Photographic Activity of Postmodernism," Crimp's influential 1980 essay, emerges from a different set of institutional battles than the ones that have shaped Spence and Dennett's milieu. It is worth briefly sketching this East Coast narrative in order to differentiate it from the account I am setting out here. Moreover, the importance of photography to the development of critical postmodernism was soon to become hegemonic in the contemporary art world, eclipsing the more heterodox British work that I am engaged with.

Crimp's understanding of photography is filtered through a Duchampian lens and with particular reference to Walter Benjamin's writing on the subject. He describes how artists such as Levine, Prince, and Sherman draw on "all those aspects of photography that have to do with reproduction, with copies, and copies of copies."[50] The art historical stakes of photography as ready-made must be seen in relation to the conflict over the authenticity of the painted mark that defined art of the previous generation. In shorthand, the autographic gestures of New York school painters—and the existentialist discourse of authenticity that supported this work—contrast with the commercial imagery and industrial processes associated with pop art and minimalism. These conflicts might have been old news by 1980, but they had a renewed sense of critical urgency because of the institutional significance of the department of photography at the Museum of Modern Art (MoMA) in New York at a time when the market value of photography had suddenly skyrocketed. While the activities of MoMA's photography department could have served as a backdrop for my earlier discussion of conceptual photography, U.S. figures such as Bruce Nauman, Douglas Huebler, and Dan Graham, as John Roberts points out, paid very little attention to the museum's exhibition agenda.[51] Their involvement with the amateur, or deskilled, aspects of photography ran counter to John Szarkowski's attempt to insert photography into the history of modern art in a series of exhibitions at MoMA. The shift at the end of the 1970s, the growing necessity to pay attention to Szarkowski's conservative curating agenda—rather than simply ignore it as irrelevant, as had previously been the case—is largely related to commercial art world factors. Furthermore, MoMA is somewhat exceptional in relation to other equivalent

museums because of its founding commitment to collect photography. It maintained an active program of exhibitions of works of contemporary photographers, and Szarkowski, then director of the department of photography, had a well-elaborated—and deeply conservative—aesthetic position on photography (a point of view that was supported by his successor, Peter Galassi). Szarkowski, drawing on statements by the celebrated modernist landscape photographer Ansel Adams, Crimp points out,

> contrive[d] a fundamentally modernist position for it [photography], duplicating in nearly every respect theories of modernist autonomy articulated earlier in this century for painting. In so doing, they [Szarkowski and Adams] ignore the plurality of discourses in which photography has participated. Everything that has determined its multiple practice is set aside in favor of *photography itself.* Thus reorganized, photography is readied to be funneled through a new market, ultimately to be housed in the museum.[52]

Photography's discursive plurality, Crimp suggests, rests on reproducibility, that is, its ability to function within a variety of contexts, for example, the library, the newspaper, and the museum, and in relation to other disciplinary formations such as sociology, ethnography, and city planning. As we have seen from the analysis of *Remodelling Photo History* thus far, the issue of discursive plurality was also of central concern in the United Kingdom, and Spence and Dennett were particularly engaged with this question. But there is a significant difference of emphasis in their approach from Crimp's.[53] Earlier I described Dennett's historical research on the uses of photography in the 1930s by working-class organizations. This was a period that saw the proliferation of illustrated news and a particular awareness of the shifting, unstable potential for the interpretation of photographs depending on their context. The widespread use of the deadly parallel, where two photographs were placed side by side in order to draw out particular absences or politicized interpretations, relied on photography's very reproducibility, on its discursive plurality. In various forms Spence and Dennett also took up this idea of photography as a key part of the dissemination of information, as an alternative mode of political journalistic communication. Crimp, by contrast, is much more engaged with the use of photography as a political tool within the

context of the art world. Its discursive plurality is a means of disrupting the fiction of the institutional autonomy of *art*. *Remodelling Photo History* may begin with a reference to photography's earliest use by avant-garde artists in *Industrialization*, but the series soon expands to suggest photography's institutional use by ethnography, criminology, and advertising. In New York the ideological dominance of MoMA is, I contend, decisive. The museum, the gallery, and the art journal shape the milieu that Crimp is charting in his robust theorization of photography in the context of contemporary *art*. But there was no equivalent convergence of economic and institutional factors in the United Kingdom.[54] In this context the dominant institutional framing was not the museum or even the gallery—at least for Spence and Dennett—but rather the British Film Institute and its heterodox educational networks. Moreover, Crimp's account does not include the educative as does that of Spence and Dennett. Spence and Dennett were much more centrally concerned with the history of photography as a broadly understood cultural form, the legacy of social documentary, and the rhetoric of the photographic message over and above the theoretical implications of reproducibility and the photograph as Duchampian ready-made.

There is a further significant difference. Spence and Dennett were part of a broader cultural field in the United Kingdom that was concerned with the redefinition of the figure of the artist in relation to the critic. (We might also include in this context the conceptual art collective Art & Language, as well as Burgin, Kelly, and the film critics turned filmmakers Laura Mulvey and Peter Wollen.) In the United Kingdom, theoretical work was understood as a kind of *practice* that, in a typically post-'68 manner, displaced the head/hand, mental/manual opposition that shaped the institutional roles of critic and artist. The thinking activity of the critic was integrated into the making process of the artist. Although there was a similar turn to theory on the part of some of the artists associated with U.S. critical postmodernism, most notably Silvia Kolbowski, in this context the figure of the theoretical art critic remained intact. I would go on to say that art criticism in New York, particularly in relation to the journal *October* (named for the October Revolution of 1917), became a kind of avant-gardist practice. Artists from this era who critically engaged with photography, including Sherman, Prince, Kruger, Levine,

and Lawler, are just as frequently associated with the names of significant art critics such as Craig Owens, Douglas Crimp, Hal Foster, Rosalind Krauss, and Benjamin Buchloh.[55] The maintenance of this division of artistic labor is perhaps one of the most significant reasons for the hegemonic success of this particular narrative in shaping our ongoing understanding of the stakes in contemporary art.[56]

Thus when Spence and Dennett described *Remodelling Photo History* as "work on photographic theory," it was because they conceived it as both an intellectual and aesthetic project. Indeed, the breadth of their publishing record also attests to the fact that they saw intellectual work as an important dimension of Photography Workshop's output. In 1979 Photography Workshop published its first book of collected essays, *Photography/Politics: One*, but prior to this, writing had long been an important aspect of their practice.[57] For Burgin, theoretical writing was also significant. His first book as a photographic theorist rather than as a photographer, *Thinking Photography*, brought together a series of key texts from the 1920s to the 1970s in order to give shape to the field of "photographic theory."[58] While *Thinking Photography* could be taken simply as a collection of academic essays, *Photography/Politics: One* is much more heterodox. It offers analyses of advertising, worker photography of the 1930s, expressions of wartime nationalism in the popular illustrated newspaper *Picture Post*, and documentary photography of the 1930s and 1970s. In this sense its case study approach seems to provide a clearer insight into what it meant to think photography in Britain in the 1970s. All of the authors are British, with the notable exception of Allan Sekula. The inclusion of Sekula's essay "Dismantling Modernism, Reinventing Documentary"—which discusses the contemporary U.S. practices of Sekula himself, Martha Rosler, Phil Steinmetz, and Fred Lonidier—is of greater significance than as just another scholarly reference. Sekula's work as an intellectual and researcher on photography, his participation in political activism, and his photographic practice emerged within a milieu that included collaboration with other like-minded practitioners, notably Rosler, Steinmetz, and Lonidier. Sekula's essay, originally written in 1976, establishes many of the same arguments set out by Crimp four years later in the much more widely read essay "The Museum's Old/The Library's New Subject." Although Crimp's analysis places a par-

ticular focus on the Duchampian ready-made, together with Sekula he also emphasizes a critique of the application of modernist formalism to photography, invokes Walter Benjamin's important writing on photography, and draws out the institutional significance of photography's discursive plurality. Crimp was likely unaware of Sekula's earlier essay, but the fact that they share so many points of intersection indicates a broadly felt engagement with photography as a newly significant political form of practice. Unlike Crimp, Sekula connects this not to a Duchampian paradigm but to a politically understood pedagogical project that includes "a political economy, a sociology, and a nonformalist semiotics of mass media." For Sekula, as with Spence and Dennett, it is the "authoritarian monologues of school and mass media" that are the principal focus, not the museum or the commercial gallery structure.[59]

While this is not the place to fully elaborate the lines of connection to West Coast photographic practice, there are indeed much stronger parallels between the work of Sekula and Rosler in particular and Spence and Dennett than the more academically oriented Burgin.[60] By the same token, there were several points of overlap between Burgin, several of the *Screen* writers, such as Peter Wollen, Laura Mulvey, and Jacqueline Rose, and the New York–based art scene, but Spence and Dennett's orbit of activity has remained peripheral to this. One of the main reasons for this was the shared engagement with the political analysis of documentary photography—the desire to revive and re-invent it photographically and intellectually—as opposed to the idea of photography as the heir to the Duchampian ready-made.[61]

Psychoanalysis and Feminism

In my earlier analysis of *Industrialization* and *Colonization*, I suggest that there is a tension between the social and psychical approaches to reading the images. In *Revisualization* the invocation of psychoanalysis is staged within a social space that also suggests the theme of labor (Figure 4.4). Spence is shown in plain workman's clothes sitting on what seems to be a construction site, with concrete pipes in the background. Wearing joke eyeglasses and either laughing or screaming, she is reading a soft-cover copy of an installment in the Penguin edition of collected Freud works, *On Sexuality*. I say "she," but as with one half of the *Industrialization* pair, this is not exactly

obvious; the body is covered so effectively that the gender of the figure is left ambiguous.[62] Sexual difference, the principal subject of *On Sexuality*, is therefore not visually evident in this half of *Revisualization*. Moreover, Spence draws on the popular perception of Freud's writing as both salacious and absurd. The equation between castration and blindness that Freud develops in his reading of the Oedipus myth is here turned into a slapstick body joke: the reader's eyes are ready to pop right out of their sockets in response to the psychoanalytic text. And in an echo of the first significant twentieth-century encounter between psychoanalysis and art, the book cover imprinted with Freud's ghostly face looks like a surrealist object.[63]

The concrete nimbus surrounding the head of the Freud reader is echoed in its companion photograph as a soft halo of light. The reference to Christian iconography, the Madonna and child, coincides with a more contemporary use of lighting in advertising imagery in order to suggest heightened sentimentality. With this, Spence and Dennett evoke the most popular affect associated with the maternal in a careful manipulation of photographic technique. The now securely female figure is shown nursing an adult man at her breast, and her photographic reworking of the Madonna and child asks us to reflect on adult sexuality as it relates to both the maternal and infantile pleasures of nurture. The carefully staged visual codes for maternal sentimentality are shockingly undercut by the insertion of a middle-aged man (with thinning hair and graying beard) in place of the infant child. This is an image about the complexity of the breast as an object of desire. The shock produced by the juxtaposition stems from the conjunction of the acceptable and the taboo: infantile nurture overlaid with adult pleasure. The idea that the former serves as the basis for the latter is also part of the condensation that the image suggests. While *Revisualization* introduces psychoanalysis in the form of a feminist joke, this popular gesture is a means of leading viewers to a more serious issue in feminism. For example, in Freud's discussion of human sexuality, the mother figures as an important object of (lost) desire, but Spence's pair of images asks us to consider the mother as a desiring subject and maternal desire as an aspect of female sexuality.[64]

The more widely known feminist and psychoanalytic elaboration of this particular theme is Mary Kelly's installation *Post-Partum Document*. It in-

cludes no photographs and no iconic depictions of the female body, but there is one photograph that has since become closely associated with it; it appears on the frontispiece for the 1985 book version of the project. This photograph was first associated with *Post-Partum Document* in 1976 when it was incorporated into a poster designed by Kelly used to advertise a panel discussion about *Post-Partum Document* (Figure 4.17). As other commentators have noted, this image, showing Kelly and her young son (like Spence as mother), evokes the Madonna and child.[65] Moreover, like Spence and Dennett's *Revisualization*, this is also a psychoanalytic joke, but one that mobilizes a very different type of humor.

With her head bowed, her body arranged in a familiar pose of reverential supplication, Kelly seems to be playing the part of the modern Madonna, all humility and peaceful grace. But the use of a diagrammatic psychoanalytic framing undercuts the photograph's tender pathos. The image sits within a mock-up of one of Jacques Lacan's diagrams of the subject—the schema for the Real—and this clues the psychoanalytically engaged spectator to Kelly's staging of the image (Figure 4.18). The photograph is inserted into a graph of the subject—a conceptual map as opposed to an iconic representation. The category of the Real is part of a larger account of the separate orders of the psychoanalytic field given by Lacan, which also includes the Symbolic and the Imaginary. The Real is what cannot be represented through either an image or language, and Lacan argues that all sorts of representations are produced precisely to cover over this lack of representability.[66] In relation to Kelly's installation, this is a particularly interesting design choice: the only photographic image and the single iconic representation that she uses alongside *Post-Partum Document* is an emblem for the unrepresentable. Kelly is making a psychoanalytic joke that few people would have been capable of getting. The poster could speak directly to a closed avant-garde milieu—a "closeted cult" as Kelly described it—that existed in 1970s London, which Spence was aware of although not exactly part of.

In chapter 2, I presented a reading of Kelly's film-loop installation *Antepartum* (1973) alongside Laura Mulvey's manifesto-like essay "Visual Pleasure and Narrative Cinema" (1975) with the historical premise that both women belonged to the Lacan Women's Study Group. In my argument, each work—

FIGURE 4.17. Mary Kelly, photocopy of poster for panel discussion about *Post-Partum Document*, Institute of Contemporary Arts, 1976. Copyright Mary Kelly. Courtesy of Mary Kelly.

FIGURE 4.18. Jacques Lacan, diagram showing the schema for the Real.

one filmic, the other textual—offers an engagement with the female body, the uncanny maternal body, and suggests a gendered viewer. I propose Kelly's installation as positing the viewer as feminine and maternal, and Mulvey presents *her* as a fetishistic masculine subject. Mulvey introduces the idea of the male gaze, a concept that would have an enormous influence on feminist film theory for several decades to follow. It is now widely acknowledged that this concept, together with her emphasis on the objectification of women's

bodies in cinema, produced a widespread misreading in the discipline of film theory of Lacan's psychoanalytic concept of the gaze. The same year that Mulvey's essay appeared in *Screen* saw the first attempt at clarifying this slippage (and there have since been many more that directly address Mulvey's particular argument). In 1975 Jacqueline Rose, a feminist literary critic and psychoanalytic theorist, who was also part of the Lacan Women's Study Group with Mulvey and Kelly, was asked to give a presentation at the BFI on Lacan's idea of the Imaginary. Rose's presentation, later published as "The Imaginary," was in fact a response to Christian Metz's recent work (namely, his essay "The Imaginary Signifier") rather than to Mulvey's essay; nonetheless, it marks the first attempt to disengage the idea of the gaze (or "the look" as Rose translates it) from vision and from any notion of objectification.[67] The Lacanian gaze does not belong to the Imaginary—the aspect of psychical life that addresses the subject's relation to the world, to all forms of representation, and identification; rather, in the field of vision, the gaze denotes the unrepresentable, or, as Lacan put it, that which is beyond the subject: death, the unimaginable absolute negation of subjectivity altogether.

Burgin, who also attended Rose's 1975 BFI presentation, in a later essay develops a critical analysis of the confusion that arose following the publication of Mulvey's landmark text. He focused on the elision of social and psychical space that, he argues, has continued to define writing about photography in particular. Burgin traces this critical confusion back to the work of Roland Barthes who, he suggests, was the first figure to fuse Lacanian psychoanalysis with Louis Althusser's theory of ideology, an intersection that placed a particular emphasis on iconic representation. (Needless to say, Barthes was a particularly important figure in the evolution of photographic theory in Britain.) Burgin describes the shift in the following way: "Instead of a contingent set of ideas that might be dissipated by reason, 'ideology' was now conceived of in terms of a space of representations that a subject inhabits, a limitless space that the desiring subject negotiates by predominantly unconscious transactions."[68] When this notion of ideology is taken up in film theory, the spatializing model—one that Burgin claims is based on Euclidian geometry—is combined with the idea of the cinematic apparatus, and the viewer is the central point with his or her relation to the image as one of identification.

In 1975 another publication further consolidated this misreading of the Lacanian gaze. In Michel Foucault's *Discipline and Punish*, as Joan Copjec points out, vision is equated with knowledge and Foucault's articulation of power is understood as an internalization of a social space—the surveillance of the nineteenth-century panopticon prison turned inward as a form of self-surveillance—finding the Lacanian idea of the unconscious further elided. Glossing this Foucauldian-influenced misunderstanding of the gaze, Copjec says, "The imaginary relation is defined as literally a relation of *re*cognition. The subject reconceptualizes as its own concepts already constructed by the other."[69] With Foucault's hypothesis about the modern subject taking center stage, a Marxist understanding of ideology intersects with something like the psychoanalytic idea of narcissism to produce a very appealing and long-standing explanation of the political value of representation (hence the idea of the politics of representation). This particular convergence of political, psychical, and representational elements suggests a perfect theoretical elaboration of the post-'68 slogan "The personal is the political," making the appeal it might have for politically engaged feminist artists all the more clear. Sexuality and sexual difference are apparently incorporated into a model that seems also to satisfy materialist questions of class and ideology—except, as Copjec points out, the psychoanalytic aspect is not quite right. She goes on to explain, "Narcissism becomes in this account the structure that instruments the *harmonious* relation between self and social order . . . whereas in the psychoanalytic account the subject's narcissistic relation to the self is seen to *conflict with and disrupt* other social relations." In this Foucauldian version of narcissism, the self-policing, self-surveilling figure is "absolutely upright [and] completely correct." The unconscious, according to psychoanalysis, does not follow such normativizing patterns. Rather than the self-recognition that the idea of identification suggests, rather than the equation of visibility with knowledge seen with Foucault, the gaze in Lacan is "this point at which something appears to be *in*visible, this point at which something appears to be missing from representation, some meaning left unrevealed. . . . It marks the *absence* of a signified."[70]

Kelly's work of this period (together with Spence and Dennett's in *Re-modelling Photo History*) is related more to the idea of the Imaginary than the

(misunderstood) Lacanian gaze. Furthermore, the confusion that emerged in the wake of Mulvey's text might even have contributed to Kelly's decision to reject iconic representation in *Post-Partum Document.*[71] Addressing a broader history of psychoanalytic writing about art from the 1970s onward, Margaret Iversen describes a shift from the idea of the mirror to the interruptive blind spot of anamorphosis. The former relates to the Lacanian Imaginary and the latter to the Real. With a focus on the Imaginary, Iversen describes how an "austere cultural politics" emerged in the 1970s; a kind of iconophobia that saw text frequently introduced over the top of images in an attempt to interrupt spectatorial identification.[72] I find this historical gloss broadly compelling but not entirely satisfactory, since artistic responses to intellectual currents rarely follow such straight paths. Kelly's *Post-Partum Document* might seem to be the perfect example of this iconophobic turn, and Iversen's discussion of psychoanalytic currents provides a partial explanation. But the iconophobic tendency predates Kelly's engagement with psychoanalysis and is more of an indication of her formation as a postconceptual artist. Amelia Jones has explored this iconophobic turn in a different way. In the context of writing about the repression of 1960s and 1970s body art in the United States, she uses Kelly as the privileged counterexample. Jones argues that Kelly is exemplary of a feminist "turn away from the corporeal" and that Kelly is "particularly vehement about the absolute need to remove the *female* body from representation."[73] While Jones makes an important intervention in art historical scholarship, I suggest that her characterization of Kelly is also partial, perhaps necessarily so because of the polemical mode in which she writes.

Post-Partum Document is centrally concerned with figuring the body but through other modes of representation than the iconic. This is the dispersed body of the drives, not a coherent body like the imagined image of the mirror stage. Kelly offers an "analysis and *visualization*," as she puts it in the introductory notes for *Post-Partum Document,* of the mother–child relationship, through a sense of tactile proximity: the (intensely corporeal) soiled diaper liner, the evocation of the aural body in an infant's first broken phrases, the scribbled mark, and the found object from nature.[74] The latter exist as emblematic fragments of a child's curiosity about the natural world made all the more

significant because the discovery of these objects coincided with his questions about the sexual difference of his and his mother's body. Corporeality is in no sense missing from *Post-Partum Document*; rather, Kelly finds other ways of representing bodily experience than the iconic. Rather than the Euclidian geometry, as Burgin puts it, of the cinematic apparatus, Kelly's installation offers a semiotic play of substitutions and metonymic relations of tactile corporeal proximity.

A photographic series such as *Remodelling Photo History* is, however, bound by a Euclidian spatial logic and inevitably invokes pictorial iconicity. Moreover, the final pair of images in the sequence directly addresses the interconnected ideas of femininity, looking, photography, voyeurism, and the semiotic (Figure 4.19). Spence and Dennett's series, when compared to both Burgin's and Kelly's work of this period, is perhaps shaped most by the desire to put psychoanalysis to work as a form of social critique. In the final pair of images Spence and Dennett do not use the single-word caption format but rather introduce a different kind of textuality. Although the textual elements are not reproduced here, one image is typically accompanied by a poem by Brecht, "Questions from a Worker Who Reads." The other is shown between parentheses, as if it is an afterthought comment on the series as a whole (and is a further indication of the semiotic structure of this work).[75] Both images show Spence in the bathtub. In one she faces the camera, and with the use of a fish-eye lens this view emphasizes the voyeuristic gaze of the photographer. But while we are spying on a woman in the bathtub whose face is obscured by an enlarged pair of binoculars, she also catches us out by being photographed looking back at the photographer and at us, the viewer/reader. This exaggerated depiction of looking is combined with a poem, "Questions from a Worker Who Reads," describing the hidden labor that went into the construction of history's great monuments: Thebes, Babylon, the Great Wall of China, and Rome's Triumphal Arches; not just the masons and soldiers, but the cooks too. This is a poem about class consciousness, about history understood through a materialist lens that is then combined with the voyeuristic observation of the female figure. The juxtaposition of text and images initially appears to be straightforward: class consciousness and feminist consciousness follow parallel tracks. But do they really align? The idea of

feminist consciousness is related to the power of looking with the looked-at woman shown looking back. At the same time, the visual equation between the comically exaggerated binoculars and the woman's large breasts suggests that her breasts can be seen as equivalent to eyes. Here I am referring to what Assia Djebar has described as "the other eyes of the body (breasts, sex, navel)," in her remarkable 1979 essay "Forbidden Gaze, Severed Sound."[76] In an analysis of Eugene Delacroix's painting *Women of Algiers* (1834) understood through the repressed position of contemporary Algerian women in the postindependent state, Djebar offers a psychoanalytically informed reading of the psychical and political power of the exposed female breast and of feminine sexuality. Djebar's feminist intervention is echoed in Spence and Dennett's photograph. Breasts and eyes—the "other eyes of the body"—have already been equated in *Remodelling Photo History*. In one half of *Colonization*, Spence adopts a powerful stance with her shoulders back, emphasizing her large breasts, thrust forward and exactly level with the camera lens (and by implication, the viewer's gaze). As with the Brecht image, Spence's eyes are obscured, not by binoculars but by another device for looking, eyeglasses with darkened lenses. Rather than a passive recipient of the viewer's surveilling gaze, here Spence's full, projecting breasts suggest feminine power. The oscillation between looking and looked at is developed even further in the final pair of the series. The tubular cones of the binocular lenses held up to and obscuring the nude Spence's eyes are in proportional relation to the tumescent roundness of her breasts, directed toward, *looking back at,* the viewer.

In contrast, the final, parenthetical image in the series stages the negation of vision. Here the woman has turned her back on the camera and is shown facedown in the bathtub. Her refusal to look back is reinforced by the placement of a pair of spectacles on the side of the bath, angled toward the viewer. Although the facedown position in the water might suggest a drowned figure, the body looks as if it is held in a pose of rigid tension, a position that could not be sustained for long. This seems to suggest the necessity of looking, the importance of the iconic image, and another way of conceiving of the complexities of feminine sexuality.

Spence and Dennett's overall approach to these constructed images invites a kind of analysis that draws on a comparable mode of semiotic substitution

FIGURE 4.19. Detail showing only the photographic element in Jo Spence and Terry Dennett, *Brecht Poem,* from *Remodelling Photo History,* 1979–82 (gelatin silver print); and Jo Spence and Terry Dennett, *Staged Attempted Suicide,* from *Remodelling Photo History,* 1979–82 (gelatin silver print). Copyright Terry Dennett / Jo Spence Memorial Archive. Courtesy of Terry Dennett / Jo Spence Memorial Archive.

and displacement used by Kelly. Meaning is made not simply through the model of the sign with an emphasis on what is present, but rather through a *chain of signifiers* that is built on absence and displacement. The strange condensations performed in this series resemble the operations of the dream work that Lyotard describes as a kind of disfiguration of the textual sign as it becomes an image.[77] In *Revisualization* (surely not a coincident echo of Kelly's reference to the "analysis and *visualization*" of the mother and child relationship in the introduction to *Post-Partum Document*), we are caught in such a chain of signification. The adult male kissing (or suckling) his lover's breast is an immediately recognizable substitution for the mother and child, and our reading of the image rests on an awareness of this absent signified. In *Colonization* the use of ethnographic codes mean that the white woman's breasts reference the (absent) black woman from another context. It is through this absent sign—the ethnographically presented black breast—that we arrive at the idea of pornography as a further displaced reference in this signifying chain. The relationship between the formal structure of the work and the way in which meaning is constructed is centrally important. The works are not montages but are spatially coherent in a way that evokes the Euclidian social space described by Burgin. Within this coherent social space, Spence and Dennett operate internal fissures and displacements in the play between the deadly parallel pairing and the textual caption. This semiotic play is put into tension with the coherence of the photograph's Euclidian space; instead, it belongs to a different kind of logic, one that suggests psychic space. As Burgin has put it, "Attention to psychic reality calls for a *psychic realism—* impossible, but nevertheless . . ."[78]

X Marks the Spot: From the Imaginary to the Real

The Barthes writing that had the greatest impact on the photographic milieu addressed in this chapter was his work prior to the most celebrated book on photography, *Camera Lucida*.[79] This seemingly modest and overtly autobiographical text changed the game altogether with regard to theories of photography.[80] Margaret Iversen offers a particularly compelling discussion of Barthes's relationship to Lacan, and *Camera Lucida*, she argues, is psychoanalytic to the core. According to Iversen, Barthes's emphasis on death and

mourning was decisive for the shift that took place in psychoanalytic writing about art, from a focus on the metaphor of the mirror to that of the stain. Or, in Lacanian terminology, this is a shift from an emphasis on the Imaginary to that of the Real. Jo Spence's work after *Remodelling Photo History* is, I suggest, marked by a similar shift, but it was not provoked by a new theoretical engagement. Rather, like Barthes facing his own mortality through the loss of his mother, in 1982 Spence was diagnosed with breast cancer. This bodily crisis provoked a transformation in her practice as she began to document her encounter with the medical profession and narrate these images through the help of therapeutic techniques. Her illness led to an involvement in phototherapy as a patient, collaborator (with Rosy Martin), and autodidactic practitioner. Plunged into a period of depression as a result of this life-threatening illness, Spence sought therapeutic help—not in the small community of psychoanalytic practitioners in London but in alternative feminist therapy. *Remodelling Photo History* had been shaped by Spence's engagement with psychoanalytic feminism, but in this new phase she moves away from an explicit identification with this theoretical approach. This might seem to contradict the parallel to Barthes suggested above, and indeed it does, if we privilege artistic intentionality. But if we read Spence's work against the grain of her intentionality, Iversen's shift to the metaphor of the stain, to the Lacanian Real, remains convincing. Furthermore, the paradox that I have suggested— between Spence's account and this art historical reading—is itself significant.

A parallel of sorts can be found in a debate about the political value of different psychological models that was taking place in feminism at the time. A visible line of division between socialist feminism and psychoanalytic feminism had emerged by the early 1980s and can be charted in a series of articles in *Feminist Review*.[81] This is around the time that Spence and Dennett were completing *Remodelling Photo History* and Spence received her cancer diagnosis. Socialist feminists rejected psychoanalysis because of the perceived sexism of the psychoanalytic establishment, because of the belief that the relationship of analyst and analysand was a depoliticizing experience for women, and because it was considered ahistorical. The challenge came from the very type of feminist therapy—based on cocounseling approaches—that Spence herself had just turned to. In an important response to these issues, and in a

defense of the feminist value of psychoanalysis, Jacqueline Rose argues that something essential is overlooked: the unconscious. This point is later reiterated by Copjec's critique of Foucauldian-inflected accounts of "the gaze." Likewise, in my reading of Spence's health work, the unconscious is working against the grain of the artist's own account.

In Barthes's *Camera Lucida*, the "underlying theme," Iversen convincingly argues, "is taken from Lacan's account of the encounter with the real, which is ultimately an encounter with the persistently denied fact of one's own mortality."[82] This speaks directly to an incident described by Spence that occurred when she was first admitted to the hospital after being diagnosed with breast cancer. It serves as the origin—the critical, traumatic origin—of this new turn in her practice. She later describes the scene thus:

> Dutifully, so as not to waste time, I took with me [into the hospital] several books on theories of representation, a thin volume on health and a historical novel. One morning, whilst reading, I was confronted by the awesome reality of a young white-coated doctor, with student retinue, standing at my bedside. As he referred to his notes, without introduction, he bent over and began to ink a cross onto the area of flesh above my left breast.[83]

The inked mark, Spence soon learned, was a sign for the surgical removal of the breast, and this was the first she had heard of the doctor's intent. The larger significance of this incident can be seen in the analysis of Spence's autobiographical text. Interrupted in her reading, she is faced with another reading figure: a doctor who reads his notes about her body and marks her up to be cut. Filled with rage, Spence recounts how she refused the surgeon's intent: "I heard myself answer, 'No.' Incredulously; rebelliously; suddenly; angrily; attackingly; pathetically; alone; in total ignorance."[84] The surgery went ahead without the intended mastectomy, but the casual indifference of this encounter with the medical profession became the subject of a new series of photographs. This marked a change in the direction of all her subsequent work with a return to documentary photography, a self-documenting practice that is combined with staged images.

The quote above was first published in 1983 and then reprinted in Spence's *Putting Myself in the Picture*, along with a further written elaboration on the

subject of health that also included a series of photographs, both staged images and traditional documentary shots. The staged photographs show Spence in numerous different guises with inked Xs marking her chest. In another she has replaced the X with a written text that says "property of Jo Spence?" (Figure 4.20). These images, and the many staged photographs that followed, circle around this traumatic encounter; they repeat it, compulsively, obsessively, in an effort to regain control, to overcome the trauma. Spence's repetition of this event is like Freud's nephew with his cotton reel who throws it away from himself while saying *fort* (gone) and pulls it back toward him declaring *da* (here), all in an effort to master the trauma of his mother's leaving him. Lacan later describes the cotton reel as the *objet petit a*, the little "other" detached from the self that is an equivalent to the gaze in the field of vision. Barthes connects this childish game to photography, which he understands as "the absolute particular, sovereign Contingent, *matte* and somehow stupid, the This . . . in short, what Lacan calls *Tuché*, the Occasion, the Encounter, the Real, in its indefatigable expression."[85] And the mechanical reproduction of the photograph, the click of the shutter, is itself like the action of the child's talismanic object, compulsively repeated over and over again.

In *Putting Myself in the Picture* Spence arranges a sequence of documentary images in the form of a short photo-essay that provides an indirect reflection on the initial traumatic encounter. These images reveal the psychical theme of the real that is the traumatic core of all her later work. From her hospital bed, Spence photographs the consultant doing his rounds (Plate 9). Not visible in the frame, he is surrounded by a group of white-coated student doctors, all seemingly male. The shot is taken from a low point of view and we are clearly aware that the photographer is located in the neighboring bed. In the foreground are objects blurred out of focus; this visual device reinforces the effect of the surreptitious view, as if the photographer does not want to be caught looking. The childlike position of sneaking a look is echoed in the descriptive text—"When he gets to my bedside I immediately stop taking photographs"—and the next image shows only an empty bed. This is not the same scene as the initial trauma (with her camera on the ready she is an alert observer, not caught up in reading a book); instead, it is a repetition that contains enough elements of the original story to clearly evoke the events

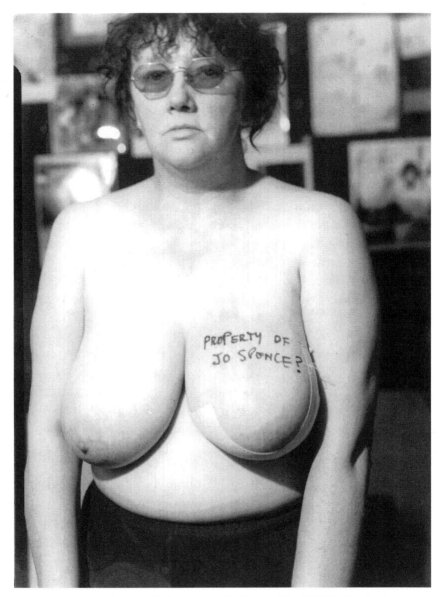

FIGURE 4.20. Jo Spence, *Property of Jo Spence* from *The Picture of Health?* 1982. Gelatin silver print. Copyright Terry Dennett / Jo Spence Memorial Archive. Courtesy of Terry Dennett / Jo Spence Memorial Archive.

described. Her obedience in the face of the doctor (as opposed to the "No" of the earlier written encounter) leads to her absence from the field of vision. The next image shows rumpled sheets and an indented pillow that refers to the body that is no longer there. Indexically suggested, like the indexicality of the photograph, death appears both in the traumatic temporal structure of the "that-has-been" and in the absent body.[86] Looking at a photograph, any photograph, "I witness something in the past by 'deferred action.'"[87] Something that is now dead. This loss is also thematized in the picture in which Spence does not appear, and in her place is another sign of negation, silence, and erasure: "Nil by Mouth." This documentary photograph is later restaged in an image that further emphasizes this experience of proximity to death (Figure 4.21). In using photography to try to master the trauma of the doctor's marking of the body, Spence must repeat the trauma over and over again.

If we refer back to the first written account, the doctor does not even *see* Spence; she does not exist as a subject but only as an object of his surgical intervention. The source of the trauma resides in the fact that Spence only exists for him through the papers that he reads. Looking at his notes, not at her, he annotates her body with an X, as if she were but a sheet of paper. This scene evokes an encounter with the real, I am arguing, not because she could die from her illness—although this fear is of course part of it—but because she is confronted by her own subjective annihilation. Spence then goes on: "I realized with horror that my body was not made of photographic paper, nor was it an image, or an idea, or a psychic structure. . . . It was made of blood, bones and tissue. Some of them now appeared to be cancerous. And I didn't even know where my liver was located."[88] The horror, of course, is that her body was indeed being seen as a piece of paper; it was quite literally being written on by a doctor who, in that moment of professional indifference, failed to see Spence as a subject. In an attempt to overcome this, she decides to take up the camera; she turns to representation in order to cover over this mortifying experience. *Fort, da, fort, da,* like Freud's nephew with his cotton reel, the shutter clicks again and again as Spence is compelled to repeat her trauma again and again (Plates 10 and 11).

Spence first published the essay "Confronting Cancer" in 1983, around the time of the publication of the series of essays in the journal *Feminist Review*

FIGURE 4.21. Jo Spence and David Roberts, *Write or Be Written Off,* 1988. Gelatin silver print. Copyright Terry Dennett / Jo Spence Memorial Archive. Courtesy of Terry Dennett / Jo Spence Memorial Archive.

illuminating the conflict between psychoanalytic feminism and socialist feminism. As Rose describes, in a superb defense of the political significance of psychoanalysis, the "challenge to psychoanalysis by feminists has come from alternative forms of therapy (feminist therapy and co-counselling)."[89] This is the very work that Spence was becoming affiliated with. While Spence's engagement with phototherapy can be understood in counterpart to the insights offered by psychoanalysis, and even as a rejection of the psychoanalytic aspects of *Remodelling Photo History*, in reading her oeuvre we can see something else at work. Paradoxically, her attempt to gain control over the trauma of the Real is at the same time the very place that the true understanding of the Lacanian gaze makes its appearance—not in the psychoanalytic reflections presented in *Remodelling Photo History* but just as Spence decides to turn away from psychoanalysis altogether.

Acknowledgments

This book evolved from my doctoral thesis, completed at Columbia University in 2005. I owe a debt of thanks to my advisers Benjamin H. D. Buchloh and Christina Kiaer, as well as to Rosalyn Deutsche, Marianne Hirsch, and Anne Wagner for their suggestions for future revision. I am deeply grateful to various artists and intellectuals who play a part in this book's narrative for offering their time and thoughts in person, via e-mail, and on the telephone: David Curtis, Terry Dennett, Mary Kelly, Griselda Pollock, Genesis Breyer P-Orridge, Esther Ronay, Sheila Rowbotham, and Humphry Trevelyan. The long road from dissertation to book involved extensive new archival research. This was supported by three PSC-CUNY research fellowships from the City University of New York. I received invaluable help from three graduate research assistants, Leila Harris, Betsy Hawley, and Meredith Mowder, at the Graduate Center of the City University of New York. The graduate students in my seminars Photography and Performance (2012) and Contemporary Photography (2011 and 2013) offered a lively intellectual forum for testing the book's ideas, particularly with regard to chapters 3 and 4.

Zahid Chaudhary, Devin Fore, Natasha Lee, Vered Maimon, Ivone Marguiles, and Sarah Whiting read chapters of the book and offered invaluable criticism, encouragement, and thoughtful insight. I am grateful to an anonymous reviewer whose challenging response helped me to reframe the Introduction and see the intersection of Marxism and feminism in 1970s Britain from another perspective. Jennifer Doyle's reader's report was particularly significant; her generous encouragement and many invaluable points of incisive critique allowed me to reach beyond my disciplinary strictures.

I could not have had a better editor in Richard Morrison. All this said, any remaining inadequacies are my own; these numerous readers did what they could.

Friends old and new provided necessary and excellent distraction, as well as emotional and practical support: Melaina Barnes, Zahid Chaudhary, Effie Delphinius, Nish Gera, Kate Isard, Kris Junker, Bill Kaizen, Vered Maimon, Meredith Martin, Soizick Porte, and Mickela Sonola-Jones. Lucinda Barnes and Roli Ross kindly lent me their flat in London at crucial final stages of research in the summer of 2012. My parents, David and Grace Wilson, offered continued support and humor. Finally, Ben Conisbee Baer read everything—from dissertation to book—many times over. He believed in the project (and its search for the "structures of feeling") even at times when I no longer did; his insights are woven throughout.

Notes

Introduction

1. Pollock, "Screening the Seventies," 227.

2. Cited in Walker, *Left Shift*, 1. For other critical art historical accounts of the period, see Pollock and Parker, *Framing Feminism*; Mulholland, *The Cultural Devolution*. Also see Battista, *Renegotiating the Body*.

3. Irigaray, *An Ethics of Sexual Difference*, 7.

4. Since I began writing this book there has been a resurgence of interest among contemporary artists with certain political practices from the 1970s. One fascinating project by the Swedish artist Petra Bauer took the Berwick Street Film Collective as a particular point of focus and identification. Bauer's residency at the Focal Point Gallery in South-End-on-Sea culminated in the exhibition *Me, You, Us, Them* (March 27 through May 8, 2010) that included a series of performance events and public talks. The archival aspects of Bauer's ambitious undertaking have been collected in a beautifully produced, limited-edition volume; see Bauer and Kidner, *Working Together*. Catherine Grant has offered an interesting analysis of several other contemporary projects including Mary Kelly's *Love Songs* (2005–7) and Emma Hedditch's collaboration with Laura Mulvey, *Visual Pleasure and Narrative Cinema* (2007)—a filmic reflection on Mulvey's classic essay of the same title; see Grant, "Fans of Feminism."

5. Kristeva, *Revolt, She Said*, 12.

6. Two good examples are McDonough, *"The Beautiful Language of My Century"*; and Ross, *Fast Cars, Clean Bodies*. For a different view see Mary Kelly, "On Fidelity." I address the question of melancholia for the 1960s in a different register in relation to works by Coco Fusco, Thomas Hirschhorn, Martha Rosler, and Sharon Hayes; see S. Wilson, "'Girls Say Yes to Boys Who Say No.'"

7. Beckett, *When the Lights Went Out*, 209.

8. The classic book on the gay liberation movement in London is Walter's *Come Together*. For an account of the movement in a broader historical context, see Weeks, *Coming Out*. For a recent historical account of the movement's relation to women's liberation, see Beckett, *When the Lights Went Out*, 210–25.

9. Mitchell, *Women: The Longest Revolution*, 17.

10. Ibid., 17–18.

11. The idea of the liberation of women following the class revolution is a common theme in the history of the left—going back as far as the French Revolution—but it is not clear to me this was indeed Fanon's position. I cannot speak, however, to the appropriation of Fanon by the British Left in the 1960s that may indeed have given his work an inadvertent sexist spin.

12. There is a vast literature on this question; the key references related to the British context are Rowbotham, *Women, Resistance, and Revolution*; Barrett, *Women's Oppression Today*; and Mitchell, *Psychoanalysis and Feminism*.

13. Coote and Campbell, *Sweet Freedom*, 23.

14. On the Institute of Race Relations (IRR), see Mullard, *Black Britain* and *Race, Power, and Resistance*; and Sivanandan, "Race and Resistance." With Hall's directorship of the Birmingham School of Cultural Studies, the academic heart of the New Left, racial issues became much more central. See Hall, *Policing the Crisis*; and Centre for Contemporary Cultural Studies, *The Empire Strikes Back*.

15. Fusco, *Young, British, and Black*; Spivak, "In Praise of Sammy and Rosie Get Laid"; Naficy, *An Accented Cinema*; and Eshun and Sagar, *The Ghosts of Songs*. Also see Malik, "Conceptualising 'Black' British Art." The first major "post colonial" exhibition was in 1989 with an extensive catalogue; see Araeen, *The Other Story*; also see Sulter, *Passion*.

16. Mitchell, "Introduction, 1999," xxii. The earliest challenges to this marginalization of questions of empire and postcoloniality within the context of feminism are Spivak, "French Feminism in an International Frame"; Mohanty, "Under Western Eyes"; and Spivak, "Three Women's Texts and a Critique of Imperialism."

17. The historical labor activist landmark of the 1970s that brought the issue of Britain's postcolonial workforce to the fore is the Grunwick strike of 1976–78. Led by an Asian woman worker, Jayaben Desai, the Grunwick strike took some time to gain any significant press coverage. After a year, the strike finally received public attention when a group of miners (together with a young Arthur Scargill) joined the Grunwick workers. Ultimately the strike failed, and an Anglo-Indian businessman, George Ward, was heralded as part of the vanguard of "hard line" that came to define Tory policy toward the unions in the next decade. For a discussion of the

Grunwick strike, see Beckett, *When the Lights Went Out*, 258–403. Also see A. Wilson, *Finding a Voice*; and Sivanandan, *From Resistance to Rebellion*.

18. L. Mark, *WACK!* The recent emphasis on women artists in a series of exhibitions and events at the Museum of Modern Art was precipitated by a substantial donation from Sarah Peter known as the Modern Women Fund (see Butler and Schwartz, *Modern Women*, 10). While the terms of the patronage seem to have been for the support of female-only exhibitions, this does not account for *WACK!*, which came to MoMA as a traveling exhibition that originated at the Museum of Contemporary Art, Los Angeles. For a further elaboration of Butler's curatorial decision for the *WACK!* exhibition, see the introductory text to the exhibition, C. Butler, "Art and Feminism." A critical defense of the woman-only approach can be found in the same volume; see Pollock, "The Missing Future." Also see Burton, "Fundamental to the Image"; and S. Wilson, "Destinations for Feminist Art." For a theoretical elaboration of the problematic subject of women within the discipline of women's studies, see Brown, "The Impossibility of Women's Studies." Other comparable all-women survey exhibitions are *Konstfeminism* at the Göteborg Museum of Art, Göteborg, Sweden, 2007; *Global Feminisms* at the Brooklyn Museum of Art, New York, 2007; *Elles* at the Centre Georges Pompidou, Paris, 2009; and *Rebelle: Art and Feminism*, at Museum voor Moderne Kunst Arnhem, 2009.

19. With regard to Cosey Fanni Tutti's work, this strategy was first established in the 2001 Phaidon book, Reckitt, *Art and Feminism*.

20. In relation to the 1960s, "the death of the author" is usually understood through its corollary, "the birth of the reader," and in relation to modes of participation in the visual arts. On this issue, see Bishop, *Artificial Hells*; Auther and Lerner, *West of Center*; and Stimson and Sholette, *Collectivism after Modernism*.

21. Baxendall, "Introduction," xxvi.

22. Mitchell, *Psychoanalysis and Feminism*, 137–226.

23. Also note the echo of one of the earliest U.S. feminist texts; see Millett, *Sexual Politics*.

24. The squatter's movement was an important aspect of post-'68 grassroots politics in Britain. While several of the artists I discuss lived in squats during this time, including Kelly, it is outside of the scope of this study to address this social architectural phenomenon. For an account of one of the largest squats in central London and its demise, see Wates, *The Battle for Tolmers Square*. For a visual record, see Perry, *The Writing on the Wall*. Proll recently turned her reflections on this period into an exhibition on radical art and the counterculture in London during the 1970s (Neue Gesellschaft für Bildende Kunst, Berlin, June 26 through August 15, 2010).

This exhibition, titled *Goodbye to London,* included several works that are discussed at length in my book, namely, the Berwick Street Film Collective's *Nighcleaners,* the Hackney Flashers' *Women and Work* (1975), and Jo Spence and Terry Dennett's *Remodelling Photo History.* There is also an exploration, by Jon Savage, of the political aspects of the British punk scene. See Proll, *Goodbye to London.*

25. Proll, "Hello London," 9.

26. Coote and Campbell, *Sweet Freedom,* 19. Also see Koedt, *The Myth of the Vaginal Orgasm.*

27. It was in fact controversial in the early 1970s to take Freudian ideas seriously, especially after the reception of U.S. feminist writing on the topic. All of the key early feminist texts from the United States characterize Freud's work as strongly antiwoman. Cf. Friedan, *The Feminine Mystique*; Figes, *Patriarchal Attitudes*; Millet, *Sexual Politics*; and Firestone, *Dialectics of Sex.* This pattern is also followed in the first book on feminism published in Britain; see Greer, *The Female Eunuch.* For a critical reaction to all of these authors' work from a feminist and psychoanalytic perspective, see Mitchell, *Psychoanalysis and Feminism,* 295–363.

28. For a good recent summary of the parallel anglophone and French intellectual traditions, see Sanford, "Sex: A Transdisciplinary Concept." Also see J. Butler, *Undoing Gender*; and Chanter, *Ethics of Eros.* The most elaborated English-language engagement with *sex* is J. Butler, *Bodies That Matter.* On the French understanding of gender, see Derrida, *Geneses, Genealogies, Genres, and Genius.* On the anglophone understanding, see J. Butler, *Gender Trouble.* For an excellent transgender engagement with these issues focused on female to male, see Salamon, *Assuming a Body.*

29. Sanford, "Sex: A Transdisciplinary Concept," 26.

30. The fact that there is no entry for "sexual difference" in the most comprehensive dictionary of Freudian concepts is evidence enough of its absence from Freudian discourse; see Laplanche, *The Language of Psycho-analysis.* The earliest feminist mappings of this term are Abel, *Writing and Sexual Difference*; Eisenstein and Jardine, *The Future of Difference*; and Brennan, *Between Feminism and Psychoanalysis.* Also see E. Wright, *Feminism and Psychoanalysis,* 402–5.

31. As Kelly points out, the History Group, part of the London Women's Liberation Workshop (the overarching nonhierarchical structure for individual geographically defined activist groups) was the only workshop that was not named after its location. She explains the thinking behind this in the following way: "We called it the History Group because we wanted to make sexuality pass into the grand narratives of social change." Carson, "Excavating *Post-Partum Document,*" 190.

32. Mulvey, "Visual Pleasure and Narrative Cinema." An earlier popular account of the gendered nature of looking is John Berger's *Ways of Seeing.* It was also pro-

duced as a BBC television series in 1972, and this must have influenced Mulvey's feminist text. See Berger, *Ways of Seeing*.

33. See Merck, "Mulvey's Manifesto"; and Mulvey, "Afterthoughts on Visual Pleasure and Narrative Cinema."

34. On Mulvey and Wollen's *Riddles of the Sphinx*, see Kaplan, "Avant-Garde Feminist Cinema"; Suter, Flitterman, and Mulvey, "Textual Riddles"; Silverman, *The Acoustic Mirror*, 129–40; Greeley, "Riddles of the Sphinx"; Pollock, "The Pathos of the Political"; and Esche, "What Does It Mean to Say That Feminism Is Back?"

35. Harris, *The New Art History*. For a good art historical explication of the intellectual currents that defined the 1970s, with a particular focus on the journal *Screen*, see Pollock, "Screening the Seventies."

36. J. Butler, *Undoing Gender*, 186.

37. This is also the same year as the first popular feminist book in Britain, Greer, *The Female Eunuch*. By 1971 it was an international best seller, and Greer was a media celebrity.

38. Spivak, *Death of a Discipline*, 32.

39. Now widely deployed in the context of contemporary art, this term was first used in relation to photography in Buchloh, "Conceptual Art 1962–1969."

40. This term first appears in Wall, "'Marks of Indifference,'" 248.

1. Nightcleaners

1. For a discussion of the American protest, see Echols, *Daring to Be Bad*. In a recent interview, Mulvey has reflected on the British protest; see Pollock and Mulvey, "Laura Mulvey in Conversation with Griselda Pollock."

2. "Why Miss World?" was first published as an anonymous pamphlet in *Seven Days*. The essay has since been reprinted in the catalogue for the 1997 exhibition *Social Process / Collaborative Practices*. See Kelly, "Miss World."

3. For an account of this protest together with the gay liberation front's *Gay Street Theatre*, see Seven Days, "Miss World One Year On." The latter staged a mock Miss World contest featuring two men in drag playing the parts of Miss Laid and Miss Used. Miss Used received the winning prize of a large phallus. For a retrospective account of the events that took place at the previous year's Miss World in 1970, see Seven Days, "Why Miss World?"

4. Kelly has recently used this newspaper photograph as the source image for another work, a series of large-scale photo light boxes, *Flashing Nipple Remix* (2005). (Also see her performance of the same title in the 2007 Documenta.) For two excellent critical accounts of Kelly's work, see Deutsche, "Not-Forgetting"; and Grant, "Fans of Feminism." None of the published accounts, including Kelly's own statements,

reference the original protest as a staged performance by the Women's Liberation Street Theatre Group. I am grateful to Margaret Harrison for telling me about the origin of this performance and to Alison Fell for her firsthand account of it.

5. For the best account of the organizational structure of the London Women's Liberation Workshops, see Setch, "The Women's Liberation Movement in Britain."

6. For an excellent overview of left documentary film in 1970s Britain, see Dickinson, *Rogue Reels*; and Winston, *Claiming the Real.*

7. My understanding of the particular issues that some feminist audiences had with the film is drawn principally from two unpublished sources: Humphry Trevelyan in a telephone interview described the reception history at length (November 6, 2003), and Sally Alexander reiterated many of the same issues at the "Work and the Image" conference in Leeds, 1997. Also see Karlin et al., "Problems of Independent Cinema" and "Making Images Explode."

8. Johnston and Willemen, "Brecht in Britain."

9. Cowie, *Recording Reality*, 8. Drawing on psychoanalysis, Cowie is complicating this long-held view of documentary film as uninvolved with psychical issues.

10. For a more elaborated situationist critique of Godard's films prior to the formation of Groupe Dziga Vertov, and for the original published instance of the insult against Godard's Maoist politics, see Vienet, "The Situationists and New Forms of Action," 185. Peter Wollen, who was a great supporter of Godard's work, later went on to organize an important retrospective exhibition of the Situationist International; see Sussman, Wollen, and Francis, *On the Passage of a Few People through a Rather Brief Moment in Time.* This is evidence enough that the Situationists and Godard were not seen as politically irreconcilable for many in Britain. In contrast, however, the negative, polemical response to this exhibition from T. J. Clark and Donald Nicholson-Smith, both of whom had been closely associated with Debord's circle in the 1960s, indicates that such divisions remain important in more orthodox situationist quarters. See Clark and Nicholson-Smith, "Why Art Can't Kill the Situationist International."

11. The marginalization of their practice was exacerbated by Guy Debord's decision to withdraw all of his films from distribution in the late 1970s, relegating his status as a filmmaker to the domain of cultural obscurantism. This contributed to a later fetishization of his work, particularly in the United States. See Debord, *Comments on the Society of the Spectacle*; Blazwick, *An Endless Adventure*; Wark, *50 Years of Recuperation of the Situationist International*; and McDonough, *The Beautiful Language of My Century.*

12. On the use of the proper name Dziga Vertov, see Cannon, "Godard, the Groupe Dziga Vertov," 74. In response to Godard's use of Vertov's name and as

a means of marking their own documentary aesthetic, the film collective SLON (Société pour le lancement des oeuvres nouvelles)—which included Chris Marker—changed its name to Groupe Medvedkin, a homage to Alexander Medvedkin. On SLON (and Groupe Medvedkin), see Lee, "Red Skies"; Alter, *Chris Marker*; and Lupton, *Chris Marker.*

13. W. Benjamin, "The Author as Producer," 777. For a contextual discussion of Benjamin's essay, see Gough, "Paris, Capital of the Soviet Avant-Garde."

14. References to the work of Brecht appear in Godard's films, most notably in *La chinoise* (1967). In this film Brecht is the only leftist figure who is not criticized by the Maoist youth. Also, Godard claims to have used Brecht's *The Rise and Fall of the City of Mahogany* as the basis for *Tout va bien*. See Lellis, *Bertolt Brecht, Cahiers du Cinéma and Contemporary Film Theory*; Groupe Lou Sin, "Les luttes de classe en France"; Walsh, "Political Formation in the Cinema of Jean-Marie Straub"; Roud, *Straub*; and Walsh, *The Brechtian Aspect of Radical Cinema.*

15. Other members of Groupe Dziga Vertov included Paul Bourron, Armand Marco, Gérard Martin, Claude Nedjan, Isabelle Pons, Jean-Henri Roger, Raphaël Sorin, and Anne Wiazemsky. For an extended discussion of Groupe Dziga Vertov, the nature of the collaboration, and the reasons for its termination, see MacCabe, *Godard: A Portrait*, 216–38.

16. Wollen, "Counter-cinema: *Vent d'est*," 16.

17. Ivone Margulies, in her definitive study of Chantal Akerman's filmmaking, uses the term *hyperrealism* to describe Akerman's use of duration. See Margulies, *Nothing Happens.*

18. In a telephone interview with the author, November 6, 2003. On the use of voice-over in the documentary tradition, see Nichols, *Representing Reality.*

19. MacCabe, *Godard: Images, Sounds, Politics.*

20. Ibid., 59.

21. Cannon, "Godard, the Groupe Dziga Vertov," 80, 79.

22. Dawson, "Letter to Jane," n.p.

23. Perhaps the most interesting counterpoint to the misogyny of the film is a queer reading of Jane Fonda's career as an actress (and activist); see Wlodarz, "Love Letter to Jane." For another interesting account of the relationship between Jane Fonda the activist and the characters played by the actor, see Anderson, "Treacherous Pin-ups, Politicized Prostitutes, and Activist Betrayals."

24. *Letter to Jane* includes production stills of Jane Fonda from *Klute* and *Tout va bien* and of Henry Fonda from *Grapes of Wrath*. The comparisons with her father, the movie star Henry Fonda, are part of a critical elaboration of Hollywood's marketing of empathy.

25. Quoted in A. Williams, *Republic of Images*, 19. The analytic strategy used in the voice-over is particularly indebted to the semiotic analysis of photojournalistic and advertising imagery developed by Roland Barthes in *Mythologies* (1957).

26. As well as being a seasoned activist, Sheila Rowbotham had an impressive list of publications. During the production period of *Nightcleaners* she published her first two books, thus establishing her status as a significant feminist figure when *Nightcleaners* was finally released. See Rowbotham, *Woman's Consciousness, Man's World* and *Women, Resistance, and Revolution*. Rowbotham also wrote regularly for New Left magazines such as *Black Dwarf* and *Seven Days*, and it is because of her feminist contributions to these publications that Godard sought her for the role in *British Sounds*.

27. MacCabe, *Godard: Images, Sounds, Politics*, 59.

28. Other films made prior to *British Sounds* (but post–May '68) are *Film-tracts* (anonymous, 1968), *Un film comme les autres* (1968), and the unfinished *One A.M. (One American Movie)* (1968). For the latter film Godard worked with the American documentary filmmakers D. A. Pennebaker and Richard Leacock. With the unused footage Pennebaker went on to make *One P.M. (One Parallel Movie)* (1971). The punctual date of May '68 as a marker for the shift in Godard's work is a little too neat as a historical categorization. The shift in his practice was in fact much more gradual. See MacCabe, *Godard: Images, Sounds, Politics*; and Bordwell, "Godard and Narration," 311–34.

29. The text is Rowbotham, "Women and the Struggle for Freedom."

30. Cannon, "Godard, the Groupe Dziga Vertov," 81. Italics in the original unless stated otherwise.

31. Ibid.

32. In an interview with Margaret Dickinson, Dave Douglass, a miner and activist for the National Union of Mineworkers who began working with the political film collective Cinema Action in 1971, describes seeing *Nightcleaners* at a mid-1970s screening:

> MD. Did you see *Nightcleaners*?
>
> DD. Yes. That was going around and was played to large audiences of working-class women in Doncaster.
>
> MD. That film could be quite surprising if you were expecting something more like *Rosie the Riveter*. How did your audience in Doncaster respond to it?
>
> DD. They responded very well.
>
> MD. They weren't worried by the repetition of certain images or the bits of black spacing?

DD. No. But then again no one else was dealing with the subject. The very fact that it was being dealt with, on the screen in a debate situation, was important. You were being presented with political questions about your own working life in the images of other workers. It wasn't expected that watching it would be like watching a cartoon.

As Douglass points out, it was precisely the perceived political relevance of the film's subject to the lived experience of this particular audience that allowed for their engagement with it. See Dickinson, *Rogue Reels,* 274. For another interesting account of the initial reception of *Nightcleaners* that confirms Douglass's insights, see Trevelyan, "Humphry Trevelyan in Conversation."

33. Rowbotham, *Promise of a Dream,* 220. When MacCabe interviewed Godard more recently about this discussion with Rowbotham, he could not remember using the phrase; see MacCabe, *Godard: A Portrait,* 401. To contemporary readers the use of the crude slang term *cunt* will generally be understood in a derogatory way, but this is not necessarily how Rowbotham understood it at the time. Like the reclamation of the negative term *queer* in the gay and lesbian community and the still controversial use of the term *nigger* by blacks, there was a (now decisively failed) feminist effort made to reclaim the word *cunt* in positive terms. A great U.S. example of this would be the "cunt cheerleaders," students from Judy Chicago and Miriam Shapiro's Feminist Art Program at Cal Arts, who would turn out at the local airport in cheerleading costumes that spelled out the word *cunt* to greet feminists visiting the program. See Broude and Garrard, *The Power of Feminist Art.*

34. Rowbotham, *Promise of a Dream,* 220. *British Sounds* was commissioned by London Weekend Television, and Rowbotham describes an unexpected result of the scandal around Godard's use of full frontal nudity: "Humphrey Burton, then head of arts at London Weekend Television, refused to show it. The ensuing row fused with the sacking of Michael Peacock from the board of LWT [London Weekend Television] in September 1969. Whereupon Tony Garnett and Kenith Trodd from Kestrel, along with other programme-makers, resigned in protest. LWT decided to go for higher ratings and brought in an Australian newspaper owner called Rupert Murdoch. The last thing *he* wanted to do was to make a cunt boring" (ibid., 221).

35. Irigaray, *This Sex Which Is Not One,* 176.

36. The classic text on the relationship between consumption and femininity is Bowlby, *Shopping with Freud.* Also see Bowlby, *Carried Away.*

37. This view was presented in explicitly feminist terms in Laura Mulvey's widely influential essay, "Visual Pleasure and Narrative Cinema," first published in 1975.

38. Gidal, "Theory and Definition," 8.

39. See Lehman, "Politics, History, and the Avant Garde." Mulvey's "Visual Pleasure and Narrative Cinema" must surely have been a contributing factor for Gidal. I address Mulvey's essay more fully in chapter 2.

40. For example, at one point in *British Sounds,* commenting on the film's logic, the voice-over tells us: "During the screening of a militant film the screen is no more than a blackboard offering a concrete analysis of a concrete situation."

41. Key examples of the development of Mulvey's position are Doane, *The Desire to Desire* and *Femmes Fatales.* There are numerous texts that offer substantive critiques of Mulvey's position and propose an alternative view; notable examples include Sobchack, *The Address of the Eye* and *Carnal Thoughts*; and L. Williams, *Viewing Positions.*

42. Initially the French film critical context provided the parameters for *Screen's* intellectual shift in focus. A series of polemical conflicts between the editors of *Cahiers du cinéma* and *Cinéthique* were quickly translated and published in *Screen.* Moreover, the renewed theoretical focus seen in the French journals was primarily responsible for a similar transformation in British film journals such as the short-run journal *Cinemantics* and *Cinema Rising.* The first issue of the intermittently published British journal *Afterimage,* which grew out of the student magazine *Platinum,* began as a critical response to *Cinéthique.* For more on the British context, see Johnston, "Film Journals in Britain and France"; and Ellis, "Introduction." For an account of the development of the journal throughout the 1970s, see Easthorpe, "Screen, 1971–1979." For a full elaboration of the French film scene at the end of the 1960s, see Harvey, *May '68 and Film Culture.*

43. Wollen, *Signs and Meaning in the Cinema,* 113–14.

44. For a recent account of the history of *Screen* and *Screen Education,* see Bolas, *Screen Education.*

45. MacCabe, *Godard: A Portrait,* 265.

46. Kristeva, *Revolt, She Said,* 42.

47. MacCabe, *Godard: A Portrait,* 265. Also see Bolas, *Screen Education*; and Merck, "Mulvey's Manifesto."

48. *Screen* journal began in 1969 as a continuation of the newsletter *Screen Education.* The 1970s revival of the companion journal *Screen Education* was, however, in name alone. This incarnation of the journal was quite different. Examples of SEFT weekend schools, from 1974 to 1977, indicate the breadth and scope of SEFT's educational work: Godard and Documentary; Narrative and the Cinema; Mise-en-scène; Women and Film; Television Fiction: The Series; The Searchers; Pleasure, Entertainment, and the Popular Culture Debate; Realism and the Cinema; British Independent Cinema / Avant-Garde; and Hollywood Melodrama. It strikes me as dis-

appointingly significant that when I was doing research on the educational outreach programs organized by SEFT, the BFI librarians were all completely ignorant of the topic. When I eventually tracked down the extensive papers of the organization, they had long since been given to an educational archive in Yorkshire (the Lawrence Batley Centre for the National Arts Education Archive, Bretton Hall, West Yorkshire), and no trace of these records remains in the BFI holdings. Terry Bolas's *Screen Education* is the in-depth historical account of this period that has long been needed. My feminist engagement with SEFT emphasizes somewhat different aspects.

49. The special event was discontinued in the 1960s but had been a regular part of the festival's program throughout the 1950s.

50. The first Brecht issue, published in the summer of 1974, established the theoretical groundwork with articles published (for the first time in English) by Barthes, Benjamin, and Brecht as well as other papers specifically addressed to *Kuhle Wampe* and other film projects. The editors qualify the importance of Brecht's work for cinema today, since he is generally celebrated not as a modernist *filmmaker* but rather as a playwright: "It is above all his reflections on his own work in literature, theatre and cinema and on the politico-aesthetic controversies of his day that provide the framework within which it is possible to begin to think of a revolutionary cinema. It is in this sense above all that Brecht is exemplary for a magazine like *Screen*, and it is to this project that we devote this special number" (Brewster and MacCabe, "Brecht and a Revolutionary Cinema?" 6). The Brecht Event also included a question-and-answer session with Straub and Huillet convened by Martin Walsh and a dramatized reading of Brecht's *Messingkauf Dialogues* by the CO-AX theater company.

51. This alternative British film production and screening facility saw itself as the London outpost for the structural film movement that emerged in New York in the 1960s.

52. Gidal, "Theory and Definition of Structural/Materialist Film," 2. Subsequent page numbers are indicated in the text. The first elaboration of the idea of structural/*materialist* film can be found in Gidal, "Un cinéma materialiste structural."

53. As David Curtis explained, *Screen* was perceived at the time as being particularly problematic precisely because of its academic commitment to publications about Hollywood film. Interview with the author, November 2003.

54. See Michelson, "Yvonne Rainer, Part 1" and "Yvonne Rainer, Part 2."

55. Rainer's discomfort with the Brechtian label is apparent in an early interview by Camera Obscura Collective, "Yvonne Rainer: Interview." I offer an alternative reading of Rainer's *Film about a Woman Who . . .* in Wilson, "Structures of Feeling." Also see Glahn, "Brechtian Journeys." Rainer told me about her appellation, "the American Godard," in an interview, December 13, 2002.

56. See Pollock, "Screening the Seventies"; and Carson, "Excavating *Post-Partum Document*," 195.

57. This is a point that Humphry Trevelyan made in an interview with the author (November 6, 2003). Marc Karlin had unfortunately passed away before I began to research *Nightcleaners* in earnest.

58. An excellent narrative of this period can be found in Carson, "Excavating *5*," 181–234. Kelly also appears in Mulvey and Wollen's *Riddles of the Sphinx*.

59. This was relayed in a telephone interview with the author (November 6, 2003). Also see the discussion of the personnel involved in Karlin, "Making Images Explode," 152–53.

60. Margaret Harrison, in an e-mail correspondence (October 19, 2013), has also endorsed the view that the male involvement during this period has not been fully acknowledged. She notes the decisive role played by Conrad Atkinson in organizing an influential early exhibition related to women's labor activism, *Strike at Brennans*, at the ICA in 1972. See Walker, *Left Shift*, 82; and Institute of Contemporary Art, *Conrad Atkinson: Picturing the System*, 35–38.

61. *Women and Work* was first exhibited at the South London Gallery in 1975 and was restaged in 1997 at the Charles Scott Gallery in Toronto, Canada, together with a significant catalogue. See Mastai, *Social Process / Collaborative Action*. I discuss this project in chapter 4.

62. I am grateful to Pollock for allowing me to read Mastai's unpublished paper, "Suffrage in the 1970s: Aesthetic Style for Representing Working Class Women in London, 1973–5."

63. Pollock, "The Pathos of the Political," 195.

64. Ibid., 206.

65. See note 32 for at least one example that complicates Mastai's view.

66. Karlin et al., "Problems of Independent Cinema," 22.

67. Lyotard, *The Postmodern Explained*, 76. Subsequent page numbers are given in the text.

68. For some brief but suggestive remarks on the phallic logic of the avant-garde, see Derrida, *The Other Heading*.

69. Walsh's comment is included in the transcription of the question-and-answer session that is printed along with the essay; see Johnston and Willemen, "Brecht in Britain," 115.

70. Pollock, "The Pathos of the Political," 209.

71. Ibid.

72. I have identified this figure as Jean Mormont based on a reference given in "The Papers of Sheila Rowbotham" in the Women's Library in London. In her essay

on *Nightcleaners,* Pollock identifies a different female figure as Mormont, but I believe that she is mistaken in identifying the woman she illustrates. Also see, for further confirmation of this, Karlin, "Making Images Explode," 153.

73. Carson, "Excavating *Post-Partum Document,*" 195.

74. Kelly's specific engagement with Warhol's film works is discussed in the next chapter. There is a good deal written on Warhol's treatment of the face; see Flatley, "Warhol Gives Good Face"; Crimp, *"Our Kind of Movie"*; Angell, *Andy Warhol Screen Tests*; Gidal, *Andy Warhol: Blow Job*; and Baume, *About Face.*

75. Maimon, "Towards a New Image of Politics," 95. For another important account of the face motif in Marker's work, see Lupton, "Imagine Another."

76. See Karlin, "Making Images Explode." Marker also used footage from the Berwick Street Film Collective's *Ireland behind the Wire* (1974) in *Le fond de l'air est rouge.*

77. Marker and Wexner Center for the Arts, *Staring Back.*

78. Another powerful art historical critique can be found in A. Jones, *Body Art / Performing the Subject,* 24–29; and A. Jones, *Postmodernism,* 24–26.

79. Silverman, *Threshold of the Visible World,* 84.

80. Ibid., 85.

81. Ngai, *Ugly Feelings,* 25.

82. R. Williams "Structures of Feeling."

83. Terada, *Feeling in Theory,* 11. Also see Berlant, "The Subject of True Feelings."

84. Grossberg, "Mapping Popular Culture," 80.

85. In the BSFC's *Ireland behind the Wire* (1974), an incredible film about the torture of detainees in Northern Ireland, this black framing device is also used but in a much more limited way and to a very different effect. Trevelyan and Mordaunt were chiefly responsible for the editing of *Ireland behind the Wire,* which overlapped with the editing of *Nightcleaners,* done primarily by Karlin and Scott. The principal use of this device in *Ireland behind the Wire* is to indicate the historical nature of certain images. One such example shows footage of the Derry civil rights marches of the late 1960s. The refilming effect in this context demonstrates a separation of these (quite recent) historical events from the more immediate experience of internment that is recounted in remarkable close-up head-shot interviews. Also, *Ireland behind the Wire* was specifically made for a British audience who had been kept in ignorance about the situation in Northern Ireland because of British government censorship of the news media. The refilming device in this context has the effect of drawing attention to the process of representation as a reminder that images of Ireland have been used by the state for propagandistic reasons. In this film the slowing-down of certain sequences is largely for dramatic effect; in one such instance it is used to emphasize the intensity

of a riot situation. But the refilmed footage in *Ireland behind the Wire* remains visually intact and narratively functional; the image is never distorted beyond recognition, becoming only film grain, nor is it slowed down to near stasis. Its integrity as a moving filmic image is retained and does not disrupt the film's conventional narrative continuity.

86. Winston, *Claiming the Real,* 199.

87. Ngai, *Ugly Feelings,* 20.

88. Ibid., 6, 6–7.

89. Other writers, following the influential work of Eve Kosofsky Sedgwick, use the term *feeling*; see Sedgwick, *Touching Feeling*; and Love, *Feeling Backward.*

90. R. Williams, "Structures of Feeling," 132.

91. Ibid., 133.

92. Love, *Feeling Backward,* 13.

93. There is one contrasting response to being watched that only further serves to highlight the sympathetic attitude that is otherwise suggested in the film. Viewed in a long shot, one of the cleaners works in a glass-fronted lobby of an office building; a middle-aged man in business attire walks up to the windows to openly observe her. With his face pressed to the glass, the cleaner, when she notices him, is clearly shown cursing at him and shooing him away.

94. The exception here might be Jean Mormont, who became more seriously engaged with feminism as a result of working on this campaign. See her oral history account, Mormont, "Jean Mormont."

95. The question of racism is discussed at length in the special issue, "Night Cleaners," *Shrew* 3, no. 9 (1971). Also see Wandor, *The Body Politic.*

96. Breakwell, *Diary Extracts,* 36. Also see Walker, *Left Shift*; Hall, *Policing the Crisis*; Centre for Contemporary Cultural Studies, *The Empire Strikes Back*; and Gilroy, *"'There Ain't No Black in the Union Jack.'"*

97. For a full, theoretically rich account of the whole oeuvre of the Black Audio Film Collective, see Eshun and Sagar, *The Ghosts of Songs.*

98. The figure that connects Kelly and the Black Audio Film Collective is art historian Adrian Rifkin, who worked at Portsmouth Polytechnic at this time.

99. Quoted in P. Wright, "A Passion for Images," 5.

2. The Spectator as Reproducer

1. As a reflection on the significance of the mine workers, it was the arrival of a young Arthur Scargill with a group of miners from Yorkshire to support the Asian women strikers at the Grunwick factory in London in 1977—after they had already

been picketing for a year—that brought this landmark action to national prominence for the first time. See Beckett, *When the Lights Went Out,* 358–403.

2. Ibid., 464–97.

3. For a good scholarly account of the 1968 exhibition, see Boettger, *Earthworks,* 8–9.

4. Smithson, *Robert Smithson,* 56.

5. *An Earth Work Performed* was restaged in 2012 at the Museum of Contemporary Art in Los Angeles; see Plate 1. For an illustration of the photograph and typewritten text combination that previously circulated as the sole record of this piece, see Kelly, *Mary Kelly,* 10–11.

6. See Bryan-Wilson, *Art Workers,* for an excellent account of issues of labor in 1960s American art. Although the term "art worker," used in her title, is drawn from the New York–based group, the Art Workers' Coalition, Bryan-Wilson's account deals with a broader set of practices and issues.

7. Kelly, *Rereading "Post-Partum Document,"* 197.

8. Tinkcom, *Working like a Homosexual,* 76. For an account of the significance of Warhol in British avant-garde film of the 1960s–1980s—from Malcolm Le Grice to Derek Jarman—see Rees, "Warhol Waves."

9. The politicization of labor and industrial production in 1960s sculpture owes a good deal to the publication in 1962 of the first significant study of Russian avant-garde art in English; see Gray, *The Great Experiment.* For a discussion of the influence of this Russian moment, in relation to the work of Frank Stella in particular, see Gough, "Frank Stella Is a Constructivist." The question of labor as an aspect of minimalist art is assumed in much of the literature on the movement, but it is addressed to its fullest extent in Bryan-Wilson, *Art Workers,* 41–82. On the significance of the studio as a space of labor during the 1960s, see Jones, *Machine in the Studio.* For a critical feminist account of masculine tropes in minimalist art, see Chave, "Minimalism and the Rhetoric of Power" and "Minimalism and Biography."

10. Cited in Tinkcom, *Working like a Homosexual,* 86. In art historical scholarship on Warhol there has been for some time a refusal to engage with the all-pervasive camp aspect of his work. The key volume to readdress this oversight, interestingly, does not come from the discipline of art history; see Doyle, Flatley, and Muñoz, *Pop Out.* For other important art historical treatments of Warhol in a queer studies framework, see R. Meyer, *Outlaw Representation*; Butt, *Between You and Me*; and Crimp, *"Our Kind of Movie."*

11. Also see James, "The Producer as Author."

12. Art historians have typically understood Warhol's parodic embrace of the

entrepreneurial spirit in two conflicting ways: either as the fully realized assimilation of the capitalist subject by the artist or as its critical undoing. The social texture of Warhol's contradictory Factory scene has been vividly summarized by Benjamin H. D. Buchloh thus: "Warhol's Factory was a countercultural model in which rituals of collective production, anti-authoritarian relations, and anti-authorial models of artistic identity were anticipated and practiced in an exemplary fashion," but at the same time, "Warhol's 'Factory' and its 'workers' were also drug-driven denizens of a lunatic asylum in which the inhabitants were put to work to realize the Master's voice and vision" (Buchloh, "Raymond Pettibon," 18–19). For an excellent overview of the political conflicts in the art historical literature on Warhol, see Jones, *Machine in the Studio*, 189–267.

13. Smith, *Andy Warhol's Art and Films*, 235.

14. See Morgan, *Sisterhood Is Powerful*, 514–19. Solanas's *SCUM Manifesto* was well-known in the United Kingdom, largely due to the inclusion of it in excerpted form in the 1970 collection *Sisterhood Is Powerful*. As an index of its widespread popular appeal beyond activist feminist circles, in 1974 Vivian Westwood decorated her London boutique, Sex, with excerpts. For other important analyses, see Ronell, "Deviant Paybacks"; Lord, "Wonder Waif Meets Super Neuter"; and Lyon, *Manifestoes*, 168–202.

15. Tinkcom, *Working like a Homosexual*, 98.

16. Special issue, "Night Cleaners," *Shrew* 3, no. 9 (December 1971). Although the collective feminist aims expressed in *Shrew* were of a very different political order to those of Warhol's assailant, there is a conceptual affinity with Solanas's *SCUM Manifesto* in the choice of the magazine's title. A few synonyms will help clarify the point: shrew, scold, fishwife, spitfire, vixen, battle-axe, misanthrope—and the name for another U.S. feminist group, the Furies.

17. For an analysis of the difference between *Sleep* and Warhol's other performance films, see Angell, *The Films of Andy Warhol: Part II*.

18. Ronell, "Deviant Paybacks," 11.

19. One of the earliest books on Warhol's work, written by an experimental filmmaker, established the idea of duration as the key theme in Warhol's work; see Gidal, *Andy Warhol: Films and Paintings*. Peter Gidal figures in the previous chapter; he is an American, London-based filmmaker and critic associated with structuralist film. Tinkcom challenges the idea of Warhol's films as principally addressed to the question of duration and argues instead for a focus on labor and performance (hence the nomenclature "performance films," a term that I also use).

20. Angell, *The Films of Andy Warhol: Part II*, 10.

21. Quoted in Tinkcom, *Working like a Homosexual*, 73.

22. Barthes, "The Death of the Author."

23. Harold Bloom's approach to the question of influence underpins Rosalind Krauss's account of the significance of Jackson Pollock's work to Cy Twombly, Andy Warhol, and Eva Hesse. See Krauss, *The Optical Unconscious*, 243–320.

24. R. Parker, "Killing the Angel in the House," 763.

25. Nochlin, "Why Have There Been No Great Women Artists?" For a recent critical engagement with these issues, see Pollock, "The Missing Future."

26. R. Parker, "Killing the Angel in the House," 765.

27. Indeed, Bloom's reference to the poet's muse reveals the gendered stakes in his whole project: "Most poets—like most men—suffer some version of the family romance as they struggle to define their most advantageous relation to their precursor and their muse" (Bloom, *The Anxiety of Influence*, 62).

28. Amelia Jones addresses these questions directly, taking the Baroness as an important case study. See Jones, *Irrational Modernism*, 2–33.

29. Doyle, *Sex Objects*, 71–96.

30. Lisa Tickner has developed a theory of influence based on Gilles Deleuze and Félix Guattari's notion of the rhizome; see Tickner, "Mediating Generations." Her use of the rhizome, however, is unhappily fused with Bloom's Freudian theory of influence making for a peculiar contradiction. Deleuze and Guattari's work is a vehement rejection of the Freudian "family romance," whereas Tickner theory maintains the familial structure through the vector of the mother/daughter.

31. De Man, "Review of Harold Bloom's *Anxiety of Influence*," 275.

32. Barthes, "The Death of the Author," 148.

33. De Man, "Review of Harold Bloom's *Anxiety of Influence*," 275.

34. Giorno, "Andy Warhol's Movie *Sleep*," 206.

35. Tinkcom, *Working like a Homosexual*, 95.

36. Ibid., 86.

37. From a telephone interview with the author, October 11, 2004.

38. I am grateful to Esther Ronay for clarifying some of the information about *Women of the Rhondda* (e-mail, March 2008). In the 1975 entry on *Women of the Rhondda* in the *British National Film Catalogue*, Kelly and Trevelyan were acknowledged as part of the film's directorial collective along with Mary Capps, Margaret Dickinson, Esther Ronay, and Brigid Segrave; see Glaessner, "Women of the Rhondda." Other regular members of the London Women's Film Group were Barbara Evans, Midge Mackenzie, and Francine Windham. I am also grateful to Emma Hedditch of Cinenova in London for information on the London Women's Film Group. Also see London Women's Film Group, "Notes." Other films by the London Women's Film Group are *Betteshanger, Kent 1972* (1972), a film about the

involvement of women in the 1972 miner's strike; and *The Amazing Equal Pay Show* (1974) and *Whose Choice* (1976), which are both staged docudramas about equal pay and abortion rights respectively. The London Women's Film Group was also a film distributor of other films by women.

39. Unlike the women featured in *Nightcleaners,* the Rhondda Valley mining community has a long history of (male) labor activism. Undoubtedly this politicized context was decisive in providing the women with an analyis of their own gendered disenfranchisement. See C. Williams, *Democratic Rhondda.*

40. Marx, *Capital,* 1:274.

41. For a particularly influential early feminist critique of Marx's writing, see Rubin, "The Traffic in Women." Also see Barrett, *Women's Oppression Today.*

42. Kelly, *Post-Partum Document,* 1.

43. The emergence of the British documentary tradition in the 1930s with the John Grierson school consolidated the depiction of British workers as decisively male. Key films are *Industrial Britain* (1931), *Shipyard* (1935), *Workers and Jobs* (1935), and the romantic depiction of a South Wales mining community in *Coalface* (1935). See Winston, *Claiming the Real*; and Cowie, "Working Images" and *Recording Reality.*

44. Marx, *Capital,* 1:717–18. Emphasis added.

45. Spivak, *Death of a Discipline,* 32. For a more in-depth analysis of the London Women's Film Group's *Women of the Rhondda,* see Wilson, "From Women's Work to the Umbilical Lens."

46. For an excellent example of the feudal analysis of women's work, see Fraad, *Bringing It All Back Home.*

47. Lyotard, "The Dream-Work Does Not Think," 26, 27, 31.

48. The 1975 installation *Women and Work,* first shown at the South London Gallery, was re-presented in 1997 in Vancouver, Canada (Mastai, *Social Process / Collaborative Action*). I am piecing together this early version of the work through descriptions given to me by Kelly and following a viewing of the film loops from the installation *Women and Work* now in the collection of the Tate Modern in London. My analysis of the two parts of the 1974 work in progress is by necessity uneven, but this is also because the "final" version, now in the collection of the Whitney Museum, does not include the *Women and Work* footage.

49. Marx, *Capital,* 1:275. The question of labor-power is fundamental to the argument of *Capital,* since it provides the source of the capitalist's ability to extract surplus value. Here is Marx on the topic from *Capital*: "The value of labour-power, and the value which that labour-power valorizes [*verwertet*] in the labour-process, are two entirely different magnitudes; and this difference was what the capitalist had

in mind when he was purchasing the labour-power. . . . What was really decisive for him was the specific use-value which this commodity possesses of being a source not only of value, but of more value than it has itself. This is the specific service the capitalist expects from labour-power, and in this transaction he acts in accordance with the eternal laws of commodity exchange" (300–301).

50. I discussed the transformation of the work for the 1999 exhibition at the Generali Foundation in Vienna with Kelly in a telephone interview, December 11, 2004. My concern was about the loss of the work's specifically filmic texture. Kelly told me that she considered transferring the degraded 8 mm "original" into 16 mm format in order to retain the filmic texture of the work but decided that this would make it seem too "precious." The transformation in technology from celluloid to digital is also a shift in sensibility, and as such Kelly was a little uncomfortable with the work's relation to recent large-scale spectacularized video and digital projection. Her contribution to the 2004 Whitney Biennale, *Circa 1968* (2004), was specifically conceived as an engagement with this problematic. *Circa 1968* uses a well-known photograph from May '68 as the source for a simplified image in black-and-white made with laundry lint. A digital projector casts only light, no image, over the top of the laundry lint that is indented into the gallery wall to appear flush with the surface, like a projected image. The slow domestic labor involved in generating the laundry lint image stands in tension with the (frustrated) invocation of the spectacular digital image evident only through the projection of light.

51. Mitchell, *Women: The Longest Revolution*, 33.

52. O'Brien, *The Politics of Reproduction*, 158–59.

53. For an excellent psychoanalytic elaboration of this concept, see MacCannell, *The Regime of the Brother*.

54. Before she wrote *The Politics of Reproduction*, O'Brien was a working midwife with many years of experience. For an interesting anthropological account of American attitudes toward female reproduction immediately following the era of the organized women's movement, see Martin, *The Woman in the Body*.

55. O'Brien, *The Politics of Reproduction*, 165.

56. Pollock, "Moments and Temporalities," 797.

57. Ibid., 798. The key text by Kristeva on this issue is "Women's Time." Kristeva's is clearly an important argument for Kelly as well since she reproduced this essay in the first comprehensive book about her work. See Kelly, *Mary Kelly*.

58. Carson, "Excavating," 199. Like the History Group, the Lacan Women's Study Group was also part of the London Women's Liberation Workshop. The Patriarchy Conference of 1976 is a reference to the annual National Women's Liberation Workshop Conference, which took patriarchy as its theme for that year.

59. Mulvey's discussion of the disembodied viewing position of classical Hollywood cinema is explicitly pitted against the embodied spectator of avant-garde film. This has subsequently been described as a totalizing opposition, and numerous film theorists have both implicitly and explicitly challenged the historical narrative described by Mulvey. It is not my intention to simply reiterate Mulvey's argument here but rather to see it as a historically and politically specific feminist intervention. The many important critical challenges to gaze theory are compelling and have informed my argument in crucial ways. For an overview of the debate, see the essays collected in L. Williams, *Viewing Positions.* For a polemical response to the unexamined racial dimensions of the films discussed by Mulvey, see hooks, "The Oppositional Gaze." For a further discussion of this text in relation to later feminist debates about psychoanalysis, see chapter 4 of this book.

60. Merck, "Mulvey's Manifesto," 2. For other interesting discussions of Mulvey's text, see Kauffman, *Bad Girls and Sick Boys,* 70–81; Naiman, "Shklovsky's Dog and Mulvey's Pleasure"; and Spigel, "Theorizing the Bachelorette."

61. Mulvey, "Visual Pleasure and Narrative Cinema," 6. With Peter Wollen, Mulvey was working on her first film, *Penthesilea,* which came out in 1974, one year prior to the publication of this essay.

62. Ibid., 7. In 1972 Wollen, writing about Godard's collaborative work with Groupe Dziga Vertov, uses the phrase "counter-cinema," also echoed by Mulvey. See Wollen, "Counter-cinema: *Vent d'est.*"

63. On the idea of suture in cinema, see Heath, "Notes on Suture"; Dayan, "The Tutor-code of Classical Cinema"; and Silverman, "Suture."

64. For all quotations in this paragraph, see Mulvey, "Visual Pleasure and Narrative Cinema," 19.

65. See Taber, *Taber's Dictionary of Gynecology and Obstetrics,* L-16.

66. The key Freudian texts on sexuality are "Three Essays on the Theory of Sexuality" (1905), "The Dissolution of the Oedipus Complex" (1924), "Some Psychical Consequences of the Anatomical Distinction between the Sexes" (1925), "Fetishism" (1927), and "Female Sexuality" 1931) and are collected in Freud, *On Sexuality.*

67. Mulvey, "Visual Pleasure and Narrative Cinema," 14.

68. Mulvey uses the masculine pronoun throughout the essay. She has subsequently described her use of this gender-specific pronominal indicator as a way of suggesting the psychical transvestism that the female spectator is compelled to perform (Mulvey, "Afterthoughts on Visual Pleasure and Narrative Cinema").

69. For feminist informed analyses of the use of ultrasound images of fetuses in relation to the abortion debates and cultural represenation, see Petchesky, "Fetal Images"; and Stabile, "Shooting the Mother." Other key texts that address fetal

metaphors in relation to the issue of abortion are Poovey, "The Abortion Question"; and Johnson, "Apostrophe, Animation, and Abortion." For an excellent critical discussion of abortion and fetal imaging in relation to contemporary performance and queer theory, see Doyle, "Blindspots and Failed Performance."

70. Hiller, *Thinking about Art,* 50. For a more extensive feminist analysis of this work by Hiller, see Betterton, "Promising Monsters." For a general overview of the figuration of maternity in contemporary art, see Liss, *Feminist Art and the Maternal.* The key art historical account of the importance of the maternal figure in early modernist sculpture is Wagner, *Mother Stone.*

71. However, Kelly adopted this strategy in her multipanel mixed-media work *Post-Partum Document* (1973–79).

72. Freud, *Art and Literature,* 14:340.

73. Kofman, "The Double Is/and the Devil," 123.

74. Spivak, "Feminism and Critical Theory," 58.

75. Felman, "Postal Survival, or The Question of the Navel," 69. Subsequent page references to this essay will be given in the text.

76. See Irigaray, "On the Maternal Order"; and Rouch, "Le placenta comme tiers." The text by Irigaray also includes an interview with the biologist Hélène Rouch from which I draw much of my foregoing argument. For a related art historical reading of the figure of the placenta, see May, "Mummification."

77. Moreover, the fact that the oedipal understanding of the "first cut" resonates so evocatively with a Judeo-Christian narrative of traumatic expulsion from paradise, exclusion, and the burden of original sin is a further cause for critical reconsideration.

78. Kracauer, *Theory of Film,* 164.

79. Barthes, *Camera Lucida,* 80–81.

80. See Derrida, "The Deaths of Roland Barthes." There are numerous feminist engagements with the figure of the mother in *Camera Lucida.* The ones that have informed my analysis of Kelly's film are Hirsch, *Family Frames*; Marder, "Nothing to Say"; and Gallop, *Living with His Camera.*

81. For an excellent analysis of the relationship between Barthes's *Camera Lucida* and Lacan's psychoanalytic writing, see Iversen, *Beyond Pleasure,* 113–29.

82. On the question of tactility in relation to film, see Sobchack, *Carnal Thoughts*; and Marks, *The Skin of the Film.*

83. Spivak, *A Critique of Postcolonial Reason,* 134. For a clinical psychoanalytic interpretation of this concept, as opposed to a cultural application of psychoanalysis, see Mitchell, *Mad Men and Medusas.*

84. In her essay "The Oppositional Gaze," bell hooks critically responds to Mulvey's

essay by using a range of varied anecdotal evidence from a series of actual female spectators differentiated by both class and race who respond to the racial coding of feminine beauty in mainstream cinema. Although the two writers are in fact describing very different kinds of spectators, hooks (empirical) and Mulvey (psychically imagined), the critique of Mulvey's inability to see the "whiteness" of classical Hollywood cinema's presentation of femininity is important and necessary. In the example of *Antepartum,* the racial identity of the woman is not decisively presented, and even though it is generally taken to be a white woman's body, motherhood is not identified with whiteness here to the extent that femininity was in Mulvey's text. See hooks, "The Oppositional Gaze."

85. For a discussion of the significance of indexicality in relation to Kelly's work, see Iversen, "Readymade, Found Object, Photograph."

86. S. Wilson, "From Women's Work to the Umbilical Lens."

3. *Prostitution* and the Problem of Feminist Art

1. For a further discussion of these two art scandals, see Mulholland, *The Cultural Devolution,* 5–30; and Walker, *Left Shift,* 157–81.

2. From a telephone interview with Mary Kelly, October 11, 2004.

3. The decade of the 1970s was marked by a more general sexualization of British popular culture that can, in part, be seen as a reaction to feminism. For a good cultural studies account of this, see Hunt, *British Low Culture.*

4. Reckitt, *Art and Feminism,* 103; and Mark, *WACK!*

5. The catalogue entry for Tutti's art action, when they were included in the 2006 Tate Triennial, states the following: "Her approach positioned her in direct opposition to the didactic exploration of gender politics favored by her contemporary female artists, and what she saw as the restrictive dictates of feminism" (Ruf and Verwoert, *Tate Triennial 2006,* 42). Needless to say, I do not endorse this parsing of 1970s feminist engaged art even if Tutti herself has come to see it in such terms. It is, nonetheless, a typical postfeminist simplification of the second-wave women's movement as limiting, judgmental, and implicitly dull.

6. The sense of *Prostitution* as implicitly engaged with feminism is clear from statements made by Tutti and P-Orridge. Here is Tutti from a 1982 lecture at the University of Leeds: "[Working in the porno industry] enabled me to work as an artist (unknown to my associates) and as a woman within a man's fantasy world and also to see women through the eyes of men" (see the liner notes for the CD *Time to Tell* with a transcript of the lecture). Also see P-Orridge, "The First Throbbing Gristle Annual Report," 24.

7. Cork, "Now What Are Those English Up To?"

8. Ford, *Wreckers of Civilization*, 6.12. Ford's is the best account so far of COUM Transmissions, and my chapter is indebted to his excellent scholarship on the performance work as well as the band, Throbbing Gristle.

9. P-Orridge, *GPO versus GPO*.

10. Throbbing Gristle included Genesis P-Orridge, Cosey Fanni Tutti, Chris Carter, and Peter Christopherson. Only Carter was not part of COUM. Although the *Prostitution* exhibition is the symbolic beginning of Throbbing Gristle, the actual debut performance was in the summer of 1976 in the AIR gallery in London. There was one other performance that summer at the Hat Fair music festival in Winchester before the opening night of *Prostitution*. Ford, *Wreckers of Civilization*, 6.16–19.

11. P-Orridge and Naylor, "Couming Along," 23. There are other examples of artists' involvement with celebrity culture, both contemporary and historical. Significant precedents for Warhol, on different points of the spectrum, might be Salvador Dalí and Jackson Pollock.

12. The best essay to date that explores these issues in relation to performance art in particular, although it does not mention *Prostitution*, is Kelly, "Re-viewing Modernist Criticism."

13. Examples of Tutti's pornographic art actions were included in the 2006 Tate Triennial. The 2007 Barbican Centre Gallery exhibition *Panic Attack: Art in the Punk Years* (June 5, 2007 to September 9, 2007) is the fullest attempt yet to reassemble *Prostitution*. The curators presented facsimiles of the media wall as it would have appeared in the original ICA show, together with examples of some of the other visual elements of the exhibition. In 2011 Tate Britain presented the exhibition *COUM Transmissions in Context: 1969–1977* with a series of original newspaper clippings presented in vitrines along with the used-tampon sculptures and examples of Tutti's art actions. See Ruf and Verwoert, *Tate Triennial 2006*; and Sladen and Yedgar, *Panic Attack!*

14. COUM did not document the media wall photographically, and I have been unable to track down any newspaper images of it. The organizing rationale for the group's use of media cuttings and their decision not to record this material was that it represented the record of their work by others. (This information was given by P-Orridge in an e-mail communication, June 22, 2013.)

15. See Joselit, *American Art since 1945* and *Feedback*.

16. The two best English-language books on Beuys are Ray and Beckmann, *Joseph Beuys*; and Mesch and Michely, *Joseph Beuys*. A full flowering of the subcultural spiritual aspect of P-Orridge in particular emerged in the 1980s in relation to the band Psychic TV. P-Orridge enacted a cultish transformation of the social

formation of the fan structure in an obscure counterinstitution known as the Temple ov Psychick Youth (TOPY). The writings related to TOPY, by P-Orridge and others, are collected in P-Orridge, *THEE PSYCHICK BIBLE*.

17. Ford, *Wreckers of Civilization*, 1.15.

18. Ibid., 1.16.

19. On Crowley, see Hutchinson, *Aleister Crowley*; and Kaczynski, *Perdurabo*.

20. Pollock, "Moments and Temporalities of the Avant-garde," 795–99.

21. See Lyotard, "The Dream-Work Does Not Think," 21. For a full elaboration of this distinction, see Lyotard, *Discourse, Figure*.

22. See P-Orridge, *Painful but Fabulous* and *Thirty Years of Being Cut Up*; P. Schapiro, "Interview: Genesis P-Orridge"; P-Orridge, "Three Splinter Test" and *THEE PSYCHICK BIBLE*.

23. See C. Harrison and Orton, *A Provisional History of Art & Language*; and C. Harrison, *Essays on Art & Language* and *Conceptual Art and Painting*. Andrew Hemingway, who knew P-Orridge briefly in the late 1960s when they were each living in Hull, told me that Art & Language's Howard Hurrell was also teaching in the art school there. While I do not know if P-Orridge and Tutti came into contact with Hurrell, they would certainly have been aware of Art & Language by the 1970s. The group's particular brand of analytic conceptual art was ascendant in the art world at this time. Furthermore, together with Colin Naylor, P-Orridge was compiling an encyclopedia-style book on contemporary art in Britain. See Naylor and P-Orridge, *Contemporary Artists*.

24. Dated September 21, 1974. I accessed this in the Victoria and Albert Museum.

25. This is in direct contrast with the approach taken by Art & Language whose work in the late 1960s and early 1970s draws on the logical investigations of analytic philosophy. The classic text on conceptual art as an "aesthetics of administration" is Buchloh, "Conceptual Art 1962–1969: From the Aesthetics of Administration to the Critique of Institutions."

26. On the idea of conceptual art and the irrational, see Krauss, "The Lewitt Matrix."

27. On Huebler, Acconci, and other conceptual approaches to photography and performance, see Costello and Iversen, *Photography after Conceptual Art*.

28. Kathy O'Dell's study is groundbreaking in its account of the issue of photographic documentation and the analysis of the dispersed conceptual art use of photography. She analyzes the location of these images in journals and other publications. See O'Dell, *Contract with the Skin*.

29. COUM Transmissions continued to participate in the art world idiosyncratically throughout the late 1970s. Most notably, in 1977 they did a U.S. performance

tour titled *Cease to Exist.* On this, and COUM Transmissions' final performance work, see Ford, *Wreckers of Civilization,* 6.30–6.33, 8.5–8.7.

30. Tutti uses the term "Magazine Action" to describe the medium of the work in order to differentiate it from straightforward performance art and from photographic documentation of performance.

31. Sontag, *On Photography,* 155.

32. Kelly, "Re-viewing Modernist Criticism," 92; Lambert-Beatty, *Being Watched,* 73.

33. O'Dell, *Contract with the Skin,* 13.

34. On this aspect of performance and installation art, see Frieling, *The Art of Participation*; and Bishop, *Participation.* For a critical engagement with the contemporary art discourse of participation as democratic, see Bishop, *Artificial Hells.*

35. For an excellent elaboration of the complex relationship between performance and photography in the 1960s and 1970s, see the exhibition and publication by Maude-Roxby, *Live Art on Camera.*

36. For an extended account of this performance, see P-Orridge and Naylor, "Couming Along," 24–25. P-Orridge told me in an interview that they were particularly interested in capturing the audience reaction (October 8, 2012).

37. Cork, "Now What Are Those English Up To?"

38. For a discussion of this issue in relation to Fluxus, see Kotz, *Words to Be Looked At,* 175–212. For a comparable argument on the incorporation of photography into the performance scenario itself with regard to the work of Gina Pane, see O'Dell, *Contract with the Skin,* 31–43.

39. Kelly, "Re-viewing Modernist Criticism," 53–57. Also see Vergine, *Body Art and Performance.* The key term here is *presence.* For a powerful and complex critical defense of presence as a founding paradox in live work, see Phelan, *Unmarked,* 146–52. For a reiteration of these ideas in relation to the art museum's recent embrace of performance art, see A. Jones, "'The Artist Is Present.'" Kelly's essay is the first critical engagement with this idea. She connects Vergine's argument about the presence of the performing body to the high modernist investment in this idea because of the centrality of the autographic mark (the original, signatory gesture of each painter) in critical writing on abstract expressionist painting. Setting aside the polemical aspects of Kelly's apparently hostile approach to the body itself—which have been addressed in an equally polemical vein by Amelia Jones (see A. Jones, *Body Art / Performing the Subject,* 22–29)—Kelly's essay has far-reaching implications for our approach to post-1960s art. She argues for an analysis of the artwork that addresses its systemic imbrication in the institutional frameworks of the museum and publishing industry (art magazines, exhibition catalogues, etc.) that she connects to

the particular gendered investment that these institutions have in the proper name of the artist. For a recent critical elaboration of this issue in relation to the Museum of Modern Art in particular, see Pollock, "The Missing Future."

40. Goldberg, *Performance*, 118.

41. Lambert-Beatty, *Being Watched*, 73.

42. Another notable example of a woman performance artist in Britain at this time known for presenting the eroticized nude female body is Rose English. See MacDonald, "Live and Kicking." For a longer history, see Buszek, *Pin-up Grrrls*.

43. M. Harrison, "Notes on Feminist Art in Britain, 1970–1977"; Tickner, "The Body Politic"; and R. Parker, "Censored!"

44. For an excellent analysis of Benglis's advertisement in *Artforum*, see A. Jones, *Body Art / Performing the Subject*, 1–14. Also see Chave, "Minimalism and Biography"; and S. Wilson, "Reading Freire in London."

45. Schneider, *The Explicit Body*, 15; and Ford, *Wreckers of Civilization*, 6.20.

46. Schneider, *The Explicit Body*, 29.

47. See Doyle, *Sex Objects*, 45–70; and Bryan-Wilson, "Dirty Commerce."

48. Conrad Atkinson put it thus: "Cosey introduced to the I.C.A. a space which was reserved for the showing of 'art,' the reality of her hard won struggle for economic survival, her own sexuality as object, her necessity to pose for pornographic pictures. Half a mile from the I.C.A. such scenes can be seen in any strip club, and in most newsagents similar photographs are openly displayed for sale" ("Art for Whom: Notes," 38).

49. M. Harrison, "Notes on Feminist Art in Britain, 1970–1977," 218. Soon after the exhibition, P-Orridge indicates that the idea of the relation to feminism is implicit in the work itself. In an interview in the music magazine *Slash*, he elaborates: "The Cosey part was so funny. . . . 'This is Tessa from Sunderland, she's an air hostess,' and then the next one was 'This is Barbara from Hawaii.' We didn't have to say anything, we didn't have to say it was feminist or anything, it ridiculed the whole thing in its own way" (P-Orridge, "The First Throbbing Gristle Annual Report," 23).

50. Schneider, *The Explicit Body*, 20. Italics in the original unless stated otherwise.

51. The title was first used for a performance at the University of Kent, Canterbury, in 1972, but I have not found any visual record of this. *Copyright Breeches* the book—hereafter simply referred to as *Copyright Breeches*—is made up of a series of photographic images.

52. This idea is carried through to Throbbing Gristle's discography; their first album is titled *The Second Annual Report* (1977), which is followed by *D.o.A.: The Third and Final Report of Throbbing Gristle* (1978).

53. The idea of an implicit contract between the performance artist and the audi-

ence is central to the argument of Kathy O'Dell's excellent book *Contract with the Skin.* She has further elaborated these issues in "Behold!"

54. I am grateful to Kevin Murphy for suggesting this line of thinking about *Copyright Breeches,* and to Andrew Hemingway for fleshing out his memories of Duchamp's reception in Britain in the early 1970s. *Copyright Breeches* comes in the wake of the publication of these influential books on Duchamp's work: Tomkins, *The Bride and the Bachelors*; Cabanne, *Dialogues with Marcel Duchamp*; and Golding, *Marcel Duchamp.* The British interest in Duchamp was preceded by the 1966 retrospective exhibition at the Tate Gallery, curated by Richard Hamilton, for which he reconstructed various works, including *The Large Glass.*

55. Derrida, "The Law of Genre," 57. Subsequent page references to this essay are given in the text.

56. M. Harrison, "Notes on Feminist Art in Britain, 1970–1977," 218.

57. The formative philosophical text on the question of performativity is Austin, *How to Do Things with Words.* Also see the widely influential poststructuralist elaboration of Austin's work, Derrida, "Signature, Event, Context." Key feminist and queer theory debates on performativity are J. Butler, *Excitable Speech*; and A. Parker and Sedgwick, *Performativity and Performance.*

58. Schneider, *The Explicit Body,* 35.

59. Summers, "Form and Gender," 397.

60. For a philosophically informed exploration of this difference, see Kristeva, "Women's Time"; Pollock, "Moments and Temporalities of the Avant-garde"; and J. Butler, *Undoing Gender.*

61. Sedgwick, *Tendencies,* 8.

62. Queerness is not understood here as a sexual identity, even though it is constitutively formed by homosexuality. Sedgwick points out that to dissociate queerness from homosexuality, "to disavow these meanings, or to displace them from the terms definitional center, would be to dematerialize any possibility of queerness itself." Ibid.

63. B. Martin, "Sexualities without Gender and Other Queer Utopias," 12.

64. For two excellent queer readings of Duchamp, see Hopkins, "Men before the Mirror"; and Franklin, "Object Choice." Also see A. Jones, *Irrational Modernism.*

65. In using the phrase "queer aesthetics," I do not wish to suggest a generalized notion of "camp," as Susan Sontag described for American art in the 1960s. Instead, I want to emphasize the mutual contamination of gender and genre seen in *Prostitution.* See Sontag, "Notes on 'Camp.'" For other key writing on the issue of camp from a queer theory perspective, see Cleto, *Camp*; M. Meyer, *Politics and Poetics*; and Tinkcom, *Working like a Homosexual.*

66. For the opening night COUM billed the band (without their consent) under the name LSD. This was chosen as the most antipunk name they could come up with; see Ford, *Wreckers of Civilization*, 6.19. Chelsea soon changed its name to Generation X. According to Peter Hitchcock in a personal conversation, the members of the Bromley Contingent did not embrace this reference to Bromley, a middle-class south London borough, since it undermined their claims to working-class street credibility.

67. While the band was willingly complicit with Christopherson's queer photo shoot, McLaren, the band's manager, was not so happy; see Ford, *Wreckers of Civilization*, 4.10, 5.13. These images of the Sex Pistols appeared in *Prostitution* and have been published in Savage, *England's Dreaming*. For an excellent discussion of this photo shoot in light of queer theory, see Nyong'o, "Do You Want Queer Theory?," 109. For a more general discussion of the racial complexities that arise at the intersection of the popular culture understanding of "punk" and "queer," see Nyong'o, "Punk'd Theory."

68. On the relationship between art and music at this time, see Frith and Horne, *Art into Pop*; Cagle, *Reconstructing Pop/Subculture*; and Molon, *Sympathy for the Devil*.

69. Minsky, "Mall Porn Exhibition."

70. Frith and Horne, *Art into Pop*, 155. For examples of work on the enduring relationship between lesbianism, queerness, and punk, see Halberstam, *In a Queer Time and Place*; Kearny, "The Missing Links"; and Fuch, "If I Had a Dick." For an excellent discussion of the intersections of queer masculinity and punk, see Nyong'o, "Do You Want Queer Theory?" As Frith and Horne point out, these women were there from the start, but bands like the Slits and Polystyrene took much longer to secure recording deals in an industry still rife with sexism. Caroline Coon's fanzine-style illustrated book on the early punk and no wave scene is unique in the attention it gives to women; see Coon, *1988: The New Wave Punk Rock Explosion*.

71. The ICA recording has been released as part of the box set *TG24—24 Hours of Throbbing Gristle* on the Mute label, 2003.

72. Daniel, *Throbbing Gristle's Twenty Jazz Funk Greats*, 12. "No Fun" is the title of a track by the Stooges that the Sex Pistols famously covered.

73. Quoted in Ford, *Wreckers of Civilization*, 7.19. In 1979, in an editorial introduction to a reprinted interview between P-Orridge and Colin Naylor, the Marxist art critic John Roberts indicates a growing discomfort with such dark sentiments in his warning that "Hackney is not Dacau. The morality becomes inverted; a cruel milieu is taken up as the image of a fashionable ennui. These are creeping signs of decadence. They have to be watched." See P-Orridge and Naylor, "Couming Along," 22.

74. Daniel, *Throbbing Gristle's Twenty Jazz Funk Greats*, 16. An anonymous re-

viewer from 1980 echoes this latter-day account in the following way: "It is the modern chain gang blues; the voices of concentration camp workers. The infinite echoing of the voices creates the sense of mass production slavery" ("Modern Music of the Chain Gang," 234). The literature on the significance of the Holocaust to subsequent cultural production is of course vast; the classic philosophical text is Horkheimer and Adorno, *Dialectic of Enlightenment*. For an interesting recent political elaboration of this issue in a cultural context, see the Introduction in Pollock, *Concentrationary Cinema*, 1–54.

75. Edelman, *No Future*, 3, 4. The key text on the question of "antisocial" queer theory is Hocquenghem, *Homosexual Desire*. Also see Bersani, *Homos*. For a further discussion of Edelman's relation to the "antisocial" strain in queer theory, see Caserio et al., "The Antisocial Thesis in Queer History," 819–21; and Nyong'o, "Do You Want Queer Theory?," 104. For an elaborated counterposition, see Halberstam, *The Queer Art of Failure*.

76. Quoted in Caserio et al., "The Antisocial Thesis in Queer Theory," 822.

77. Quoted in Young, *Break All Rules!*, 8. The seminal political analysis of punk is Hebdige, *Subculture, the Meaning of Style*. Also see O'Hara, *The Philosophy of Punk*.

78. Nyong'o, "Do You Want Queer Theory?," 110.

79. As Doyle points out, the only feminist text cited by Edelman is Johnson, "Apostrophe, Animation, and Abortion." Also see Poovey, "The Abortion Question"; and Stabile, "Shooting the Mother." An extensive bibliography on this issue in feminist thinking can be found in Doyle, "Blindspots and Failed Performance."

80. Stabile, "Shooting the Mother," 72.

81. Daniel, *Throbbing Gristle's Twenty Jazz Funk Greats*, 14.

82. Kristeva, "Women's Time," 14.

83. M. Schapiro, "The Education of Women as Artists"; Harper, "The First Feminist Art Program"; and Broude and Garrard, *The Power of Feminist Art*.

84. For an excellent analysis of Chicago's installation and the presumption of its literalism on the part of male viewers (as evidenced by viewer interviews in Johanna Demetrakas's film, *Womanhouse*, 1974), see Blocker, *What the Body Cost*, 107–8.

85. Kristeva, *Powers of Horror*, 1.

86. Ibid., 2. The idea of abjection as a significant theme in contemporary art is exemplified by two exhibitions; see Houser et al., *Abject Art*; and S. Morgan, *Rites of Passage*. For a critical polemic against the use of abjection as a curatorial theme that also includes a critique of Kristeva (but seems to be more of a response to the curatorial application of Kristeva's work), see Bois and Krauss, *Formless*. Also see Foster, "Obscene, Abject, Traumatic."

87. Edelman, *No Future*, 7.

88. For an excellent feminist analysis of this piece by Kubota (along with other New York–based women artists who used their own bodies, such as Carolee Schneemann and Yoko Ono) in comparison with Yves Klein, see Schneider, *The Explicit Body in Performance*, 38–40. For a general overview of Kubota's work, see Yoshimoto, *Into Performance*, 169–94. Also see Schor, "Representations of the Penis."

89. Edelman, *No Future*, 13.

90. Doyle, "Blindspots and Failed Performance," 35.

91. Kristeva, *Powers of Horror*, 2.

92. For a recent close reading of *Post-Partum Document*, fresh in its treatment of the density of Kelly's theoretical reference, see Meltzer, "After Words."

93. Kristeva, *Powers of Horror*, 24.

4. Revolting Photographs

1. Wall, "'Marks of Indifference,'" 250.

2. For an excellent overview of these issues in relation to developments in photographic theory, see Batchen, "Palinode."

3. Spence, *Putting Myself in the Picture*, 118. The series also went by an alternate title, *The History Lesson*.

4. Wollen, "Photography and Aesthetics," 27.

5. Spence began working with her principal collaborator, Dennett, in 1973 through the children's rights movement giving photographic workshops to inner city kids. Spence's engagement with children's rights was rooted in her own traumatic experience of being evacuated from her parental home in London to the countryside during the Second World War because of the Blitz bombings. For an account of this, see Jo Spence, The Oral History of British Photography, audio recordings held in the British Library Sound Collections; and Dennett, "The Wounded Photographer," 26.

6. Spence, *Putting Myself in the Picture*, 27–46.

7. When Burgin was hired to teach in the highly regarded degree program in photography and film at the Polytechnic of Central London in 1973, it was housed in the School of Communication not the School of Fine Art. For a discussion of this prehistory, see Roberts, "Interview with Victor Burgin."

8. Barthes, "The Photographic Message," 15.

9. Burgin, *Between*, 84.

10. Kotz, *Words to Be Looked At*, 194.

11. Roberts, "Photography, Iconophobia, and the Ruins of Conceptual Art."

12. For a critique of Wall's position, see Costello and Iversen, *Photography after Conceptual Art*; and Stallabrass, "Museum Photography and Museum Prose."

13. Wall, "'Marks of Indifference,'" 250, 248.

14. Roberts, "Photography, Iconophobia, and the Ruins of Conceptual Art," 25–26.

15. While Roberts makes a general connection between conceptual photography and workerism, I do not mean to say that he is guilty of sentimentality. Moreover, he has written widely on Spence's work and has paid close attention to figures of working-class disruption in other work. See Roberts, *Postmodernism, Politics, and Art* and *The Art of Interruption*.

16. See Hanisch, "The Personal Is the Political."

17. Spence's radical politics and growing theoretical engagement led to irreconcilable tensions, and in 1977 the collaboration dissolved when Spence was fired. For a full account of this, see Evans, *The Camerawork Essays*.

18. Spence, The Oral History of British Photography, audio recordings held in the British Library Sound Collections.

19. Burgin also had a working-class background, but he was able to transcend its social limitations through higher education and his intellectual status as a university professor and theoretically engaged artist. See Roberts, "Interview with Victor Burgin."

20. Other members of the collective at some point during its period of operation were Ruth Barrenbaum, An Dekker, Helen Grace, Sally Greenhill, Liz Heron, Gerda Jager, Maggie Millman, Michael Ann Mullen, Maggie Murray, Jini Rawlings, Christine Roche, Nanette Salomon, Arlene Strasberg, Sue Tweweek, and Julia Vellacott. They also produced an educational pack of slides called *Domestic Labour and Visual Representations* and presented their work in numerous discursive contexts. For a general account of the project, see Heron, "The Hackney Flashers."

21. Other projects that began under the aegis of Photography Workshop and then developed independently were the Camberwell Beauties, a group of black women who used photography as part of a literacy program; the Working-Class Women's Post-Education Group, which included Valerie Walkerdine; and Faces, a group that included Elizabeth Wilson and was addressed to personal appearance and identity. More Photography Workshop groups started in Brazil and India. Information on these international groups was given to me by Terry Dennett in an interview in London on December 12, 2004. Also see Dennett, "The Wounded Photographer."

22. Heron, "The Hackney Flashers," 67.

23. In the course of the project, the artists took documentary photographs within the factory space that showed women and men at workstations, but none of these appeared in the final project. Examples of these images have been included in the 1997 catalogue that was published when the exhibition was restaged by the curator Judith Mastai for the Charles H. Scott Gallery in Vancouver, Canada. In this publication

the images are labeled "archival" in order to differentiate them from the final installation. See Mastai, *Social Process / Collaborative Action.*

24. Wall "'Marks of Indifference,'" 248. For a recent theoretical elaboration of this idea within modernism and its relation to contemporary art, see Roberts, *The Intangibilities of Form.*

25. Carson, "Excavating *Post-Partum Document,*" 194, 230; and Harrison in an e-mail (October 9, 2013). For an overview of Atkinson's work of the period, see Institute of Contemporary Art, *Conrad Atkinson: Picturing the System.* In the same e-mail communication Harrison also notes Spence's close engagement with Atkinson's work, particularly following his 1974 ICA exhibition, *Work, Wages, and Prices,* which led to her approaching him directly, offering to work as his assistant.

26. This term is first used in Buchloh, "Conceptual Art 1962–1969."

27. The Hackney Flashers took their name from the East London Borough of Hackney, where the group worked. The reference to flashers was meant as a nod toward the invention of flash photography by Jacob Riis, who developed this lighting technique in the early twentieth century to reveal the terrible living conditions in New York tenements. As a feminist joke, the name was also an implicit pun on the idea of the sexual pervert; this was a group of women "flashing" women but with cameras; see Spence, The Oral History of British Photography, audio recordings held in the British Library Sound Collections.

28. My account of the Film and Photo League is greatly indebted to Dennett's excellent and informative articles; see Dennett, "England: The (Workers') Film and Photo League" and "Popular Photography." Other useful accounts are Hogenkamp, *Deadly Parallels*; S. Jones, *The British Labour Movement and Film, 1918–1939*; Tucker, "A History of the Film and Photo League"; Dejardin, "The Photo-League"; Ollman, "The Photo League's Forgotten Past"; and Museo National Centro de Arte Reina Sofía, *The Worker Photography Movement.*

29. Originally called the Workers Film and Photo League, the name was changed in 1935 to simply the Film and Photo League. Dennett was able to record interviews with eight of the existing members of the Film and Photo League during the course of his research: Norman King, John Maltby, Sam Serter, Hetty Vorhans, Ivan Seruya, Charles Cooper, Joe Arloff, and David Brotmacher. The extant films *Bread* (1934) and *Hunger March* (1934) are now in the BFI's collections along with documentation. Dennett's taped oral history of the Film and Photo League is part of the Jo Spence Memorial Archive.

30. The Film and Photo League in Britain emerged prior to the more widely known anthropological research associated with Mass Observation (established 1937) and photographically represented by Humphrey Spender. The few extant pho-

tographs that resulted from the activities of the Film and Photo League certainly do not hold up in aesthetic terms when compared to other photography from the period, such as Spender's work for Mass Observation, the formal radicalism of Heartfield's montages, or the documentary photography associated with the New York–based Photo League. The aesthetic sophistication of the New York Film and Photo League was recently made very clear to me with the extensive survey exhibition at the Jewish Museum in New York, *The Radical Camera: New York's Photo League, 1936–51.*

31. Dennett, "Popular Photography and Labour Albums," 76. See Benjamin, "A Small History of Photography," 255.

32. See Museu d'Art Contemporani (Barcelona, Spain), *Jo Spence: Beyond the Perfect Image.*

33. Terry Dennett has indicated, in a personal conversation with this author, that the use of the proper name Jo Spence for the work they made collaboratively became a strategy that he used for the art world. It was also a means of honoring Spence as the dominant dynamic figure driving many of the collaborative works produced. Perhaps this approach became easier after Spence's early death in 1992 and with the formation of the Jo Spence Memorial Archive. Rosy Martin, one of Spence's collaborators during the 1980s who was instrumental in the evolution of the photo-therapy technique, has been the most vocal in her objection to her marginalization in relation to Spence. Furthermore, George Vasey, the researcher for the London retrospective (at Space and Studio Voltaire in 2012), indicated in conversation with the author that the issue of Spence's work being fundamentally collaborative and thus superseding the proper name Jo Spence came up several times in both public and private discussions related to the retrospective. Spence, however, always clearly credited her collaborators.

34. For further reflection on the hands-on aspect of the work, see S. Wilson, "Reading Freire in London."

35. Lacan, *Four Fundamental Concepts of Psychoanalysis,* 279–80.

36. See Lacan "The Mirror Stage." In this much-reprinted essay Lacan does not actually refer to the term "the Imaginary," although this is widely thought to be his earliest exploration of these ideas. The term is explored in more depth in his later book *The Four Fundamental Concepts of Psycho-analysis.*

37. The standardized use of the measuring device in ethnographic photography was established by John Lamphrey.

38. Key black photographers of the next generation who have engaged with these questions in a more profound way include Sunil Gupta, Zarina Bhimji, Chila Kumari Burman, and Sutapa Biswas. See Gupta, *Disrupted Borders, Pictures from Here,* and *Queer*; Bhimji, *Zarina Bhimji*; and Nead, *Chila Kumari Burman.*

39. Quoted in Lutz and Collins, "The Color of Sex," 298.

40. Rosler, "In, Around, and Afterthoughts." For a more recent reflection on these issues, see Rosler, "Post-documentary, Post-photography?"

41. In a follow-up essay in 1983, originally published in *Screen* journal, Spence and Dennett discuss how the series can also be understood as a reflection of their collaboration as photographers. "We also hoped that the tension between us as two individuals, with overlapping philosophies of historical materialism—grounded here in Terry's study of apparatuses and the economic point of production as central to any understanding of history, and Jo's interest in women in a class society in relation to *re*production and domestic labour—could productively raise a series of presently unvoiced questions" (Spence and Dennett, "Remodelling Photo-History: An Afterword," 76–77).

42. Spence, *Putting Myself in the Picture*, 118–19.

43. For the classic study on the discourse of taste, see Bourdieu, *Distinction*.

44. For an extended reading of this work in relation to U.S.-language-based conceptual art, see Kotz, *Words to Be Looked At*, 238–47.

45. Barthes, "The Photographic Message, 17." The now widespread discussion of photography in terms of the linguistic theories of Charles Sanders Peirce, who developed the idea of the indexical and iconic sign, is not seen in Barthes's early writing. In fact, his insight about the fundamentally paradoxical nature of photography as a coded message (a language) that is founded on "a message without a code" (the uncoded analog of reality) is eclipsed by the question of indexicality since the index *is* a kind of sign. Thus the uncoded ground of photography becomes subsumed by another kind of sign system. For a widely influential two-part essay on the question of indexicality in relation to photography and art of the 1970s, see Krauss, "Notes on the Index." The question of photography as an indexical sign underpins a recent edited collection on theories of photography; see Elkins, *Photography Theory*. For different kind of theorization of photography's relation to written language, see Flusser, *Towards a Philosophy of Photography*.

46. For a good overview of Burgin's career, see Burgin, *Relocating*. On his work during the 1970s and 1980s, see Burgin, *Between*.

47. The original artists in the exhibition were Troy Brauntuch, Jack Goldstein, Sherrie Levine, Robert Longo, and Philip Smith. Although the phrase "Pictures Generation" preceded the 2009 survey exhibition at the Metropolitan Museum of Art in New York, curated by Douglas Eklund, that exhibition consolidated the use of the term. See Eklund, *The Pictures Generation, 1974–1984*.

48. This exhibition, curated by Kate Linker and Jane Weinstock, was shown in three venues: the New Museum in New York, the Renaissance Society at the Univer-

sity of Chicago, and the Institute of Contemporary Art in London. The artists included Sherrie Levine, Richard Prince, Cindy Sherman, Barbara Kruger, Silvia Kolbowski, Mary Kelly, Victor Burgin, and Jeff Wall. See Linker and Weinstock, *Difference*.

49. For a further elaboration of the popular in Spence's work in relation to ideas of avant-gardism within feminism at the time, see S. Wilson, "Reading Freire in London."

50. Crimp, "The Photographic Activity of Postmodernism," 94.

51. Roberts, "Photography, Iconophobia, and the Ruins of Conceptual Art," 30–31.

52. Crimp, "The Museum's Old," 6.

53. The question of photography's discursive plurality is a central theme in John Tagg's groundbreaking work on photography; see Tagg, *Grounds of Dispute* and *The Burden of Representation*. Also see Krauss, "Photography's Discursive Spaces."

54. Any comparative account of the development of practices of institutional critique would need to take into account the different functions of the museum. The ways in which New York art institutions were (and are) implicated in both city and state politics is, for example, central to the work of Hans Haacke. This issue is addressed most clearly in Haacke, *Hans Haacke, Unfinished Business*.

55. Owens, *Beyond Recognition*; Crimp, "The Photographic Activity of Postmodernism" and "Cindy Sherman"; Foster, "Obscene, Abject, Traumatic" and "Signs Taken for Wonders"; and Krauss, "Cindy Sherman's Gravity" and "Bachelors."

56. For a critical feminist discussion of the influence of the *October* writers, see A. Jones, *Postmodernism*.

57. Spence, *Putting Myself in the Picture*, 119. See also the writings collected in Spence, *Cultural Sniping*; and Holland and Spence, *Family Snaps*.

58. Burgin, *Thinking Photography*. For a critical contextualization of Burgin's text, see Tagg, "Mindless Photography," 116–18.

59. Sekula, "Dismantling Modernism," 172.

60. This comparison is based on Rosler's description of the study and discussion group that she was part of in the 1970s, together with Sekula, Lonidier, and Steinmetz. Although this was within the context of being a graduate student at the University of California at San Diego, it nonetheless sounds a lot like Spence and Dennett's own collaborative autodidactic process: "We met virtually every week for several years and considered ourselves in many ways a working group, batting ideas around. . . . We were all quite aware of photographic conceptualism. We read political theory and art and film theory and criticism, especially *Screen* magazine, discussed contemporary work, talked and argued with David Antin, met with a literary group organized by Fred Jameson, and interacted with Herbert Marcuse and his students—who included Angela Davis—in class situations and in conjunction with

the constant protest events" (Buchloh, "A Conversation with Martha Rosler," 32). Furthermore, this echoes Mary Kelly's description of the Lacan Women's Study Group as a "closeted cult" and is in keeping with the intellectual avant-gardism of this era. Spence and Dennett met with Sekula and Rosler in London in 1980, when Rosler was included in the Institute of Contemporary Art exhibition *Issue: Social Strategies by Women Artists,* curated by Lucy Lippard, and Sekula also contributed to the 1986 publication *Photography/Politics: Two.* See Dennett, "The Wounded Photographer," 26.

61. Benjamin H. D. Buchloh might be said to bridge this division between East Coast Duchampian and West Coast documentary postmodernism. His name is bound up with the published materials of both Rosler and Sekula as editor, essayist, and interlocutor. See Rosler, *3 Works / Critical Essays on Photography and Photographs* and *Martha Rosler*; Shedden and Shedden, *Mining Photographs and Other Pictures, 1948–1968*; and Sekula, *Fish Story.*

62. The gendering of the figure in this photograph is so ambiguous that Marianne Hirsch, in her reading of this image, assumes it is a male figure; see Hirsch, *Family Frames,* 113–50.

63. This connection to surrealism is also evident in terms of the overall composition. The horrified reader (if this is indeed the expression offered) has a surrealist precedent in a painting by René Magritte, *The Submissive Reader* (1928). The painting depicts a woman reading an unidentified book with an expression of horror on her face, eyes bulging and mouth wide open.

64. This is a major theme in feminist psychoanalysis; for two representative texts, see Chodorow, *The Reproduction of Mothering*; and J. Benjamin, *Like Subjects, Love Objects.*

65. For a discussion of *Post-Partum Document* in light of Christian representations of the Madonna and child, see Pollock, "Still Working on the Subject."

66. For an account of Lacan's theory of the subject in relation to these three categories, see Lacan, *Écrits.*

67. See Metz, "Le signifant imaginiaire." This text became very influential in anglophone writing on the cinematic apparatus. The representative text on this is De Lauretis and Heath, *The Cinematic Apparatus.*

68. Burgin, "Perverse Space," 39.

69. Copjec, *Read My Desire,* 23. This is not to suggest that Foucault misunderstood Lacan. Rather, his account is a challenge to the psychoanalytic approach—a critical alternative.

70. Ibid., 23, 26, 34.

71. In the Introduction to this book I discuss how Mulvey's own practice as a

filmmaker reveals her changing attitude toward psychoanalytic questions, and it is in this realm that we see a more notable evolution in her thinking with regard to aesthetic questions.

72. Iversen, *Beyond Pleasure*, 10.

73. A. Jones, *Body Art*, 24.

74. Kelly, *Post-Partum Document*, xvii. Emphasis added.

75. Unfortunately I was not able to acquire a reproduction showing the textual elements. See Spence, *Putting Myself in the Picture*, 132–33.

76. Djebar, *Women of Algiers in Their Apartment*, 139.

77. See Lyotard, "The Dream-Work Does Not Think."

78. Burgin, "Geometry and Abjection," 56.

79. See the essays collected in Barthes, *Image, Music, Text*.

80. Two book-length studies have compiled many of the most significant writings on *Camera Lucida*; see Rabaté, *Writing the Image after Roland Barthes*; and Batchen, *Photography Degree Zero*. Also see Shawcross, *Roland Barthes on Photography*.

81. E. Wilson, "Psychoanalysis: Psychic Law and Order?"; Sayer, "Psychoanalysis and Personal Politics"; and Rose "Femininity and Its Discontents."

82. Iversen, *Beyond Pleasure*, 114.

83. Spence, *Putting Myself in the Picture*, 150.

84. Ibid.

85. Barthes, *Camera Lucida*, 4.

86. Ibid., 96.

87. Iversen, *Beyond Pleasure*, 120.

88. Spence, *Putting Myself in the Picture*, 151.

89. Rose, "Femininity and Its Discontents," 84.

Bibliography

Abel, Elizabeth, ed. *Writing and Sexual Difference*. Brighton, Sussex, England: Harvester Press, 1982.

Alter, Nora M. *Chris Marker*. Urbana: University of Illinois Press, 2006.

Anderson, Emily. "Treacherous Pin-ups, Politicized Prostitutes, and Activist Betrayals: Jane Fonda's Body in Hollywood and Hanoi." *Quarterly Review of Film and Video* 25, no. 4 (July 2008): 315–33.

Angell, Callie. *Andy Warhol Screen Tests: The Films of Andy Warhol: Catalogue Raisonné*. New York: H. N. Abrams, 2006.

———. *The Films of Andy Warhol: Part II: Andy Warhol Film Project*. New York: Whitney Museum of American Art, 1994.

Araeen, Rasheed. *The Other Story: Afro-Asian Artists in Post-war Britain*. London: South Bank Centre, 1989.

Atkinson, Conrad. "Art for Whom: Notes." In *Art for Whom?* London: Serpentine Gallery, 1978.

Austin, J. L. *How to Do Things with Words*. The William James Lectures 1955. New York: Oxford University Press, 1965.

Auther, Elissa, and Adam Lerner, eds. *West of Center: Art and the Counterculture Experiment in America, 1965–1977*. Minneapolis: University of Minnesota Press; published in cooperation with the Museum of Contemporary Art Denver, 2012.

Barrett, Michele. *Women's Oppression Today: The Marxist-Feminist Encounter*. London: Verso, 1988.

Barthes, Roland. *Camera Lucida: Reflections on Photography*. Translated by Richard Howard. London: Hill and Wang, 1981.

———. "The Death of the Author." In *Image-Music-Text*, translated by Stephen Heath, 142–48. New York: Noonday Press, 1988.

———. "The Photographic Message." In *Image-Music-Text*, translated by Stephen Heath, 15–31. New York: Noonday Press, 1988.

Batchen, Geoffrey. "Palinode: An Introduction to *Photography Degree Zero.*" In *Photography Degree Zero,* 3–30. Cambridge, Mass.: MIT Press, 2009.

———, ed. *Photography Degree Zero: Reflections on Roland Barthes's "Camera Lucida."* Cambridge, Mass.: MIT Press, 2009.

Battista, Kathy. *Renegotiating the Body: Feminist Art in 1970s London.* London: I. B. Tauris, 2013.

Bauer, Petra, and Dan Kidner, eds. *Working Together: Notes on British Film Collectives in the 1970s.* Southend-on-Sea, England: Focal Point Gallery, 2010.

Baume, Nicholas, ed. *About Face: Andy Warhol Portraits.* Hartford, Conn.; Andy Warhol Museum, 1999.

Baxendall, Lee. "Introduction." In *Sex-Pol: Essays 1929–1934,* translated by Anne Bostock, Tom BuBose, and Lee Baxandall. New York: Vintage Books, 1972.

Beckett, Andy. *When the Lights Went Out: Britain in the Seventies.* London: Faber, 2009.

Benjamin, Jessica. *Like Subjects, Love Objects: Essays on Recognition and Sexual Difference.* New Haven, Conn.: Yale University Press, 1995.

Benjamin, Walter. "The Author as Producer." In *Selected Writings, 1927–1934,* edited by Michael W. Jennings, Howard Eiland, and Gary Smith, 2:768–82. Cambridge, Mass.: Harvard University Press, 1999.

———. "A Small History of Photography." In *One-Way Street,* 240–57. London: NLB, 1979.

Berger, John. *Ways of Seeing.* London: British Broadcasting Corp.; Penguin Books, 1977.

Berlant, Lauren. "The Subject of True Feelings: Pain, Privacy, and Politics." In *Feminist Consequences: Theory for the New Century,* edited by Elisabeth Bronfen and Misha Kavka, 126–60. New York: Columbia University Press, 2000.

Bersani, Leo. *Homos.* Cambridge, Mass.: Harvard University Press, 1996.

Betterton, Rosemary. "Promising Monsters: Pregnant Bodies, Artistic Subjectivity, and Maternal Imagination." *Hypatia* 21, no. 1 (2006): 80–100.

Bhimji, Zarina. *Zarina Bhimji: I Will Always Be Here.* Edited by Elizabeth McGregor. Birmingham: Ikon Gallery, 1991.

Bishop, Claire. *Artificial Hells: Participatory Art and the Politics of Spectatorship.* Original. New York: Verso Books, 2012.

———. *Participation.* Cambridge, Mass.: MIT Press, 2006.

Blazwick, Iwona. *An Endless Adventure—an Endless Passion—an Endless Banquet: A Situationist Scrapbook; The Situationist International Selected Documents from 1957 to 1962: Documents Tracing the Impact on British Culture from the 1960s to the 1980s.* New York: Verso, 1989.

Blocker, Jane. *What the Body Cost: Desire, History, and Performance.* Minneapolis: University of Minnesota Press, 2004.

Bloom, Harold. *The Anxiety of Influence: A Theory of Poetry.* 2nd ed. New York: Oxford University Press, 1997.

Boettger, Suzaan. *Earthworks: Art and the Landscape of the Sixties.* Berkeley: University of California Press, 2002.

Bois, Yve-Alain, and Rosalind Krauss. *Formless: A User's Guide.* New York: Zone Books, 1997.

Bolas, Terry. *Screen Education: From Film Appreciation to Media Studies.* Bristol: Intellect Books, 2009.

Bordwell, David. "Godard and Narration." In *Narration in the Fiction Film.* Madison: University of Wisconsin Press, 1985.

Bourdieu, Pierre. *Distinction: A Social Critique of the Judgement of Taste.* Cambridge, Mass.: Harvard University Press, 1984.

Bowlby, Rachel. *Carried Away: The Invention of Modern Shopping.* New York: Columbia University Press, 2001.

———. *Shopping with Freud.* London: Routledge, 1993.

Breakwell, Ian. *Diary Extracts, 1968–76.* Nottingham: Midland and Group, 1977.

Brennan, Teresa. *Between Feminism and Psychoanalysis.* London: Routledge, 1989.

Brewster, Ben, and Colin MacCabe. "Brecht and a Revolutionary Cinema?" *Screen* 15, no. 2 (1974): 4–6.

Broude, Norma, and Mary D. Garrard, eds. *The Power of Feminist Art: The American Movement of the 1970s, History and Impact.* New York: Harry N. Abrams, 1994.

Brown, Wendy. "The Impossibility of Women's Studies." *Differences* 9, no. 3 (Fall 1997): 79–101.

Bryan-Wilson, Julia. *Art Workers: Radical Practice in the Vietnam War Era.* Berkeley: University of California Press, 2009.

———. "Dirty Commerce: Art Work and Sex Work since the 1970s." *Differences* 23, no. 2 (2012): 71–112.

Buchloh, Benjamin H. D. "Conceptual Art 1962–1969: From the Aesthetic of Administration to the Critique of Institutions." *October* 55 (Winter 1990): 105–43.

———. "A Conversation with Martha Rosler." In *Martha Rosler: Positions in the Life World,* edited by Catherine de Zegher, 23–55. Cambridge, Mass.: MIT Press, 1998.

———. "Raymond Pettibon: After Laughter." *October* 129 (Autumn 2009): 13–50.

Burgin, Victor. *Between.* Oxford, Oxfordshire: B. Blackwell; Institute of Contemporary Arts, 1986.

————. "Geometry and Abjection." In *In/Different Spaces: Place and Memory in Visual Culture*, 39–56. Berkeley: University of California Press, 1996.

————. "Perverse Space." In *In/Different Spaces: Place and Memory in Visual Culture*, 57–76. Berkeley: University of California Press, 1996.

————. *Relocating*. Bristol: Arnolfini, 2002.

————, ed. *Thinking Photography*. Communications and Culture. Houndmills, Basingstoke, Hampshire: Macmillan Education, 1987.

Burton, Johanna. "Fundamental to the Image: Feminism and the Art of the 1980s." In *Modern Women: Women Artists at the Museum of Modern Art*, edited by Cornelia H. Butler and Alexandra Schwartz, 428–43. New York: Museum of Modern Art, 2010.

Buszek, Maria Elena. *Pin-up Grrrls: Feminism, Sexuality, Popular Culture*. Durham, N.C.: Duke University Press, 2006.

Butler, Cornelia H. "Art and Feminism: An Ideology of Shifting Criteria." In *Wack! Art and the Feminist Revolution*, edited by Lisa Gabrielle Mark, 14–25. Cambridge, Mass.: MIT Press with the Museum of Contemporary Art, 2007.

Butler, Cornelia H., and Alexandra Schwartz, eds. *Modern Women: Women Artists at the Museum of Modern Art*. New York: Museum of Modern Art , 2010.

Butler, Judith. *Bodies That Matter: On the Discursive Limits of "Sex."* New York: Routledge, 1993.

————. *Excitable Speech: A Politics of the Performative*. New York: Routledge, 1997.

————. *Gender Trouble: Feminism and the Subversion of Identity*. New York: Routledge, 1999.

————. *Undoing Gender*. New York: Routledge, 2004.

Butt, Gavin. *Between You and Me: Queer Disclosures in the New York Art World, 1948–1963*. Durham, N.C.: Duke University Press, 2005.

Cabanne, Pierre. *Dialogues with Marcel Duchamp*. The Documents of 20th Century Art. New York: Viking Press, 1971.

Cagle, Van M. *Reconstructing Pop/Subculture: Art, Rock, and Andy Warhol*. Thousand Oaks, Calif.: Sage Publications, 1995.

Camera Obscura Collective. "Yvonne Rainer: Interview." *Camera Obscura* no. 1 (Fall 1976): 76–96.

Cannon, Steve. "Godard, the Groupe Dziga Vertov, and the Myth of Counter Cinema." *Nottingham French Studies* 32, no. 1 (1993): 74–83.

Carson, Juli. "Excavating *Post-Partum Document*: Mary Kelly in Conversation with Juli Carson." In *Rereading "Post-Partum Document."* Vienna: Generali Foundation, 1999.

Caserio, Robert L., Lee Edelman, Judith Halberstam, José Esteban Muñoz, and

Tim Dean. "The Antisocial Thesis in Queer Theory." *PMLA* 121, no. 3 (May 1, 2006): 819–28.

Centre for Contemporary Cultural Studies. *The Empire Strikes Back: Race and Racism in the 70s in Britain.* London: Hutchinson in Association with the Centre for Contemporary Cultural Studies, University of Birmingham, 1982.

Chanter, Tina. *Ethics of Eros: Irigaray's Re-Writing of the Philosophers.* New York: Routledge, 1995.

Chave, Anna C. "Minimalism and Biography." *Art Bulletin* 82, no. 1 (March 1, 2000): 149–63.

———. "Minimalism and the Rhetoric of Power." *Arts Magazine* 64, no. 5 (January 1990): 44–63.

Chodorow, Nancy. *The Reproduction of Mothering: Psychoanalysis and the Sociology of Gender.* Berkeley: University of California Press, 1978.

Clark, T. J., and Donald Nicholson-Smith. "Why Art Can't Kill the Situationist International." *October* 79, no. 31 (Winter 1997): 15–31.

Cleto, Fabio, ed. *Camp: Queer Aesthetics and the Performing Subject; A Reader.* Triangulations. Ann Arbor: University of Michigan Press, 1999.

Coon, Caroline. *1988: The New Wave Punk Rock Explosion.* London: Orbach and Chambers, 1997.

Coote, Anna, and Beatrix Campbell. *Sweet Freedom: The Struggle for Women's Liberation.* 2nd ed. Oxford: B. Blackwell, 1987.

Copjec, Joan. *Read My Desire: Lacan against the Historicists.* Cambridge, Mass.: MIT Press, 1994.

Cork, Richard. "Now What Are Those English Up To?" *London Evening Standard.* March 1976, 4th ed.

Costello, Diarmuid, and Margaret Iversen, eds. *Photography after Conceptual Art.* Chichester: Wiley-Blackwell, 2010.

Cowie, Elizabeth. *Recording Reality, Desiring the Real.* Minneapolis: University of Minnesota Press, 2011.

———. "Working Images: The Representation of Documentary Film." In *Work and the Image: Work in Modern Times; Visual Meditations and Social Processes,* edited by Griselda Pollock and Valerie Mainz. Vol. 2. Aldershot, England: Ashgate, 2000.

Crimp, Douglas. "Cindy Sherman: Making Pictures for the Camera." *Bulletin of the Allen Memorial Art Museum* 38, no. 2 (January 2, 1981): 86–91.

———. "The Museum's Old / The Library's New Subject." In *The Contest of Meaning: Critical Histories of Photography,* edited by Richard Bolton, 3–14. Cambridge, Mass.: MIT Press, 1990.

———. *"Our Kind of Movie": The Films of Andy Warhol.* Cambridge, Mass.: MIT Press, 2012.

———. "The Photographic Activity of Postmodernism." *October* 15 (Winter 1980): 91–101.

Daniel, Drew. *Throbbing Gristle's Twenty Jazz Funk Greats.* London: Continuum, 2007.

Dawson, Jonathan. "Letter to Jane." *Senses of Cinema* 19 (April 2002). http://sensesofcinema.com.

Dayan, Daniel. "The Tutor-code of Classical Cinema." In *Movies and Methods: An Anthology,* edited by Bill Nichols. Berkeley: University of California Press, 1985.

Debord, Guy. *Comments on the Society of the Spectacle.* Verso Classics 18. London: Verso, 1998.

Dejardin, Fiona. "The Photo-League: Left-Wing Politics and the Popular Press." *History of Photography* 18, no. 2 (1994).

De Lauretis, Teresa, and Stephen Heath. *The Cinematic Apparatus.* London: Macmillan Press, 1980.

De Man, Paul. "Review of Harold Bloom's Anxiety of Influence." In *Blindness and Insight: Essays in the Rhetoric of Contemporary Criticism,* 267–76. Minneapolis: Minnesota University Press, 1983.

Dennett, Terry. "England: The (Workers') Film and Photo League." In *Photography/Politics: One,* 110–17. London: Photography Workshop, 1979.

———. "Popular Photography and Labour Albums." In *Family Snaps: The Meaning of Domestic Photography,* edited by Patricia Holland and Jo Spence. London: Virago, 1991.

———. "The Wounded Photographer: The Genesis of Jo Spence's Camera Therapy." *Afterimage* 29, no. 3 (November 2001): 26–27.

Dennett, Terry, and Jo Spence, eds. *Photography/Politics: One.* London: Photography Workshop, 1979.

Derrida, Jacques. "The Deaths of Roland Barthes." In *Philosophy and Non-Philosophy since Merleau-Ponty,* edited by Hugh Silverman, translated by Pascale-Anne Brault and Michael Naas. London: Routledge, 1988.

———. "Declarations of Independence." *New Political Science* 7, no. 1 (1986): 7–15.

———. *Geneses, Genealogies, Genres, and Genius: The Secrets of the Archive.* New York: Columbia University Press, 2006.

———. "The Law of Genre." *Critical Inquiry* 7, no. 1 (October 1, 1980): 55–81.

———. *The Other Heading: Reflections on Today's Europe.* Translated by Pascale-Anne Brault and Michael B. Naas. Bloomington: Indiana University Press, 1992.

———. "Signature, Event, Context." In *Margins of Philosophy*, translated by Alan Bass, 307–30. Chicago: Chicago University Press, 1982.

Deutsche, Rosalyn. "Not-Forgetting: Mary Kelly's 'Love Songs.'" *Grey Room*, no. 24 (July 1, 2006): 26–37.

Dickinson, Margaret, ed. *Rogue Reels: Oppositional Film in Britain, 1945–90*. London: British Film Institute, 1999.

Djebar, Assia. *Women of Algiers in Their Apartment*. CARAF Books. Charlottesville: University Press of Virginia, 1992.

Doane, Mary Ann. *The Desire to Desire: The Woman's Film of the 1940s*. Theories of Representation and Difference. Bloomington: Indiana University Press, 1987.

———. *Femmes Fatales: Feminism, Film Theory, and Psychoanalysis*. New York: Routledge, 1991.

Doyle, Jennifer. "Blindspots and Failed Performance: Abortion, Feminism, and Queer Theory." *Qui Parle* 18, no. 1 (Fall/Winter 2009): 25–52.

———. *Sex Objects: Art and the Dialectics of Desire*. Minneapolis: University of Minnesota Press, 2006.

Doyle, Jennifer, Jonathan Flatley, and José Esteban Muñoz, eds. *Pop Out: Queer Warhol*. Durham, N.C.: Duke University Press, 1996.

Easthorpe, Antony. "Screen, 1971–1979." In *The Politics of Theory*, edited by Pat Barker. Colchester: University of Essex, 1983.

Echols, Alice. *Daring to Be Bad: Radical Feminism in America, 1967–1975*. Minneapolis: University of Minnesota Press, 1989.

Edelman, Lee. *No Future: Queer Theory and the Death Drive*. Series Q. Durham, N.C.: Duke University Press, 2004.

Eisenstein, Hester, and Alice Jardine, eds. *The Future of Difference*. The Scholar and the Feminist 1. Boston: G. K. Hall; Barnard College Women's Center, 1980.

Eklund, Douglas. *The Pictures Generation, 1974–1984*. New York: Metropolitan Museum of Art, 2009.

Elkins, James, ed. *Photography Theory*. The Art Seminar 2. London: Routledge, 2007.

Ellis, John. "Introduction." In *Screen Reader: Cinema/Ideology/Politics*, vol. 1. London: Society for Education in Film and Television, 1977.

Esche, Charles. "What Does It Mean to Say That Feminism Is Back? A Reaction to Riddles of the Sphinx." *Afterall: A Journal of Art, Context, and Enquiry*, no. 15 (2007): 118–25.

Eshun, Kodwo, and Anjalika Sagar, eds. *The Ghosts of Songs: The Film Art of the Black Audio Film Collective*. Liverpool: Liverpool University Press, 2007.

Evans, Jessica, ed. *The Camerawork Essays: Context and Meaning in Photography*. London: Rivers Oram Press, 1997.

Felman, Shoshana. "Postal Survival, or the Question of the Naval." *Yale French Studies,* no. 69 (1985): 49–72.

Figes, Eva. *Patriarchal Attitudes.* Women in Revolt. New York: Stein and Day, 1970.

Firestone, Shulamith. *Dialectics of Sex: The Case for Feminist Revolution.* New York: Bantham, 1970.

Firestone, Shulamith, and Anne Koedt, eds. *Notes from the Second Year: Women's Liberation; Major Writings of the Radical Feminists.* New York: Radical Feminism, 1970.

Flatley, Jonathan. "Warhol Gives Good Face: Publicity and the Politics of Prosopopoeia." In *Pop Out: Queer Warhol,* edited by Jennifer Doyle, Jonathan Flatley, and José Esteban Muñoz, 101–33. Durham, N.C.: Duke University Press, 1996.

Flusser, Vilém. *Towards a Philosophy of Photography.* London: Reaktion, 2000.

Ford, Simon. *Wreckers of Civilization: The Story of COUM Transmissions and Throbbing Gristle.* London: Black Dog, 2000.

Foster, Hal. "Obscene, Abject, Traumatic." *October,* no. 78 (Fall 1996): 107–25.

———. "Signs Taken for Wonders." *New Quasi-abstract Painters* 74 (June 1986): 80.

Fraad, Harriet. *Bringing It All Back Home: Class, Gender, and Power in the Modern Household.* A New Directions / Rethinking Marxism Title. London: Pluto Press, 1994.

Franklin, Paul B. "Object Choice: Marcel Duchamp's Fountain and the Art of Queer Art History." *Oxford Art Journal* 23, no. 1 (Winter 2000): 23–50.

Freud, Sigmund. *Art and Literature.* Vol. 14. London: Penguin Books, 1990.

———. *On Sexuality.* Translated by James Strachey. Vol. 7. London: Penguin Books, 1991.

Friedan, Betty. *The Feminine Mystique.* New York: Norton, 1963.

Frieling, Rudolf. *The Art of Participation: 1950 to Now.* New York: Thames & Hudson, 2008.

Frith, Simon, and Howard Horne. *Art into Pop.* New York: Methuen, 1987.

Fuch, Cynthia. "If I Had a Dick: Queers, Punks, and Alternative Acts." In *Mapping the Beat: Popular Music and Contemporary Theory,* edited by Thomas Swiss, John M. Sloop, and Andrew Herman, 101–18. Harmondsworth, England: Blackwell, 1998.

Fusco, Coco. *Young, British, and Black: The Work of Sankofa and Black Audio Film Collective.* Michigan: Hallwalls Inc., Contemporary Arts Center, 1988.

Gallop, Jane. *Living with His Camera.* Durham, N.C.: Duke University Press, 2003.

Gidal, Peter. *Andy Warhol: Blow Job.* London: Afterall Books, 2008.

———. *Andy Warhol: Films and Paintings.* London: Studio Vista, 1971.

———, ed. "Theory and Definition of Structural/Materialist Film." In *Structural Film Anthology*. London: British Film Institute, 1976.

———. "Un cinéma materialiste structural." *Art Vivant Chronique*, no. 55 (1975).

Gilroy, Paul. *"There Ain't No Black in the Union Jack': The Cultural Politics of Race and Nation*. Chicago: University of Chicago Press, 1991.

Giorno, John. "Andy Warhol's Movie *Sleep*." In *In a Different Light: Visual Culture, Sexual Identity, Queer Practice*, 200–214. San Francisco: City Lights Books, 1995.

Glaessner, Verina. "Women of the Rhondda." In *British National Film Catalogue*. London: BFI, 1975.

Glahn, Philip. "Brechtian Journeys: Yvonne Rainer's Film as Counter-Public Art." *Art Journal* 68, no. 2 (Summer 2009): 76–93.

Goldberg, RoseLee. *Performance: Live Art since 1960*. New York: Harry N. Abrams Publishers, 1998.

Golding, John. *Marcel Duchamp: The Bride Stripped Bare by Her Bachelors, Even*. Art in Context. New York: Viking Press, 1973.

Gough, Maria. "Frank Stella Is a Constructivist." *October* 119 (Winter 2007): 94–120.

———. "Paris, Capital of the Soviet Avant-Garde." *October* 101 (Summer 2003): 53–83.

Grant, Catherine. "Fans of Feminism: Re-writing Histories of Second-Wave Feminism in Contemporary Art." *Oxford Art Journal* 34, no. 2 (2011): 265–86.

Gray, Camilla. *The Great Experiment: Russian Art, 1863–1922*. London: Thames and Hudson, 1962.

Greeley, Lynne. "Riddles of the Sphinx: Filmic Puzzle or Feminist Password?" *Text and Performance Quarterly* 10, no. 3 (1990): 218–26.

Greer, Germaine. *The Female Eunuch*. New York: Farrar, Straus and Giroux, 2001.

Grossberg, Lawrence. "Mapping Popular Culture." In *We Gotta Get Out of This Place: Popular Conservatism and Postmodern Culture*, 69–87. New York: Routledge, 1992.

Groupe Lou Sin. "Les luttes de classe en France, deux films: *Coup pour coup* and *Tout va bien*." *Cahiers du cinéma*, 1972.

Gupta, Sunil, ed. *Disrupted Borders: An Intervention in Definitions of Boundaries*. London: Rivers Oram, 1993.

Gupta, Sunil. *Pictures from Here*. London: Chris Boot, 2003.

———. *Queer*. New Delhi: Prestel; Vadehra Art Gallery, 2011.

Haacke, Hans. *Hans Haacke: Unfinished Business*. Edited by Rosalyn Deutsche and Brian Wallis. Cambridge, Mass.: New Museum of Contemporary Art; MIT Press, 1986.

/ 250 / Bibliography

Halberstam, Judith. *In a Queer Time and Place: Transgender Bodies, Subcultural Lives*. Sexual Cultures. New York: New York University Press, 2005.

———. *The Queer Art of Failure*. Durham, N.C.: Duke University Press, 2011.

Hall, Stuart. *Policing the Crisis: Mugging, the State, and Law and Order*. New York: Holmes and Meier, 1978.

Harper, Paula. "The First Feminist Art Program: A View from the 1980s." *Signs* 10, no. 4 (Summer 1985): 762–81.

Harris, Jonathan. *The New Art History: A Critical Introduction*. New York: Routledge, 2001.

Harrison, Charles. *Conceptual Art and Painting: Further Essays on Art & Language*. Cambridge, Mass.: MIT Press, 2003.

———. *Essays on Art & Language*. Cambridge, Mass.: MIT Press, 2001.

Harrison, Charles, and Fred Orton. *A Provisional History of Art & Language*. Paris: E. Fabre, 1982.

Harrison, Margaret. "Notes on Feminist Art in Britain, 1970–1977." *Studio International* 193, no. 987 (1977): 212–20.

Harvey, Sylvia. *May '68 and Film Culture*. London: British Film Institute, 1980.

Heath, Stephen. "Lessons from Brecht." *Screen* 15, no. 2 (Summer 1974): 103–28.

———. "Notes on Suture." *Screen* 18, no. 4 (Winter 1977): 48–76.

Hebdige, Dick. *Subculture: The Meaning of Style*. London: Methuen, 1979.

Heron, Liz. "The Hackney Flashers: Who's Still Holding the Camera?" In *Photography/Politics: One*, edited by Terry Dennett and Jo Spence, 124–32. London: Photography Workshop, 1979.

Hiller, Susan. *Thinking about Art: Conversations with Susan Hiller*. Edited by Barbara Einzig. Manchester: Manchester University Press, 1996.

Hirsch, Marianne. *Family Frames: Photography, Narrative, and Postmemory*. Cambridge, Mass.: Harvard University Press, 1997.

Hocquenghem, Guy. *Homosexual Desire*. Series Q. Durham, N.C.: Duke University Press, 1993.

Hogenkamp, Bert. *Deadly Parallels: Film and the Left in Britain, 1929–1939*. London: Lawrence and Wishart, 1986.

Holland, Patricia, Jo Spence, and Simon Watney, eds. *Photography/Politics: Two*. London: Comedia, 1986.

Holland, Patricia, and Jo Spence, eds. *Family Snaps: The Meaning of Domestic Photography*. London: Virago, 1998.

hooks, bell. "The Oppositional Gaze: Black Female Spectators." In *Black Looks: Race and Representation*, 115–32. Boston: South End Press, 1992.

Hopkins, David. "Men before the Mirror: Duchamp, Man Ray, and Masculinity." *Art History* 21, no. 3 (1998): 303–23.

Horkheimer, Max, and Theodor W. Adorno. *Dialectic of Enlightenment*. New York: Continuum, 1988.

Houser, Craig, Leslie C. Jones, Simon Taylor, and Jack Ben-Levi. *Abject Art: Repulsion and Desire in American Art*. New York: Whitney Museum of Art, 1993.

Hunt, Léon. *British Low Culture: From Safari Suits to Sexploitation*. London: Routledge, 1998.

Hutchinson, Roger. *Aleister Crowley: The Beast Demystified*. Edinburgh: Mainstream, 1999.

Institute of Contemporary Art. *Conrad Atkinson: Picturing the System*. London: Pluto Press in association with ICA Projects, 1981.

Irigaray, Luce. *An Ethics of Sexual Difference*. Translated by Carolyn Burke and Gillian C. Gill. Ithaca, N.Y.: Cornell Univeristy Press, 1993.

———. "On the Maternal Order." In *Je, Tu, Nous: Toward a Culture of Difference (Thinking Gender)*, translated by Alison Martin. New York: Routledge, 1992.

———. *This Sex Which Is Not One*. Ithaca, N.Y.: Cornell University Press, 1985.

Iversen, Margaret. *Beyond Pleasure: Freud, Lacan, Barthes*. Pennsylvania State University Press, 2007.

———. "Readymade, Found Object, Photograph." *Art Journal* 63, no. 2 (2004): 44–57.

James, David. "The Producer as Author." In *Andy Warhol: Film Factory*, edited by Michael O'Pray, 124–35. London: BFI, 1989.

Johnson, Barbara. "Apostrophe, Animation, and Abortion." *Diacritics* 16, no. 1 (Spring 1986): 29–47.

Johnston, Claire. "Film Journals in Britain and France." *Screen* 12, no. 1 (1971): 39–46.

Johnston, Claire, and Paul Willemen. "Brecht in Britain: The Independent Political Film (on *The Nightcleaners*)." *Screen* 16, no. 4 (June 1975): 62–80.

Jones, Amelia. "'The Artist Is Present': Artistic Re-enactments and the Impossibility of Presence." *TDR / The Drama Review* 55, no. 1 (2011): 16–45.

———. *Body Art / Performing the Subject*. Minneapolis: University of Minnesota Press, 1998.

———. *Irrational Modernism: A Neurasthenic History of New York Dada*. Cambridge, Mass.: MIT Press, 2004.

———. *Postmodernism and the En-gendering of Marcel Duchamp*. New York: Cambridge University Press, 1994.

Jones, Caroline A. *Machine in the Studio: Constructing the Postwar American Artist*. Chicago: University of Chicago Press, 1996.

Jones, Stephen G. *The British Labour Movement and Film, 1918–1939.* Cinema and Society. London: Routledge & Kegan Paul, 1987.

Joselit, David. *American Art since 1945.* London: Thames & Hudson, 2003.

———. *Feedback: Television against Democracy.* Cambridge, Mass.: MIT Press, 2007.

Kaczynski, Richard. *Perdurabo: The Life of Aleister Crowley.* Berkeley: North Atlantic Books, 2010.

Kaplan, E. Ann. "Avant-Garde Feminist Cinema: Mulvey and Wollen's Riddles of the Sphinx." *Quarterly Review of Film Studies* 4, no. 2 (1979): 135–44.

Karlin, Marc. "Making Images Explode." In *Looking at Class: Film, Television, and the Working Class in Britain,* edited by Sheila Rowbotham and Huw Beynon. London: Rivers Oram Press, 2001.

Karlin, Marc, Claire Johnston, Mark Nash, and Paul Willemen. "Problems of Independent Cinema: A Discussion between Marc Karlin, Claire Johnston, Mark Nash, and Paul Willemen." *Screen* 21, no. 4 (January 1980).

Kauffman, Linda S. *Bad Girls and Sick Boys: Fantasies in Contemporary Art and Culture.* Berkeley: University of California Press, 1998.

Kearney, Mary Celeste. "The Missing Links: Riot Grrrl—Feminism—Lesbian Culture." In *Sexing the Groove: Popular Music and Gender,* edited by Sheila Whiteley, 207–29. London: Routledge, 1997.

Kelly, Mary. *Mary Kelly.* Contemporary Artists. London: Phaidon Press, 1997.

———. "Miss World." In *Social Process / Collaborative Action: Mary Kelly 1970–1975,* edited by Judith Mastai, 57–60. Vancouver, B.C.: Charles H. Scott Gallery, 1997.

———. "On Fidelity: Art, Politics, Passion, and Event." In *Digital and Other Virtualities: Renegotiating the Image,* edited by Anthony Bryant and Griselda Pollock, 183–89. London: I. B. Taurus, 2010.

———. *Post-Partum Document.* Berkeley: University of California Press, 1999.

———. *Rereading Post-Partum Document.* Vienna: Generali Foundation, 1999.

———. "Re-viewing Modernist Criticism." *Screen* 22, no. 3 (1981).

Koedt, Anne. *The Myth of the Vaginal Orgasm.* Somerville, Mass.: New England Free Press, 1970.

Kofman, Sarah. "The Double Is/And the Devil: The Uncanniness of 'The Sandman (Der Sandmann).'" In *The Childhood of Art,* translated by Sarah Wykes. New York: Columbia University Press, 1988.

Kotz, Liz. *Words to Be Looked At: Language in 1960s Art.* Cambridge, Mass.: MIT Press, 2010.

Kracauer, Siegfried. *Theory of Film.* London: Oxford University Press, 1960.

Krauss, Rosalind. "Bachelors." *Sherrie Levine: Mary Boone Gallery, New York; Exhibit*, no. 52 (April 15, 1990): 53–59.

———. "Cindy Sherman's Gravity: a Critical Fable." *Artforum International* 32 (November 1993): 162.

———. "The Lewitt Matrix." In *Sol LeWitt: Structures 1962–1993*, 25–33. Oxford: Museum of Modern Art, Oxford, 1993.

———. "Notes on the Index: Seventies Art in America." *October* 3 (1977): 68.

———. "Notes on the Index: Seventies Art in America. Part 2." *October* 4 (1977): 58.

———. *The Optical Unconscious*. Cambridge, Mass.: MIT Press, 1993.

———. "Photography's Discursive Spaces: Landscape/View." *Art Journal* 42, no. 4 (December 1, 1982): 311–19.

Kristeva, Julia. *Powers of Horror: An Essay on Abjection*. New York: Columbia University Press, 1982.

———. *Revolt, She Said*. Los Angeles: Semiotext(e), 2002.

———. "Women's Time." *Signs* 7, no. 1 (October 1, 1981): 13–35.

Lacan, Jacques. *Écrits: A Selection*. Translated by Bruce Fink. New York: Norton, 1977.

———. *Four Fundamental Concepts of Psycho-analysis*. Translated by Alan Sheridan. New York: W.W. Norton, 1981.

———. "The Mirror Stage." *New Left Review* 51 (September–October, 1968): 63–77.

Lambert-Beatty, Carrie. *Being Watched: Yvonne Rainer and the 1960s*. Cambridge, Mass.: MIT Press, 2011.

Laplanche, Jean. *The Language of Psycho-analysis*. New York: Norton, 1974.

Lee, Min. "Red Skies: Joining Forces with the Militant Collective SLON." *Film Comment* 39, no. 4 (July–August 2003): 38–41.

Lehman, Peter. "Politics, History, and the Avant Garde: An Interview with Peter Gidal." *Wide Angle* 15, no. 2 (1982): 72–77.

Lellis, George. *Bertolt Brecht, "Cahiers du Cinéma," and Contemporary Film Theory*. Ann Arbor, Mich.: UMI Research Press, 1982.

Linker, Kate, and Jane Weinstock, eds. *Difference: On Representation and Sexuality*. New York: New Museum of Contemporary Art, 1984.

Liss, Andrea. *Feminist Art and the Maternal*. Minneapolis: University of Minnesota Press, 2009.

London Women's Film Group. "Notes." In *Rogue Reels: Oppositional Film in Britian, 1945–90*, edited by Margaret Dickinson, 119–22. London: BFI, 1999.

Lord, Catherine. "Wonder Waif Meets Super Neuter." *October* 132 (May 1, 2010): 135–63.

Love, Heather. *Feeling Backward: Loss and the Politics of Queer History.* Cambridge, Mass.: Harvard University Press, 2007.

Lupton, Catherine. *Chris Marker: Memories of the Future.* London: Reaktion Books, 2005.

———. "Imagine Another: Chris Marker as a Portraitist." *Film Studies* 6 (Summer 2005): 74–90.

Lutz, Catherine, and Jane L. Collins. "The Color of Sex: Postwar Photographic Histories of Race and Gender in National Geographic." In *The Gender/Sexuality Reader: Culture, History, Politcal Economy,* edited by Roger N. Lancaster and Micaela di Leonardo, 295–308. New York: Routledge, 1997.

Lyon, Janet. *Manifestoes: Provocations of the Modern.* Ithaca, N.Y.: Cornell University Press, 1999.

Lyotard, Jean-François. *Discourse, Figure.* Minneapolis: University of Minnesota Press, 2011.

———. "The Dream-Work Does Not Think." *Oxford Literary Review* 6, no. 1 (1983): 3–34.

———. *The Postmodern Explained: Correspondence, 1982–1985.* Edited by Julian Pefanis and Morgan Thomas. Translated by Barry Don et. al. Minneapolis: University of Minnesota Press, 1992.

MacCabe, Colin. *Godard: A Portrait of the Artist at Seventy.* New York: Farrar, Straus and Giroux, 2003.

———. *Godard: Images, Sounds, Politics.* Bloomington: Indiana University Press, 1980.

MacCannell, Juliet Flower. *The Regime of the Brother: After the Patriarchy.* New York and London: Routledge, 1991.

MacDonald, Clare. "Live and Kicking." *Women's Art Magazine,* no. 61 (November–December 1994): 12–17.

Maimon, Vered. "Towards a New Image of Politics: Chris Marker's Staring Back." *Oxford Art Journal* 33, no. 1 (March 1, 2010): 81–101.

Malik, Amna. "Conceptualising 'Black' British Art through the Lens of Exile." In *Exiles, Diasporas, and Strangers,* edited by Kobena Mercer, 166–88. London and Cambridge, Mass.: INIVA and MIT Press, 2008.

Marder, Elissa. "Nothing to Say: Fragments on the Mother in the Age of Mechanical Reproduction." *Esprit Createur* 40, no. 1 (2000).

Margulies, Ivone. *Nothing Happens: Chantal Akerman's Hyperrealist Everyday.* Durham, N.C.: Duke University Press, 1996.

Mark, Lisa Gabrielle, ed. *WACK! Art and the Feminist Revolution.* Cambridge, Mass.: MIT Press with the Museum of Contemporary Art, Los Angeles, 2007.

Marker, Chris, and Wexner Center for the Arts. *Staring Back.* Cambridge, Mass.: MIT Press, 2007.

Marks, Laura U. *The Skin of the Film: Intercultural Cinema, Embodiment, and the Senses.* Durham, N.C.: Duke University Press, 2000.

Martin, Biddy. "Sexualities without Gender and Other Queer Utopias." In *Coming Out of Feminism?,* edited by Mandy Merck, Naomi Segal, and Elizabeth Wright, 11–35. Oxford: Blackwell, 1998.

Martin, Emily. *The Woman in the Body: A Cultural Analysis of Reproduction.* Boston: Beacon Press, 1987.

Marx, Karl. *Capital: A Critique of Political Economy.* Translated by Ben Fowkes. Vol. 1. London: Penguin in association with New Left Review, 1990.

Mastai, Judith, ed. *Social Process / Collaborative Action: Mary Kelly 1970–1975.* Vancouver, B.C.: Charles H. Scott Gallery and the Emily Carr School of Art and Design, 1997.

Maude-Roxby, Alice, ed. *Live Art on Camera: Performance and Photography.* Southampton, England: John Hansard Gallery, 2007.

May, Marianne. "Mummification: The Subject of the Placenta in Marc Quinn's 'Lucas.'" *Women: A Cultural Review* 17, no. 3 (2006).

McDonough, Tom. *"The Beautiful Language of My Century": Reinventing the Language of Contestation in Postwar France, 1945–1968.* Cambridge, Mass.: MIT Press, 2007.

McLuhan, Marshall. *Understanding Media: The Extensions of Man.* New York: McGraw-Hill, 1965.

Meltzer, Eve. "After Words." In *Systems We Have Loved: Conceptual Art, Affect, and the Antihumanist Turn,* 153–205. Chicago: University of Chicago Press, 2013.

Merck, M. "Mulvey's Manifesto." *Camera Obscura: Feminism, Culture, and Media Studies* 22, no. 3 66 (Winter 2007): 1–23.

Mesch, Claudia, and Viola Maria Michely. *Joseph Beuys: The Reader.* Cambridge, Mass.: MIT Press, 2007.

Metz, Christian. "Le signifant imaginaire." *Communications* 23 (1975).

Meyer, Moe, ed. *The Politics and Poetics of Camp.* London: Routledge, 1994.

Meyer, Richard. *Outlaw Representation: Censorship and Homosexuality in Twentieth-century American Art.* Ideologies of Desire. Oxford: Oxford University Press, 2002.

Michelson, Annette. "Yvonne Rainer, Part 1: The Dancer and the Dance." *Artforum,* January 1974.

———. "Yvonne Rainer, Part 2: Lives of Performers." *Artforum,* February 1974.

Millet, Kate. *Sexual Politics.* New York: Garden City, 1971.

Minsky, Helen. "Mall Porn Exhibition." *London Evening News,* October 19, 1976.

Mitchell, Juliet. "Introduction, 1999." In *Psychoanalysis and Feminism: A Radical Reassessment of Freudian Psychoanalysis,* xvi–xxxviii. 2nd rev. ed. London: Basic Books, 2000.

———. *Mad Men and Medusas: Reclaiming Hysteria.* New York: Basic Books, 2000.

———. *Psychoanalysis and Feminism: A Radical Reassessment of Freudian Psychoanalysis.* New York: Basic Books, 2000.

———. *Women: The Longest Revolution.* London: Virago, 1984.

"Modern Music of the Chain Gang: A Review of Throbbing Gristle's 20 Jazz Funk Greats." *Fuse,* May 1980.

Mohanty, Chandra Talpade. "Under Western Eyes: Feminist Scholarship and Colonial Discourses." *Boundary 2* 12/13 (April 1, 1984): 333–58.

Molon, Dominic. *Sympathy for the Devil: Art and Rock and Roll since 1967.* New Haven, Conn.: Yale University Press, 2007.

Morgan, Robin, ed. *Sisterhood Is Powerful: An Anthology of Writings from the Women's Liberation Movement.* New York: Vintage Books, 1970.

Morgan, Stuart. *Rites of Passage: Art for the End of the Century.* London: Tate Gallery Publications, 1995.

Mormont, Jean. "Jean Mormont." In *Dutiful Daughters Talk about Their Lives,* edited by Sheila Rowbotham and Jean McCrindle, 139–56. Austin: University of Texas Press, 1977.

Mulholland, Neil. *The Cultural Devolution: Art in Britain in the Late Twentieth Century.* Aldershot: Ashgate Publishing Limited, 2003.

Mullard, Chris. *Black Britain.* London: Allen and Unwin, 1973.

———. *Race, Power, and Resistance.* London: Routledge and Kegan Paul, 1985.

Mulvey, Laura. "Afterthoughts on Visual Pleasure and Narrative Cinema." In *Visual and Other Pleasures.* Bloomington: Indiana University Press, 1989.

———. "Visual Pleasure and Narrative Cinema." *Screen* 16, no. 3 (1975): 6–18.

Mulvey, Laura, and Margarita Jimenez. "The Spectacle Is Vulnerable: Miss World, 1970." In *Visual and Other Pleasures,* edited by Laura Mulvey. Bloomington: Indiana University Press, 1989.

Museo National Centro de Arte Reina Sofía, *The Worker Photography Movement [1926–1939]: Essays and Documents.* Madrid: Museo National Centro de Arte Reina Sofía; TF Editores, 2011.

Museu d'Art Contemporani (Barcelona, Spain). *Jo Spence: Beyond the Perfect Image; Photography, Subjectivity, Antagonism.* Barcelona: Museu d'Art Contemporani de Barcelona, 2005.

Naficy, Hamid. *An Accented Cinema: Exilic and Diasporic Filmmaking.* Princeton, N.J.: Princeton University Press, 2001.

Naiman, Eric. "Shklovsky's Dog and Mulvey's Pleasure: The Secret Life of Defamiliarization." *Comparative Literature* 50, no. 4 (October 1, 1998): 333–52.

Naylor, Colin, and Genesis P-Orridge, eds. *Contemporary Artists.* London: St. James Press; St. Martin's Press, 1977.

Nead, Lynda. *Chila Kumari Burman: Beyond Two Cultures.* London: Kala Press, 1995.

Ngai, Sianne. *Ugly Feelings.* Cambridge, Mass.: Harvard University Press, 2004.

Nichols, Bill. *Representing Reality: Issues and Concepts in Documentary.* Bloomington: Indiana University Press, 1991.

Nochlin, Linda. "Why Have There Been No Great Women Artists?" In *Women, Art, and Power and Other Essays*, 145–78. New York: Harper and Row, 1988.

Nyong'o, T. "Do You Want Queer Theory (or Do You Want the Truth)? Intersections of Punk and Queer in the 1970s." *Radical History Review* 2008, no. 100 (Winter 2008): 103–19.

Nyong'o, Tavia. "Punk'd Theory." *Social Text*, no. 84–85 (October 1, 2005): 19–34.

O'Brien, Mary. *The Politics of Reproduction.* London: Harper Collins Publishers, 1981.

O'Dell, Kathy. "Behold!" In *Live Art on Camera: Performance and Photography*, edited by Alice Maude-Roxby, 30–38. Southampton: John Hansard Gallery, 2007.

———. *Contract with the Skin: Masochism, Performance Art, and the 1970s.* Minneapolis: University of Minnesota Press, 1998.

O'Hara, Craig. *The Philosophy of Punk: More Than Noise!* Edinburgh: AK, 1995.

Ollman, Leah. "The Photo League's Forgotten Past." *History of Photography* 18, no. 2 (1994).

Owens, Craig. *Beyond Recognition: Representation, Power, and Culture.* Edited by Scott S. Bryson. Berkeley: University of California Press, 1994.

Parker, Andrew, and Eve Kosofsky Sedgwick, eds. *Performativity and Performance.* Essays from the English Institute. New York: Routledge, 1995.

Parker, Rozsika. "Censored! The Feminist Art That the Arts Council Is Trying to Hide." *Spare Rib*, January 1977.

———. "Killing the Angel in the House: Creativity, Femininity, and Aggression." *International Journal of Psychoanalysis* 79 (1998): 757–74.

Perry, Roger. *The Writing on the Wall: The Graffiti of London.* Photographed by Roger Perry. London: Elm Tree Books, 1976.

Petchesky, Rosalind Pollack. "Fetal Images: The Power of Visual Culture in the

Politics of Reproduction." In *The Gender/Sexuality Reader: Culture, History, Politcal Economy*, edited by Roger N. Lancaster and Micaela di Leonardo. New York and London: Routledge, 1997.

Phelan, Peggy. *Unmarked: The Politics of Performance*. New York: Routledge, 1993.

Pollock, Griselda. *Concentrationary Cinema: Aesthetics as Political Resistance in Alain Resnais's "Night and Fog."* Edited by Griselda Pollock and Max Silverman. New York: Berghahn Books, 2012.

———. "The Missing Future: MoMA and Modern Women." In *Modern Women: Women Artists at the Museum of Modern Art*, edited by Cornelia H. Butler and Alexandra Schwartz, 29–55. New York: Museum of Modern Art, 2010.

———. "Moments and Temporalities of the Avant-Garde 'in, of, and from the Feminine.'" *New Literary History* 41, no. 4 (2010): 795–820.

———. "The Pathos of the Political: Documentary, Subjectivity, and a Forgotten Moment of Feminist Avant-Garde Politics in Four Films from the 1970s." In *Work and the Image: Work in Modern Times, Visual Meditations, and Social Processes*, edited by Valérie Mainz and Griselda Pollock. Vol. 2. Aldershot: Ashgate, 2000.

———. "Screening the Seventies: Sexuality and Representation in Feminist Practice—a Brechtian Perspective." In *Vision and Difference: Femininity, Feminism, and Histories of Art*, 212–68. New York: Routledge, 1988.

———. "Still Working on the Subject: Feminist Poetics and Its Avant-Garde Moment." In *Rereading Post-Partum Document*, by Mary Kelly, 237–62. Vienna: Generali Foundation, 1999.

Pollock, Griselda, and Laura Mulvey. "Laura Mulvey in Conversation with Griselda Pollock." *Mamsie: Studies in the Maternal* 2, no. 1–2 (2009).

Pollock, Griselda, and Rozsika Parker, eds. *Framing Feminism: Art and the Women's Movement, 1970–85*. London: Pandora Press, 1987.

Poovey, Mary. "The Abortion Question and the Death of Man." In *Feminists Theorize the Political*, edited by Judith Butler and Joan W. Scott, 239–56. New York: Routledge, 1992.

P-Orridge, Genesis. "The First Throbbing Gristle Annual Report: A Conversation with Genesis P-Orridge, Part 1." *Slash* 2, no. 8 (September 1979): 22–24.

———. *GPO versus GPO: A Chronicle of Mail Art on Trial*. Geneva: Ecart Publications, 1976.

———. *Painful but Fabulous: The Lives and Art of Genesis P-Orridge*. London: Turnaround, 2002.

———. *Thirty Years of Being Cut Up*. New York: Invisible Exports, 2009.

P-Orridge, Genesis, and Colin Naylor. "Couming Along." *Art and Artists* 10, no. 9 (December 1975): 22–25.

P-Orridge, Genesis Breyer. *Thee Psychick Bible: Thee Apocryphal Scriptures ov Genesis Breyer P-Orridge and thee Third Mind ov thee Temple ov Psychick Youth.* Port Townsend: Feral House, 2010.

———. "Three Splinter Test." In *Arcana V: Music, Magic, and Mysticism,* edited by John Zorn. New York: Hips Road, 2010.

Proll, Astrid, ed. *Goodbye to London: Radical Art and Politics in the Seventies.* Ostfildern: Hatje Cantz, 2010.

———. "Hello London." In *Goodbye to London.* Ostfildern: Hatje Cantz, 2010.

Rabaté, Jean-Michel. *Writing the Image after Roland Barthes.* New Cultural Studies. Philadelphia: University of Pennsylvania Press, 1997.

Ray, Gene, and Lukas Beckmann. *Joseph Beuys: Mapping the Legacy.* New York: Distributed Art Publishers, 2001.

Reckitt, Helena, ed. *Art and Feminism.* Survey by Peggy Phelan. London: Phaidon, 2001.

Rees, A. L. "Warhol Waves: The Influence of Andy Warhol on the British Avant-Garde Film." In *Andy Warhol: Film Factory,* edited by Michael O'Pray, 124–35. London: BFI, 1989.

Roberts, John. *The Art of Interruption: Realism, Photography, and the Everyday.* The Critical Image. Manchester: Manchester University Press, 1998.

———. *The Intangibilities of Form: Skill and Deskilling in Art after the Readymade.* London: Verso, 2007.

———. "Interview with Victor Burgin." In *The Impossible Document: Photography and Conceptual Art in Britain, 1966–1976,* 80–104. London: Camerawords, 1997.

———. "Photography, Iconophobia, and the Ruins of Conceptual Art." In *The Impossible Document: Photography and Conceptual Art in Britain, 1966–1976,* 7–45. London: Camerawords, 1997.

———. *Postmodernism, Politics, and Art.* Cultural Politics. Manchester: Manchester University Press, 1990.

Ronell, Avital. "Deviant Paybacks: The Aims of Valerie Solanas." In *SCUM Manifesto,* by Valerie Solanas, 1–31. London: Verso, 2004.

Rose, Jacqueline. "The Imaginary." In *Sexuality in the Field of Vision,* 167–98. London: Verso, 1986.

———. "Femininity and Its Discontents." In *Sexuality in the Field of Vision,* 225–34. London: Verso, 1986.

Rosler, Martha. "In, Around, and Afterthought (on Documentary Photography)."

In *The Contest of Meaning: Critical Histories of Photography,* edited by Richard Bolton, 303–42. Cambridge, Mass.: MIT Press, 1992.

———. *Martha Rosler: Positions in the Life World.* Cambridge, Mass.: Ikon Gallery; Generali Foundation; MIT Press, 1998.

———. "Post-documentary, Post-photography?" In *Decoys and Disruptions: Selected Writings, 1975–2001,* 207–44. October Books. Cambridge Mass.: MIT Press, 2006.

———. *3 Works / Critical Essays on Photography and Photographs.* The Nova Scotia Pamphlets 1. Halifax, N.S.: Press of the Nova Scotia College of Art and Design, 1981.

Ross, Kristin. *Fast Cars, Clean Bodies: Decolonization and the Reordering of French Culture.* Cambridge, Mass.: MIT Press, 1995.

Rouch, Helene. "Le placenta comme tiers." *Languages* 85 (1987): 71–79.

Roud, R. *Straub.* London: Secker and Warburg, 1971.

Rowbotham, Sheila. *Promise of a Dream: Remembering the Sixties.* London: Verso, 2001.

———. *Woman's Consciousness, Man's World.* Harmondsworth, England: Penguin, 1973.

———. "Women and the Struggle for Freedom." *Black Dwarf,* January 1969.

———. *Women, Resistance, and Revolution.* Harmondsworth, England: Penguin, 1974.

Rubin, Gayle. "The Traffic in Women: Notes on the 'Political Economy' of Sex." In *Towards an Anthropology of Women,* edited by Rayna Reiter, 157–210. New York: Monthly Review Press, 1975.

Ruf, Beatrix, and Jan Verwoert, eds. *Tate Triennial 2006: New British Art.* London: Tate Publishing, 2006.

Salamon, Gayle. *Assuming a Body: Transgender and Rhetorics of Materiality.* New York: Columbia University Press, 2010.

Sanford, Stella. "Sex: A Transdisciplinary Concept." *Radical Philosophy,* no. 165 (February 2011).

Savage, Jon. *England's Dreaming: Anarchy, Sex Pistols, Punk Rock, and Beyond.* New York: St. Martin's Griffin, 2002.

Sayer, Janet. "Psychoanalysis and Personal Politics." *Feminist Review,* no. 10 (Spring 1982): 91–95.

Schapiro, Miriam. "The Education of Women as Artists: Project Womanhouse." *Art Journal* 31, no. 3 (Spring 1972): 268–70.

Schapiro, Peter. "Interview: Genesis P-Orridge." In *Modulations: A History of*

Electronic Music, Throbbing Words on Sound, edited by Peter Schapiro. New York: Caipirinha Productions, 2000.

Schneider, Rebecca. *The Explicit Body in Performance.* London: Routledge, 1997.

Schor, Mira. "Representations of the Penis." In *Wet: On Painting, Feminism, and Art Culture,* 13–35. Durham, N.C.: Duke University Press, 1997.

Sedgwick, Eve Kosofsky. *Tendencies.* Series Q. Durham, N.C.: Duke University Press, 1993.

———. *Touching Feeling: Affect, Pedagogy, Performativity.* Durham, N.C.: Duke University Press Books, 2002.

Sekula, Allan. "Dismantling Modernism, Reinventing Documentary (Notes on the Politics of Representation)." In *Photography/Politics: One,* edited by Jo Spence and Terry Dennett, 171–85. London: Photography Workshop, 1979.

———. *Fish Story.* Rotterdam: Witte de With, Center for Contemporary Art; Richter Verlag, 1995.

Setch, Eve Grace. "The Women's Liberation Movement in Britain, 1969–1979, Organisation, Creativity, and Debate." PhD diss., University of London, Royal Halloway, 2000.

Seven Days. "Miss World One Year on." *Seven Days* 4 (November 17, 1971): 5.

———. "Why Miss World?" *Seven Days* 3 (November 10, 1971): 21–23.

Shawcross, Nancy M. *Roland Barthes on Photography: The Critical Tradition in Perspective.* Crosscurrents. Gainesville: University Press of Florida, 1997.

Shedden, Leslie, and Studio Shedden. *Mining Photographs and Other Pictures, 1948–1968: A Selection from the Negative Archives of Shedden Studio, Glace Bay, Cape Breton.* The Nova Scotia Series. Halifax, N.S.: Press of the Nova Scotia College of Art and Design, 1983.

Silverman, Kaja. *The Acoustic Mirror: The Female Voice in Psychoanalysis and Cinema.* Bloomington: Indiana University Press, 1988.

———. "Suture." In *The Subject of Semiotics.* Oxford: Oxford University Press, 1983.

———. *Threshold of the Visible World.* New York: Routledge, 1996.

Sivanandan, A. *From Resistance to Rebellion.* London: Institute for Race Relations, 1986.

———. "Race and Resistance: The IRR Story." *Race & Class* 50, no. 2 (Autumn 2008): 1–30.

Sladen, Mark, and Ariella Yedgar. *Panic Attack! Art in the Punk Years.* London: Merrell Publishers, 2007.

Smith, Patrick S. *Andy Warhol's Art and Films.* Studies in the Fine Arts: The Avant-garde, no. 54. Ann Arbor, Mich.: UMI Research Press, 1986.

Smithson, Robert. *Robert Smithson: The Collected Writings.* Edited by Jack D. Flam. The Documents of Twentieth Century Art. Berkeley: University of California Press, 1996.

Sobchack, Vivian Carol. *The Address of the Eye: A Phenomenology of Film Experience.* Princeton, N.J.: Princeton University Press, 1991.

———. *Carnal Thoughts: Embodiment and Moving Image Culture.* Berkeley: University of California Press, 2004.

Solanas, Valerie. *SCUM Manifesto.* London: Verso, 2004.

Sontag, Susan. "Notes on 'Camp.'" In *Against Interpretation,* 275–92. New York: Picador, 1966.

———. *On Photography.* New York: Picador, 2001.

Spence, Jo. *Cultural Sniping: The Art of Transgression.* Comedia. New York: Routledge, 1995.

———. *Putting Myself in the Picture: A Political, Personal, and Photographic Autobiography.* Seattle: Real Comet Press, 1988.

Spence, Jo, and Terry Dennett. "Remodelling Photo-History: An Afterword on a Recent Exhibition." In *Cultural Sniping: The Art of Transgression,* by Jo Spence, 76–86. New York: Routledge, 1995.

Spigel, Lynn. "Theorizing the Bachelorette: 'Waves' of Feminist Media Studies." *Signs* 30, no. 1 (September 1, 2004): 1209–21.

Spivak, Gayatri Chakravorty. *A Critique of Postcolonial Reason: Towards a History of the Vanishing Present.* Cambridge, Mass.: Harvard University Press, 1999.

———. *Death of a Discipline.* New York: Columbia University Press, 2003.

———. "Feminism and Critical Theory." In *The Spivak Reader,* edited by Donna Landry and Gerald Maclean. New York: Routledge, 1996.

———. "French Feminism in an International Frame." *Yale French Studies,* no. 62 (Winter 1981): 154–84.

———. "In Praise of *Sammy and Rosie Get Laid.*" *Critical Quarterly* 31, no. 2 (1989): 80–88.

———. "Three Women's Texts and a Critique of Imperialism." *Critical Inquiry* 12, no. 1 (Fall 1985): 243–261.

Stabile, Carol. "Shooting the Mother: Fetal Photography and the Politics of Disappearance." In *The Visible Woman: Imaging Technologies, Gender, and Science,* edited by Lisa Cartwright, Constance Penley, and Paula Treichler, 171–97. New York: NYU Press, 1998.

Stallabrass, Julian. "Museum Photography and Museum Prose." *New Left Review,* no. 65 (October 2010): 93–125.

Stimson, Blake, and Gregory Sholette, eds. *Collectivism after Modernism: The Art of Social Imagination after 1945.* Minneapolis: University of Minnesota Press, 2007.

Sulter, Maud, ed. *Passion: Discourses on Blackwomen's Creativity.* Hebden Bridge, West Yorshire: Urban Fox Press, 1990.

Summers, David. "Form and Gender." *New Literary History* 24, no. 2 (Spring 1993): 243–71.

Sussman, Elisabeth, Peter Wollen, and Mark Francis. *On the Passage of a Few People through a Rather Brief Moment in Time: The Situationist International, 1957–1972.* Cambridge, Mass.: MIT Press; Institute of Contemporary Art, 1989.

Suter, Jacquelyn, Sandy Flitterman, and Laura Mulvey. "Textual Riddles: Woman as Enigma or Site of Social Meanings? An Interview with Laura Mulvey." *Discourse* 1 (1979): 86–127.

Taber, Clarence Wilber. *Taber's Dictionary of Gynecology and Obstetrics.* Philadelphia: F.A. Davis Co., 1944.

Tagg, John. *The Burden of Representation: Essays on Photographies and Histories.* Minneapolis: University of Minnesota Press, 1993.

———. *Grounds of Dispute: Art History, Cultural Politics, and the Discursive Field.* Communications and Culture. Houndmills, Basingstoke, Hampshire: Macmillan Education, 1992.

———. "Mindless Photography." In *Photography: Theoretical Snapshots,* edited by J. J. Long. New York: Routledge, 2009.

Terada, Rei. *Feeling in Theory: Emotion after the "Death of the Subject."* Cambridge, Mass.: Harvard University Press, 2003.

Tickner, Lisa. "The Body Politic: Female Sexuality and Women Artists since the 1970s." In *Framing Feminism: Art and the Women's Movement, 1970–1985,* edited by Rozsika Parker and Griselda Pollock, 263–77. New York: Pandora Press, 1987.

———. "Mediating Generations: The Mother-Daughter Plot." In *Women Artists at the Millennium,* edited by Carol Armstrong and Catherine de Zegher. Cambridge, Mass.: MIT Press, 2006.

Tinkcom, Matthew. *Working like a Homosexual: Camp, Capital, and Cinema.* Series Q. Durham, N.C.: Duke University Press, 2002.

Tomkins, Calvin. *The Bride and the Bachelor: The Heretical Courtship in Modern Art.* New York: Viking Press, 1965.

Trevelyan, Humphry. "Humphry Trevelyan in Conversation with Petra Bauer and Dan Kidner." In *Working Together: Notes on British Film Collectives in the 1970s,* edited by Petra Bauer and Dan Kidner, 47–55. Southend-on-Sea, England: Focal Point Gallery, 2010.

Tucker, Anne. "A History of the Film and Photo League: The Members Speak." *History of Photography* 18, no. 2 (1994).

Vergine, Lea. *Body Art and Performance: The Body as Language.* Milan: Skira Editore, 2000.

Vienet, Rene. "The Situationists and New Forms of Action against Politics and Art (1967)." In *Guy Debord and the Situationist International: Texts and Documents,* edited by Tom McDonough, 181–86. Cambridge, Mass.: MIT Press, 2002.

Wagner, Anne Middleton. *Mother Stone: The Vitality of Modern British Sculpture.* New Haven, Conn.: Yale University Press, 2005.

Walker, John Albert. *Left Shift: Radical Art in 1970s Britain.* New York: I. B. Tauris, 2002.

Wall, Jeff. "'Marks of Indifference': Aspects of Photography in, or as, Conceptual Art." In *Reconsidering the Object of Art: 1965–1975,* edited by Anne Rorimer and Anne Goldstein, 247–67. Los Angeles and Cambridge, Mass.: Museum of Contemporary Art and MIT Press, 1995.

Walsh, Martin. *The Brechtian Aspect of Radical Cinema.* London: British Film Institute, 1981.

———. "Political Formation in the Cinema of Jean-Marie Straub." *Jump Cut* 4 (1974): 12–18.

Walter, Audrey. *Come Together: The Years of Gay Liberation, 1970–1973.* London: Gay Men's Press, 1980.

Wandor, Michelene. *The Body Politic: Women's Liberation in Britain.* London: Stage 1, 1972.

Wark, McKenzie. *50 Years of Recuperation of the Situationist International.* FORuM Project. New York: Temple Hoyne Buell Center for the Study of American Architecture, Princeton Architectural Press, 2008.

Wates, Nick. *The Battle for Tolmers Square.* Boston: Routledge & Keegan Paul, 1976.

Weeks, Jeffrey. *Coming Out: Homosexual Politics in Britain from the Nineteenth Century to the Present.* London: Quartet Books, 1977.

Williams, Alan Larson. *Republic of Images: A History of French Filmmaking.* Cambridge, Mass.: Harvard University Press, 1992.

Williams, Chris. *Democratic Rhondda: Politics and Society, 1885–1951.* Cardiff: University of Wales Press, 1996.

Williams, Linda, ed. *Viewing Positions: Ways of Seeing Film.* New Brunswick, N.J.: Rutgers University Press, 1994.

Williams, Raymond. "Structures of Feeling." In *Marxism and Literature,* 128–35. Oxford: Oxford University Press, 1977.

Wilson, Amrit. *Finding a Voice: Asian Women in Britain.* London: Virago, 1978.

Wilson, Elizabeth. "Psychoanalysis: Psychic Law and Order?" *Feminist Review,* no. 8 (Summer 1981): 63–78.

Wilson, Siona. "Destinations for Feminist Art: Past, Present, and Future." *Women's Studies Quarterly* 36, no. 1/2 (2008): 302–7.

———. "From Women's Work to the Umbilical Lens: Mary Kelly's Early Films." *Art History* 31, no. 1 (February 2008): 79–102.

———. "'Girls Say Yes to Boys Who Say No': Four Artists Refigure the Sex-War on Terror." *Oxford Art Journal* 32, no. 1 (2009): 121–42.

———. "Reading Freire in London: Jo Spence's Photographs between Popular and Avant-Garde." In *The Popular Avant-Garde,* edited by Renée M. Silverman, 183–99. Amsterdam: Rodopi, 2010.

Winston, Brian. *Claiming the Real: The Documentary Film Revisited.* London: British Film Institute, 1995.

Wlodarz, Joe. "Love Letter to Jane." *Camera Obscura.* no. 67 (2008): 160.

Wollen, Peter. "Counter-cinema: *Vent d'est.*" *Afterimage* 4 (1972): 6–16.

———. "Photography and Aesthetics." *Screen* 19 no. 4 (Winter 1978): 9–28.

———. *Signs and Meaning in the Cinema.* Rev. ed. Bloomington: Indiana University Press, 1972.

Wright, Elizabeth, ed. *Feminism and Psychoanalysis: A Critical Dictionary.* Blackwell Reference. Cambridge, Mass.: Blackwell, 1992.

Wright, Patrick. "A Passion for Images." *Vertigo* 1, no. 9 (1999).

Yoshimoto, Midori. *Into Performance: Japanese Women Artists in New York.* New Brunswick, N.J.: Rutgers University Press, 2005.

Young, Tricia Henry. *Break All Rules! Punk Rock and the Making of a Style.* Studies in the Fine Arts: The Avant-garde, no. 68. Ann Arbor, Mich.: UMI Research Press, 1989.

Index

Marker, Chris, 34, 35, 208–9n12
"'Marks of Indifference': Aspects of Photography in, or as, Conceptual Art" (Wall), 148
Martin, Biddy, 123
Martin, Gérard, 209n15
Martin, Rosy, 193, 235n33
Marx, Karl, xvi, xxiv, 58, 66, 68, 69–70, 71, 220n49; historical materialism of, 76; labor power and, 70, 74; reproduction and, 69
Marxism, xvi, xvii, 61, 66, 70, 76, 93, 173
masculinity, xxii, 53, 121; institutional construction of, xxiii; labor and, 122; social/cultural ideas of, xxiii
Mass Observation, 234n30
Mastai, Judith, 25, 214n62, 214n65, 233n23; *Nightcleaners* and, 26, 27–28
materialism, 38–49
maternal body, 83, 185; antepartum, 72–73; connection to/disconnection from, 85
maternal-feminine, 77, 90
Mathison, Trevor, xviii
May '68 uprisings, xv, xvi, xxi, xxv, xxvi, 1, 35, 101; art after, 102; art historical accounts of, xiv; BFI and, 145; politicization of film after, 20–24; situationists and, 6; women/class struggle and, 43–44
McLaren, Malcolm, 124, 230n67
McLuhan, Marshall, 98, 103
media, 95, 106, 181
Medvedkin, Alexander, 208–9n12
Megson, Neil, 98
Meizer, Michael, 54
Menstruation Bathroom (Chicago), 130, 132, 134
Merck, Mandy, xxiv, 78

Messingkauf Dialogues (Brecht), 213n50
Metropolis Pictures, 159
Metropolitan Museum of Art, 236n47
Metz, Christian, 186
Me, You, Us, Them (exhibition), 203n4
Michelson, Annette, 22, 24, 109
Midnight's Children (Rushdie), xviii
Millman, Maggie, 233n20
Ministry of Antisocial Insecurity (MAI), 103, 104
Minsky, Helen, 124
"Mirror Stage, The" (Lacan), 165
Miss America Beauty Pageant: feminist disruption of, 1
Miss World Beauty Contest, 1, 2, 3, 207n3; action at, 6, 20, 25
Mitchell, Juliet, xix, xxii, xxiv, xxvii, 66, 75, 78, 136; Reich and, xxi; on reproduction/production, xviii, 77; woman question and, xviii; women's liberation and, xvi
modernism, 28, 149, 178, 234n24
modernity, 28, 77, 150, 164; rewriting, 71–72, 90
Modern Women Fund, 205n18
MoMA. *See* Museum of Modern Art
Mordaunt, Richard, 24, 215–16n85
Mormont, Jean, 33, 214–15n72; feminism and, 216n94; film still of, 33, 34
Morris, Robert, 56
Mother Stone (Wagner), 223n70
Mozart, Wolfgang Amadeus, 99
Mulholland, Neil, 99
Mullen, Michael Ann, 233n20
Mulvey, Laura, xxiv, xxv, xxvii, 1, 6, 22, 26, 77–78, 80, 136, 179, 181, 183, 185, 188, 203n4, 211n37, 212n39, 212n41, 214n58; analysis by, 79, 84; beauty and, 85; BFI and, 20; essay by, 168; female

SIONA WILSON is associate professor of art history at the Graduate Center and the College of Staten Island, the City University of New York.